© Text and personal archives: 2008, George Lois.

© 2008 Assouline Publishing
601 West 26th Street, 18th Floor
New York, NY 10001, USA
www.assouline.com

ISBN: 978 2 75940 299 1

Writer and Designer: George Lois
Digital Design and Composition: Luke Lois, Good Karma Creative

Printed in China

GEORGE LOIS
ON HIS CREATION OF
THE BIG IDEA

ASSOULINE

**This book
is gratefully
dedicated
to my Motivators**

Haralampos Lois
Ida Engel
Paul Rand
Herschel Levit

my Mentors

Reba Sochis
Bill Golden
Kurt Weihs
Herb Lubalin
Lou Dorfsman
Bill Bernbach
Bob Gage

and my Muse

Rosemary Lois

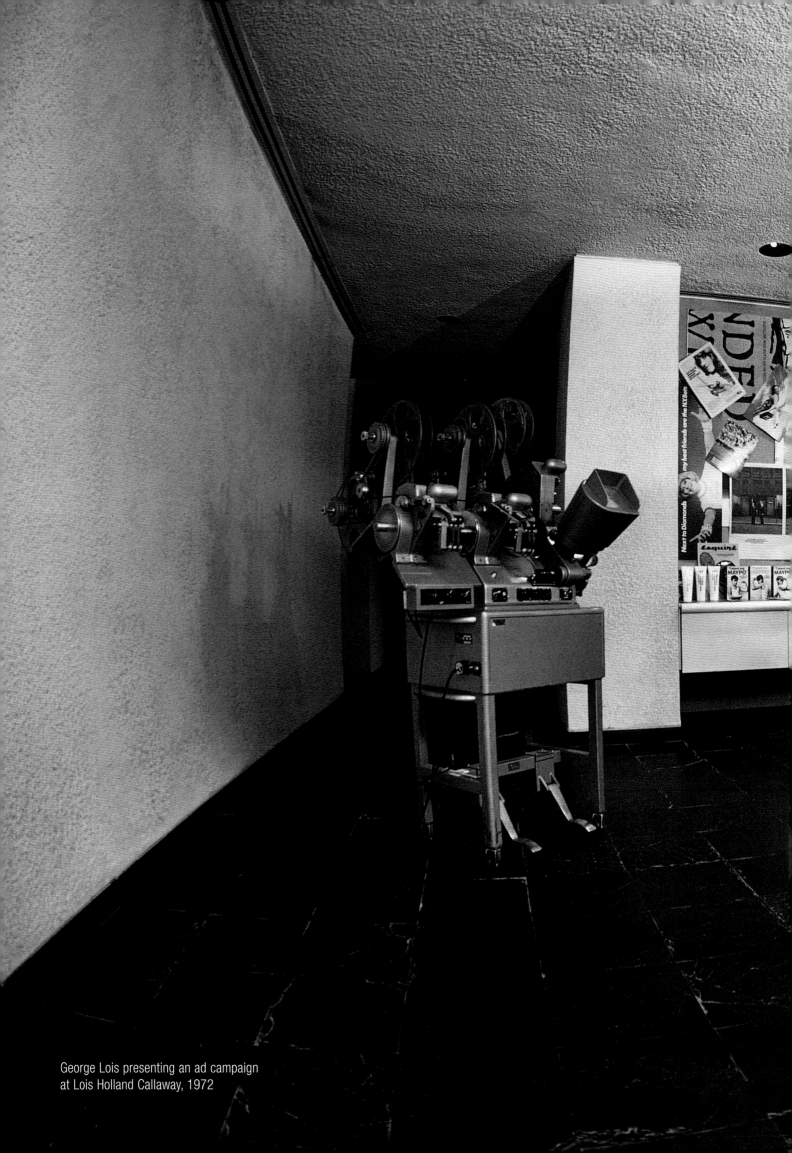

George Lois presenting an ad campaign
at Lois Holland Callaway, 1972

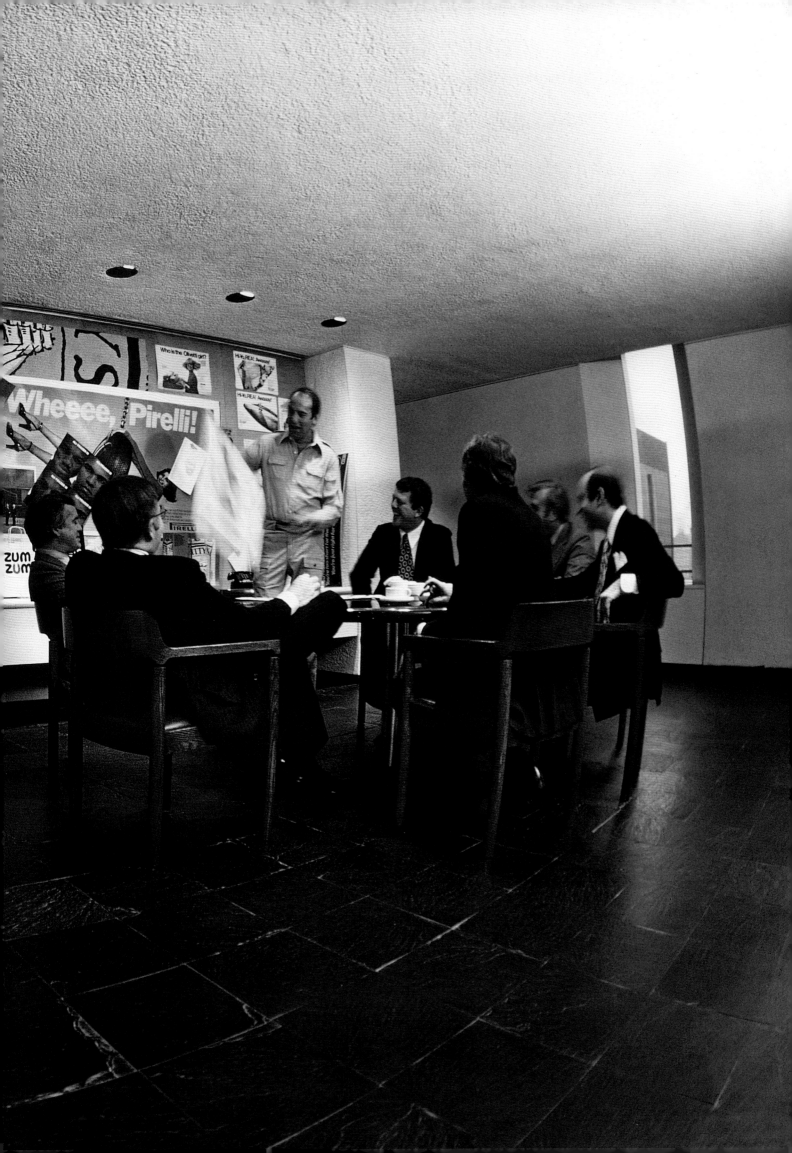

TABLE OF CONTENTS

Motivators, Mentors & Muse
Timeline

George Lois, 1960

INTRODUCTION

Eureka—"I have found it!"
The thousands of times I cried "Eureka" (pronounced correctly in the Greek of my forefathers) was, each time,
the culmination of what I have always called "the search for the Big Idea": To solve a specific communications problem
with words and images that catch people's eyes, penetrate their minds, warm their hearts, and cause them
to act. The ethos of my life has been the passionate belief that creativity can solve almost any problem—the Big Idea,
the defeat of habit by originality, overcomes everything.

With this book, I now understand that my search for the present seems to have been a poetic recovery of the past.

The shock of an epiphany, a word derived from the Greek word *epiphanie* that elegantly expresses the emotional appearance
of a simple, striking, sudden manifestation, a perception of a powerful experience, has been an almost daily occurrence
since I was ten years old. The essence of its power enters the central nervous system and the deep recesses of the mind,
mystically echoing throughout much of my work. Museums are custodians of epiphanies. My spiritual day of worship is spent
each Sunday at New York City's Metropolitan Museum of Art, where I experience, without fail, the Shock of the Old.

I was struck dumb at the first sight of a Cycladic idol, blinded by the radiance of Mantegna's *Dead Christ*, Ingres's heavenly
drawings, Uccello's entangled battle scenes, and penetrating portraits by Holbein, El Greco and Velasquez.
Epiphanies of the eye have given my life endless days of thrilling euphoria. In high school I worshiped the paintings
of the American modernist Stuart Davis, with his floating words jammed between objects and shapes,
but strangely the spontaneity of a Cassandre poster, with its merging of words and images into a wholly new language
seemed even more thrilling. There were more hints of this new way of communicating in the work of Paul Rand
(greatly inspired by the oeuvre of Calder, Klee and Miro), who struck out boldly during the forties by visualizing copy in an
individualistic manner. At age 15, I started to get more of a kick out of Cassandre and Rand than Picasso
or Leger or Brancusi or Davis. I knew I was hooked. I would spend my life producing advertising to sell products and ideas.
And mysteriously, the history of the art of mankind somehow mythically formed the ethos that has inspired
my career of creating breakthrough ideas for selling.

With the shock of a thunderbolt that seemingly comes out of the blue (always a combination of thinking *and* intuition),
the mythical and artful blending of context, image, words, and art can lead to magic, a juxtaposition of opposites
that are dramatically connected visually. Concepts spring from the earth, and if they are big enough, are earth shattering.
Great graphic communication depends on understanding and adapting to the culture, anticipating the culture,
criticizing changes in the culture, and sometimes helping to change the culture—but an eagle eye focused on five thousand
years of the history of art remains the DNA of creative thought.

A work of art derives its identity from its visibility and from the response it evokes. I spend all my time feeding
the inner eye, the artistic persona that operates, somewhat mysteriously, from the subconscious. I drink in that art created
by generations of mentors who have been the antennae of human sensibility, artists who kept faith with the past
without being captive to it. More than any time in world history, the genius of thousands of years of art have inspired and
influenced the modern artists of the twentieth century. There remains a timelessness of great art of the past
that resonates with the present. The greatest artists have always been those who understood the art of the past but who
broke with it according to the needs of their time. I see my own role as precisely that of those artists whose work
I epiphanize. This book probes the echoes in my mind's eye, attempting to trace the images I have created during the last
half century back to each original shock, whether works of Art with a capital A, the pervading influence of popular
culture, or penetrating news events.

And yet, with inspirations everywhere in sight, the artist becomes the last champion of the individual mind against
a conservative, indoctrinated society. So, fair warning: Genuine innovation, originality, and creativity (nailing The Big Idea)
go beyond previous learning, sightings, or experience—and remain a mystery.

GEORGE LOIS

A 5,000 YEAR GUIDE TO GEORGE LOIS

While others have succeeded brilliantly in the advertising agency business (Bernbach, Ogilvy, Reeves, Burnett, Wells), the success of George Lois has been the achievement of an *art director*. This seemingly fluke development came about through ego, personal force, demonic drive, indefatigability, and an almost savage competitive passion. But beyond these qualities of personality, a fierce talent has governed his career and has inspired a remarkable body of work.

The art of Lois, that audacious blending of image and word, that fury to communicate what he calls "The Big Idea," is his major contribution to the history of advertising. This influential adman/art director is the product of many influences. From the purity and mystery of African sculpture, a lifelong Lois love, through the comics, and right up to twentieth-century painting and sculpture, the advertising art of Lois draws many of its techniques. He was dubbed "Parlor primitive" by *New York* magazine for his remarkable collection that literally dominates his Greenwich Village apartment. Lois lives with his wife Rosemary, a Cycladic figure (3,000 BC!), a Greek vase, Eskimo masks, Maori sculpture, an Easter Island skeleton figure, a Northwest Coast rattle, Fang heads, bannerstones, Asmat shields, fertility dolls, stone pipes, ivory fetishes, flaring headdresses, cult objects, ceremonial staffs and assorted primitive statuary, including a four-foot Uli (a rarity of Oceanic art from the Pacific island of New Ireland, a wooden male god with pagan Halloween eyes, large breasts, and an erect penis, painted and pigmented over generations to a magical luster). Unexpected, mystical, profoundly simple, geometrically enthralling—these common chords of primitive art that hypnotized Picasso and led to Cubism—these same sources of wonder surround an ad-agency art director named George Lois as he watches *King Kong* on TV in his Manhattan apartment.

As a high school student, Lois was mesmerized by the American painter Stuart Davis, who dramatically simplified forms and reduced them to a system of flat planes and geometric shapes. Brancusi, the Rumanian peasant mystic, was another Lois favorite as a youngster. There is a sturdy coherence to this attraction. *Bird in Flight*, *Sleeping Muse*, *The Kiss*, *The Prayer*, *The Seal*, and *The Fish* are all the boldest possible simplifications of form, while producing an overwhelming, entirely unexpected emotional response. And years before Georges de La Tour became suddenly known in 1974, Lois was urging me to study his work. One day, he brought in a French volume of La Tour's paintings. They were stark scenes without backgrounds, forms of intense simplicity, lights and darks in concentrated juxtaposition. From Uccello to Corbusier, from Della Francesca to Noguchi, from Bellini to Bauhaus, from Oceanic art to Arthur Dove, Lois soaked in the details and saw the essence of their work.

Look at any layout or storyboard by Lois and you'll find a game board of his eclectic obsessions. The face of a Lois woman is strikingly similar to Ella Cinders, that oval-eyed innocent of the comics. Or are her arcs of hair closer to a Bakota reliquary figure from Gabon? The male figures in his layouts are a ringer for Dick Tracy. Or is it the flat-chinned face of a Cycladic idol? His drawings of people, male and female, are two-dimensional renderings of Elie Nadelman's painted cherrywood carvings. Or are they more like the Greek vase paintings of a sixth-century BC amphora? Invariably, his work reaches out for an unexpected effect, that common denominator of primitive art. To a much larger extent than meets the eye, the works of George Lois derive from an unconscious connection with primitive myth and art. His unashamedly commercial career has produced a body of work that recaptures and recycles the common experience of video age Americans. This unexpected transformation of cultural matter clarifies our out-of-focus times—in advertising! These works of a modern art director will one day be seen as the work of an *artist*.

BILL PITTS (1925-1992)
Written on the occasion of George Lois' induction into the Art Directors Hall of Fame, November 1978

CLARITY THAT COMES
FROM A RELENTLESS SEARCH FOR THE TRUTH

A Lifetime Achievement Award to George Lois leads one to a mind-bending
archeological dig for the lost tribe of the '60s era and after, turning up an advertising
artifact here, a magazine cover there, astonished to a consciousness of the
engravings on the walls of the caves of your own psyche. You are suddenly filled with
a mixture of joy and dread that comes from discovering that the past,
the present, and the future exist simultaneously through the portal of a single image.
Thus is the power of design. This is cosmology, paleontology.

Time collapses whenever George Lois shuffles the icons of deadly sin as if they were
a deck of playing cards, and then, right before your eyes, he deals them
face up with the gusto of a wheeler-dealer out of Harland Ellison's science fiction.
The minute you sat down to play—the second you looked at his work—
he knew, and you knew, he gotcha!

His *Esquire* magazine covers: the prettified Richard Nixon; a smiling Lieutenant Calley
hugging beautiful children of My Lai, reminding us of our nation's current
campaign to hold contradictory perceptions simultaneously; JFK, Dr. King, RFK—standing
erect in a sea of tombstones (is our innocence buried?); Muhammad Ali,
hands tied behind his back, shot through with arrows (we inflicted his wounds).
Searing juxtapositions—see it once, you own it—and it owns you!
(Which is what all great art achieves—it makes us both observer and participant.)
See Andy Warhol drowning in a can of Campbell's and you realize Lois
is pulling you into the primal soup of life-and-death confrontation with avant-garde art.

Blunt, direct, uncompromising—George Lois's work challenges anything today which strives
to achieve an accommodation with hypocrisy. A review of his life's work produces
a longing for the clarity that comes from a relentless search for truth. Bring us home, George.
Tonight our nation turns its lonely eyes to you.
Bring us home.

Dennis J. Kucinich

CONGRESSMAN DENNIS KUCINICH

*A speech delivered on the occasion of George Lois
receiving a Lifetime Achievement Award
from the Society of Publication Designers, May 7, 2004*

INEXPLICABLE, BUT UNDENIABLE, LINKAGES

Stop. Imagine a man, completely blind, whose sight was suddenly and completely restored.
Just watch his reaction. Gaping, open-mouthed, shocked at his newfound world.
Greedily devouring the miracle of a flower, of a tree, of a cloud. Thirstily exploring the face
of his spouse, his child—even the humdrum world the rest of us no longer see.
Delighting in the most majestic (and the most mundane) things that surround him.

Well, from the moment of his birth (and maybe even before), George Lois has used his
eyes, nonstop, as though they'd just been issued to him. He not only looks,
he sees. Every waking moment, he's worked his baby blues to death. Nothing escapes
his curiosity, and everything is worth a closer look. A lifetime search for
treasured epiphanies.

Prowling the world's museums, stealing the essence of their paintings and sculptures.
Sneaking into Yankees games as a kid; sitting ringside at championship bouts
as a grown-up. Using his R&R time during the Korean War to watch Kabuki plays in Japan.
Remembering every movie since 1936, every Broadway show since *Oklahoma*.
Architecture, street brawls, ballets, politics, fashion, restaurants, churches, strip shows,
all captured and permanently stored in the limitless tunnels and corridors of his brain.

But here's the weird part: George Lois is advertising's most famous art director. He founded
the Creative Revolution that spawned modern advertising. His "Big Idea" concepts and
iconoclastic design genius energized word with picture in ways that shocked, then pleased,
and finally convinced the viewer. And yet...and yet...the ideas that inspired Lois's
greatest works had no connection to the mother lode of visuals socked away in a lifetime
of looking.

Or so George Lois thought...until now.

Because in this book, side by side, you'll see the eye-stopping images that Lois created
and their uncanny traces to something...anything...that passed through his eye,
was subconsciously stored, and unconsciously retrieved. And in his punchy, pungent,
and funny writing, George explains the inexplicable, but undeniable linkages
between his work and his lifetime of looking, oh so deeply.

Each double page is a journey that'll keep your eyes shifting back and forth, between
Lois' concepts and the unconnected seed that gave them life.

This is a disturbing and delightful book.

P.S. If you read each caption, you'll laugh and understand this book.
If you read the accompanying text, you'll get an informal but memorable gallop
through classical art and pop culture.

J. RONALD HOLLAND

George Lois, 2004

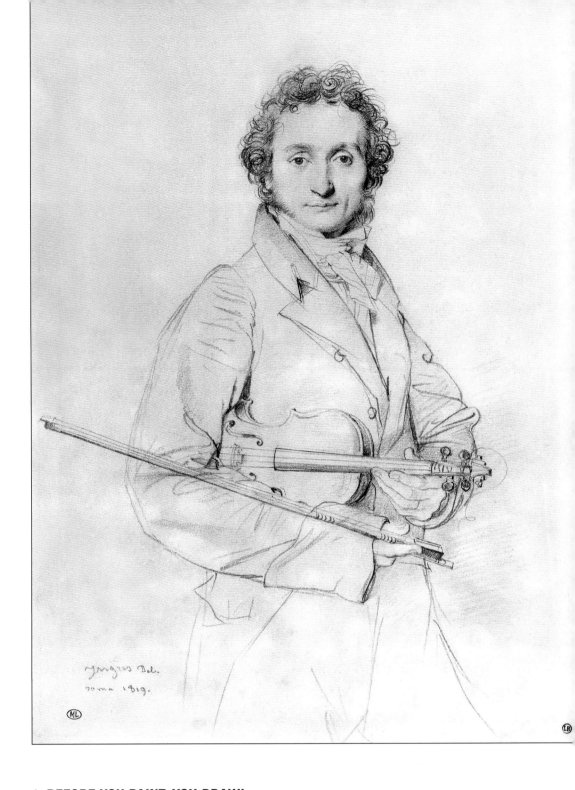

1. BEFORE YOU PAINT, YOU DRAW!

There were no faux pas in the drawings of Jean-Auguste-Dominique Ingres. Along with
Delacroix, Courbet and Manet, Ingres was one of the foremost French painters
and draftsmen of the nineteenth century, a great classicist and a master of line and form in
the magnificent mainstream of the European tradition. Above all, he was an
artist outside of time. The power of his work, for those of us who believe in the
march of time, is his way of being unplaceable in time. Ingres stood firm
for the principles of classical composition. Yet so strong and original was his artistic
temperament that his synthesis of linear pattern and color harmonies border
on the abstract; indeed the abstraction of Ingres inspired some of Picasso's boldest
departures. But first, and always, came the thrilling act of drawing. For Ingres,
for Picasso, for anyone who wishes to spend their lifetime as a painter, sculptor,
architect, director, graphic designer, clothes designer or inventor—if you can't
draw—it means you can't *see*. (Study this penetrating drawing by Ingres of the great
violinist Niccolò Paganini, and you'll hear beautiful music.)

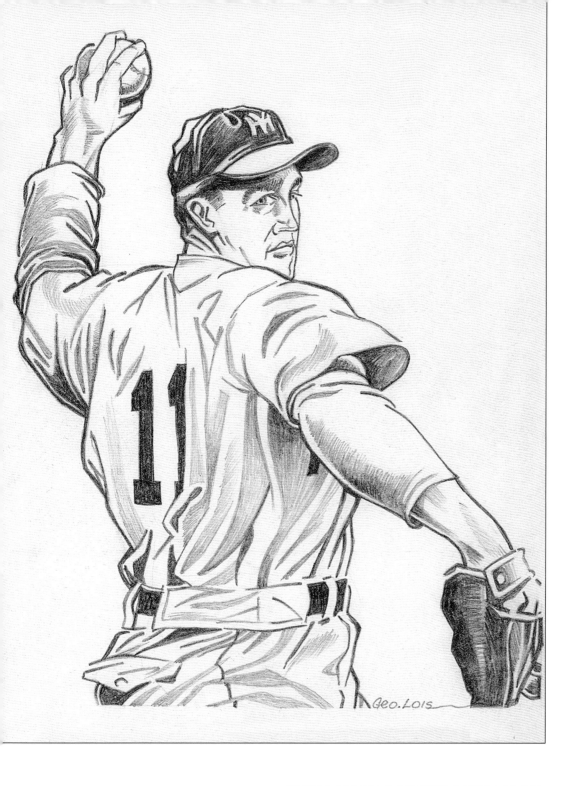

IF YOU CAN'T DRAW, YOU CAN'T CREATE!

On May 13, 1944, just called up from the minor leagues, lefty Joe Page threw a
five-hitter, beating the Cleveland Indians. I was 13 years old and, with
much adulation, I did an ultrastylized drawing of Smokin' Joe. It was among
dozens of drawings I did of the athletes of that time, all in the same
manneristic hand of a cocky kid who knew he could draw, and was showing off
with flamboyant line and shading. In the day when starting pitchers were
counted on to pitch nine full innings, Joe went on to become the star reliever
for three Yankees World Championships, triggering the widespread
use of the relief specialist. When I entered the High School of Music & Art in
Manhattan, I discarded the slick, sleight-of-hand drawing style of my
Joe Page drawing for more elegant, simplified, naturalistic abstraction, and
I continue to draw with a seemingly effortless, flowing line, truly *seeing*.

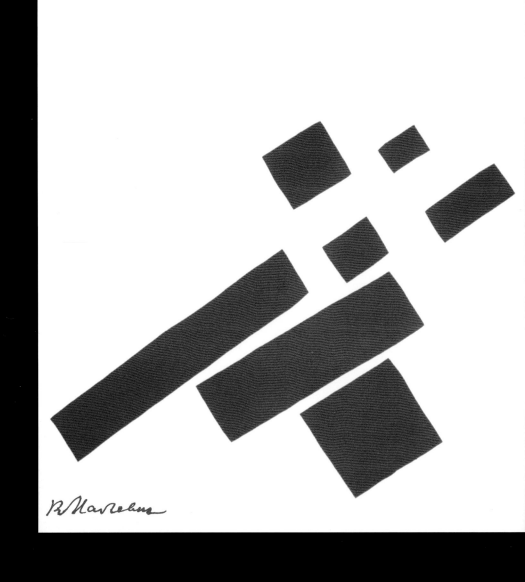

2. RECTANGLES, RECTANGLES, RECTANGLES

In the early twentieth century, there was an explosion of creativity that gained world-renown before
the Soviet Union clamped down on modern art and imposed the creed of Socialist realism.
In the footsteps of the design work of the Scot Charles Rennie Mackintosh; the Wiener Werkstätte in Austria;
Mondrian and the De Stijl movement in Holland; and the harbinger of the Bauhaus in Germany,
the Suprematist artists of the Russian Revolution set out to transform the visual universe by setting
geometric forms in motion through endless space. Foremost among the creators of the new
abstract art, which through its application in architecture was intended to be the blueprint for a new world,
was Kazimir Malevich, who coined the word "Suprematist." In 1915, Malevich changed the
future of modern art when his experiments in painting led the Russian avant-garde into pure abstraction.
Circles and triangles made their appearance in Malevich's work, but dynamic hard-edged
rectangles were his visual battering ram. (Somehow, even after the Soviets' official rejection of abstract art,
Malevich retained his importance as a pioneering display designer celebrating the new
power of the nation's production industry.) Debate on Suprematism covered a wide range of opinions.
At one extreme was the belief that the movement was a manifestation of the decay and ruin
of painting; the opposite point of view saw it as a portent of the art of the future.

AND THE ULTIMATE RECTANGLE DESIGN!

As a 15-year-old, in my first year at the High School of Music & Art, in a basic design course, we were asked
to create similar compositions, in a 40-minute class, each and every day. The more we ripped off a Herbert Bayer,
Paul Klee, Josef Albers, Mondrian, or a Malevich, the better Mr. Patterson liked it. Bo-r-r-ring! So in the
last class of the year, when Mr. Patterson sternly, once again, asked us to create a design on 18×24 illustration board
using only rectangles and called it a final exam, I made my move. As 26 classmates worked furiously,
cutting, pasting, and eye-balling, I sat, somewhat smugly, motionless. Mr. Patterson, keeping his eye on me, was doing
a slow burn as he walked through the aisles of the studio classroom, peering over the shoulder of
each student. Time was up. He grew apoplectic as he was stacking the final designs in a pile, and, truly pissed,
he went to grab my completely empty board, when I thrust my arm forward and interrupted him by
casually signing "G. Lois" in the bottom left-hand corner. He was thunderstruck when he realized that I had
created" a pure 18×24 rectangle—the ultimate rectangle design! I had taught myself that my work had
to be fresh, different, seemingly outrageous. Mr. Patterson (reluctantly) gave me an A. I knew art background was
essential, but I had finally come to understand, through my empty page as a design solution, that
nothing is as exciting as an *idea*. Since that career-defining escapade at M&A, I've always thought of the execution
of an idea as a drag race whose finish line is the edge of a cliff: If you push your idea to within a few
inches of the edge, you win. (Of course, if you go too far, you plummet to a fiery death.) Today I recognize
my ultimate rectangle design as the epiphany that signaled that I would spend my life, not merely
as a designer of form, but as a conceiver of big ideas.

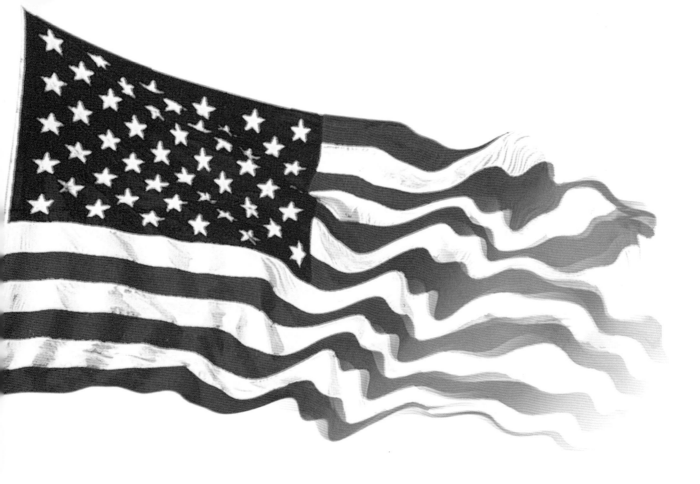

3. WE SENT IT UP THE FLAGPOLE...

The fathers of our country conspired and fought under the "Rebellious Stripes."
The stripes were created ahead of our stars, with no need for a redundant design
to represent the Thirteen Colonies. In our early national flags, the depiction
of the states was small, showing a reluctance to interfere with the beloved stripes.
(As late as 1814, when Francis Scott Key wrote a poem that would become
lyrics for our national anthem, he hailed the "broad stripes and bright stars.")
But as the country grew, the function of visually representing the states
of the nation became paramount, politically and emotionally. In 1818, the Monroe
administration wisely limited the stripes to the original thirteen (they had
grown to fifteen, along with fifteen stars). The thirteen stripes of our original colonies
remained our cornerstone, but the field of stars expanded into an ever-more
glowing galaxy. Our grand old flag has been a living symbol that expanded with
the nation, a flag continuously shaped by the people. Finally, as a dynamic
and provocative graphic design, the waving American flag transforms even more
gloriously in undulating ripples and waves.

...TO SEE IF ANYONE WOULD SALUTE.

In 1952, a few weeks after I returned home from the war in Korea, Bill Golden, the corporate design pioneer
who branded the CBS graphic style, asked me to design a letterhead for the daily CBS press releases
for the upcoming Democratic and Republican presidential conventions. I responded with a surprising design,
with type forming the bars of Old Glory, and a starlike pattern of an overhead convention scene with
posters being held up high by state delegates. There have been numerous flag rip-offs since my letterhead, but
in 1952, this one created a helluva flap. The day the first press release appeared under my letterhead,
the shit hit the flag! In the dreaded days when civil liberties were suffocating in America, Senator Joseph McCarthy
and a host of Red-baiters attacked CBS for "desecrating" our flag. The House Un-American Activities
Committee denounced CBS, and the FBI paid them a visit. Chairman William Paley and President Frank Stanton,
already under attack as "Eastern establishment liberal pinkos," flinched. The CBS honchos were staunch
supporters of my letterhead, but the pressure was on. One evening, Bill Golden warned me there could be a
decision made that night to kill the flag letterhead to placate the critics. Early the next morning,
"through the perilous fight...gave proof though the night that our flag was still there." Golden informed me
that the CBS brass said "to hell with McCarthy and his gang."

**DEMOCRATIC &
REPUBLICAN
PRESIDENTIAL
CONVENTION**
NEWS FROM CBS TELEVISION
PRESS INFORMATION ⊚ 485
MADISON AVENUE NEW YORK

4. A WILD-EYED ABSTRACT PAINTER INSTILLS MY LOVE FOR TYPE FONTS.

Though I hand-lettered my poster designs at the High School of Music & Art, my first type course
was at Pratt Institute in 1949. My teacher, paradoxically, was a first-generation Abstract
Expressionist painter, James Brooks, a pal and soul mate of Jackson Pollack's. Abstract painting
(and certainly "accidental" drip painting) have nothing in common with classical type forms!
But his class was an epiphany, as he precisely drew, as large as he could fit on a blackboard, a dozen
fonts—Caslon, Times Roman, Cheltenham, and all the greats—with such gusto that it took my
breath away. I'll always be indebted to Mr. Brooks for opening my eyes to the great typefaces,
and for making me realize that they were as monumentally sculpted as any Brancusi.

"GEORGE," SAID BILL GOLDEN, "THERE'S NEVER BEEN A MORE BEAUTIFUL TYPEFACE THAN BODONI. REDESIGN IT!"

In 1953, four years after leaving school and back from the Korean War and a few days into my dream job as a designer
at CBS Television, my boss, Bill Golden, swept into my office and told me he wanted me to "redesign" the
Bodoni typeface. Huh? Golden's corporate design styling for the network, highlighted by the great CBS eye, was capturing
the imagination and adoration of the whole world. He handed me a variation of Bodoni by the French designer
Pierre Didot and said he craved a unique CBS font—but he wanted *Bodoni*. I was shocked. He might as well have asked
me to redesign the *Parthenon*! But, in between hundreds of ads and sales kits and promotion pieces, I drew in
pencil and then in India ink a 12-inch-high alphabet, along with a full set of numbers, that was used for theater marquees
and advertising headlines for almost forty years. Other than the curves of a woman's legs, I find no visual pleasure
greater than the architecture of a truly great typeface. Thank you, Mr. Brooks.

LOIS
1234
567
89

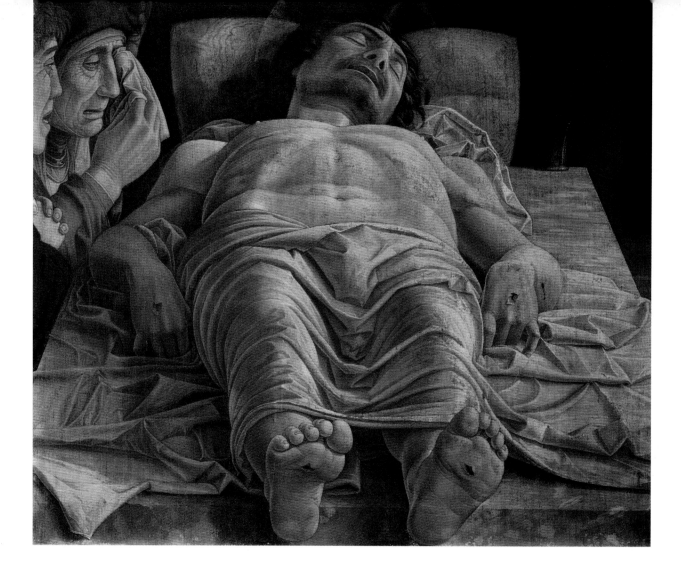

5. THE VISUAL POWER OF FORESHORTENED PERSPECTIVE...

The Lamentation over the Dead Christ was one of the last works of Andrea Mantegna, the most sublime of the
northern Italian painters of the Renaissance, who created masterworks full of tension through bold use of perspective,
and very high or low viewpoints. Many great artists, aware of their approaching death, have expressed their
state of mind with chilling, somber subject matter. This great easel painting was in Mantegna's studio when he died.
(Perhaps the artist had painted the crucified Jesus, not for the usual patron, but as a lamentation for himself.)
The Italian title in the inventory of his estate was *Cristo in Scurbo* ("Foreshortened Christ"). Unprecedented in the
history of Christian art, Mantegna gives us a view of the pierced soles of the Redeemer's feet, which are
hanging out towards us over the edge of a mortuary slab, as his internment cloth molds itself to his body and to the
slab as though they were wet. The breathtaking, rapidly vanishing perspective, beginning at the feet of Jesus,
forces us to be transfixed by the sight of the wounds to his feet and hands. The skin cracks dryly around each wound,
and his body lies pallid on the reddish slab, the figure drained of blood. Two mourners are at the side
of Mary, excruciatingly drying her tears, with the composition radically cropped at the upper left-hand corner.
After being removed from the cross, in accordance with Jewish burial rites, Jesus' corpse was washed,
dressed with aromatic oils, and then wrapped in a clean linen. This ritual was carried out on a slab on which Mary's
tears, many believe, "left marks which, to this day, have not been eradicated." In my High School of
Music & Art history of art course on the Renaissance, my first sight of the *Dead Christ*, lying prostrate, his toes
a foot from his chin, absolutely floored me.

This is a public confession: As a returning 21-year-old Korean War veteran, I bolted out of the starting gate at CBS Television with the assignment to design a cover to a sales promotion and advertising kit for its most important sports spectacular and ratings winner of the year, the Triple Crown, that included ad mats and film trailers for CBS stations all over the country. I dug up a news shot of a phalanx of thoroughbreds pounding around a turn as seen by the hoi polloi cramming the rail. I went out to the Belmont Park racetrack on Long Island to photograph fresh turf, took a ground-level photo, in head-on "Mantegna perspective," and printed the two pictures to create one image. You would have thought that I had taken the photo lying on my belly on the track (and given my life to my network). The chilling image of a photographer about to be trampled to death obviously caught the eye of the pro news photographers—I was shocked to read in the *New York Daily News* that my doctored assemblage was named the best sports photograph of 1954 by the New York Press Photographer's Club! I almost called up to say "Neigh," but I figured what they didn't know wouldn't hurt them

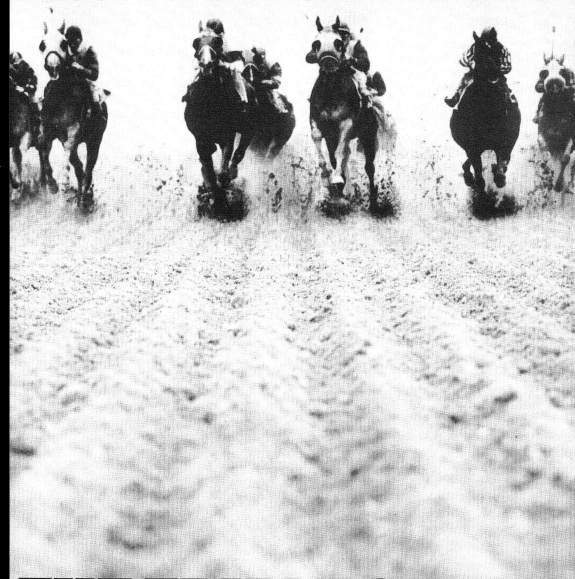

THE TRIPLE CROWN
KENTUCKY DERBY, SATURDAY, MAY 4, PREAKNESS, SATURDAY, MAY 18, AND BELMONT STAKES, SATURDAY, JUNE 15 A CAVALCADE OF SPORTS EXCLUSIVE SPONSORED BY THE GILLETTE SAFETY RAZOR CO. LIVE ON ◉ CBS TELEVISION

6. SAINT GEORGE SLAYS THE DRAGON.

The image of the dragon-slayer legend remains the most memorable and romantic of the genre of
Christian martyrdom: Saint George, a heroic Christian knight in full armor, mounted upon a
rearing white horse, his lance (or sword) powerfully spearing the gullet of evil. George was an actual
Roman soldier in the third century who refused to participate in the persecution of Christians.
Having confessed that he himself was a believer, he was tortured on a wheel of swords, then decapitated.
He has been venerated ever since as a true Christian martyr. The Crusaders brought back
a mythical legend of the chivalrous knight rescuing a princess in distress, and the veneration of
Saint George took on epic proportions. Triumphant images of Saint George were depicted
in early Greek and Russian Orthodox icons and later by Mantegna, Holbein, Raphael, Carpaccio,
Uccello, and van der Weyden. (Shown is a woodcut by Albrecht Dürer.) But to me the
most sacred depiction is a brass medallion on a gold chain I have worn since I was a toddler, when
my father slipped it around my neck, and I have worn it, resting on my heart, ever since.

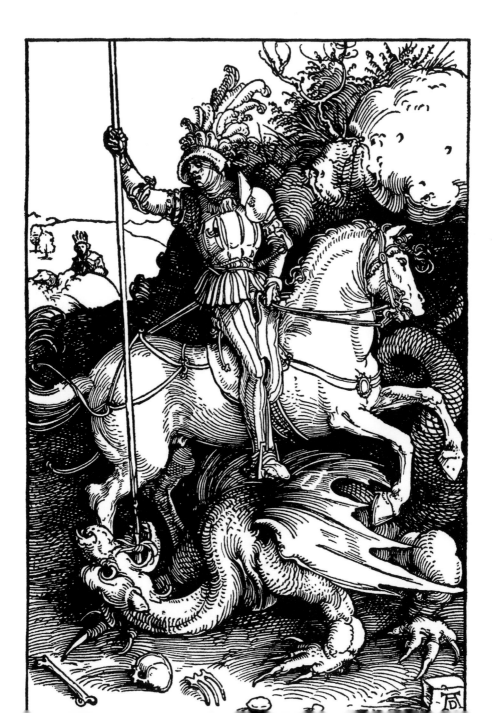

EDWARD R. MURROW SLAYS McCARTHYISM.

CBS Television scheduled a stinging indictment on March 9, 1954, of Senator Joseph McCarthy and the shameful period of McCarthyism that gripped the very soul of America. I was a 23-year-old Korean War vet who was thrilled to be a designer in Bill Golden's "Corporate Image" design department, when he had the courage to give blacklisting victim Ben Shahn the assignment to do a satirical drawing of McCarthy for a tune-in ad to run the morning of the fateful CBS broadcast of *A Report on Senator Joe McCarthy*, part of the *See It Now* series.
Showing Golden my Saint George medallion, I said to my intrepid boss, "Bill, if you really want to nail that son-of-a-bitch, ask Ben Shahn to do a drawing of Edward R. Murrow as Saint George spearing Joe McCarthy as a fuckin' dragon." A few days later, Shahn proudly handed us his powerful image, and the rest is history. Edward R. Murrow, the legendary television news broadcaster who had first come to prominence with his radio broadcasts during World War II, slayed the dragon of McCarthyism. "Good night, and good luck."

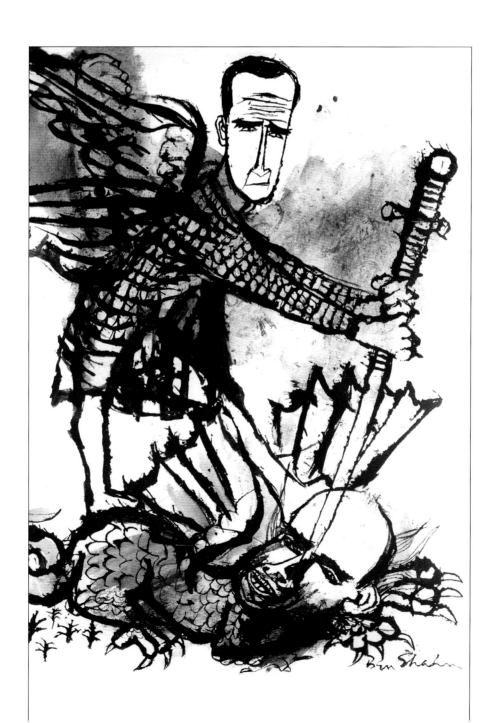

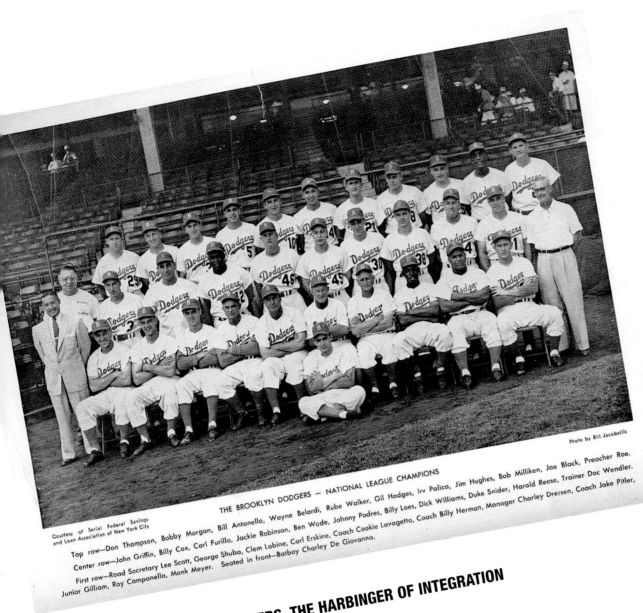

THE BROOKLYN DODGERS — NATIONAL LEAGUE CHAMPIONS

Photo by Bill Jacobellis

Courtesy of Serial Federal Savings
and Loan Association of New York City

Top row—Don Thompson, Bobby Morgan, Bill Antonello, Wayne Belardi, Rube Walker, Gil Hodges, Irv Palica, Jim Hughes, Bob Milliken, Joe Black, Preacher Roe.

Center row—John Griffin, Billy Cox, Carl Furillo, Jackie Robinson, Ben Wade, Johnny Podres, Billy Loes, Dick Williams, Duke Snider, Harold Reese, Trainer Doc Wendler.

First row—Road Secretary Lee Scott, George Shuba, Clem Labine, Carl Erskine, Coach Cookie Lavagetto, Coach Billy Herman, Manager Charley Dressen, Coach Jake Pitler, Junior Gilliam, Roy Campanella, Monk Meyer. Seated in front—Batboy Charley De Giovanna.

7. IN 1954, THE BROOKLYN DODGERS, THE HARBINGER OF INTEGRATION OF SPORTS IN AMERICA, STOOD (AND SAT) TALL.

The Brooklyn Dodgers won pennants in 1941, 1947 (the year the color barrier was broken by the legendary Jackie Robinson), 1949, 1952, and 1953, only to be beaten by the dreaded New York Yankees in each of the World Series. "Wait 'til next year!" became the Brooklyn lament. But finally, in 1955, "Dem Bums" shot down the Bronx Bombers and Brooklyn fans were ecstatic!

**A YEAR LATER, RUMORS WERE RAMPANT THAT OUR
BELOVED BUMS WERE HEADED WEST.
(HOW DO YOU TAKE A TRAGEDY AND TURN IT INTO
A GLORIOUS AD?)**

In 1955, when New York was traumatized by rumors that Brooklyn Dodgers
owner Walter O'Malley would move the franchise to La La Land,
I saw it as a golden opportunity to create a memorable American Airlines
destination ad. My almost poignant visual shows a Dodger peering
west, with the headline *Thinking of going to Los Angeles?* I tried to get one
of the players to pose for the ad, but every one of my heroes
chickened out. So yours truly posed for it, casting my baby blues westward,
and I slammed an airline logo over my puss to keep the message
authentic. Bookings on American to Los Angeles took off the next day—and
alas, as feared, the treacherous O'Malley did the dirty deed.
My only memento from those good ol' days is a baseball signed by
the great Jackie Robinson...and my American Airlines ad.

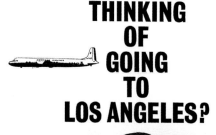

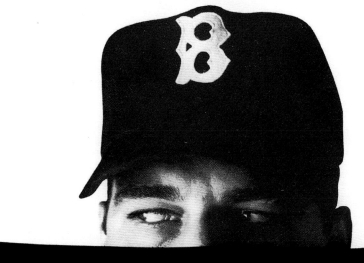

Four flights daily to Los Angeles! Call American Airlines or see your travel agent.

FLOYD PATTERSON, LEFT FOR DEAD, ALONE IN THE RING.

The bout between heavyweight champ Floyd Patterson and monster challenger Sonny Liston was scheduled a week after the October 1962 issue of *Esquire* would hit the newsstands. So, for my first-ever magazine cover, I called a title fight! To bring a new attitude and excitement to the magazine, I created a surrealistic image of defeat (using a Floyd Patterson look-alike), of how the world treats a loser in the boxing ring, in business, in life (and in the bullring). I admired Patterson but knew Liston would demolish him (even though Floyd was a 5 to 1 favorite). The press went to town writing about the chutzpah of calling a fight on a magazine cover (mostly ridiculing the prediction), and the issue was a sellout. Liston KO'd Patterson in the first round. The cover poignantly said that nobody loves a loser, but *Esquire* went on to legendary fame and fortune, climbing in circulation from a half-million to nearly two million during that golden age of journalism. Both images, the toreador and the pugilist, are of courageous men whose livelihood is to fight for their very lives.
P.S. I now realize, four decades after depicting Patterson left for dead in the middle of an abandoned ring, that I had witnessed, only a few months before, the horrific sight of Emile Griffith, an angry 23-year-old middleweight, drive Benny "The Kid" Paret into the corner ropes and pummel him into oblivion. (The first telecast to use slow-motion instant replay in a sports event, it was replayed over and over again.) Paret died ten days later. Griffith, an immigrant from the Virgin Islands, fought with homicidal rage after being goaded by his Cuban opponent, who had called him a *maricón*, a Spanish slur word for "homosexual" at a time when an athlete being gay seemed unthinkable.

8. DEAD TOREADOR IN A BULLRING.

In 1864, the audacious painter Édouard Manet exhibited a multifigured composition called *Incident at a Bullfight*. All that remains of the original painting are two fragments that Manet cropped (with a pair of shears), in the style of the new, budding art of photography. He named the larger fragment, *The Dead Toreador*, a beautifully sleek, opaquely modeled bullfighter, slain by his noble opponent, a raging bull, and seemingly left for dead in an empty, haunted bullring. Manet described a bullfight he witnessed as "one of the finest...and most terrifying sights to be seen."

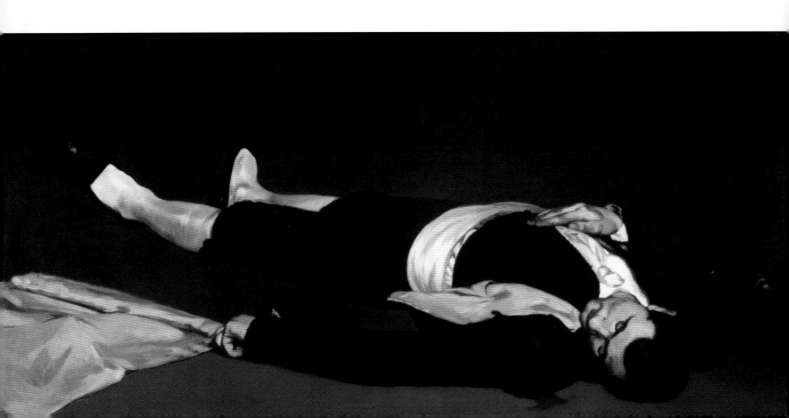

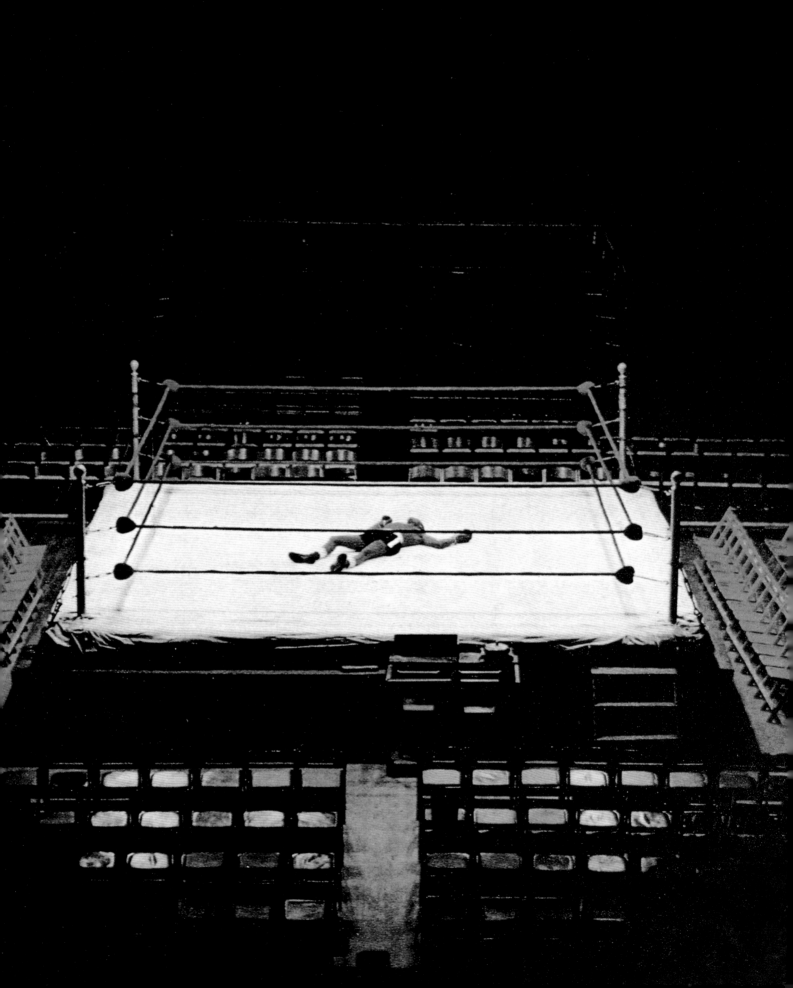

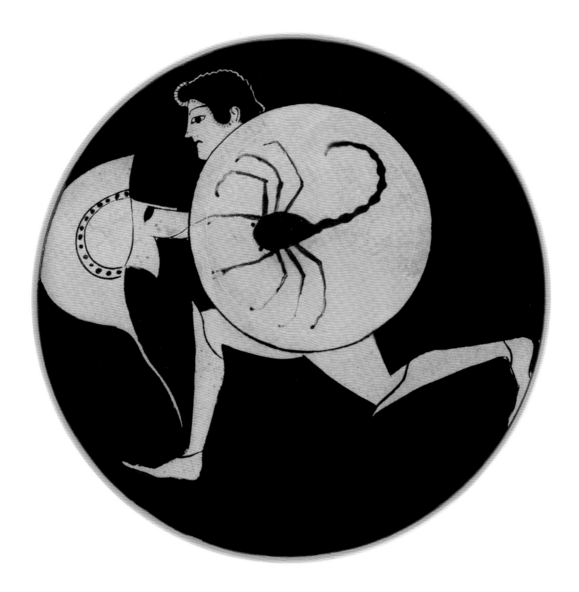

9. 490 BC
AFTER ARM-TO-ARM COMBAT, PHEIDIPPIDES RUNS 26 MILES TO ATHENS
AND PROCLAIMS, IN HIS DYING BREATH,
THE DEFEAT OF THE INVADING PERSIANS AT THE BATTLE OF MARATHON.

The newly created democracy in Athens, the first the world had ever known, quaked in fear of annihilation by an invading Persian army landing at Marathon, 26 miles away. The Greeks had an army of men who put down their plows for swords, facing an invading Persian empire thirty-five times larger than all of Greece. The battle-experienced Persian force of 100,000 outnumbered the idealistic citizen-soldiers ten to one, with a penetrating strike force of cavalry. Greek general Miltiades ordered an all-out attack. Ten thousand hoplites in battle armor charged into the Persian forces on foot. They fought with a fury the mercenary Persians had never seen. By the end of the battle, the Greeks had lost 192 men. Six thousand Persians were slain, and their remaining army fled to the sea in disarray, forever leaving the sacred soil of Greece. General Miltiades asked Pheidippides (who had just run 150 miles in two days to ask for help from Sparta), to race the 26 miles to Athens to proclaim the news of their victory. Exhausted, he entered the city, ran up the steep stairs of the Acropolis, stood before the assembly and yelled out in his dying breath, "Rejoice! We are victorious!" According to legend, he then collapsed and died. Democracy survived! The Battle of Marathon can arguably be called the most important land war in the history of the world, one that salvaged and inspired the glorious continuation of the world's first experiment in democracy. That brave land went on to become the wellspring of Western civilization, inspiring the poet, the philosopher, the scientist, the statesman, the healer, the playwright, the artist, and the dreamer.

1959 A.D.
**GEORGE LOIS TAKES THE 7 TRAIN (AND THEN RUNS A FEW BLOCKS TO DDB)
AND PROCLAIMS THE DEFEAT OF THE
PHILISTINE ACCOUNT MEN AT THE BATTLE OF LONG ISLAND CITY.**

A year before I started the second creative agency in America, I worked for the first creative agency in America,
Doyle Dane Bernbach. One of my first assignments was to create a Passover subway poster for Goodman's Matzos.
My headline was in Hebrew with two universally understood words (at least in New York), and under it,
a gigantic matzoh. The poster screamed, "Goodman's are the most Jewish matzos you can buy!" I was shocked
when I was told that the art director "doesn't go to presentations." I balked, and when the account man
came back with a resounding "no" from the client, I went to my boss, Bill Bernbach, and insisted he make an appointment
with the Goodman's honcho, an Old Testament, bushy-eyebrowed tyrant, a master kvetch. "The art director has
to sell his job to the client—not a know-nothing account stiff," I pleaded to my slightly embarrassed boss. Bernbach
made the call and told me to go to Long Island City. The buzz got around the agency, and my solo re-pitch
to Goodman's became a polarizing event: The Creative Gang against the Account/Marketing Department! The matzoh
maven yawned as I opened with a passionate pitch. When I unfurled my poster, he muttered, "I dun like it."
I disregarded him and pressed forward, selling my guts out. The tyrant tapped the desk for silence as one, then two,
then three of his staff registered support for the powerful Hebrew headline. "No, no," he said, "I dun like it!"
I had to make a final move—so I walked up to an open casement window. As I began to climb through the window,
he shouted after me, "You're going someplace?" He and his staff gasped at me as if I was some kind of
meshugenah, poised on the outer ledge three floors above the pavement like a window washer. I gripped the vertical
window support with my left hand, waved the poster with my free hand, and screamed from the ledge at the top
of my lungs, "You make the matzoh, I'll make the ads!" "Stop, stop," said the old man, frantically. "Ve'll run it. You made
your point already. Come in, come in, please!" I climbed back into the room and thanked the patriarch for
the nice way he received my work. As I was leaving, he shouted after me, "Young man, if you ever qvit advertising,
you got yourself ah job as ah matzos salesman!" The visual of me running back to DDB, holding my poster
aloft like an Olympic flame to proclaim to the Creative Department that we were victorious, ran in a 1972 issue
of *Esquire* to illustrate an excerpt relating to my Matzohs War, from my first book, *George, be careful*.
From that day on, during DDB's glory days, the people who created the work pitched the work.

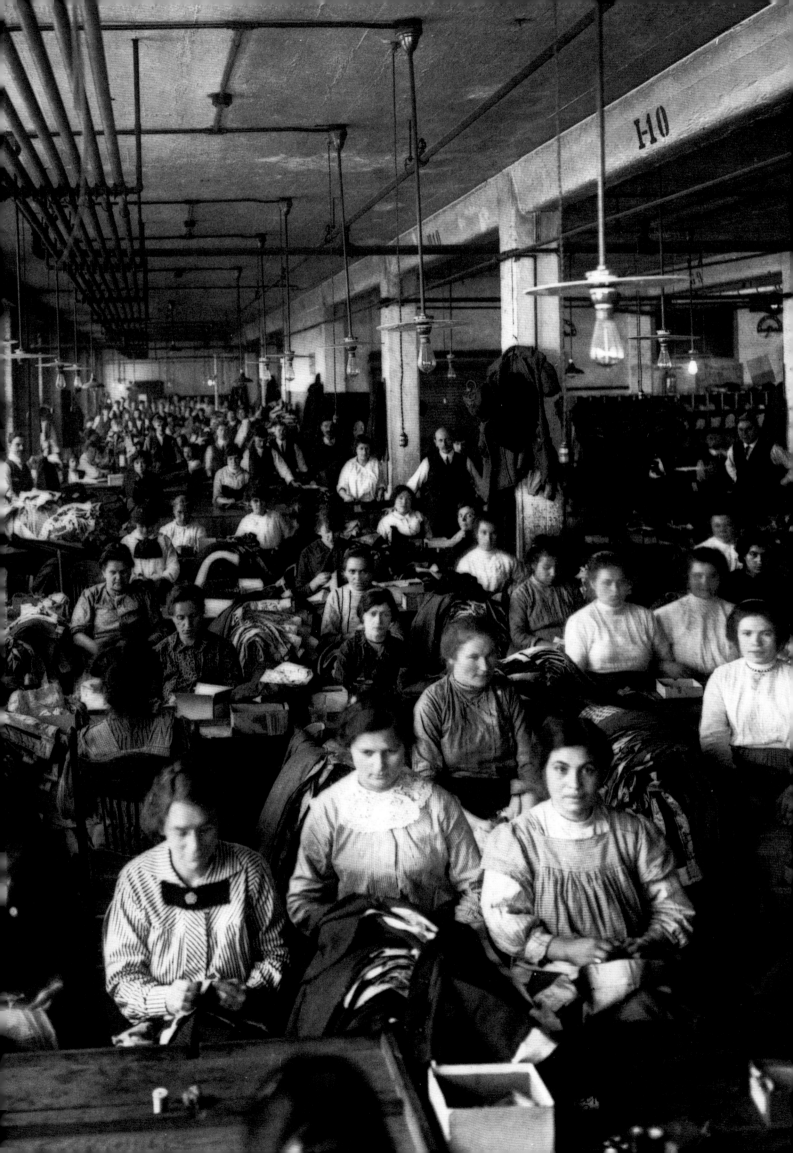

10. BEFORE THE UNION, THERE WERE SWEATSHOPS.

In the early twentieth century, New York was filled with immigrants, now living in the land of plenty, working in wretched conditions, barely eking out a living. Unionism, won with blood, sweat, and tears, has allowed hundreds of thousands of members of the International Ladies Garment Workers Union (ILGWU) to work in dignity and make ends meet.

SYMBOLIZING WHAT GROWING UP IN NEW YORK MEANT TO ME

For the opening print ad of a 1959 campaign, these side-by-side images of the torch of the Statue of Liberty and an ice cream cone, visually stated that freedom had to include food, shelter, and security for the hardworking women of the ILGWU—and reminded American consumers that an ILGWU label sewn into their clothes was a vote for the American Dream.

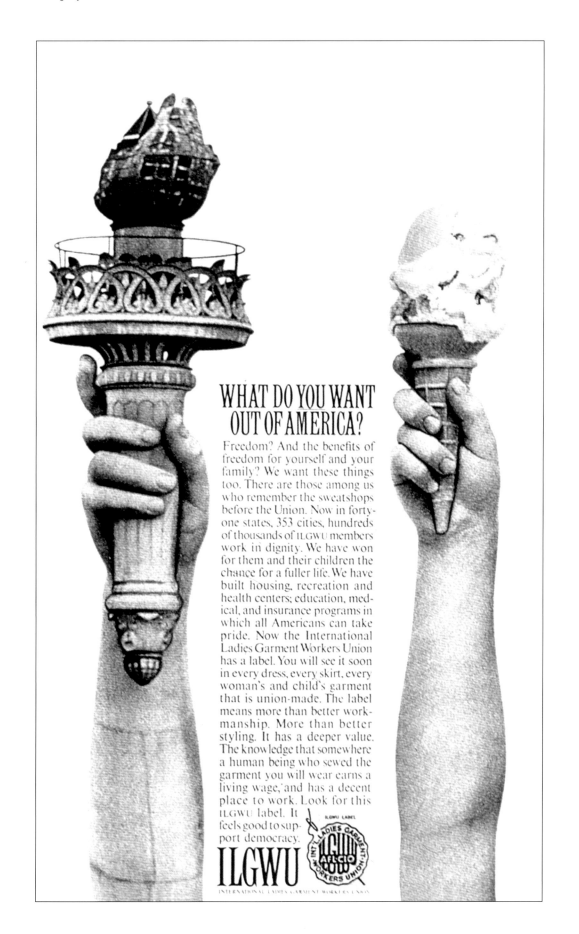

WHAT DO YOU WANT OUT OF AMERICA?

Freedom? And the benefits of freedom for yourself and your family? We want these things too. There are those among us who remember the sweatshops before the Union. Now in forty-one states, 353 cities, hundreds of thousands of ILGWU members work in dignity. We have won for them and their children the chance for a fuller life. We have built housing, recreation and health centers; education, medical, and insurance programs in which all Americans can take pride. Now the International Ladies Garment Workers Union has a label. You will see it soon in every dress, every skirt, every woman's and child's garment that is union-made. The label means more than better workmanship. More than better styling. It has a deeper value. The knowledge that somewhere a human being who sewed the garment you will wear earns a living wage, and has a decent place to work. Look for this ILGWU label. It feels good to support democracy.

ILGWU
INTERNATIONAL LADIES GARMENT WORKERS UNION

**11. JOE BAUM POINTED ONE OF HIS SAUSAGE FINGERS AT ME
AND BELLOWED "IT CAN'T BE PRUSSIAN.
AND IT CAN'T BE 'ACHTUNG!' IT HAS TO BE *KATZENJAMMER KIDS.*"**

Starting in 1960, under the brilliant direction of the now-legendary Joseph Baum at Restaurant Associates,
the most imaginative and certainly the boldest food chain in America,
I created new restaurant concepts, suggested locations, developed their personalities, came up with
ideal names, irritated architects by revising their plans, styled all the graphics,
fought realtors to get signs approved, hustled publicity, designed everything from menus to sugar packets,
and even hung pictures on the walls. When RA won the dining locations in the
lobby of the new Pan Am building in Manhattan in the early '60s, one of the joints we wanted to create
was a high-class Chock Full O' Nuts, but with a gemütlich flavor,
and the best hot dogs, sausages, knockwursts, and bratwursts in the world.

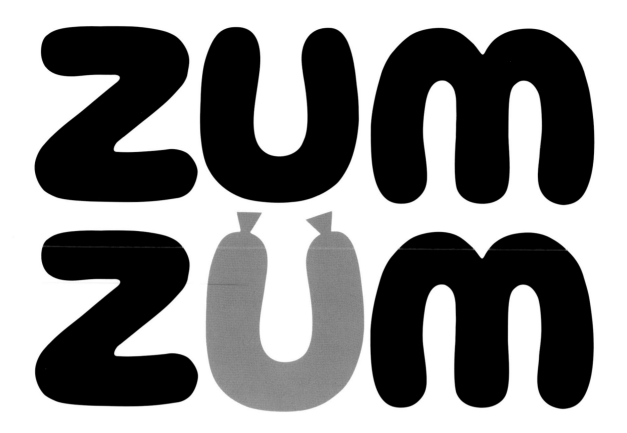

**SO WE NAMED THE JOINT ZUM ZUM
AND I DESIGNED A LOGO. I CALLED UP JOE BAUM AND SAID BREATHLESSLY,
"JOE, YOU NEVER SAUSAGE A LOGO!"**

When Joe and I were messing *mit* German-sounding names, I fell in love with the fast-moving sound
of the words, Zum Zum, and I knew I could design a hot sausage-shaped logo.
We served Hell Beer (and my ads said *Raise Hell with your secretary*) and the best of the wurst.
We cast plump German waitresses, and they all said *"Auf Wiedersehen"*
(and whatever else Katzenjammer Kids and nice Germans say). Zum Zum coffee containers, slaw buckets,
strudel boxes, and takeout bags became an indelible part of the New York scene.
From the Pan Am lobby prototype, the chain expanded and became *the* class fast-food retailer
in the U.S.A. *The New York Times* architecture critic Paul Goldberger called Zum Zum
"a reminder that fast-food need not mean the visual schlock of a McDonald's or a Burger King." *Jawohl!*

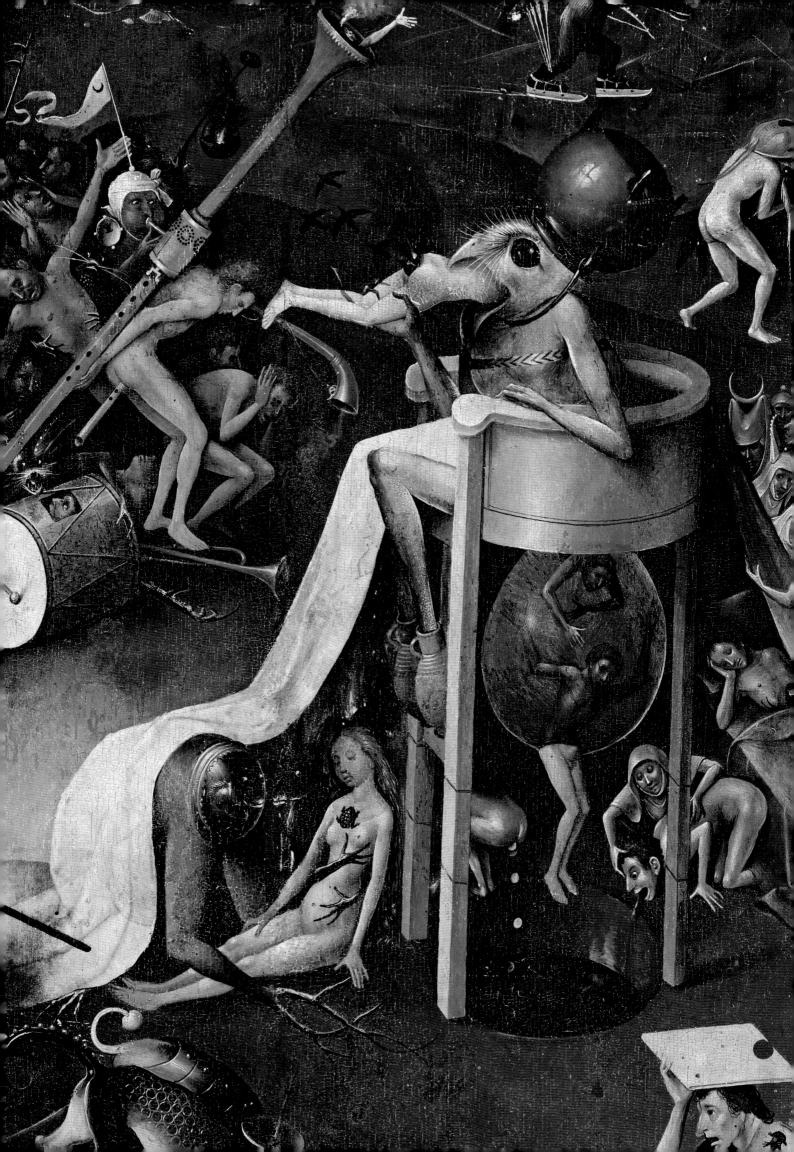

12. BLOW IT OUT YOUR ASS...

Hieronymus Bosch was an Early Netherlandish painter whose outrageous works are religious sermons, difficult to translate. *The Musician's Hell* (detail shown opposite) is the right panel of a great panoramic, action-filled triptych entitled *The Garden of Earthly Delights.* The laws of nature have collapsed, and distinctions between the plant and animal kingdom, between living and dead, real and unreal, true and false have blurred. Bosch's satire includes fantastic creatures and lurid landscapes with hundreds of intriguing, impenetrable symbols. He demonstrates a fall into a godless, frightening pandemonium of musical sinfulness. The startling image of a creature swallowing a musician is a detail of Bosch's depiction of how the medieval Roman Catholic Church regarded musicians who strayed from the church party line by playing new forms of "dissonant" music, resulting in "the informed tortures of cacophonic compositions." *The Musician's Hell* was inspired by the rebel archangel Lucifer and his descent into Hell, with ear-splitting trumpets shrilling, kettle drums exploding, and an insidious fife blowing a bombardment of blackbirds out of a man's rear. It is a firestorm of sound and visual symbols—a graphic blast beyond any image I've seen in the history of art. Check out that poor soul frantically covering his ears to block out the maddening cacophony!

13. "I LIKE CATS BETTER THAN DOGS, TAKE IT OR LEAVE IT."

I gave these words to legendary heavyweight champ Jack Dempsey, as he unexpectedly gave
no-nonsense advice to cat owners in a Tabby cat food commercial about feeding
cats a proper diet. Men are dog lovers. Women adore cats. The open display of affection for cats,
coming from a macho world champ delighted the cat crowd in America.
The Manassa Mauler's opening words in that spot came from my heart, because I'm a sucker
for a pussycat. Always have been. I've had a feline roaming my apartment
and sleeping on my bed since I was a little puppy in the Bronx. I love their looks. I love their feel.
I love their company. (All cat owners ain't sweet old ladies with scratches on their wrists.)
The ferocious tiger cat shown here is my ol' pal Rousseau, named after Henri Rousseau's 1908 painting
Fight Between a Tiger and a Buffalo, a fantasy creation of a tiger sinking his teeth
into the neck of a water buffalo, set in the thick of an exotic jungle.
P.S. The last words in the Tabby TV spot was a voice-over of the great Dempsey saying,
I hope my dog doesn't hear this commercial!

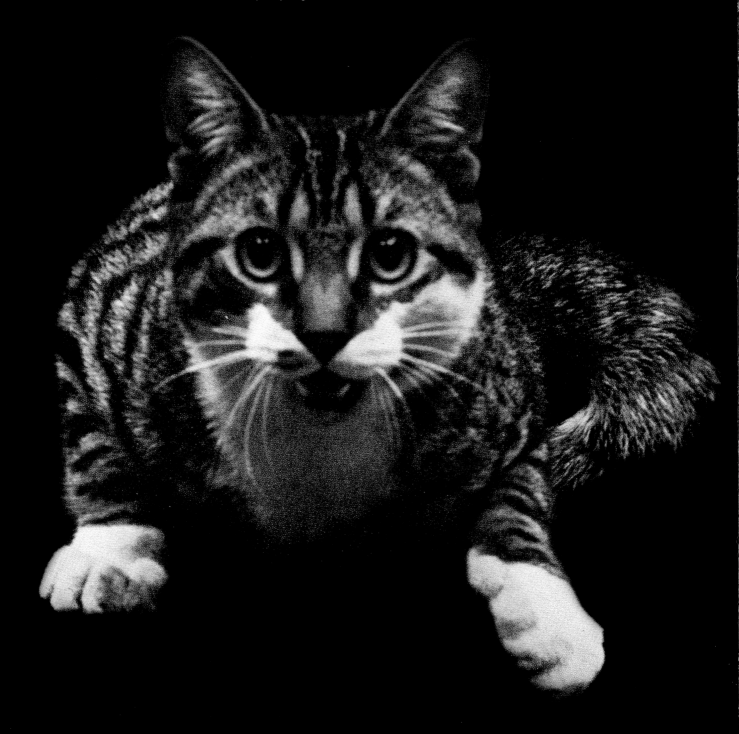

"AH-AH-AH-CHOO!"

This introductory ad for a breakthrough anti allergy product named Allerest informed many people, for the first time in their lives, that their sneezing or runny nose or itchy eyes was probably an allergy to cats, dogs, pillow feathers, makeup, etc. (the thick cat's tail under comedian Ken Norton's nose belonged to none other than my cat Rousseau!) The drug industry was shocked to see this ad a few months after the birth of my first ad agency, when I created this print and TV campaign for Dr. Edward Sheckman, the maverick president of Pharmacraft Laboratories, a bald, bullet-headed ringer for Erich von Stroheim. The good doctor was a dream client: He demanded that the advertising for his new baby be unlike any past or present drug advertising, because he believed that good taste could mean good business. Madison Avenue thought I was a fool to forsake what they called time-tested hard-sell advertising, and derided this new style of selling. But Dr. Sheckman and I were made for each other, because I championed the belief that witty, human advertising would always communicate more powerfully to people. That was in 1960. Almost half a century later, the marketing stiffs in the ad industry still haven't caught up with this trailblazing campaign. Kinda brings a tear to your eye.

ARE YOU ALLERGIC to cats, dogs, dust, pillow feathers, make-up, pollen, et cetera? Take Allerest. Do you have allergic colds? (Many colds are really allergies.) Take Allerest. Do you wake up sneezing? Take Allerest. This new tablet calms the cough, the sneeze, the runny nose, the itchy eye of allergy. Allerest is the first drug of its kind available without prescription; no cold tablet can work as well. Ah-ah-ah-choo! I better **TAKE ALLEREST.**

ALLEREST

Allergy Tablets: designed
to relieve the symptoms of
upper respiratory allergies

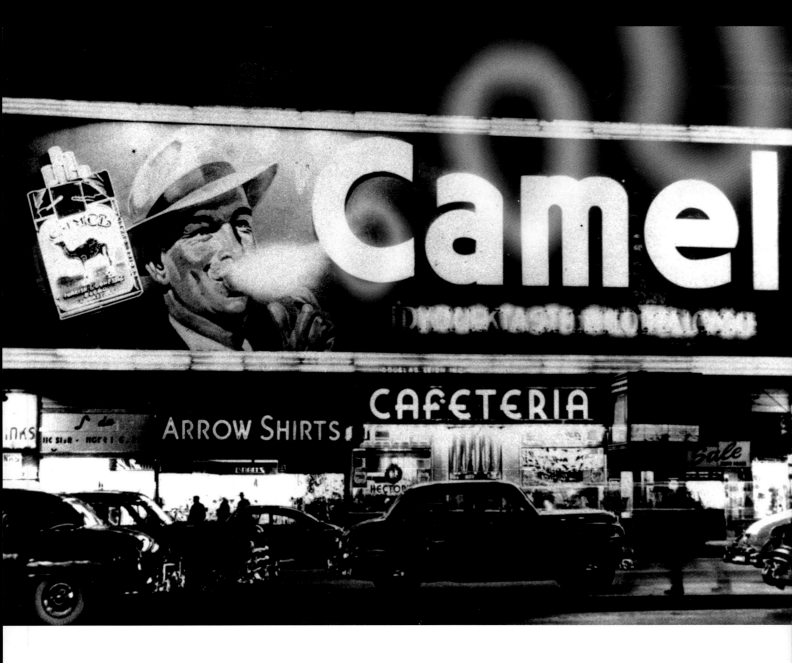

14. IN 1941, A SPECTACULAR CAMEL BILLBOARD APPEARED
IN TIMES SQUARE THAT WAS SMO-O-O-KING!

On December 12, 1941, five days after the Japanese attack on Pearl Harbor, Douglas Leigh unveiled his legendary
Camel cigarette billboard on 44th Street. It became an almost instant Times Square landmark, attracting worldwide attention
for 25 years as a chain-smoker blew hypnotic smoke rings every four seconds (actually steam) across the
Great White Way of Broadway, growing wider as they went. Unfortunately, the Camel billboard proved to be the most famous,
and persuasive, outdoor poster of all time. As a kid, I remember teenagers and adults alike, puffing, puffing, puffing,
trying to emulate those picture-perfect smoke rings. (A good portion of them probably coughed themselves to death years ago.)

IN 1963, A *CLEOPATRA* BILLBOARD APPEARED
IN TIMES SQUARE THAT WAS HOT!

Cleopatra was a $40 million production—the most expensive movie ever made at that time. During its filming, the affair
between chain-smoking Richard Burton and Elizabeth Taylor (while hubby Eddie Fisher was being labeled
a cuckold) was a worldwide scandal. *Esquire* did a long, hilarious piece on the egocentric stars' open romancing on the set.
The hotter their affair, the better for *Cleopatra's* box office (or so the producers hoped). A few days before
the deadline, my wife Rosie was in a cab driving down Broadway and spotted a gigantic *Cleopatra* poster being painted
over the Rivoli Theatre where it was to premiere. She jumped out of the cab and into a pay phone and called me
at my office and described the almost surrealistic scene to me. It was an *Esquire* cover in the making if I could get the shot
in time. I rushed down to the Rivoli (not too far from the Camel billboard, which was snuffed out in 1966),
saw it, ran across the street, rented a hotel room on the sixth floor facing the Rivoli marquee, and called photographer
Carl Fischer. The sign painters had already finished Liz's enormous breasts, so I slipped them a twenty
to raise the scaffold and get back to the focal point of that incredible real-life farce.
P.S. These days, billboards are no longer hand-painted because they're all printed photographically
on vinyl by computers. Pop artist James Rosenquist was inspired by his early career standing on scaffolds three
stories high, painting women with eye-blinding smiles and eye-popping cleavages.

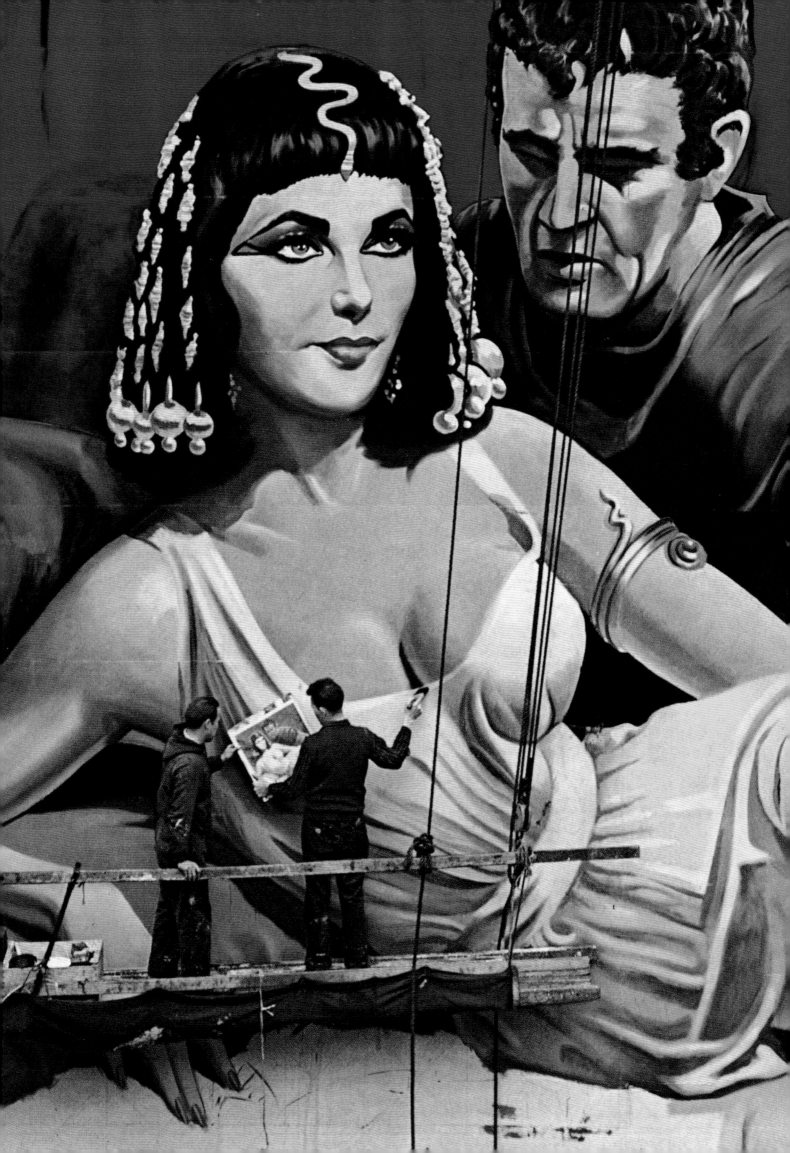

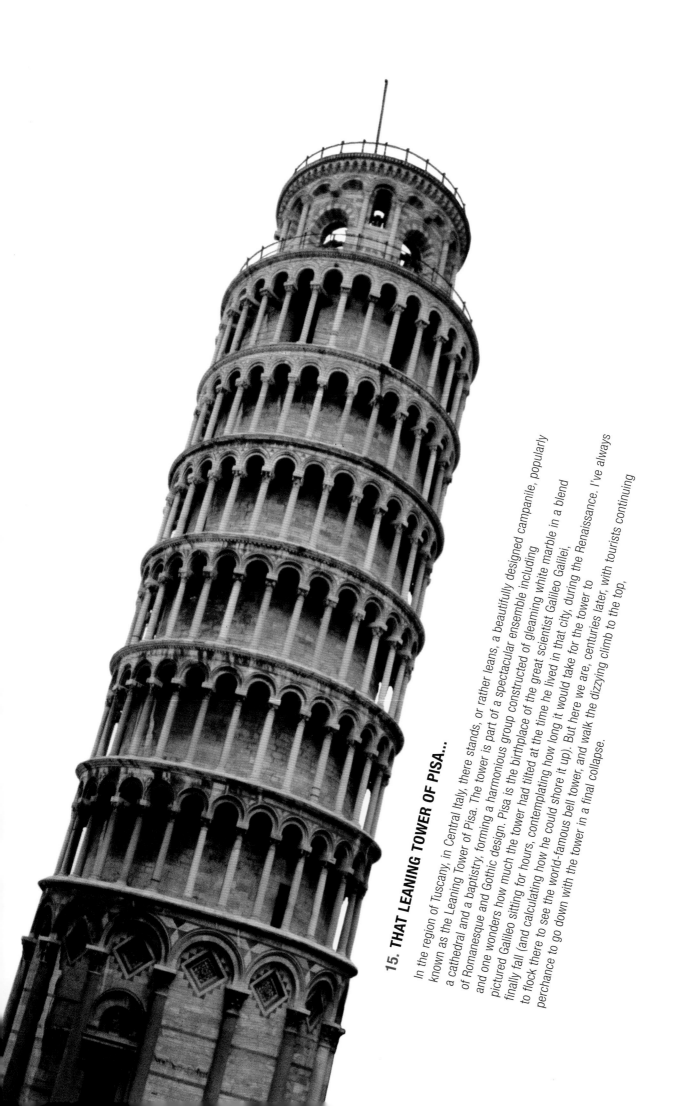

15. THAT LEANING TOWER OF PISA...

In the region of Tuscany, in Central Italy, there stands, or rather leans, a beautifully designed campanile, popularly known as the Leaning Tower of Pisa. The tower is part of a spectacular ensemble including a cathedral and a baptistry, forming a harmonious group constructed of gleaming white marble in a blend of Romanesque and Gothic design. Pisa is the birthplace of the great scientist Galileo Galilei, and one wonders how much the tower had tilted at the time he lived in that city, during the Renaissance. I've always pictured Galileo sitting for hours, contemplating how long it would take for the tower to finally fall (and calculating how he could shore it up). But here we are, centuries later, with tourists continuing to flock there to see the world-famous bell tower, and walk the dizzying climb to the top, perchance to go down with the tower in a final collapse.

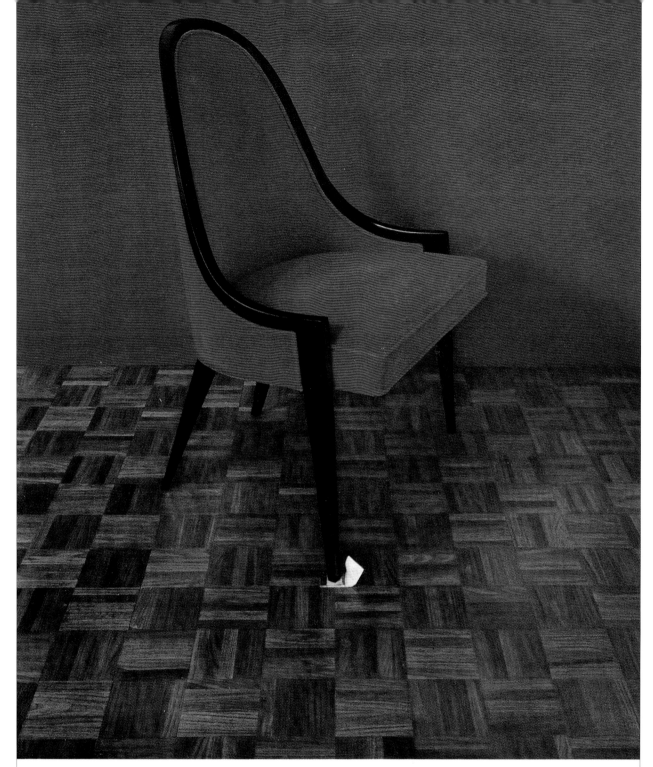

If your Harvey Probber chair wobbles, straighten your floor.

Every piece of furniture that Harvey Probber makes at Fall River, Mass. is placed on a test platform to make sure it's on the level. If you get it, it is. Mr. Probber loses a lot of furniture this way.
Mr. Probber's furniture has an almost luminous satin finish. It is produced by a unique machine that has 5 fingers and is called the human hand.

This luminous finish takes a long time to achieve, but it lasts a long time. The lovely chair above could be made with 14 less dowels, 2 yards less webbing, thinner woods and so forth. You wouldn't know the difference, but Harvey Probber would. Of course, in a few years you would know too.

NEW YORK/CHICAGO/DALLAS/BOSTON/ST. LOUIS/MILWAUKEE/NASHVILLE/HARVEY PROBBER DESIGN BOOK: ONE DOLLAR, DEPT. N610, HARVEY PROBBER, INC., FALL RIVER, MASS.

...AND THE WOBBLY HARVEY PROBBER CHAIR.

In 1961, Julian Koenig (my partner at Papert Koenig Lois) and I were visiting the furniture factory of Harvey Probber in Fall River, Massachusetts, for an orientation on how their chairs were precision-made. Each Probber chair was placed on an electronic test platform to be sure that its four legs sat well on a floor. "If they don't get tested, a chair could be a Leaning Tower of Pisa! Got a book of matches?" I asked Julian, a chain-smoker.
Koenig handed me a matchbook, and I slid it under one leg of the chair on the test platform. "I got the ad," I said.
"If your Harvey Probber chair leans, straighten your floor." Julian scowled and shot back,
"Asshole—if your Harvey Probber chair *wobbles*, straighten your floor." Then I photographed a red chair against a red background to dramatize the white matchbook. On the level, that's how it happened.
(Having finally given credit to being inspired by the Leaning Tower of Pisa, I think I finally got my story straight.)

16. THE MOST BELOVED AND BEST-KNOWN CHARACTER IN THE HISTORY OF THE WORLD...

Santa Claus. Mention those two little words, and billions of people around the world immediately bring to mind the unmistakable image of a mirthful, plump, white-bearded old man clad in an ermine-trimmed scarlet suit, a wide black belt, heavy black boots, and trademark stocking cap, sporting famously rosy cheeks and an equally celebrated twinkle in his crinkled blue eyes. He, as we all know, lives at the North Pole with Mrs. Claus, where they oversee a bustling toy workshop manned by legions of diligent elves. He carries a huge knapsack packed with toys for every (good) kid in the whole wide world. He flies through the skies in a sleigh pulled by eight reindeer, delivering gifts to children by squeezing his girth down their chimney flue, and leaving toys to be discovered on Christmas morning. If your home doesn't have a chimney—he finds other ways to get in. (And last but not least, he's white.)

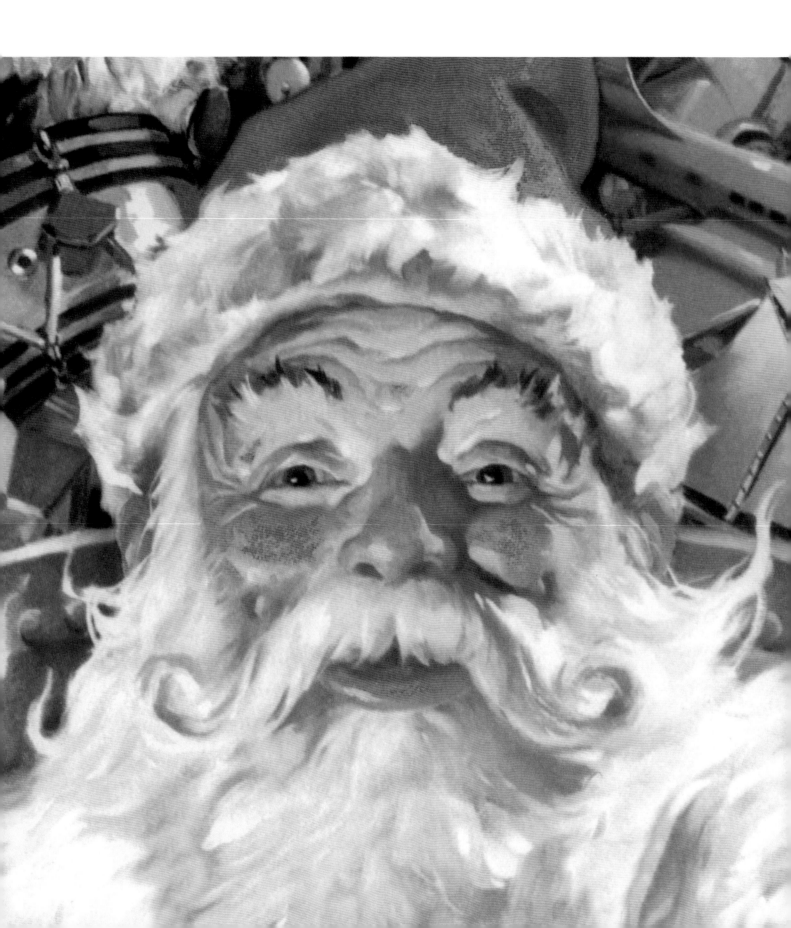

...AND "THE LAST MAN ON EARTH AMERICA WANTED TO SEE COMING DOWN ITS CHIMNEY."

During the turbulent '60s, every time I delivered a new magazine cover to editor Harold Hayes from my drawing table, *Esquire's* publisher, ad salesmen, and assorted bureaucrats crossed their hearts and fingers. For an upcoming Christmas issue, Hayes called me and pleaded, "Ol' buddy, ya gotta compromise this time. Y'all gotta give me a *Christmassy* cover!" "You got it!" I promised. When Hayes opened my monthly envelope and saw Sonny Liston (who had served time for armed robbery and was a labor goon and a hitman for the mob) as America's first black Santa, respirators were rushed to *Esquire's* ad offices. *Esquire* lost advertisers and received threatening phone calls and hate mail, but the cover set the spirit for the magazine for years to come (with a circulation leap from half a million to almost two million). In a recollection of the Liston cover eighteen years later, *Sports Illustrated* recalled the era, calling it a chillingly accurate anticipation of the Black Power Revolution: "Four months after Liston won the title, *Esquire* thumbed its nose at its white readers with an unforgettable cover. On the front of its December 1963 issue, there was Liston glowering out from under a tasseled, red-and-white Santa Claus hat, looking like the last man on earth America wanted to see coming down its chimney." And *Time* magazine described the cover as "one of the greatest social statements of the plastic arts since Picasso's *Guernica*." Ho, ho, ho.

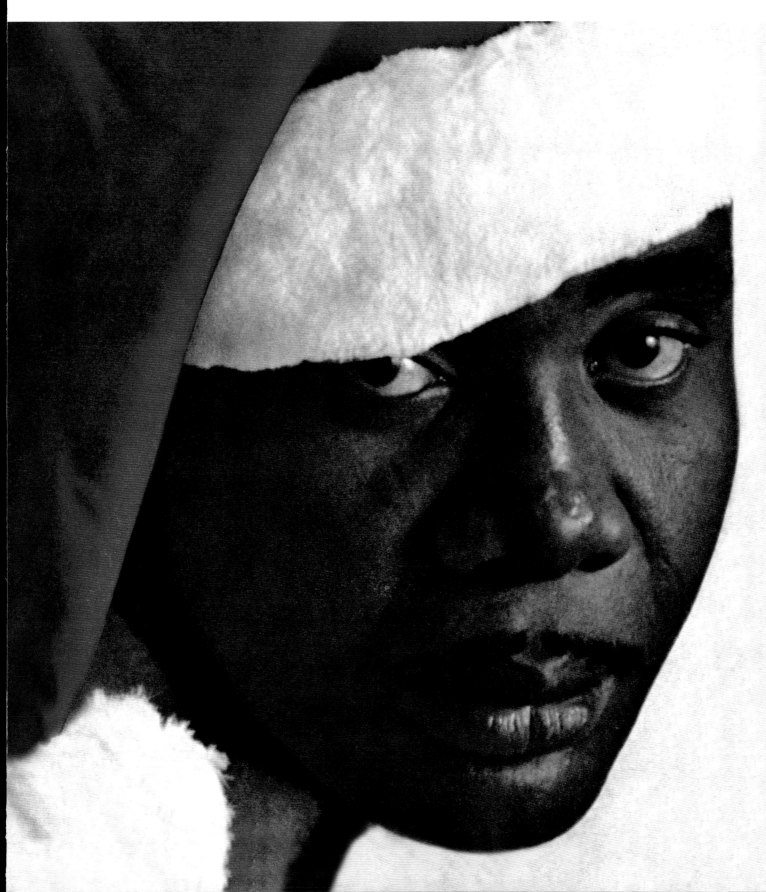

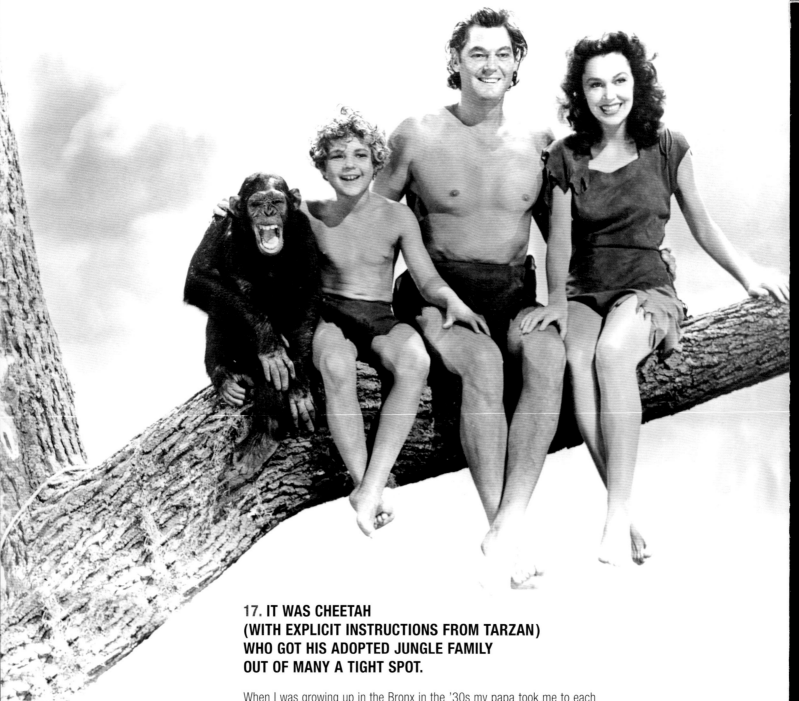

17. IT WAS CHEETAH
(WITH EXPLICIT INSTRUCTIONS FROM TARZAN)
WHO GOT HIS ADOPTED JUNGLE FAMILY
OUT OF MANY A TIGHT SPOT.

When I was growing up in the Bronx in the '30s my papa took me to each
Tarzan movie, the only films we attended together, in an unstructured
act of father-and-son bonding. Superman, Batman and Captain Marvel were
OK, but Tarzan was good, brave, fearless, athletic and, alone among
superheroes, a family man. Tarzan, the swinging Lord of the Apes, and Jane,
the sophisticated Englishwoman, proved that social barriers disappeared
when hearts beat like native drums. Tarzan (played by Olympic swimming
champion Johnny Weissmuller), Jane (played by the elegant,
high-toned Maureen O'Sullivan), and Boy, the only issue of their jungle
love match (played by young Johnny Sheffield), were incomplete
without Cheetah, their faithful, madcap chimp companion, the smartest,
nonhuman ever portrayed on the silver screen—including E.T.

SO WHEN THE FTC CHARGED THAT OUR
TV COMMERCIAL SHOWING A LITTLE GIRL MAKING
A XEROX COPY WAS A HOAX,
WE RESHOT THE SPOT...WITH A CHIMPANZEE.

The process of xerography was conceived in 1938 by Chester Carlson, who made his momentous discovery in solitude and offered it to more than 20 major corporations, among them IBM, General Electric, Eastman Kodak and RCA. The Abominable No-Men of Corporate America turned him down flat, passing up the opportunity to produce what *Fortune* magazine would describe as "the most successful product ever manufactured in America." Carlson finally made a deal with the Haloid Company, an obscure photographic-supply company, and produced the Haloid Xerox 914, a seemingly miraculous machine that made sharp, permanent copies on ordinary paper. In the early sixties, if you mentioned "office copying" or "duplicating," the picture that came to mind was a shlocky back room where a kid in white socks splattered ink. In 1960, at my newborn ad agency, Papert Koenig Lois, I told my new client, the head of Haloid-Xerox (we convinced him to change the name to Xerox a few days later), that we could make his incredible new product famous and prestigious overnight if he would allow us to do a classy demonstration on television. He lectured me on his product's minimal ad requirements—ads in trade magazines (certainly *not* commercials) aimed at a mere 5,000 purchasing agents—and threw us out of his Rochester office. The next morning, he reflected and told us to go ahead. Our very first commercial showed a little girl visiting her father's office, where she runs off a Xerox copy for him. His reaction, "Which one is the original?" The message was crystal clear: Even a child could operate a Xerox 914. But the day after it ran, A.B. Dick (a company aptly named) insisted our demonstration was a hoax, and the Federal Trade Commission ordered us to can the spot. So we immediately scheduled a new shoot and invited the perplexed FTC investigators to bear witness. Only this time, we cast a chimpanzee (who made the copies with a lot less coaching than the little girl required). The chimp lifted the Xerox pad, slipped the original in place, jabbed the correct buttons, and scratched his armpits while the Xerox 914 clicked out a copy. He grabbed it, waddled back to the same actor who had played the little girl's father, and scampered away for his banana. That week, on a CBS network news show, we ran the little-girl spot, followed at the next newsbreak by our outrageous chimp commercial—and America went ape for Xerox. Its ten-year sales objectives were accomplished in six months, and the Xerox culture was born! Today, the world makes two trillion copies a year based on xerography—made famous by the grandson of Cheetah the Chimp.

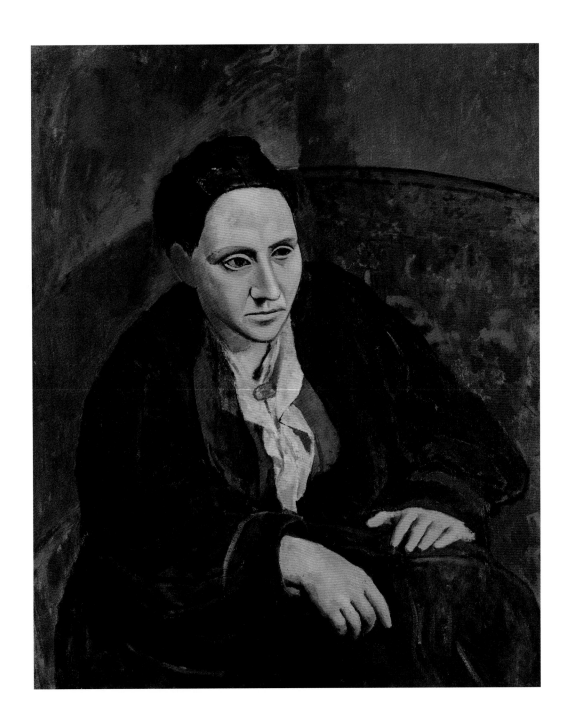

18. "MY DEAR PABLO,"
GERTRUDE STEIN LAMENTED,
"I DON'T LOOK LIKE THAT!"
PICASSO SHOT BACK,
"YOU WILL."

Picasso had been laboring over a commissioned painting of his grim-faced patron,
Gertrude Stein. His portrait of this brilliant if eccentric lady finally
emerged as a work of sublime art in a masklike African style, punctuated by the
fierce accents of Picasso's ancient Iberian origins. This work is now
universally revered as a milestone in the history of art, but when Stein finally laid
her eyes on her long-awaited portrait, still wet, her heart sank.
Her shocked complaint, "I don't look like that!" was followed by Picasso's immortal
words, "You will," proved for all time that art should never be a mirror.

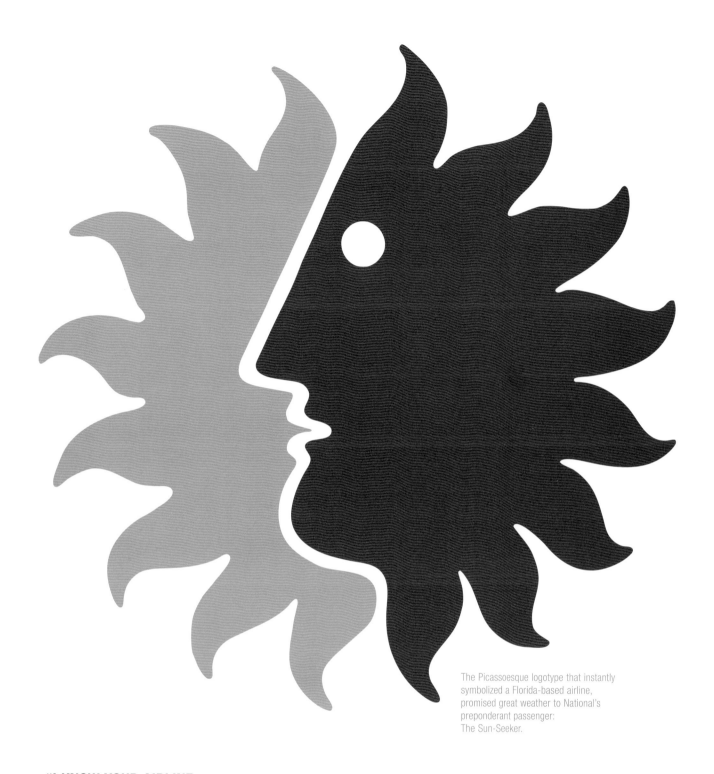

The Picassoesque logotype that instantly symbolized a Florida-based airline, promised great weather to National's preponderant passenger: The Sun-Seeker.

"I KNOW YOUR AIRLINE ISN'T NEARLY AS GOOD AS MY NEW LOGO AND AD CAMPAIGN— BUT IT WILL BE, IT WILL BE."

I've always believed that a great advertising campaign should portray what I feel in my heart the product can grow to become. The ad imagery should be ahead of the product—literally—not in a way that assails credulity, but in a way that inspires belief in the product's benefits and imparts a greater sense of purpose and inspiration to those who produce and sell it. In 1963, Lewis "Bud" Maytag, the 36-year-old president of National Airlines, needed a startling campaign to save his young, troubled airline. My presumptuous campaign, *Is this any way to run an airline? You bet it is!* declared, almost overnight, that the company that was about to go out of business suddenly was taking off, and the New York-to-Miami market ate it up! Advertising, like art, should never be a mirror. Advertising should be a compass that points its arrow toward new standards of consumer satisfaction.

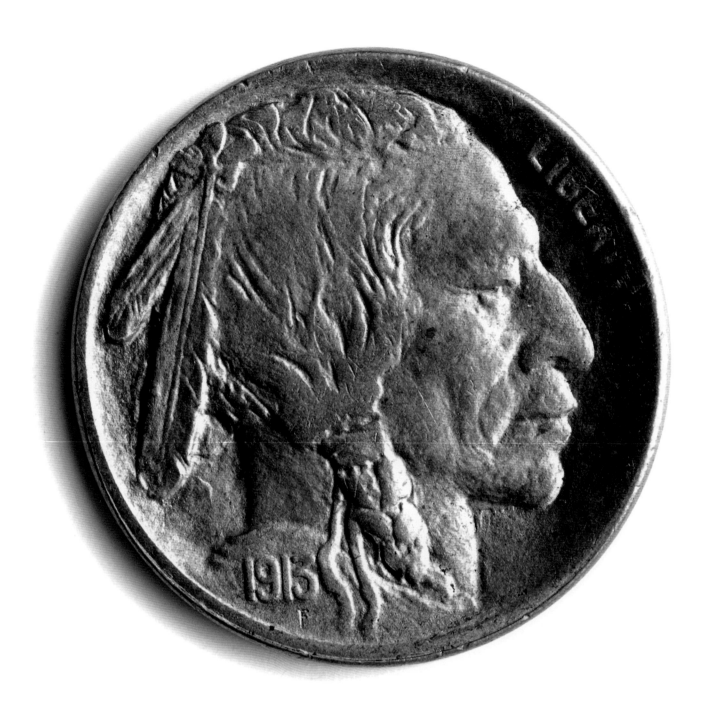

19. THE GREATEST (AND MOST POIGNANT) COIN IN HISTORY.

The greatest coin ever created, surpassing even the ancient Greeks,
who invented coinage in the seventh century BC, is our simple "Buffalo" nickel.
Designed in 1913 by the sculptor James Earle Fraser, both sides
are masterpieces, each image caressed in a circle. The slaughtered buffalo
(40 million!) and the noble head of the defeated Native American
(an "unknown amount" killed) are subjects that were perfectly chosen to symbolize
with staggering honesty the shameful, genocidal past of a great nation.

**A HALF-CENTURY AFTER THE NATIVE AMERICAN AND THE BUFFALO WERE MEMORIALIZED,
I WONDERED WHO THE MAN WAS WHO POSED FOR JAMES EARLE FRASER.**

The advance draft of the March '64 *Esquire* included an article on the American Indian. On a lark, I phoned the
Bureau of Indian Affairs, in Washington D.C., to inquire whether they had the remotest notion as to which brave posed for the
Indian Head/Buffalo nickel and if he might still be alive. The Washington paleface called back a day later and stammered,
"His name was, I mean is...Chief John Big Tree...He m-m-may still be alive...if so, he should be on his Onondaga Reservation."
My father-in-law, Joe "Big Feet" Lewandowski, a Syracusan, drove out to the reservation, where he found the chief
in the flesh, toting twigs to light a fire in his primitive dirt-floor cabin. He was a vigorous 87-year-old and stood six-foot-two.
I couldn't wait to catch the first plane up there, but Chief John loved to fly. He showed up at the shoot in a business
suit that smelled of mothballs, sporting a crewcut. In 1912, the sculptor James Earle Fraser had eyed the chief in a Coney Island
Wild West show and asked him to pose for his Indian Head nickel. Chief John was a Seneca, a descendent of the
Iroquois Confederacy, which dates back to the 1500s. We dressed him in a black wig and built up his toothless mouth with
cotton wads. He looked awesome. We shot his historic profile and he flew back to Syracuse on Mohawk Airlines.
It was vintage Americana—the now legendary Chief John Big Tree, fifty years after he posed for the Indian Head nickel!
After his noble profile hit the newsstands, he became a hit on the TV talk-show circuit, and the unknown
chief became a heroic, iconic celebrity.

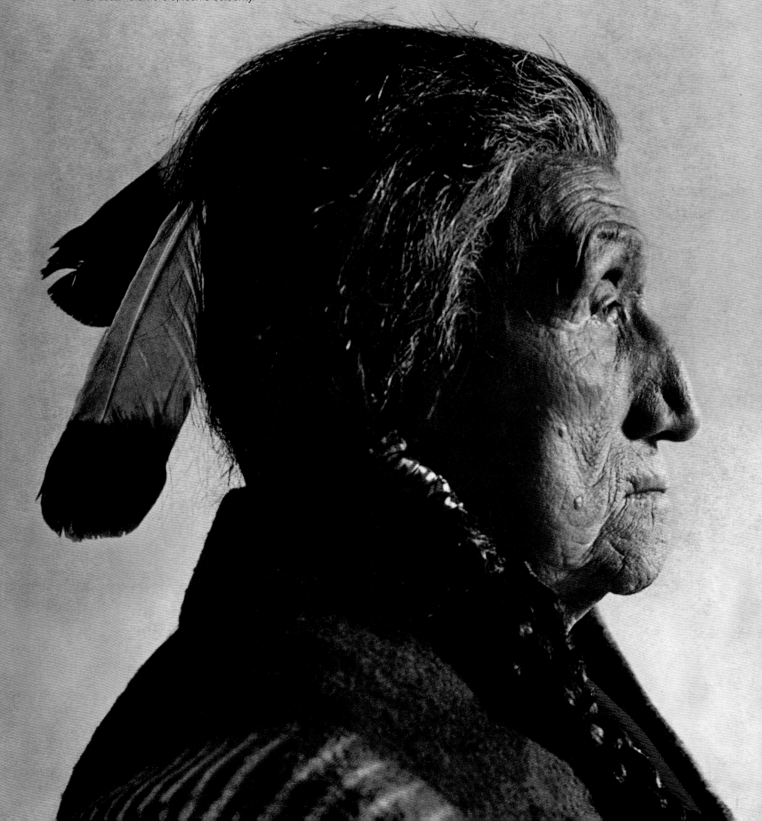

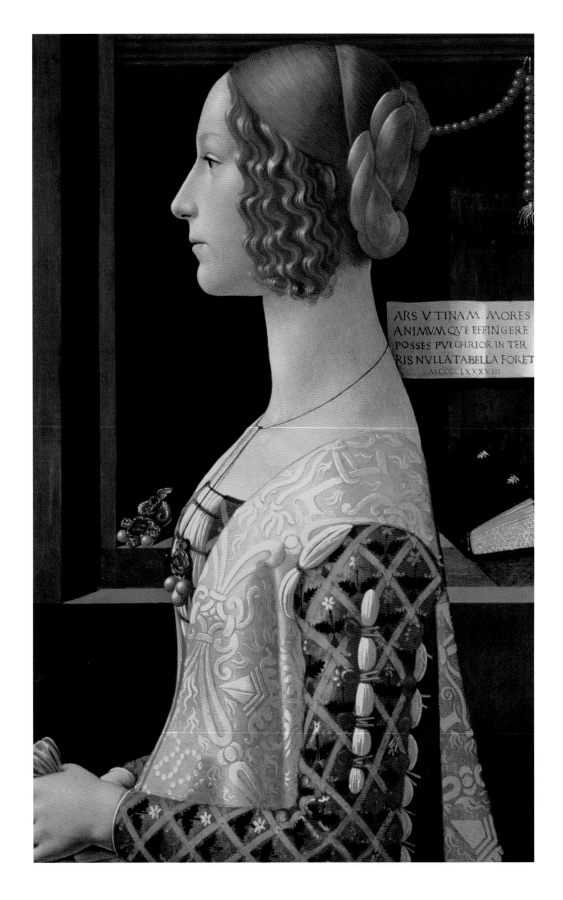

The inscription in the image reads:

ARS VTINAM MORES
ANIMVM QVE EFFINGERE
POSSES PVLCHRIOR IN TER
RIS NVLLA TABELLA FORET
MCCCCLXXXVIII

20. THE FLORENTINE BEAUTY WHO DIED DURING CHILDBIRTH

This posthumous portrait of Giovanna delgi Albizzi Tornabuoni (modeled from a full-length image of her painted by Domenico Ghirlandaio a few years earlier) is an exceptionally striking depiction of a young Florentine woman painted in the Flemish manner (in profile). Giovanna was born into an old and distinguished Florentine family in 1468, married Lorenzo Tornabuoni in 1486, produced a son, and then died during her second childbirth, in 1488, not yet twenty years old. Affixed to the wall in the poignant portrait is a Latin inscription that translates as: "Art, would that you could represent character and mind. There would be no more beautiful painting on earth." To my eye, the great Ghirlandaio made Giovanna's virtue visible by creating a luminous image of the beautiful and proud woman who tragically died young, enclosed within the dark frames in which he depicted her, as in a tomb, conveying as well as any poet could, the survival of her spirit through his masterwork of art. Truly, there is "no more beautiful painting on earth!"

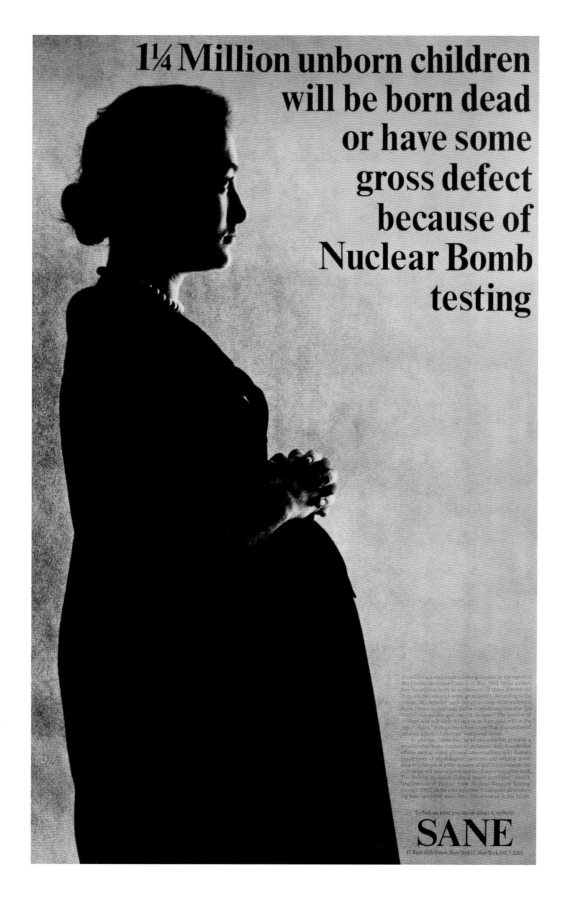

AN ATTEMPT TO SAVE THE FUTURE BABIES OF THE WORLD

In 1961, Dr. Benjamin Spock asked me to do a New York subway poster. Nuclear testing in the atmosphere by the U.S. and the Soviet Union was threatening the continuation of life on our planet, without one bomb being dropped in conflict. Dr. Spock, one of the brave leaders of the Committee for a Sane Nuclear Policy (SANE), was instrumental in alerting the public with warnings by Nobel scientists that the fallout from radioactive materials would result in a growing number of birth defects and deaths. I showed, in homage to Giovanna and Ghirlandaio, the image of a profile of a conspicuously pregnant young woman (my secretary at that time) with this absolutely factual headline: *1 1/4 Million unborn children will be born dead or have some gross defect because of Nuclear Bomb testing.* The press called me a pinko. Today, four and a half decades after the Nuclear Test Ban Treaty of 1963, it seems incomprehensible that protests against a poster about the malignant peril of nuclear fallout could ever have caused such extreme reaction. But Dr. Spock and the Nobel laureates who manned the barricades in those scary days were a band of heroes who saved the world.

21. MAN RAY'S DREAMLIKE TEARS

In 1859, Charles Baudelaire articulated his abhorrence for photography's success as an enemy of poetry:
"Day by day, art diminishes respect for itself, prostates itself before the external reality, and
the painter becomes more inclined to paint, not what he dreams, but what he sees." The years that
followed largely confirmed Baudelaire's opinion—until the advent of Man Ray. The best of
Man Ray's photographs do dream. As a colleague of Marcel Duchamp and the New York Dadaists,
Man Ray became the most celebrated experimentalist of his time. Straddling the worlds of art,
photography, and iconoclasm, he then became an American in Paris, joining the dream team of Max Ernst,
André Breton, Tristan Tzara, and Paul Eulard at the vanguard of Surrealism. Man Ray's classic
photograph of pearl-drop tears (made of glass) and spider eyelashes on a woman's face is a stunning
example of the dreams conjured up in his head, with his eyes wide shut. In Man Ray's words:
"The streets are full of admirable craftsman, but so few practical dreamers."
(In an exploding photography market, a print of *Glass Tears* sold for $1.3 million in 1999.)

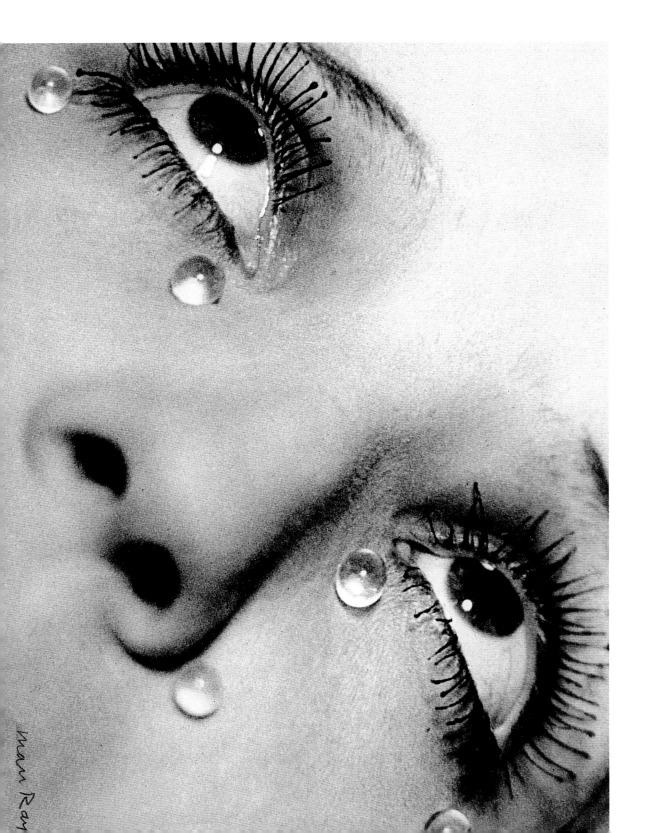

A NATION'S NIGHTMARISH TEARS

"Kennedy Without Tears" was an article by Tom Wicker that looked at JFK "objectively," a mere
seven months after his assassination. This *Esquire* cover defined an opposite symbolism—of Kennedy
himself, crying for his lost destiny. (Or are they, after all, the tears of the reader?) For most
Americans, the murder of our president was an unrelieved trauma. Nerves and emotions were apparently
as raw in June 1964 as they had been in November. Even though the issue was a very big seller,
prompting another jump in circulation, I caught hell for being "insensitive." But this trompe l'oeil (trick
of the eye), dreamlike image of a photograph and a "real hand" still moves me. The death of FDR,
the savior of our nation...the assassination of JFK, Dr. King and RFK...the horrific 9/11 terrorist attack
on my hometown...bring tears to fortify the soul.

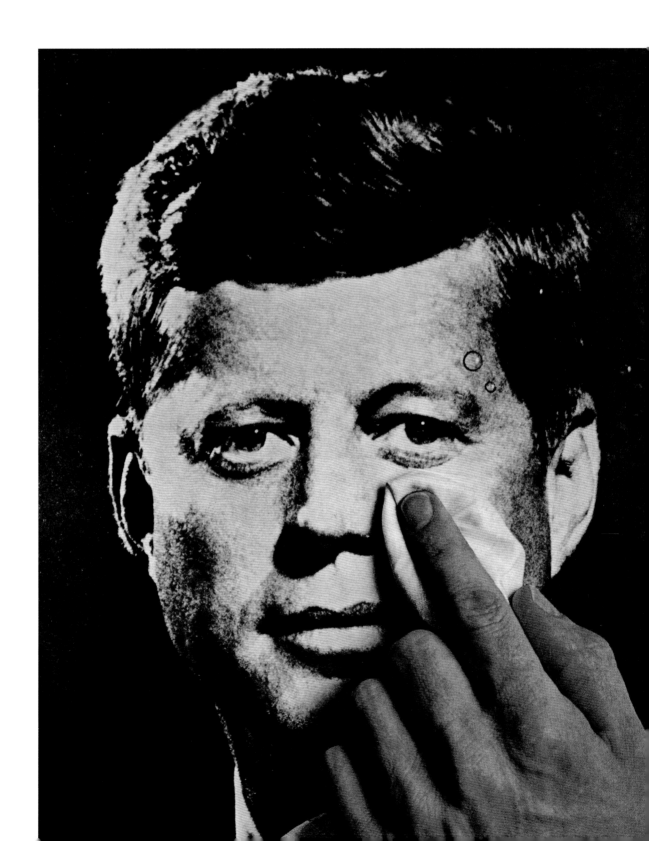

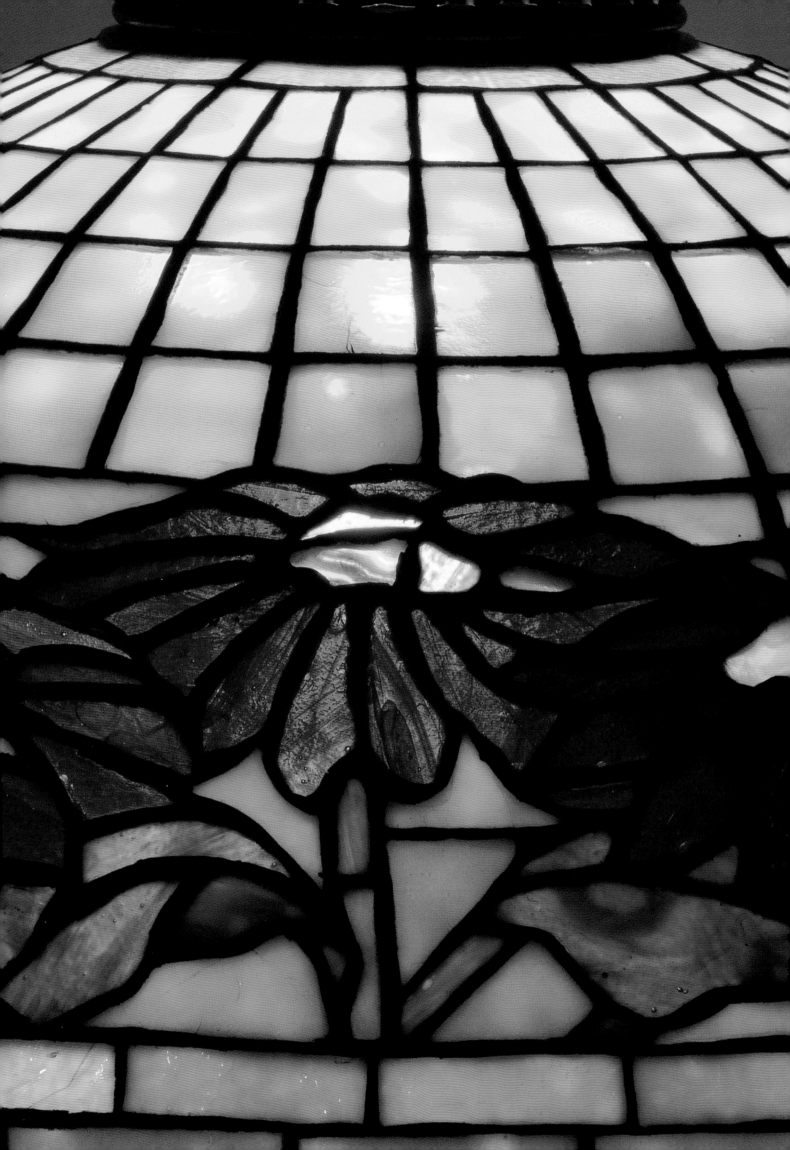

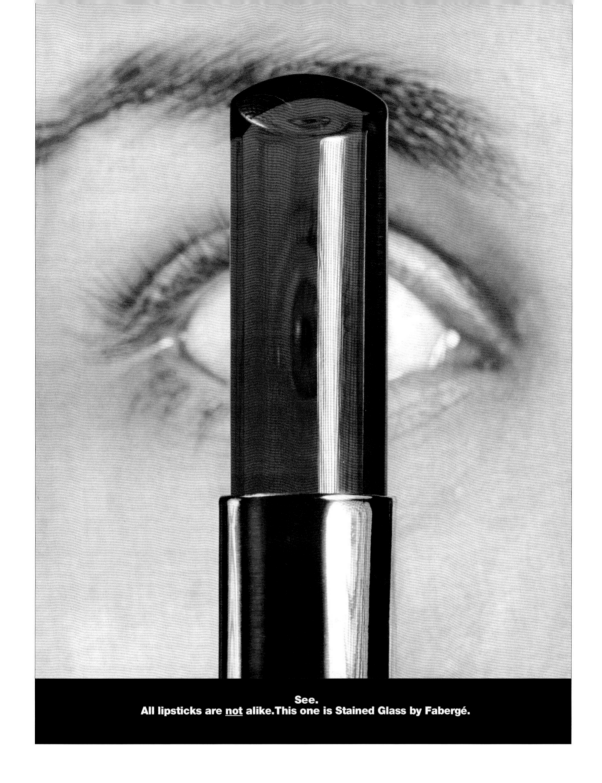

See.
All lipsticks are <u>not</u> alike. This one is Stained Glass by Fabergé.

22. A $250,000 TIFFANY STAINED GLASS LAMP...

The artist Louis Comfort Tiffany was the eldest
son of Charles Lewis Tiffany, founder of the prestigious
firm Tiffany & Co. in New York City in the
nineteenth century. The son refused to join his father's
business. Instead, following his passion,
he went on to become the name synonymous with
the American version of the Art Nouveau
movement with his creation of Favrile glass, the most
beautiful ever created on the face of
the earth. There is no more breathtaking objet d'art
than a great Tiffany lamp, whether a
Wisteria, a Dogwood, a Dragonfly, a Magnolia, or the
beauty shown here, a brilliant Poinsettia.
I have five Tiffanys in my home, and I turn every
one on at the first sign of twilight.

...AND A $3.50 LIPSTICK

In 1968, when I was first shown a
Coty see-through lipstick rising out of its tube,
I blurted out "Stained Glass lipstick!"–
and Timothy Galfas took a stunning photograph
of a beautiful woman's eye staring
through the luminous phallic symbol.

23. WHY CAN'T A WOMAN...BE MORE LIKE A MAN?

In the early '30s, the young femme fatale Marlene Dietrich would stride up the Champs-Élysées wearing her famous trouser suits, her hair smoothed into a neat bob. Parisians abandoned their cars and sidewalk tables and followed her up the avenue. The demands on Hollywood actresses during the Depression to be more than flesh and bones were met head-on by Dietrich, and by Paramount, which turned her masculine attire into a publicity triumph, touting its new star in 1930 as "the woman even women can adore." No actress brought as much taste and style to the business of glamour—not Joan Crawford, nor even Dietrich's Swedish rival—Greta Garbo. All her long life, Dietrich blurred gender lines and looked the part of the modern, emancipated woman (with lovers chosen freely from both sexes). She was a woman's woman and a man's man. The still shot from the 1930 movie *Morocco* is of the young Marlene Dietrich wearing one of her trademark tuxedos. It fits her to a T.

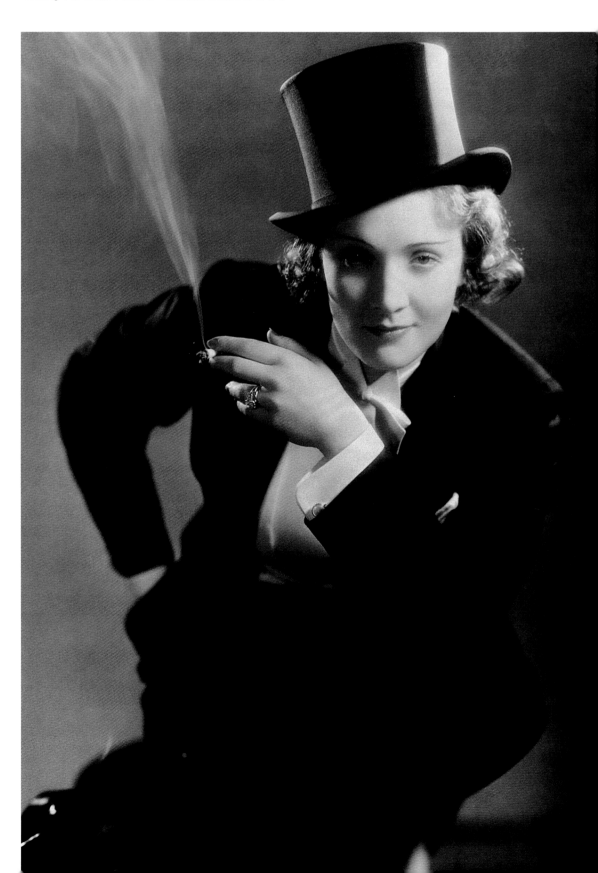

35 YEARS LATER, ANOTHER WOMAN WITH BALLS

The year 1965 was pre-Friedan, pre-Steinhem, pre-Abzug. For an article on the masculinization of the American woman, just as the hoopla about the women's movement had caught the public's eye, I wanted to do a spoof of a movie star caught in a manly act. The budding movement wanted liberation from women's traditional roles. Like any Greek male, I wondered where it would take us. The best way to draw attention to a trend on the horizon in the '60s was a cheeky *Esquire* cover. But in those uptight days, I got turned down by every American beauty queen in Hollywood, including Kim Novak, Marilyn Monroe, and Jayne Mansfield. Then the molta belissima star of *How to Murder Your Wife*, Virna Lisi, visited New York with Jack Lemmon for a movie preview, and I hoped there was a chance a foreign actress had the machismo to pose for it. I contacted her and explained what I wanted. The Italian beauty, a knockoff of the German Marlene Dietrich, laughed with gusto, slapped on some shaving cream, and took it off on the front cover of America's leading men's magazine.

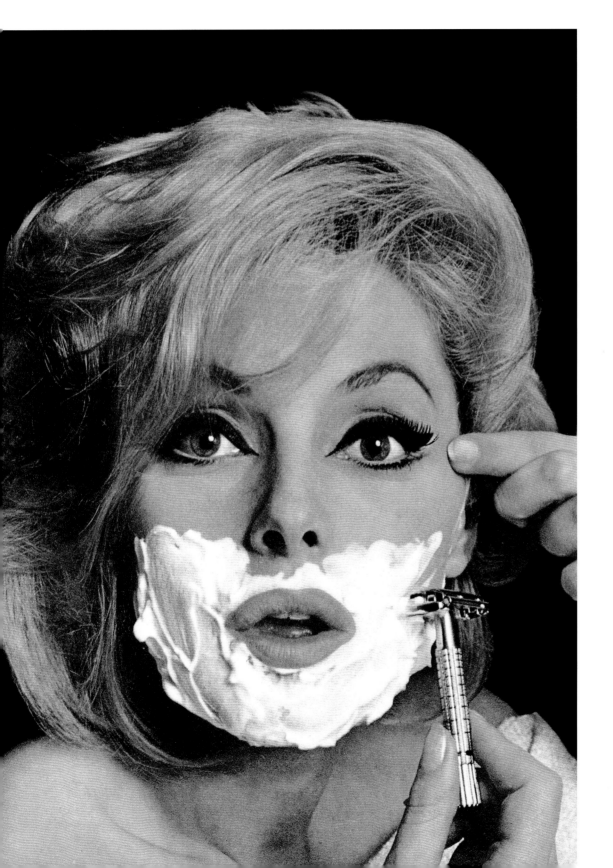

24. *THE ODD COUPLE*, THE ADVENTURES OF A NEUROTIC TRYING TO LIVE WITH A SLOB...

Jack Lemmon and Walter Matthau, an irresistible pair of comic greats, play divorced pals (Felix Unger and Oscar Madison) who set up house together (so they can save for alimony) and find out why their wives probably took a powder. Felix is a compulsive-neurotic commercial photographer who tries to commit suicide by jumping out of a window but can't get it open, and Oscar is a beer-drinking, compulsive gambler, an easy-going sportswriter slob always ready to have a good time. (Unfortunately, his eccentric flatmate bursts into tears whenever he suggests female companionship.) Oscar revels in the smoke-filled ambiance of poker playing, cigarette butts, and empty beer bottles strewn around their apartment, while Felix, a connoisseur of French wines, rushes home each evening to frantically vacuum, clean, and cook gourmet meals. The 1968 Neil Simon masterpiece forever defines the juxtaposition of the dueling opposites.

...INSPIRES MY TV CAMPAIGN OF CELEBRITY ODD COUPLES, PORTRAYED AS LOVABLE SPOTLIGHT-HUSTLERS TRYING TO OUT-BULLSHIT EACH OTHER AS THEY FLY BRANIFF.

In 1967, *When you got it, flaunt it!* became an American colloquialism as well as a standard entry in the anthologies of American sayings. It was my Bronx-created slogan for Braniff—a zany, outrageous campaign, inspired by *The Odd Couple*, that featured a smorgasbord of the world's oddest couples, exchanging the screwiest and most sophisticated chatter on television. Our juxtaposition of unlikely couples was unprecedented, creating the perception that when you flew Braniff International, you never knew who might be in the next seat to you. Salvador Dali *(Wen yo godet, flawndet!)* talked baseball with Hall of Famer Whitey Ford. Black baseball legend Satchel Paige (who pitched in the majors in his late '50s) talked about youth and fame with neophyte Dean Martin Jr. Poet Marianne Moore discussed writing with crime pulp-novelist Mickey Spillane. Ethel Merman gives us a what-a-jerk look when publisher Bennet Cerf asks her if she ever heard of *There's No Business like Show Business*. British comedienne Hermione Gingold trumped movie legend George Raft at his own game whilst inundating him with pretentious palaver. Pop guru Andy Warhol tried (but failed) to engage the sullen heavyweight champ Sonny Liston. Sounds wacky on the face of it, but as we eavesdrop on these odd couples trying to outflaunt each other, we hear everything that has to be said about Braniff. We also imply that *you* might bump into a celebrity or two on a Braniff flight.

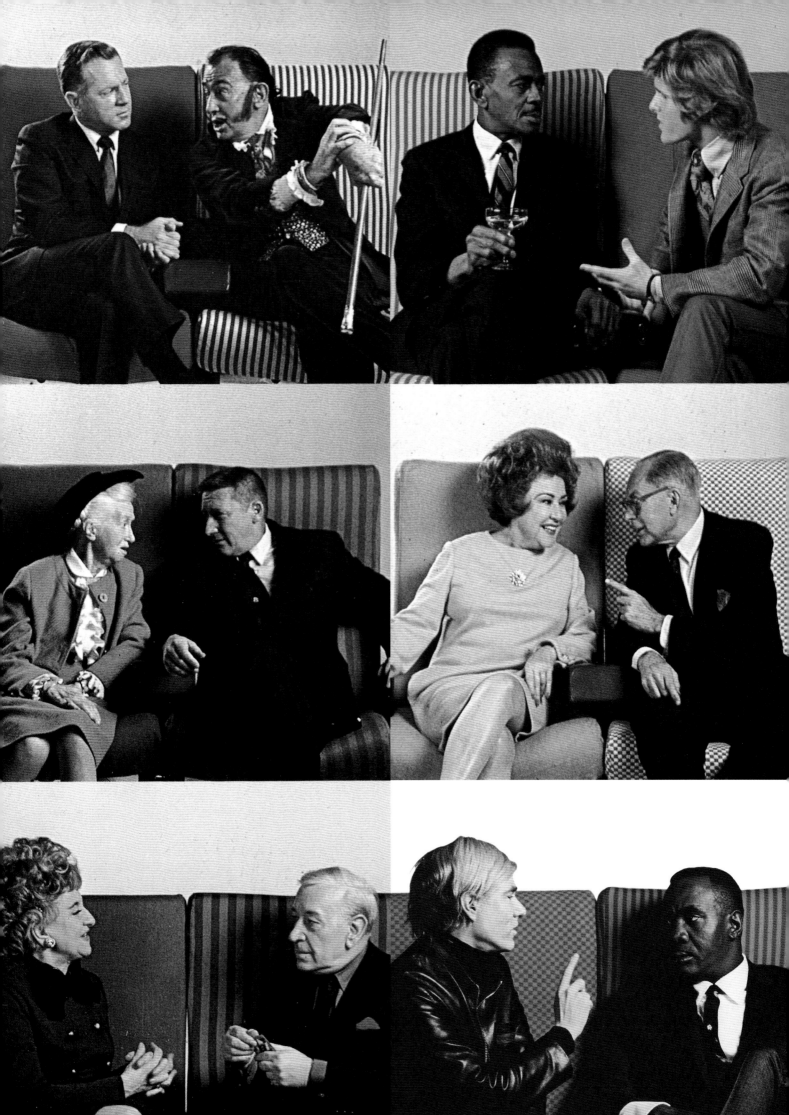

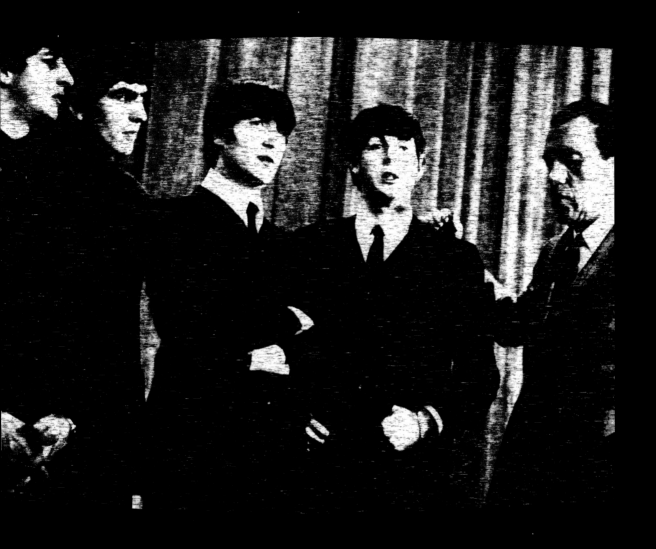

25. THE STIFF WHO BROUGHT THE BEATLES TO AMERICA

For more than 20 years, *The Ed Sullivan Show* on CBS had been famous
for introducing new entertainers to America. Sullivan, a former
gossip columnist-about-town, combined an uncanny instinct for sensational
new talent (along with Russian dancing bears and ubiquitous
juggling acts). He was thought of as a square by the cultural avant-garde,
but it was Sullivan who, in 1956, had booked the "outrageous"
Elvis Presley to sing *Hound Dog* (on condition that cameras showed him only
from the waist up!). Despite the objections of his production staff,
Sullivan also booked the quartet with the bowl haircuts. The show received
50,000 applications for the 700 seats for that night.
On February 9, 1964, *The Ed Sullivan Show* was watched by an audience
of 75 million—60 percent of all television viewers. That night,
The Beatles' assault on America made them world famous (along with
UPI breaking the news that Reverend Billy Graham, the uptight
evangelist, had broken a lifetime rule by watching television on the Sabbath).

THE NIGHT AFTER ED SULLIVAN INTRODUCED THE FAB FOUR TO AMERICA, HE FLIPPED HIS WIG.

When showman Ed Sullivan brought Beatlemania to our shores on his Sunday-night TV variety show, I knew *Esquire* had to acknowledge this seemingly uncool establishment elder with his knack for being on the cutting edge of popular culture (even though he had kept his camera off the pelvis of Elvis eight years before). The Liverpool Fab Four with their outrageous bowl cuts had landed, and they swiftly reached the apex of pop music. So that Monday morning, I ambled over to the Ed Sullivan Theater and camped at the entrance, like a sicko fan, right there on Broadway. When Sullivan finally came out, I beat off some autograph-seekers and shoved a sketch under his nose of my proposed *Esquire* cover showing the impresario wearing a Beatles wig. He took a long look and grinned from ear to ear, just like the photo we took the next day. My caption next to his portrait said, *"Does today's teenager influence the adult world?"* *"Ridiculous,"* answers Ed Sullivan.

The only major league team named after a borough (rather than a city or a state), the Brooklyn Dodgers entered American mythology as a metaphor for lost innocence when "The Boys of Summer" were packed up and sent off to Los Angeles in 1957 by their treacherous owner, Walter O'Malley (see No. 7). Only ten years after the dramatic breaking of the color barrier, our beloved Bums were outta town. When columnists Pete Hamill and Jack Newfield played a game naming the three most evil men of the twentieth century, they ticked off Hitler, Stalin, and Walter O'Malley (and not necessarily in that order). As the pioneering African American to play in the majors, Jackie Robinson had become the most historically significant baseball player ever. Babe Ruth changed baseball; Jackie Robinson changed America. Two short years after their greatest triumph on the playing field, the Flock having finally beaten the hated Yankees in a World Series after five fateful losses (as well as losing two National League playoffs during those "Wait 'til next year" days) and bam—the proud residents of Brooklyn were jilted for La La Land, as O'Malley took flight with Jackie, Pee Wee, Campy, and the Duke. New York had lost the most colorful team (double entendre intended) in the history of the game, and it traumatized our town.

26. BROOKLYN LOSES ITS BELOVED BASEBALL TEAM

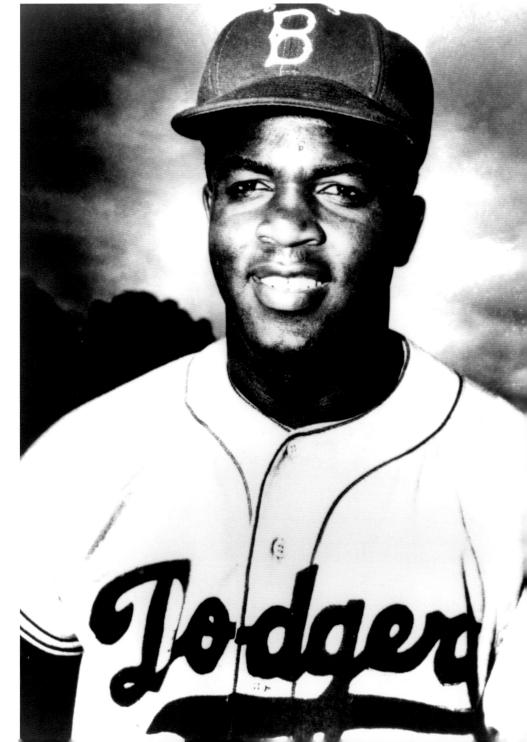

In 1970, to popularize Off-Track Betting in New York, I initiated every New Yorker into a new team. As a homage to the Dodger logo, I designed the New York Bets logo in a similar sporty script style. Our New York Bets T-shirts became a hot fashion item on the streets of New York, and we celebrated our new team imagery with ads, subway posters, and commercials, starring (gratis!) showbiz biggies Rodney Dangerfield, Carol Channing, Lainie Kazan, Jack Gilford, Joel Grey, Ben Vereen, Professor Irwin Corey, Henny Youngman, Joey Heatherton, Lynn Redgrave, Imogene Coca, Bobby Short, Joey Heatherton, jockeys Eddie Arcaro and Willie Shoemaker, and finally megastars Bob Hope, Jackie Gleason, and Frank Sinatra. OTB's previous macho image didn't invite female bettors—indeed, it hardly lured New York's sporting businessmen (who wouldn't want to be spotted by their bosses in a cigar-smoke-filled betting parlor). All of a sudden, betting on a horse at a sidewalk betting parlor was now socially OK! The campaign jumped Off-Track Betting from a $700 million handle to a galloping $1.8 billion.
P.S. On second thought, if the Dodgers (and then the baseball Giants) had not left town, there would have been no Mets.
Dodgers, *Jets*, *Nets*, *Bets* sure doesn't rhyme, so maybe all's well that ends well.
Naah. I still hate Walter O'Malley's guts.

INTRODUCING A NEW TEAM IN TOWN:
YOU'RE TOO HEAVY FOR THE METS?
YOU'RE TOO LIGHT FOR THE JETS?
YOU'RE TOO SHORT FOR THE NETS?
YOU'RE JUST RIGHT FOR THE BETS!

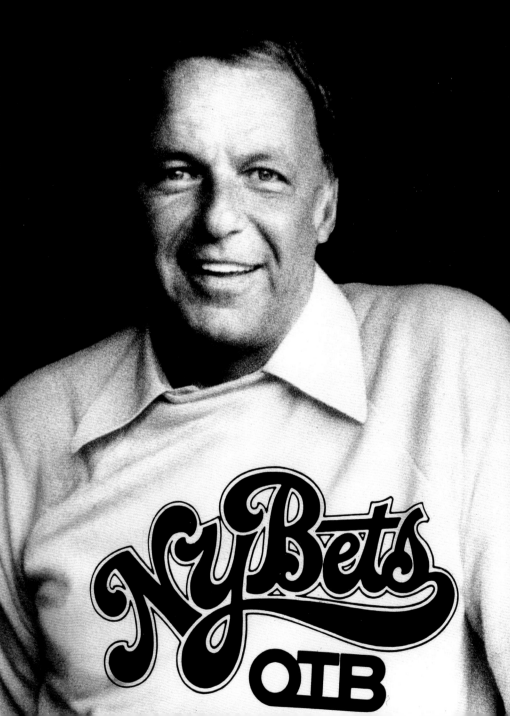

27. THE CULTURE-BASHING INFLUENCE OF AFRICAN ART ON PICASSO, MATISSE, BRANCUSI, KLEE...

The African mask shown here is a very old, rare example of its type, originating in the upper Ogowe region, and made by the Tsaayi, a Teke group in the Republic of Congo. Its profuse geometric motif is arranged nearly symmetrically along both vertical and horizontal axes. The narrow eye slits flanking the small nose enabled the dancer to see as he held the mask by gripping a woven cord on the back between his teeth, as he performed during Tsaayi initiation ceremonies. African ritual art, with its rich history of face masks, has a presence, a fierce, contained energy and a robust conceptual approach to the human face and form. The masks were not conceived as likenesses. When we look at them in their wide disparity, we are at once thrilled and disoriented, awed and even a bit alarmed at their extreme design (the "shock of the new"). Abstraction of such beauty and superb shapes has rarely come our way. Inspired by their outrageous form and magical powers, modern Western avant-garde sensibility owes a spiritual debt to the tribal societies of Africa (as well as Oceania and the Americas). From 1907 on, Picasso, Braque, Matisse, Derain, Vlaminck, and others found in "primitive" art a criterion of imaginative energy that was more thrilling, more raw, more intellectual, than anything they could find at the Louvre or the British Museum (until they realized that the Musée de l'Homme housed stupendous works of tribal art and had been open for 25 years before Picasso went there in 1907 and was struck dumb with a monumental epiphany). The impact of African art on Western culture honors the enormously inventive powers of the tribal artists—their objects transcend the context of their own societies, demolishing Western presumptions linking human potential to technological progress. Nothing in Western (or Eastern) art prepared modern artists for the raw power, exquisite abstraction, and the "otherness" of tribal art. Yet they were deeply moved by it, freeing their eyes, minds, and hands to vivid experimentation, and we are too, totally and profoundly. In 1919, the Cubist painter Juan Gris wrote that to rid themselves of what they considered "a too brutal and descriptive reality," they created a new "imaginary reality." An apt description of African art.

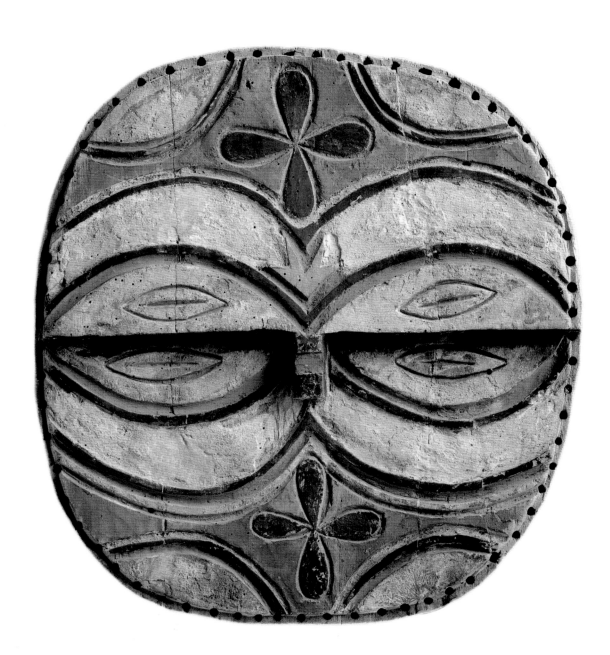

...AND ME.

For an *Esquire* Back to College Issue in 1965, a time when we still embraced heroes, I created this composite of the four men that college students all across America had chosen as their leading heroes of American youth. Bob Dylan, Malcolm X, Fidel Castro, and President John Kennedy are divided (and joined) by the crossbars of a rifle sight. Kennedy and Malcolm X had been murdered, and Castro (we now know) escaped assassination attempts and is still regarded by many (including me) as a romantic revolutionary. The musician-poet Dylan remained to compose and sing of that violent, revolting age. (Today, alas, without heroes, we must do with celebrities.) I conceived this controversial *Esquire* cover (Malcolm and Fidel pissed off the deep South) at a time when I was studying and collecting African art. When I knocked out a rough image of my pie-chart hero, I told my wife, Rosie, that it would be a "modern" Teke mask. The fact that she knew what I was talking about explains why our marriage is still going strong after 57 years.

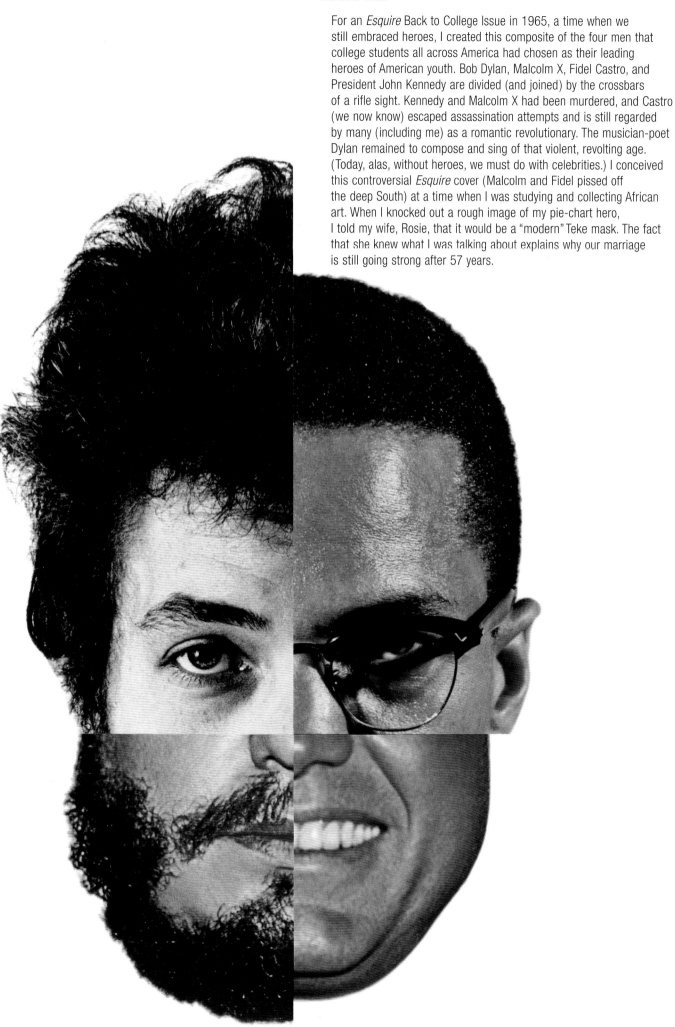

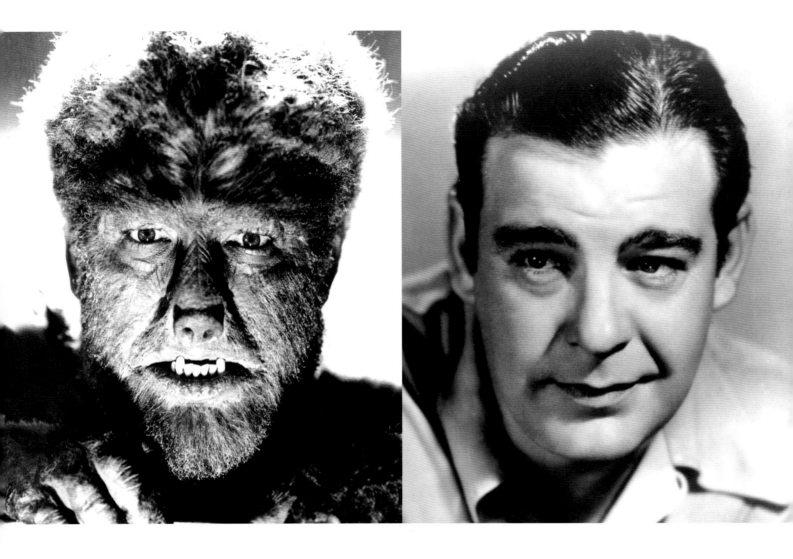

28. LON CHANEY DISSOLVES INTO A WEREWOLF (AND VICE VERSA).

The year 1941 saw the remarkable debut film of 25-year-old Orson Welles' *Citizen Kane*; John Huston's rookie film, *The Maltese Falcon*; Howard Hawks's *Sergeant York*; and Alfred Hitchcock's auspicious *Suspicion*. But the movie imagery with real teeth was *The Wolf Man,* starring Lon Chaney Jr. and showcasing the talents of makeup artist Jack Pierce. Larry Talbot (Chaney) returns to his ancestral home, in Wales, following the death of his brother. He visits a gypsy camp and fights off and kills a gypsy who is a werewolf, but not before falling victim to Bela Lugosi's fanged bite. The bereaved werewolf's mother, played by the scene-stealing Maria Ouspenskaya, mutters Slavicly, "Even a man who is pure in heart and says his prayers by night may become a wolf when the wolf bane blooms and the moon is full and bright." Talbot pours his heart out to his unbelieving father, Sir John Talbot (Claude Raines). At the first sighting of a full moon, we witness the terrible transformation, via a slow-w-w cross-dissolve of the clean-shaven young aristocrat into a vicious wolf-man. The villagers, accompanied by Sir John, chase and kill the lupine creature in a forest, and his father pathetically watches dumbstruck as the hairy werewolf transforms back into his beloved son. When I was ten years old, seeing Lon Chaney Jr. morph into a werewolf was more poignant than the pursuit of the meaning of the word "Rosebud" (the last word uttered by the megalomaniac Charles Foster Kane); more macho than private eye Sam Spade outwitting Sidney Greenstreet and Peter Lorre for the black "boid"; more suspenseful than Hitchcock's *Suspicion* (is Cary Grant going to murder his new bride?); and more iconic than Sergeant York becoming a reluctant hero in the Great War, picking off krauts in a turkey shoot.

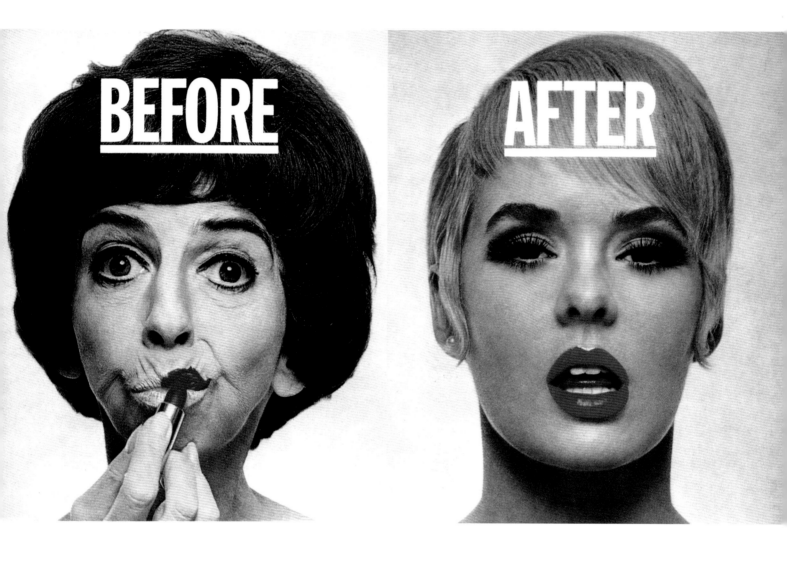

ALICE PEARCE WEREWOLF-DISSOLVES INTO JOEY HEATHERTON.

On the assumption that most (intelligent) women regarded lipstick ads as the usual cosmetics con job,
I created this 1968 Coty ad that spoofed instant glamour. Comedienne Alice Pearce,
applying lipstick, proved that a little dab would not only do ya, it would turn any wallflower
into a young, sensual Joey Heatherton! Before I could film Pearce for a TV spot,
she tragically died, so I sadly cast Alice Ghostley, another beautifully talented nonbeauty, dissolving
werewolf-style into luscious Joey. (Using unknowns as the Beauty and the Beast
would have been a total turnoff, but using celebrities was a total delight.) As Richard Avedon was
filming Ghostley, I explained to her how I would dissolve her footage, werewolf-style,
into a preening Heatherton. "Maybe I shouldn't have shaved this morning," she said, gamely,
as she smeared her mush with a Coty Cremestick.

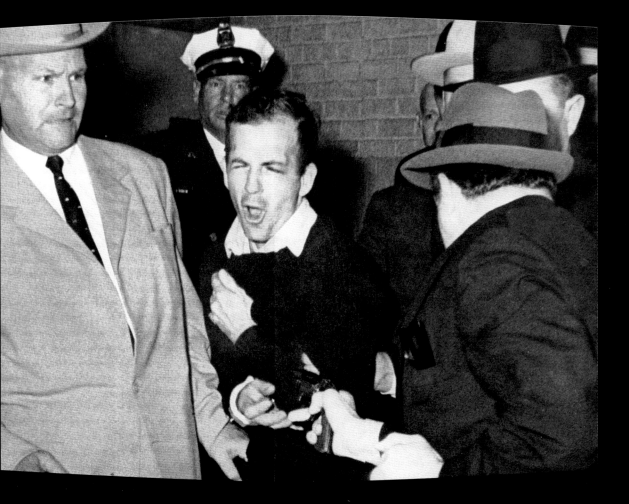

29. A THUNDERBOLT OUT OF THE BLUE...

The killing of Lee Harvey Oswald, President John F. Kennedy's alleged assassin,
who was literally in the hands of the Dallas police, was undoubtedly the most astonishing
scene ever projected, live, to a television audience of millions. Jack Ruby was the
proprietor of a popular Dallas striptease joint, a do-it-yourself bouncer in his own club.
The small-time bar-brawling gambler was always ready to glad-hand policemen
and give them one on the house. On Sunday morning, November 24, 1963, he walked
into the city prison, just one of the boys, to witness the president's killer being
transferred to the county jail. Emerging from an elevator, Oswald was led toward an
armored car by a group of detectives, three of them wearing short-brimmed
Stetsons. Suddenly, a burly form in a natty suit plunged forward, arm outstretched,
pointed a gun and drove it into Oswald's ribs and fired one shot. Oswald slumped,
and an astonished policeman shouted, "Jack, you son of a bitch!" Later, Ruby's sister
insisted that her brother had acted as a revengeful vigilante and that his
motive for killing Oswald was his admiration for the slain president.

...WITNESSED BY MILLIONS, OLD AND YOUNG

November 24, 1963, was a definitive TV moment, as Jack Ruby shot Lee Harvey Oswald dead, live, in front of millions. On an *Esquire* cover, I captured the moment when make-believe ended—when an all-American Norman Rockwell kid started to grow up, with real violence in his carpeted den, complete with an all-American burger and Coke. Oswald killed our president and our dreams for building a better America, and Ruby killed our chance to make any sense of what went down, and to find out whether Oswald had been part of a vast conspiracy. May two of the most infamous men in American history burn in hell.

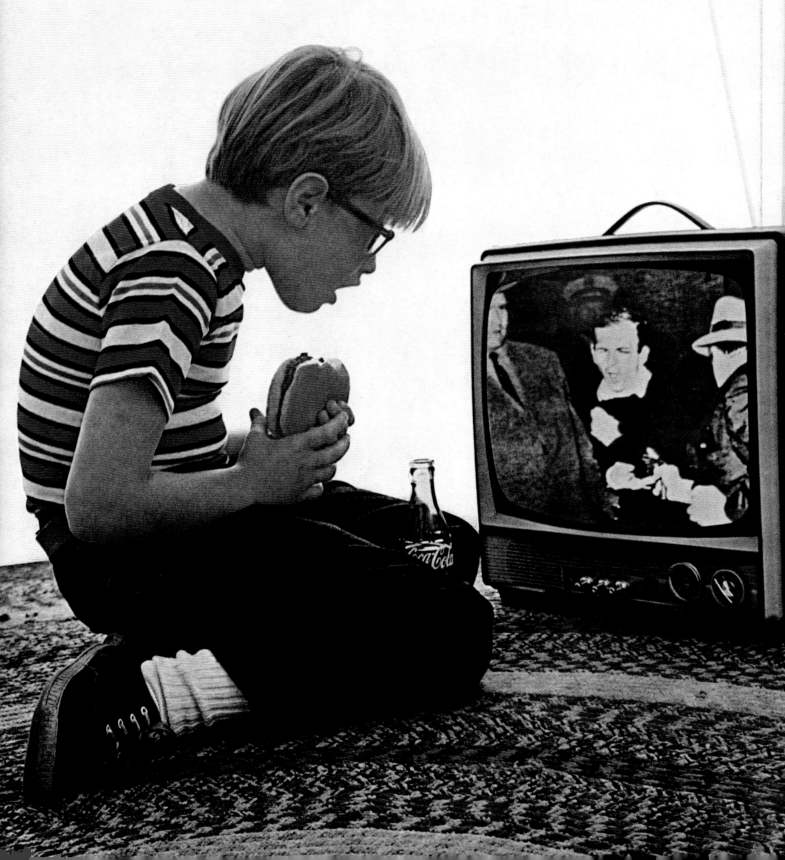

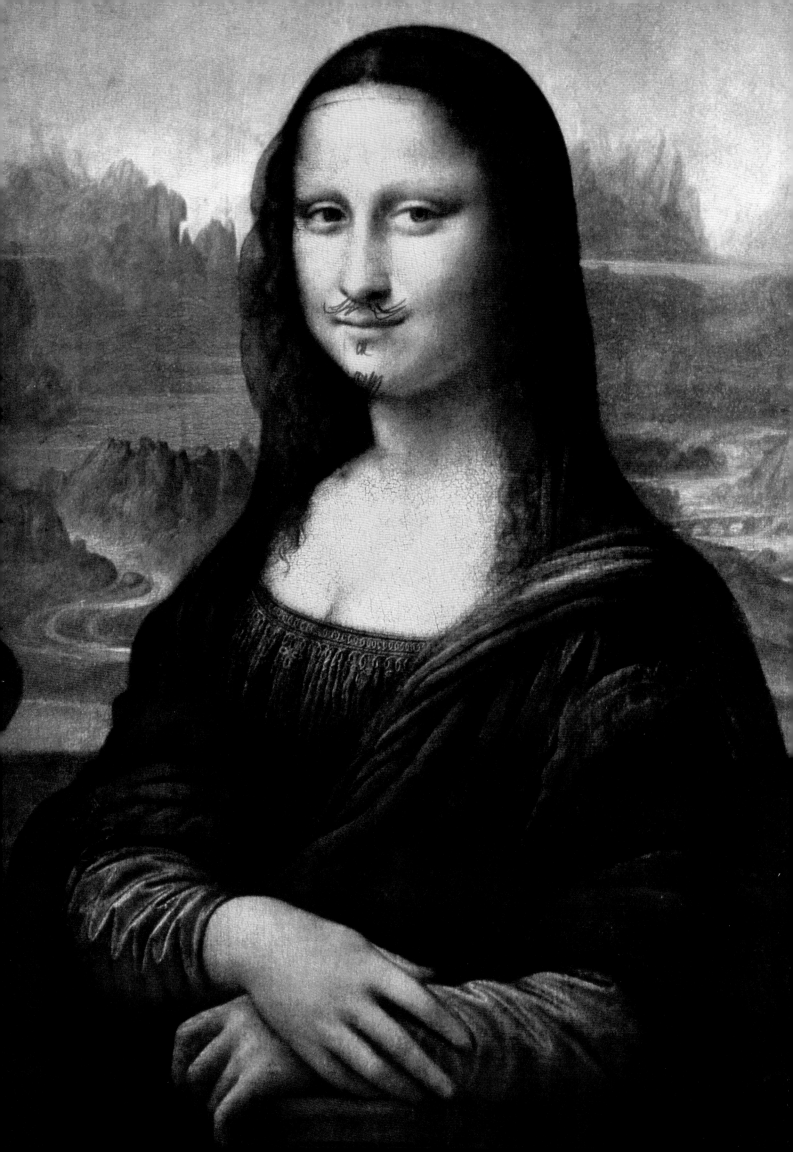

SCRIBBLING HER DADA'S MOUSTACHE ON JOE STALIN'S FINK DAUGHTER

Graffiti artists have defaced works of art since
prehistory, although Marcel Duchamp's
intention was not to denigrate Leonardo da Vinci's
sitter. But I did a hatchet job on
Svetlana Stalin! When Joe Stalin's daughter
came to the U.S. in 1967, her face
showed up on the cover of every magazine
except *Popular Mechanics*. Her
old man was a despot, but I felt that anyone
who told stories about her father was
a lousy fink. (Call me old-fashioned.) Then
Esquire ran a lead article on
Stalin's little girl, and I was stuck with coming
up with still another Svetlana cover.
The story, written by Gary Wills, was at least
a skeptical piece. It described her
weird dabblings in assorted religions.
It analyzed how she was taken
in hand by the smart boys in publishing and
our Red-baiting State Department
when she came to America with her red-hot
manuscript about Life with
Father Joseph. I was so offended by her that
I picked up a copy of *Newsweek*,
splashed with a dreamy shot of Svetlana,
grabbed a grease pencil and
scribbled Stalin's moustache on her mush.
Some people were offended by
my act of graffiti because Svetlana had been
elevated to sainthood by the time
my cover appeared. To those people I can
only say: "Your father's moustache!"

30. DUCHAMP AND DADA SAY PHOOEY TO 5,000 YEARS OF ART.

In 1919, Marcel Duchamp created the iconic symbol of the Dada movement by drawing a moustache and a goatee on a cheap reproduction of the most famous painting in world history, Leonardo da Vinci's *Mona Lisa*, and inscribed the work "L.H.O.O.Q." (Spelled out in French, these letters form a risqué pun: Elle a chaud au cul, or "She has a hot ass.") Dada, a word suggesting a child's babbling, was a movement that brought together both plastic arts and writers. The raison d'etre of the Dadaist movement (which included Arp, Man Ray, Picabia, and Max Ernst) had been expressed in a manifesto a year earlier by the radical young poet Tristan Tzara when he wrote, "There is great destructive negative work to be done...if one day we hope to rebuild." Duchamp's most outrageous and infamous "ready-made" was an upside-down porcelain urinal signed "R. Mutt"—the name of the manufacturer—and titled *Fountain* (1917). Kurt Schwitters, another Dadaist provocateur, exclaimed, "Everything an artist spits out is art." The sons of Dada insisted that their artists' materials had to be "antiartistic," so they used found objects of scraps and trash. They believed that the execution had to be brisk to minimize the once-sacred aura of the artistic act. But Duchamp picked up a traditional artist's pencil and carefully drew a disrespectful moustache, graffiti style, saying "phooey" to art. Dada far exceeds Cubism as the watershed iconoclastic moment in visual expression.

31. "THANKS FOR RAISING ALL THAT MONEY FOR THE WAR EFFORT WHEN YOU JOINED THE ARMY, CHAMP. YOU'RE A GREAT PATRIOT. (BY THE WAY, YOU OWE ME A MILLION BUCKS!)"

Joe Louis, arguably the greatest heavyweight boxing champion ever, became a national hero for both black and white America in that turbulent era of racism before WWII. His prime years were taken from him when he served in the U.S. Army from 1942 to 1945. As the national spokesman for the Army, he traveled throughout Europe, boxing in exhibitions and bolstering the spirit of his fellow GIs. To back up his belief in our war against fascism, Joe contributed all his fight purses to the U.S. Army and Navy relief fund. After the war, unbelievably, the U.S. government handed him a tax bill! The Brown Bomber fought on and retired in 1949 but was pressured by the government to make a comeback to earn purses to continue repaying his "back taxes." He entered the ring far from his prime years and was subjected to a humiliating knockout by the young Rocky Marciano. A defeated champion, Louis had earned $5 million in his illustrious career, but didn't have a single cent to show for it. To support himself, the great man was forced to make a living as a Las Vegas casino host, still trying to "pay back" his unappreciative Uncle Sam.

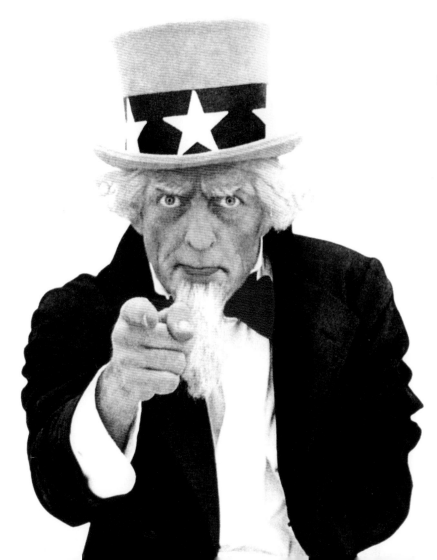

INEXPLICABLY BEING HARASSED BY UNCLE SAM FOR "BACK TAXES," THE GREAT JOE LOUIS KEEPS HIS SENSE OF HONOR (AND SENSE OF HUMOR).

In 1967, when creating the first TV campaign ever for a stockbroker (and for Edwards & Hanly, the least known), I needed unlikely celebs whose presence would swiftly suggest that here was a smart, sharp bunch of brokers, unlike all the traditional, stuffy Wall Street houses. Joe Louis led my list, a great American who was screwed by the IRS and ended his years shilling for a Vegas casino. Using Joe was a powerfully subtle way of telling the world that he had been treated disgracefully by the government and that the boys at Edwards & Hanly were tuned in to the real world. The TV spot was a mere ten seconds long: *Edwards & Hanly—where were you when I needed you?*, he asked. It was also a full-page *New York Times* ad with Joe's beautiful puss—sad, deep, and spectacular. The commercial was an immediate sensation as the media exploded with TV interviews and articles about the almost forgotten champ and his mistreatment by an ungrateful Uncle Sam. Edwards & Hanly's business skyrocketed as it became, in a few weeks' time, as well known as Merrill Lynch. *Where were you when I needed you?* declared that Edwards & Hanly was an honest and thoughtful broker that understood the perils of flashy advice. Because the Joe Louis saga was a thorn in America's conscience, the message had the impact of Joe's first-round knockout of Hitler's favorite fighter, Max Schmeling. *P.S.* Ultimately, Joe's ten seconds became too famous for Wall Street to take. Racism, once again, reared it's ugly head, and the Big Boy Bigots at the exchange KO'd Joe Louis.

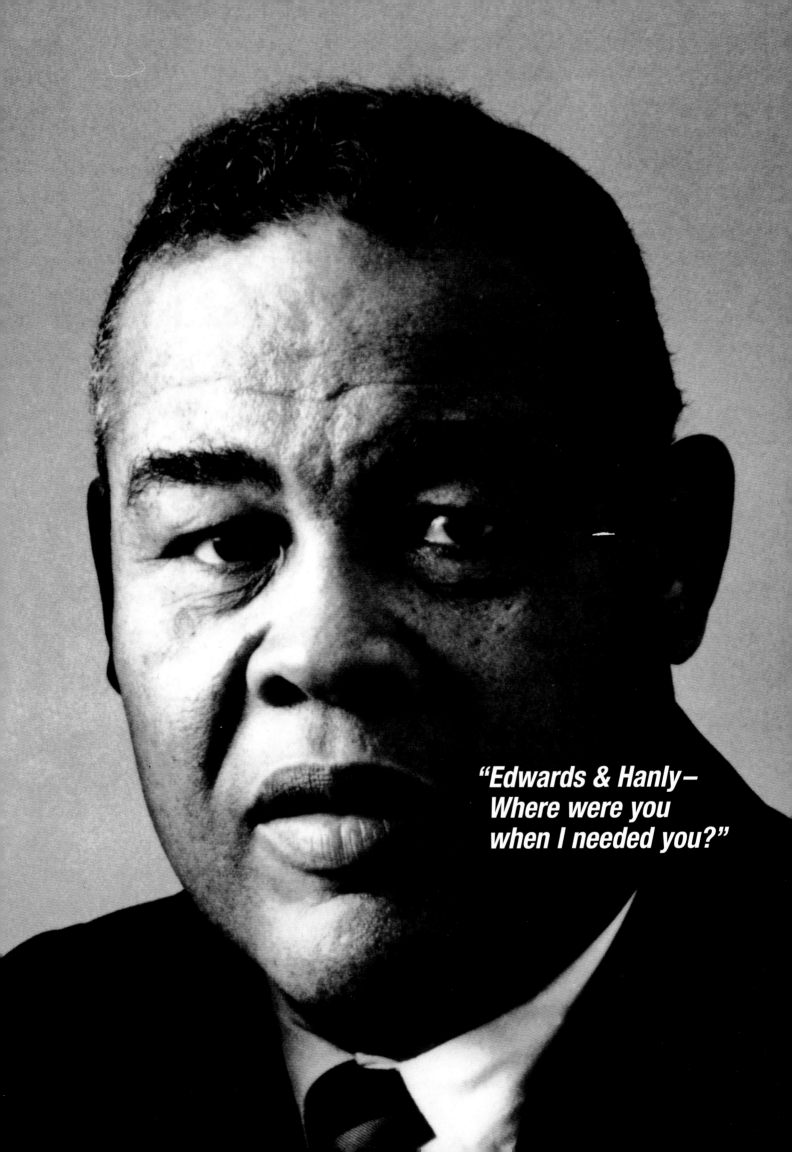

"Edwards & Hanly—
Where were you
when I needed you?"

Francisco de Zurbarán was an artist of the Spanish Baroque, but modern art has opened
our eyes to his monumental imagery and his extraordinary ability to translate inner
mystical experience into aesthetic sculptural expression. His devotional portraits of supplicant
monks, saints, and holy figures placed in glowing light against stark backgrounds
are works of art that can bring even a nonbeliever to his knees. Saint Francis was one of
Zurbarán's frequently painted subjects, most depictions showing the ascetic hermit
in prayer, usually holding a skull (he has been called the "Saint Francis Hamlet"), meditating
upon death, and looking upward, communicating with God. A strong shaft of light
pierces the darkness and dramatically illuminates the kneeling monk in his patchwork robe.
Painted in 1639, *St. Francis in Meditation*, a masterwork of the rapture of
monkish mysticism, is my favorite Saint Francis of Assisi, even greater than El Greco.

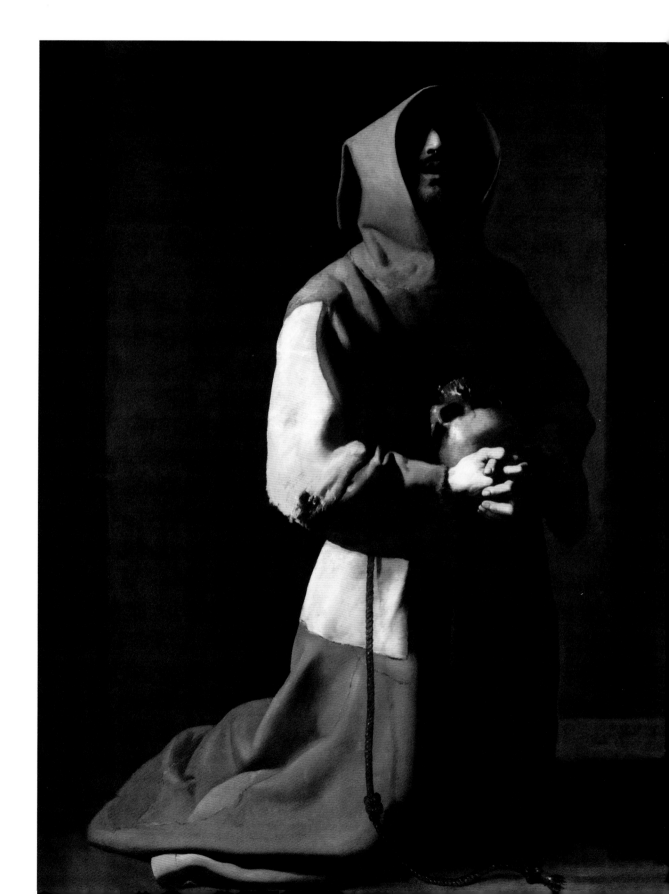

ALAS, POOR DARREL DESS OF THE GIANTS

This image is a cover of an *Esquire* issue crammed full of exhilarating sportswriting analyzing the NFL football wars. Instead of a sports action cover, I depicted Darrel Dess, a pugnacious New York Giants guard, in the mood of a Zurbarán painting of Saint Francis, praying for survival. My headline: *Heaven help him—he's going to play 60 minutes of pro football.* Back then, a professional athlete praying on his knees was a sight gag. My joke in 1965 has become a reality. In today's hyped-up, showbiz game, born-again Christians preach to teammates, opponents, fans, the media, and anyone within earshot that the only way to heaven is through Jesus Christ, insisting that those who aren't Christians are doomed to hell, meanwhile invoking God's aid against their opponents on the playing field. We all have a right to views of the Absolute, but none of us have a right to absolute views. In his second inaugural address, meditating on the paradoxes of the Civil War, Abraham Lincoln, the greatest moral leader in the Western world since Jesus Christ (and Saint Francis of Assisi) intoned: "Both read the same Bible and pray to the same God and each invokes His aid against the other."

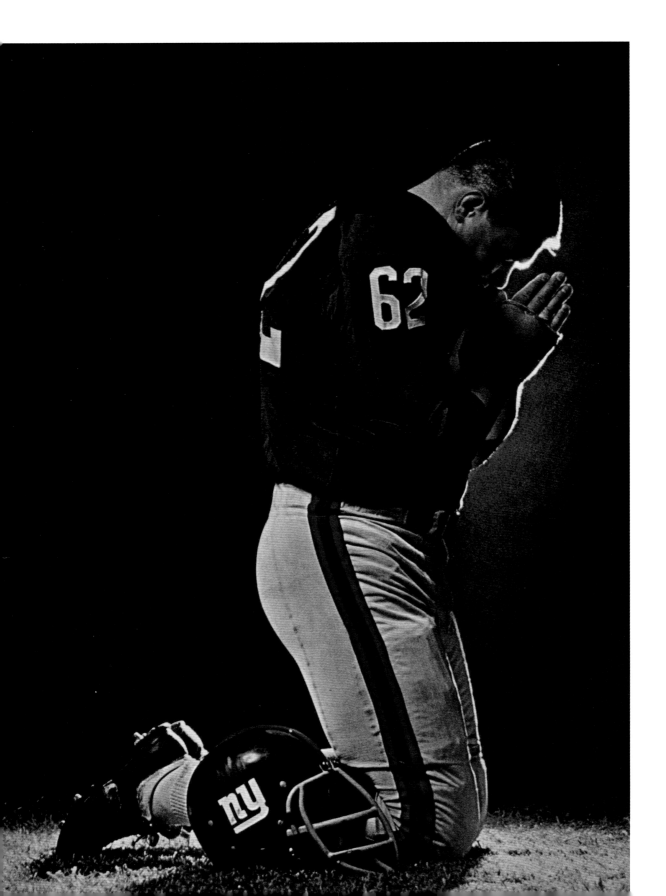

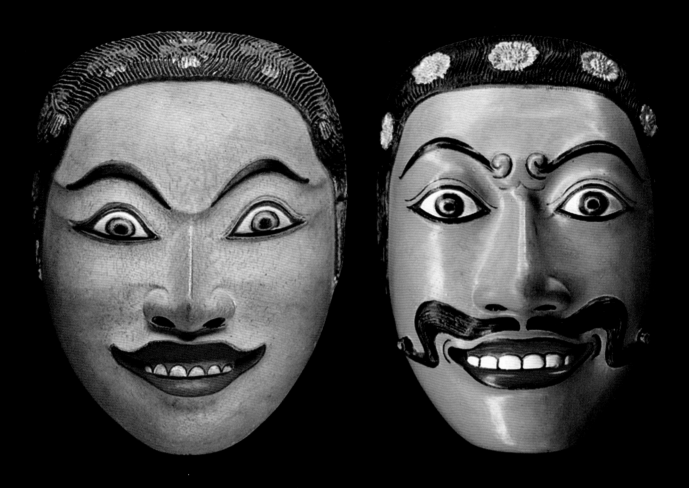

33. LIGHTING UP THE ROYAL COURTS OF INDONESIA...

Indonesia is the fourth most populous country in the world—a vast archipelago with more than 13,000 islands
and more than 300 languages. Its history is one of royal courts that once
governed the islands and island groups of the archipelago. The masked dance is one of the
oldest of the performing arts in its exotic islands, popular since the
early sixteenth century. Elegant dancers with animated masks (shown here are nineteenth century Topeng
masks from Central Java) performed at royal circumcisions, in funeral processions,
and in initiation and exorcism ceremonies. Far more than mere expressions of splendor and glory,
Indonesia's royal art objects are intensely powerful symbols,
sacred embodiments of unseen forces capable of radically affecting its inhabitants' lives,
including rainfall and protection for crops.

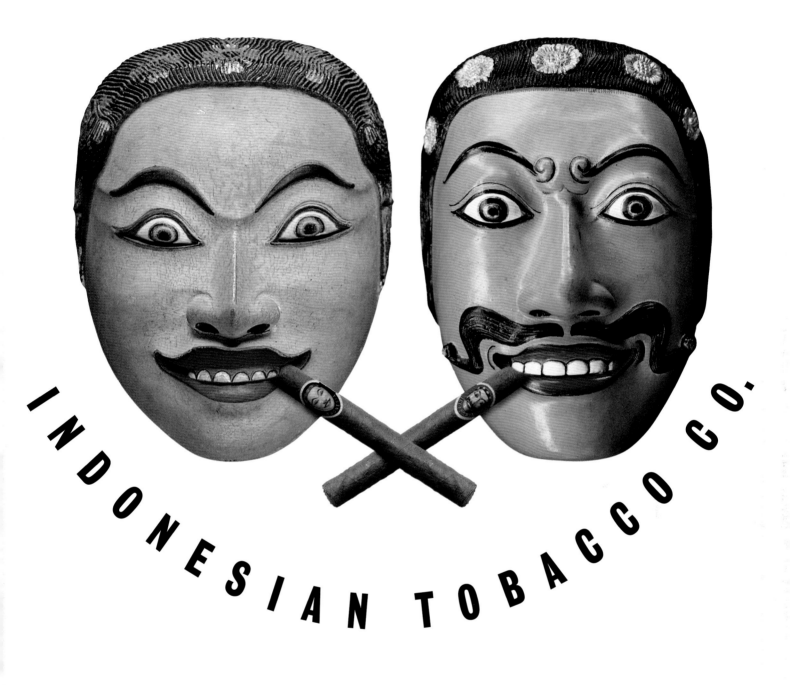

...AND INDONESIAN CIGARS ALL OVER THE WORLD

Indonesian tobaccos have always been prized by cigar makers. In the deep valleys of Java,
the soil is the result of volcanic action that turns it into the most
precious on earth, producing pure Indonesian long-leaf tobacco that provides an extraordinary filler,
binder, and wrapper—especially prized because of the unique
hints of coffee and cocoa in its glorious smoke (or so my cigar-chomping pals tell me).
My logo portrays two royal Indonesian masks—representing two
brand names—proudly flaunting cigars that sprang from their exotic land, firmly clenched
in their rapturous smiles.

34. HOW TO BEAT IT OUTTA TOWN AND STAY ALIVE

To avoid being rubbed out after they witness the Saint Valentine's Day Massacre, two musicians flee Chicago disguised as women in an all-girl orchestra on its way to a gig in Florida. Billy Wilder's *Some Like It Hot*, shot in lush black-and-white, is undoubtedly the most delicious comedy ever produced, one of the most enduring treasures in the history of the movies, a film that's loaded with sex but pretends it's about crime and greed. The band's red-hot singer, Marilyn Monroe, wants only to marry a millionaire; and lipstick-and-eye-makeup-adorned Tony Curtis wants only sex; and they end up wanting only each other. The other female impersonator, the tart Jack Lemmon, captivates a moneybags played by Joe E. Brown. While still in drag, he has a hilarious scene the morning after his big date, lying in bed, a rose in his teeth, playing castanets, and announcing his engagement to the screwball millionaire. His roommate, Tony Curtis, is incredulous and blurts out, "What are you going to do on your *honeymoon*?!" Lemmon excitedly answers, "He wants to go to the Riviera, but I kinda lean toward Niagara Falls." Outrageously, both Curtis and Lemmon are practicing cruel deceptions—Curtis has Monroe thinking she's met a millionaire (when he masquerades as one on a purloined yacht), and Joe E. Brown thinks Lemmon is a woman—but Monroe and Brown finally learn the truth and don't give a damn. In the final scene, Lemmon reveals he's a man and delivers the best curtain line in the history of the movies (sorry, Rosebud). If you've seen the movie, you know what it is, and if you haven't, get to a Blockbuster fast.

HOW TO BEAT THE DRAFT AND STAY ALIVE.

Back in the days when being homosexual was kept a deep, dark secret, my rendition of the gay way to dodge the draft expressed the deep-down knowledge among college students that the Vietnam War stunk, that any way out of it was (supposedly) morally acceptable. My headline for this 1966 *Esquire* cover was *How our red-blooded campus heroes are beating the draft (for 37 other ways, see page 125)*. The model was a Columbia University football player, a very tough antihero hetero, unashamedly pouring it on. Forty years later, most of the eligible cannon fodder that beat the draft, especially those in politics (many of whom recently authorized President George *Dubya* Bush to engage in un-American preemptive wars), excruciatingly explain the back or knee or sinus or hangnail problem that kept them out of combat in their youth. None of them, as far as I know, has ever fessed up that they threw a clue or two at their draft boards that they were light on their feet.

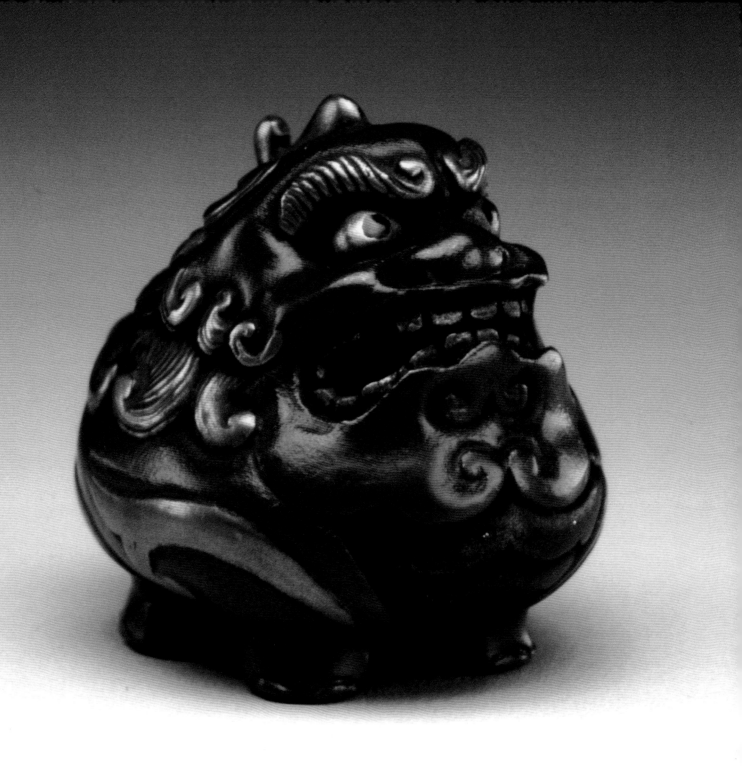

35. THE REVERED ANCESTOR OF THE NAUGA

This tiny beast, called a Shishi, is supposed to be a lion but bears little
resemblance to the ferocious king of the beasts. The same character often
appears in pairs at the entrances to temples in Japan as guardian
figures and divine protectors. This cute little sucker is a netsuke from the
Edo period (1615–1868)—made of wood and lacquered. It is
a mere 1¹/₈ inches. Japanese artists invented these miniature sculptures in
thousands of different images as buttonlike toggles to secure the
cord at the top of elegant containers that men carried to hold personal
objects, since traditional Japanese kimonos had no pockets.
This snarling curmudgeon beast with a golden mane is a tiny treasure
of wit, whimsy, and craftsmanship—an ancestor of the mythical
Nauga I created in 1966.

SAY SAYONARA TO THE SHISHI, AND HELLO TO THE UGLY NAUGA.

First, UniRoyal created Naugahyde, a superb, leathery vinyl. An instant winner in the furniture market, it begat
many rip-offs. Soon the world was surfeited with fake leathers and bewildered decorators who
couldn't tell which was which. To distinguish Naugahyde from the copycats, I spawned the beastly Nauga, a mythical species
which sheds its hide once a year for the good of humankind (and UniRoyal). The Nauga,
taller than a basketball center, became a spokesman for Naugahyde on TV and in national magazines.
It also became a hangtag, and a 12-inch doll for kids. But before our first ad ran
(*The Nauga is ugly, but his vinyl hide is beautiful*), legal objections were raised. Too many people, it was claimed
by the UniRoyal legal brains (the Abominable No-Men), might look upon the ugly Nauga
as a for-real living species. Huh?! Its hide might be considered genuine leather, they contended, and the
Federal Trade Commission could deem it deceptive advertising. "Kill the Nauga," they said.
"Over my dead body," I retorted. Research to the rescue! A bunch of us from my ad agency hit Fifth Avenue
and showed tourists and New Yorkers our Nauga ads. We asked, "Is this a real animal?"
They answered, "What, are you nuts? That's just a big, fat, ugly, snarling, make-believe creature with a cute tush."
(A Japanese gentleman thought it looked like a netsuke he owned.) The ugly Nauga was spared.
He went into the marketplace, and UniRoyal overwhelmed their competitors.
Today, my original 12-inch Nauga doll,
in dozens of colors, is a collector's item.
(Jenette Kahn, the high-voltage
ex-president of DC Comics, sleeps with 37
of the sexy beasts in her bedroom.)
The ugly Nauga lives on.
That's my boy.

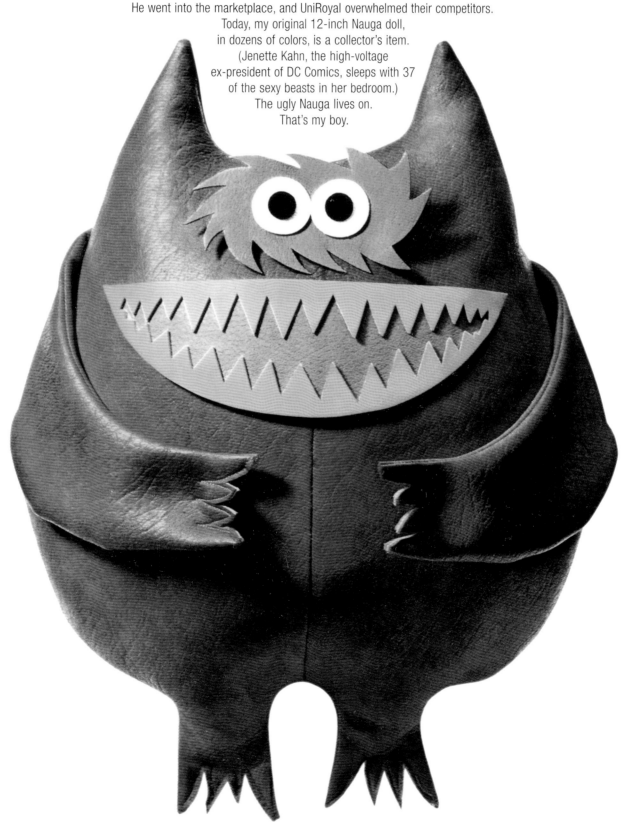

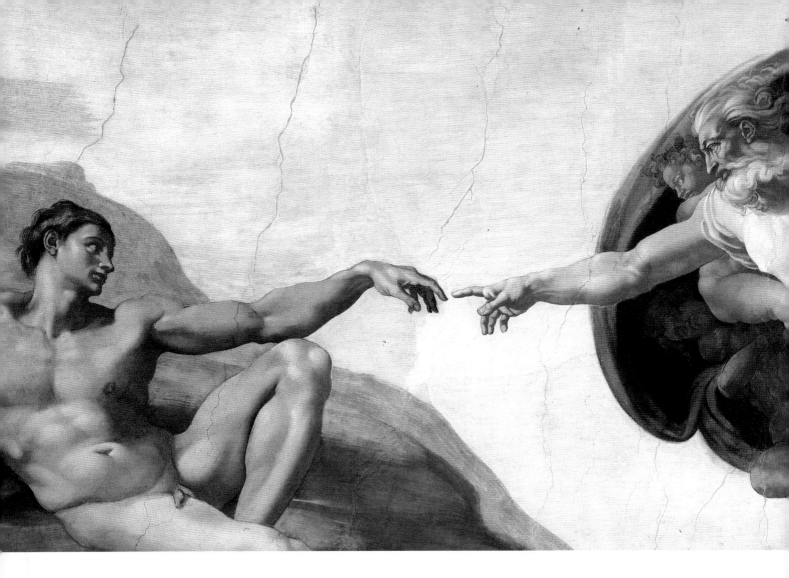

36. LIFE FLOWS FROM THE INDEX FINGER OF GOD.

Commissioned by a demanding Pope Julius II, Michelangelo painted the frescoes for the vast
ceiling of the Sistine Chapel between 1508 and 1512. *The Creation of Adam*, from the Book of Genesis,
illustrates a white-haired, muscular God in a flowing robe, suffusing Adam, a chip off the old block,
with the gift of life. God extends his forefinger to touch that of Adam, about to transfer immense power
to the waking "first man." God's finger points with authority, while Adam, not yet fully alive, can
barely lift his hand. There is almost a spark in the space between their fingers, as if a transmission of energy
is visible. (God's life-giving touch can also be interpreted as a rule-giving command for obedience.)

LOOKING UP FROM MY CRIB, GOD COMMANDED, "GEORGE, BE CAREFUL." (I REMEMBER IT WELL.)

My earliest childhood recollections were punctuated by three words (in Greek) from the lips of my immigrant mother, Vasilike Thanasoulis Lois:
"George, be careful." They have been a refrain throughout my life—a sincere admonition from the lips of people who have always
meant well but never fathomed my attitude toward life and work. In the art of advertising, being careful guarantees sameness and mediocrity,
which means your work will be invisible. Better to be reckless than careful. Better to be bold than safe. Better to have your work
seen and remembered—or you've struck out. There is no middle ground. When I turned my back on the expectations of my father, Haralampos,
that I would become a florist and take over the family store in the west Bronx, he said to me as I headed out for a career in art,
"George, be careful" (in Greek). When I quit Pratt Institute to get my first design job, my sisters, Paraskeve and Hariclea, said to me,
"George, be careful." When I was drafted into the U.S. Army to go to Korea, my young bride, Rosemary Lewandowski Lois, said
to me, "George, be careful." When I left Doyle Dane Bernbach after just one year and gave up being a hotshot at the world's first creative
agency to start the world's second creative agency, Papert Koenig Lois, my normally ballsy boss, Bill Bernbach, said to me,
"George, be careful." Throughout my career in the advertising arena, my partners, my lawyers, my colleagues, my clients, and my friends
have all cautioned me, "George, be careful." It's understandable, because talent gets you in trouble, especially in advertising.
Safe, conventional work is a ticket to oblivion. Talented work is ipso facto unconventional. In 1972, I wrote my first book and called it
George, be careful, the antislogan of my life. Whenever I'm asked to autograph a copy, my inscription reads
"_____, be reckless." (If you're in advertising, write in your name. If you're not in advertising, write in your name.)

George, be careful

A Greek florist's kid in the roughhouse world of advertising

George Lois
with Bill Pitts

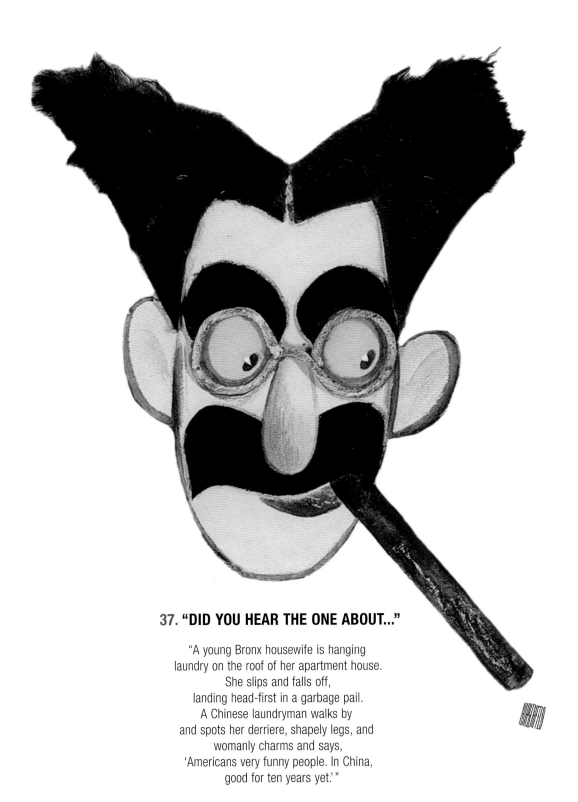

37. "DID YOU HEAR THE ONE ABOUT..."

"A young Bronx housewife is hanging
laundry on the roof of her apartment house.
She slips and falls off,
landing head-first in a garbage pail.
A Chinese laundryman walks by
and spots her derriere, shapely legs, and
womanly charms and says,
'Americans very funny people. In China,
good for ten years yet.'"

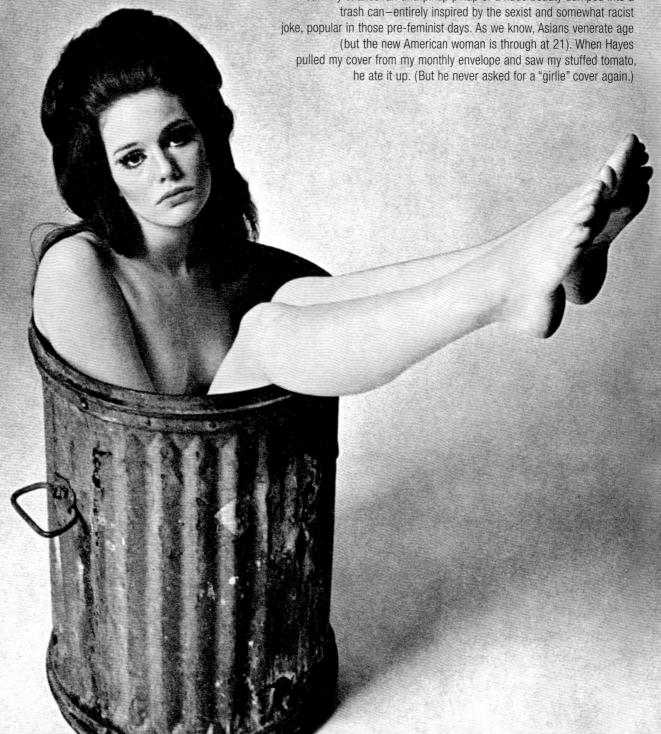

YOU WANT TO KNOW WHERE SOME OF THE BEST VISUAL "STATEMENTS" COME FROM? DIRTY JOKES!

From the time of the very first cover I created for editor Harold Hayes, *Esquire* newsstand sales and circulation grew dramatically. Nonetheless, the ad-sales gang at *Esquire* bitched and moaned, fearful of my "controversial" covers. Though ad pages rose and rose through the Hayes decade, some of my covers scared some stiff agencies into pulling their monthly ads. But in the sexist '60s, the ad bunch was drooling over the traditional *Esquire* covers of the previous three decades and hounded Harold Hayes for Lois cheesecake. Hayes, embarrassed, called to ask me to help take some heat off him. As I remember my reaction, I said, "Harold, ol' pal—you got it!" I knew the great editor was planning an issue on *The New American Woman: Through at 21.* I saw my chance: an anti-pinup pinup of a nude beauty dumped into a trash can—entirely inspired by the sexist and somewhat racist joke, popular in those pre-feminist days. As we know, Asians venerate age (but the new American woman is through at 21). When Hayes pulled my cover from my monthly envelope and saw my stuffed tomato, he ate it up. (But he never asked for a "girlie" cover again.)

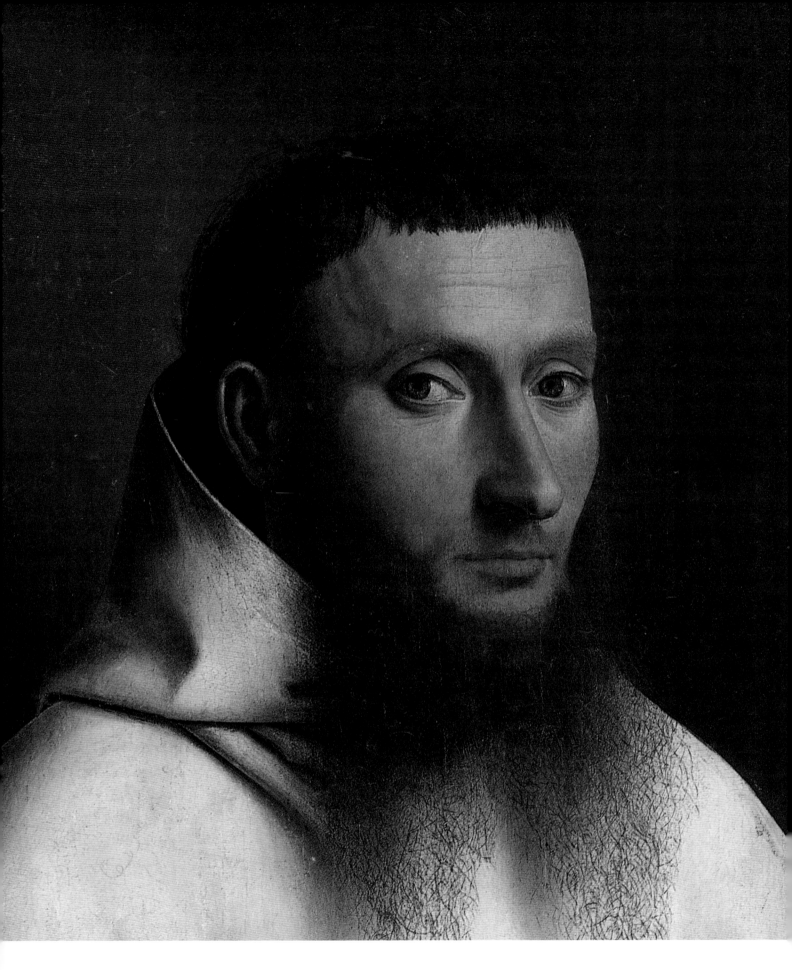

38. A CARTHUSIAN MONK AND HIS MISSING HALO

Portrait of a Carthusian is a hypnotic painting divined by Petrus Christus, a northern Netherlander who immigrated to Bruges and became one of the fab five (along with Dieric Bouts, Hugo van der Goes, Hans Membling, and Gerard David) of the Flemish school of painting in the second half of the fifteenth century. I first laid eyes on this great masterpiece when it was acquired in 1949. Surrounding his penetrating countenance was a cosmic, golden halo, bestowing upon an unknown monk an aura of glory. Sometime in the late 1990s, on one of my many pilgrimages to the Metropolitan Museum of Art, to my astonishment—the holy halo had vanished, stripping the monk of his sainthood. The Met had ascertained that the halo was a later addition, almost a vandalous alteration in its illegitimate canonization of a lowly cleric.

ROY COHN AND HIS SELF-APPLIED HALO

Roy Cohn was Senator Joe McCarthy's favorite terrorist during the terrible '50s in America. To illustrate a self-serving book by the demagogue McCarthy's favorite hatchet man and gofer, excerpted in *Esquire* magazine, I asked him to pose as the saint he said he was. I made no bones about the photo: As McCarthy's stooge, I would show him wearing a halo that was visibly attached, a self-applied halo, maintaining his innocence. He somberly posed for the shot, knowing I was making him look like a fool, but drooling to be on an *Esquire* cover to help sell his book. As he was leaving Carl Fischer's studio, he said through gritted teeth, "I suppose you left-wing crackpots are going to pick the ugliest one." "You bet," I said. "I hate your guts." For once in his life, this evil mouthpiece of McCarthyism was speechless.

39. 1913: AN ICONIC VISUAL STATEMENT OF THE PARTNERSHIP OF TWO GREEK IMMIGRANT BROTHERS, ANNOUNCING TO THE FAMILY IN THE OLD COUNTRY THAT THEY HAVE SUCCEEDED IN AMERICA

When he was a restless youngster of 14, my father, Haralampos, came to America from the tiny village of Kastaniá, where the Lois clan had lived since the mid-fifteenth century, when they scrambled up the steep mountain above the town of Návpaktos to escape the savage occupation of the bloody Turks. After the glorious Greek Revolution (1821–29) Návpaktos, which had not been in Greek hands since before the Byzantine era, was repatriated. Haralampos was raised as a shepherd, tending the family's flock of sheep and goats while playing a flute (the Greek *floghera*) among the cypress trees, dreaming of new horizons. In New York, he sold hot dogs at Coney Island, then went to work at a cousin's florist shop and, in 1913, barely 19 years old, opened his own store on Broadway and 137th Street. A short time before, he had managed to bring his younger brother, Vasile, to join him in America and made him his equal partner in his Columbia Florist. The requisite statement to be made to his beloved family back home was to pose for this professionally taken photograph of him (left) and his baby brother, proudly displaying their wares, a visual testament that they were a success in a faraway land. In 1965, when Haralampos and my wife, Rosie, and I made a pilgrimage to my father's birthplace, Kastania was still a primitive village, with no plumbing, no privies, no electricity, one store, a one-room schoolhouse, a taverna, and a Greek Orthodox church. When we visited the taverna, off-limits to women, we sat among the few dozen men of the village, average age about ninety, who were zestfully jabbering, totally thrilled that Haralampos and his son Yioryos and his non-Greek wife (who had the hubris to crash the men's saloon) were among them. On an honored wall was a bank of dozens of photos my father had sent them over the years (along with envelopes of money), a chronicle of his life in America. Among a myriad of family snapshots was the very same 1913 sepia-toned photo of Haralampos and Vasile, the Lois boys who made good in their new country.

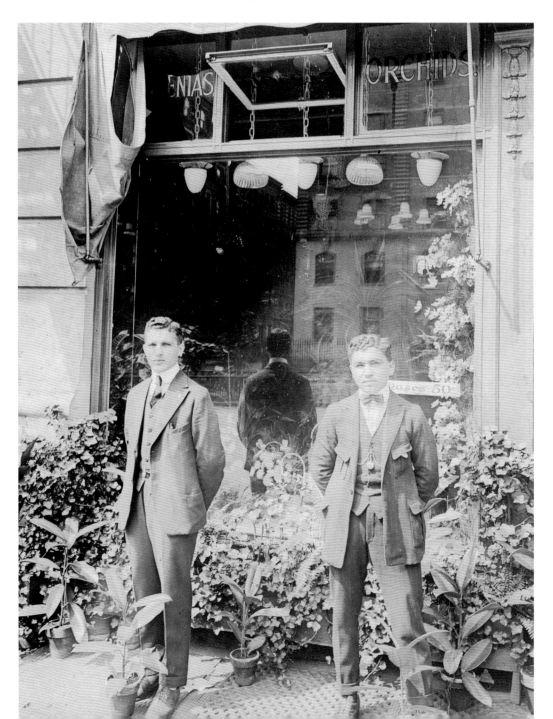

**1974: AN IMAGE OUT OF THE PAST ANNOUNCING THE PARTNERSHIP
OF TWO HUNGARIAN IMMIGRANTS,
PROMISING A 24/7 DEVOTION TO MIND THEIR NEW STORE.**

The '70s was shaping up as the disaster decade for New York's great restaurants. Landmarks like Le Pavillon and Chauveron went out of business. And by 1974 the 15-year-old Four Seasons restaurant, created by the legendary restauranteur Joe Baum, was losing money and sliding toward extinction. It had been part of a chain and was becoming a casualty of creeping neglect. It was perceived, increasingly, as a "tourist restaurant," forsaking its power-base Manhattan loyalists, and was regarded by the restaurant industry as a white elephant and, lamentably, a lost cause. With all these odds stacked against them, two Hungarian expatriates, Tom Margittai and Paul Kovi, an intrinsic part of Joe Baum's marketing team, bravely bought The Four Seasons and asked me to help them get its clientele back—and fast. Inspired by the images of immigrant partners standing in front of their establishments (and specifically my father and my uncle), I positioned the new owners as "the-two-of-us" shaking hands in front of their "store" and ran a full-page ad in the *New York Times*. The ad charmed New York food lovers who valued great cuisine, service, ambiance, and dedication to a work ethic—and they flocked back. Overnight, the hungry Hungarians became the hot restaurateur-entrepreneurs in the Big Apple. Like Haralampos and Vasile Lois 61 years before, Margittai and Kovi sent this photograph of them shaking hands, standing at the entrance of The Four Seasons, home to their families in Hungary to document their success in America.

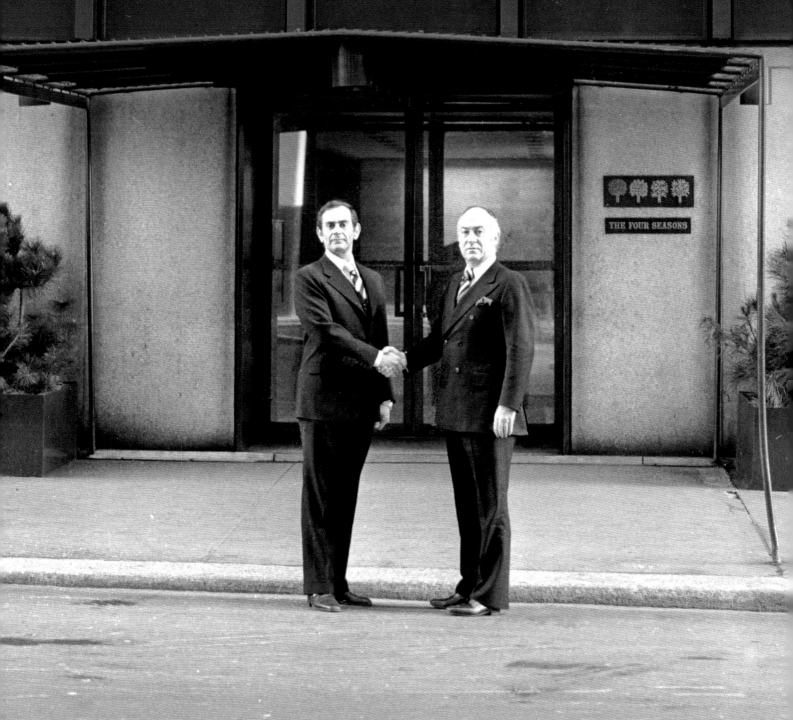

40. JOE DIMAGGIO, THE EPITOME OF YANKEE STYLE

Joe D was this Bronx boy's first hero. The Cuban fisherman that Ernest Hemingway wrote about in *The Old Man and the Sea* spoke of him as "the great DiMaggio." Joltin' Joe, without question, was the most elegant practitioner of the game of baseball who ever lived, with a mythic 13 year career (he lost three seasons in his prime serving in the U.S. Army during WWII). The Yankee Clipper's majestic swing; his grace running down fly balls in the centerfield expanses of Yankee Stadium; his classic base running especially when you were lucky enough to see him glide out a triple—a dazzling scene still in my mind's eye—made him, to me, the most aesthetically pleasing athlete of all time. In 1966, Gay Talese wrote *The Silent Season of a Hero*, a now famous piece about the retired Joe DiMaggio in *Esquire*, depicting him as a sad guy spending time hanging out at Toots Shor's, attending boring political dinners or ogling a looker filing her nails at a gas station. I got to know DiMag after he had retired and had moved on to other interests (Marilyn Monroe, for one). Every time I was with him, he wore a finely tailored suit, with not a hair out of place. He was a was man's man, but a gent. Even as a civilian, he was a man of infinite grace and style. When I asked Joe to sign a large photo of himself that captured the climax of his swing so I could present it to Sadaharu Oh, the slugging Japanese star, he didn't say no to Oh. As I requested, he wrote, in his elegant script, *To Sadaharu Oh. From No. 5 to No.1. Joe DiMaggio.* (Oh's number on his uniform was 1, and being called No. 1 in Japan was the ultimate accolade.) DiMag met me at his hotel bar and gracefully gave Sadaharu Oh the thrill of his life. It was a true act of magnanimity, an important way to measure a man.

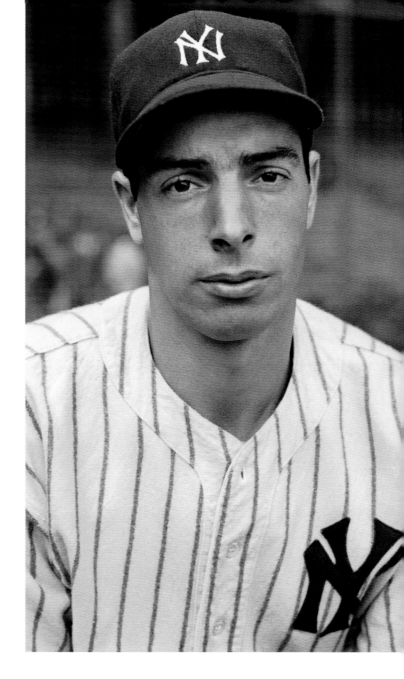

"WHERE HAVE YOU GONE, JOE DIMAGGIO?"

The great DiMaggio, a perennially private person but always with an eye out for the ladies, came out of hiding when he surprised the world by marrying the ultravisible Marilyn Monroe, Hollywood's sex goddess. As a husband, he modestly ducked behind her voluptuous curves and out of the limelight. Too proud, classy, and important to become "Mr. Monroe," he and Marilyn split and the Yankee Clipper was out of sight again. This July 1966 *Esquire* cover hauntingly reflected on his absence (inspired by yet another Gay Talese profile of one of the iconic celebs of the time). Carl Fischer caught this dreamlike apparition of Joe in one of his expensive civilian suits, frozen at the apex of the most classic swing in the history of the game, hitting one into the empty left-field seats at Yankee Stadium. I almost asked No. 5 himself to pose, but even *I* don't have that kind of chutzpah. So I cast dozens of lithe, athletic 52-year-old men, but finally chose a 35-year-old who, as a kid, worshiped the ground Joe D walked on—and had his swing down pat. Moi! A year later, the song *Mrs. Robinson*, from the hit movie *The Graduate*, sported a lyric evoking all the nostalgia of the time: *Where have you gone, Joe DiMaggio?*

The 1964–65 World's Fair brandished as its symbol the Unisphere, a big skeletal metal globe that looked like the world had imploded (and, in retrospect, an unintended vision of Armageddon). But to me, there was only one World's Fair. A fantasy of showmanship, the epitome of stagecraft, a real-life Land of Oz with a visual epiphany at every turn of the head, the 1939–40 New York World's Fair had become indelibly etched in the memories of all who attended. Born of national tragedy, it signaled the end of the American Depression and reflected our boundless belief in "The World of Tomorrow." (One wide-eyed prediction was that by 1960 there would be sidewalks 20 feet above the roads, with civilians flying around town in their own individual autogyros.) The Trylon and the Perisphere, a brilliant, enormous, white futuristic temple, became the fair's centerpiece, architectural symbol, and logo. Designed by Wallace Harrison and André Fouilhoux, it symbolized a beacon of hope that had endured one storm of conflict (as we were about to enter another). The 1939–40 New York World's Fair, and its inspiring logo, remain the stuff of memories!

...INSPIRES THE AWARD FOR RECIPIENTS OF THE
ART DIRECTORS CLUB HALL OF FAME.

When I was elected president of the prestigious Art Directors Club of New York, in 1972, my officers, executive committee, and I created a long-overdue Hall of Fame and inaugurated the first eight giants of our craft—innovators and conceptual thinkers who laid the groundwork for those of us who followed to become the modern and meaningful art directors and graphic communicators of our time. The selection each year since then not only informs young people aspiring to be designers but also serves as an absolutely imperative source of inspiration. By the year 2008, 147 men and women from around the world have gained this highest Lifetime Achievement Award. All lived their lives as art directors, salespeople, thinkers, and innovators, but most of all—artists. In their hands, advertising and graphic communication has been an art form. It behooved the great authority of the world-renowned Hall of Fame to create an award, a physical representation of its power and importance. I teamed up with the great graphic designer Gene Federico (whose work had inspired me since I was a student at the High School of Music & Art) to design an inspirational award. "The award has to be heroic. Here it is." I flashed an old photo of the Trylon and Perisphere at Gene. "The Trylon becomes our *A* (in the shape of a cone). The Perisphere becomes a moveable *D* (that fits around the cone)." In a few weeks' time, following precise drawings by Gene, Tiffany & Co. produced a prototype of our A.D. Hall of Fame award in silky silver. The award, inspired by Harrison and Fouilhoux, is yet another example of standing on the shoulders of those we have followed.

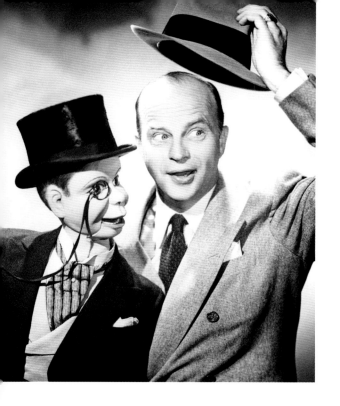

42. THE VENTRILOQUIST EDGAR BERGEN AND HIS OUT-OF-CONTROL DUMMY, CHARLIE McCARTHY

Charlie McCarthy, a wooden bon vivant, started giving voice to ventriloquist Edgar Bergen's wit in 1930s. Bergen and his wisecracking alter ego of innuendo and snappy comebacks, Charlie McCarthy, ruled the radio waves in America for two decades beginning in 1937. Amazing, since the major part of the illusion of a ventriloquist is a shut mouth and a talking dummy! The gentlemanly Bergen's schtick was that he couldn't control Charlie's dirty mouth. His dummy, usually dressed in a tux, got away with flirty, sexual innuendos with the ladies without once getting slapped and developed on-air feuds with male guests on the *Edgar Bergen/Charlie McCarthy Show*, such as the master of the insult, W.C. Fields. In his time, Charlie McCarthy's mischievous sexual banter was considered shocking, as his creator, Edgar Bergen, looked on helplessly.

"I have known for 16 years his courage, his wisdom, his tact, his persuasion, his judgement, and his leadership."

**VENTRILOQUIST LYNDON BAINES JOHNSON,
IN FULL CONTROL OF THE DUMMY ON HIS KNEE, HUBERT HUMPHREY**

When the great progressive senator Hubert Humphrey was shamefully
defending LBJ's Vietnam War escalations, *Esquire* editor Harold Hayes assigned
a writer to do a major piece on the vice president. Humphrey had
certainly disappointed me by kowtowing to the war-escalating president, so I
designed a punishing image of HHH as LBJ's dummy. Johnson was
tied up at the time picking out mud huts in Vietnam, so I never asked him to pose.
The photograph was shot in a studio using a model as large as LBJ. Then I
decapitated the photo and substituted the president's head, one of my precomputer
notorious transplants. (On the newsstands, only the dummy Humphrey
was visible on the cover, seemingly speaking for himself—the foldout revealed
the source of his words!) A year later, a distinguished group of America's
business leaders was in the Senate building for a meeting with Humphrey, and a
visiting LBJ spotted them and asked why they had come to Washington.
When they told him they were working with the VP on sought-after changes in a trade
agreement, Johnson blurted out in his inimitable, tasteless way:
"Sheeeet, let me handle Hubert for y'all. I got his pecker in my pocket!"
(You can say that again!)

"You tell 'em, Hubert."

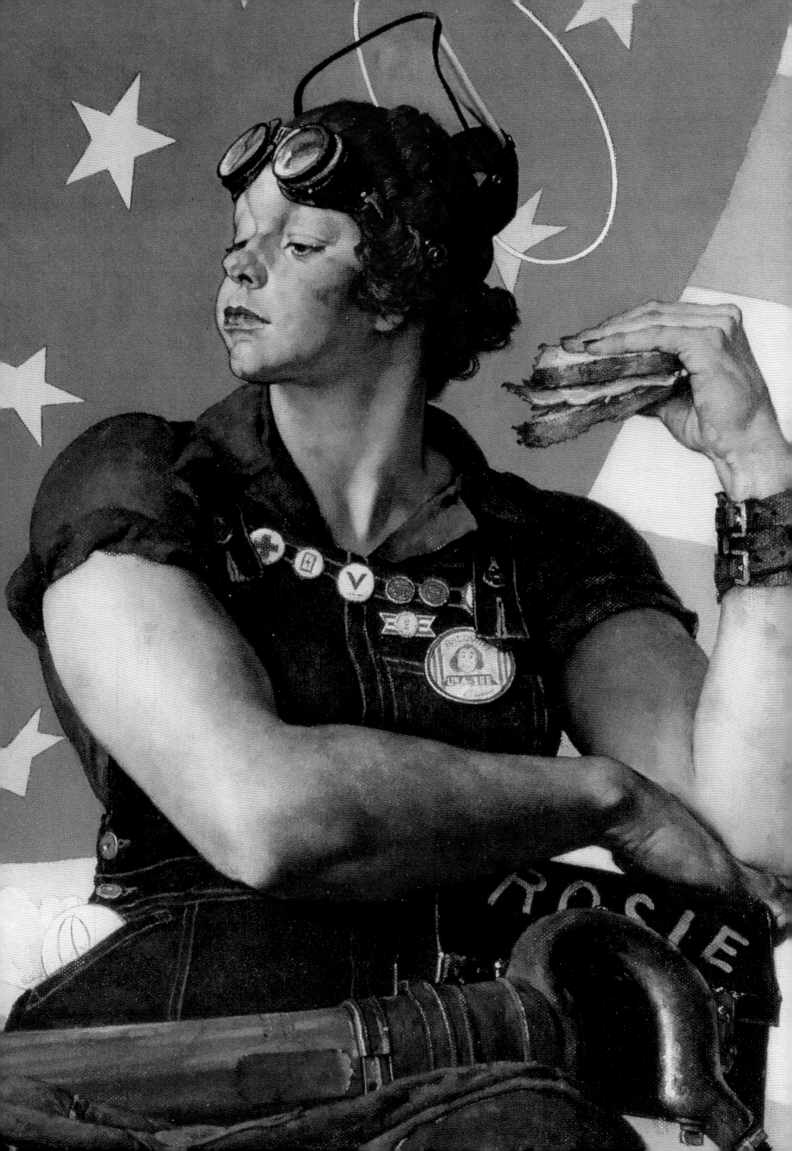

43. THE FURIOUS WOMEN OF *NOW* PROMISED TO STOP PICKETING OLIVETTI
IF I CREATED A ROLE-REVERSAL. "SHOW A BOSS AS A WOMAN...AND A SECRETARY AS A MAN!"

Among industrial-design cognoscenti, Olivetti was synonymous with beauty, but most people wouldn't recognize good design
if they tripped over it. To break through the IBM barrier, my Olivetti Girl TV and print campaign was directed
at America's secretaries who typed faster, neater, and sharper, making her the female in the office most likely to succeed.
Secretaries who wouldn't be caught dead without an IBM clamored for an Olivetti, and their sales in the
U.S. doubled. The campaign burst on the scene in 1972, just as the National Organization for Women, founded in 1966,
was flexing its muscles. NOW attacked the campaign for stereotyping women as underlings (they were pissed
that only women were shown in my commercials as secretaries), and they called me a male chauvinist pig. They picketed
the Olivetti building on Park Avenue and sent hecklers up to my office to un-n-n-nerve me. Something had
to be done. Who can fight a woman's fury? The classic image of role-reversal leapt to my mind. From the populist
vision and talented brush of the beloved Norman Rockwell, *Rosie the Riveter* appeared
on a *Saturday Evening Post* cover in 1943—a hungry, macho gal who was ready, willing, and
obviously quite able to fill a man's shoes (literally) for the duration of the war.
(The pose of Rockwell's gung-ho aircraft factory worker was based on one of Michelangelo's
male prophets from the Sistine Chapel ceiling!)

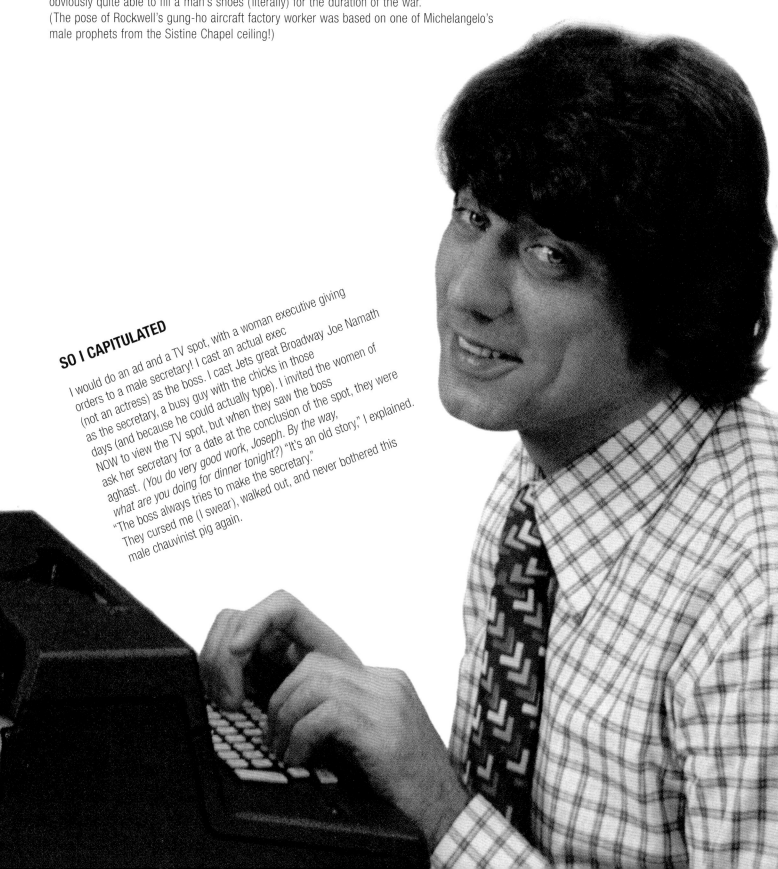

SO I CAPITULATED

I would do an ad and a TV spot, with a woman executive giving
orders to a male secretary! I cast an actual exec
(not an actress) as the boss. I cast Jets great Broadway Joe Namath
as the secretary, a busy guy with the chicks in those
days (and because he could actually type). I invited the women of
NOW to view the TV spot, but when they saw the boss
ask her secretary for a date at the conclusion of the spot, they were
aghast. (*You do very good work, Joseph. By the way,
what are you doing for dinner tonight?*) "It's an old story," I explained.
"The boss always tries to make the secretary."
They cursed me (I swear), walked out, and never bothered this
male chauvinist pig again.

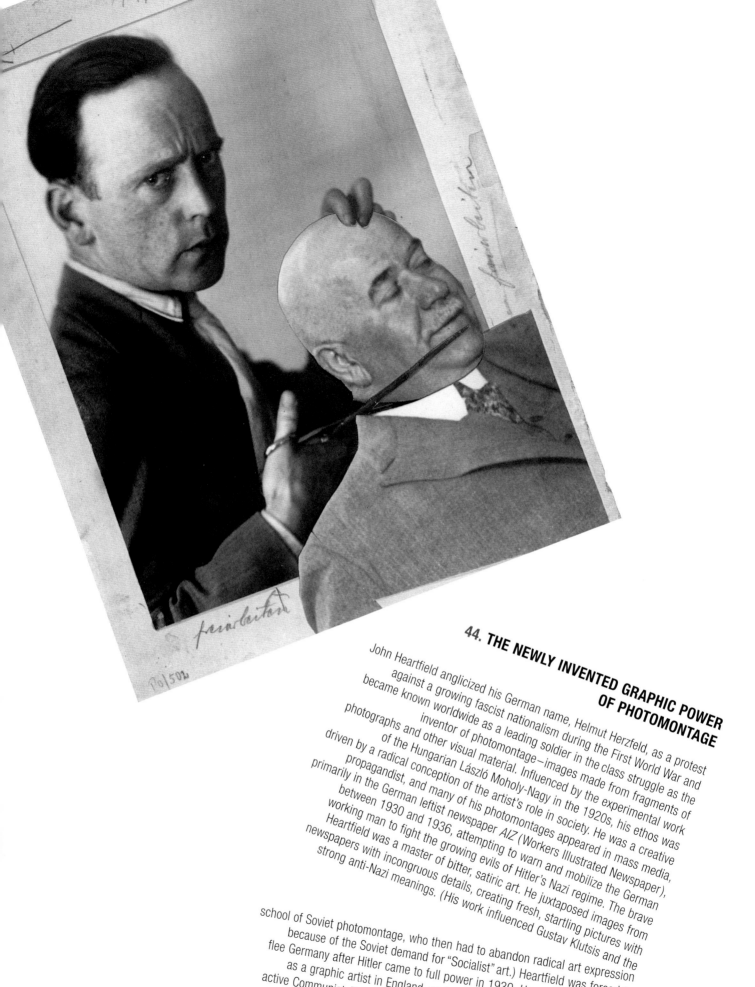

44. THE NEWLY INVENTED GRAPHIC POWER OF PHOTOMONTAGE

John Heartfield anglicized his German name, Helmut Herzfeld, as a protest against a growing fascist nationalism during the First World War and became known worldwide as a leading soldier in the class struggle as the inventor of photomontage—images made from fragments of photographs and other visual material. Influenced by the experimental work of the Hungarian László Moholy-Nagy in the 1920s, his ethos was driven by a radical conception of the artist's role in society. He was a creative propagandist, and many of his photomontages appeared in mass media, primarily in the German leftist newspaper AIZ (Workers Illustrated Newspaper), between 1930 and 1936, attempting to warn and mobilize the German working man to fight the growing evils of Hitler's Nazi regime. The brave Heartfield was a master of bitter, satiric art. He juxtaposed images from newspapers with incongruous details, creating fresh, startling pictures with strong anti-Nazi meanings. (His work influenced Gustav Klutsis and the

school of Soviet photomontage, who then had to abandon radical art expression because of the Soviet demand for "Socialist" art.) Heartfield was forced to flee Germany after Hitler came to full power in 1930. He spent the war years as a graphic artist in England, and returned to East Berlin in 1950 as an active Communist. This 1929 photomontage from AIZ depicts John Heartfield brandishing a pair of shears as he goes about severing the head of Berlin's notorious Police Commissioner Zörgiebel from his massive body.

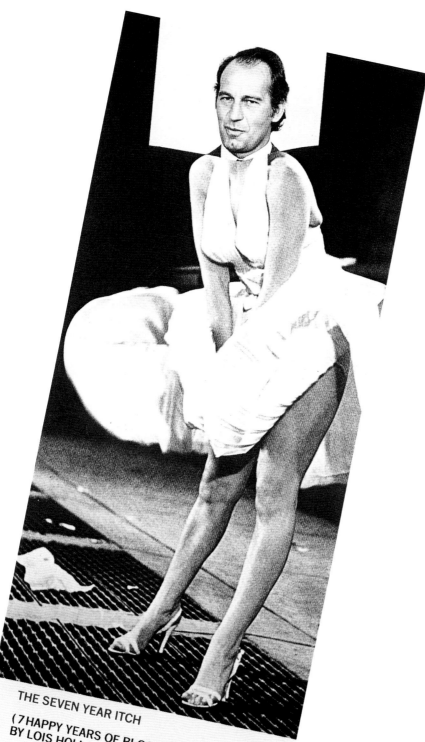

THE SEVEN YEAR ITCH
(7 HAPPY YEARS OF BLOOD SWEAT AND TEARS
BY LOIS HOLLAND CALLAWAY INC.)

OFF WITH THEIR HEADS!

I left Papert Koenig Lois (the first ad agency I started in 1960) after seven years, and this put-on of Marilyn Monroe's now-legendary scene from *The Seven Year Itch* (1955) announced that I had spent another full seven years at my second agency, Lois Holland Callaway. This Heartfield-inspired photomontage of my severed head slapped on Marilyn's body to graphically announce my seven-year itch was not loved by everyone. "You're a board chairman," said my wife, Rosie. "Why don't you grow up?" "Is this your way of saying you're not really a male chauvinist?" asked my faithful secretary. "Those aren't your legs," said my son Luke. And my older boy, Harry, wanted the broad's phone number. I was speechless. All I can tell you is that thrill-seekers absolutely mobbed the TGI Gallery in Manhattan in 1974 to see an exhibition of seven years of my legwork at LHC.

45. THE AGONIZING TORMENT OF SAINT SEBASTIAN.

Contemporary British figurative painter Lucian Freud once wrote, "What do I ask of a painting? I ask it to astonish, disturb, seduce, convince." In every image of Saint Sebastian, whether by Mantegna, Della Francesca, Carpaccio, or Francesco Botticini (shown here), the mythic martyr was rendered as a handsome, tormented youth, pierced by Roman arrows, bravely withstanding, while standing, a perverse enemy in a struggle for what he believed in. Saint Sebastian was popularized by dozens of Renaissance painters because of the violent visual imagery of his martyrdom. The dictionary defines a martyr as one who suffers death on account of adherence to one's religious faith or cause. Saint Sebastian and martyrdom are totally synonymous audio/visual imagery, and remain a glorious cliche, the epitome of expressive emotionalism in the history of art. According to legend, the young Sebastian joined the Roman army and later became a captain of the Praetorian Guard under Emperor Diocletian. When it was discovered that he was a Christian who had converted many fellow soldiers, Sebastian was ordered to be killed by arrows. The sharpshooting archers let fly, leaving the young warrior for dead, but a Christian widow nursed him back to health. Sebastian, scarred but intrepid, presented himself again before Diocletian, who condemned him to death once more, this time by beating.

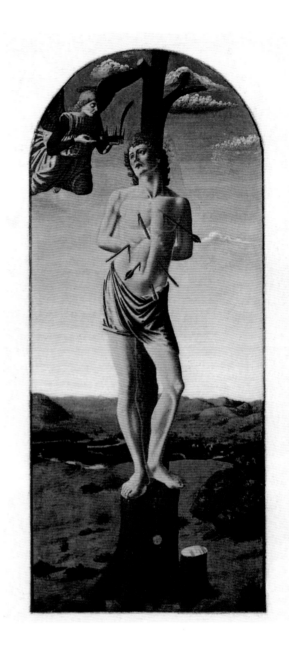

THE PUNISHMENT OF MUHAMMAD ALI FOR REFUSING TO FIGHT IN AN UNJUST WAR.

Muhammad Ali's life paralleled that of the legendary Jack Johnson, the first black Heavyweight Champion of the World (1908). Both were defensive virtuosos and brash iconoclasts who faced racist-inspired federal charges that interrupted their careers at the peak of their powers. In 1967, the heavyweight champion refused to be inducted into the U.S. Army. He had converted to the Nation of Islam, and under Elijah Muhammad he had become a Black Muslim minister. When Ali refused military service as a conscientious objector because of his new religion, a federal jury sentenced him to five years in jail for draft evasion. Boxing commissions then stripped him of his title and denied him the right to fight, in the prime of his fighting years. He was widely condemned as a draft dodger and even a traitor. When Cassius Clay became Muhammad Ali, he had also become a martyr. For the April 1968 cover of *Esquire*, while he was waiting for his appeal to reach the U.S. Supreme Court, I posed him as a modern Saint Sebastian, a portrait of a deified man against the authorities, modeled after the fifteenth century painting by Francesco Botticini that hangs in the Metropolitan Museum of Art. When I saw the first Polaroid as we were posing Ali, I believe my exact words to photographer Carl Fischer were "Jesus Christ, it's a masterpiece!" *Esquire* had a terrifying (and very controversial) cover that has become an iconic symbol of a period of nonviolent protest in those turbulent times. The cover gave voice to the plight of many Americans who took a principled stand against the Vietnam War and paid a heavy price for doing the right thing. Three years after the cover ran, the U.S. Supreme Court unanimously threw out Muhammad Ali's conviction. Allah be praised!

P.S. In 2008, reflecting on the influence my *Esquire* covers had on the political tenure of that period, the Associated Press wrote, "the most iconic image of the '60s was Ali as Saint Sebastian, tying together the incendiary issues of the Vietnam War, race and religion. The image is so powerful that some people remember where they were when they saw it for the first time."

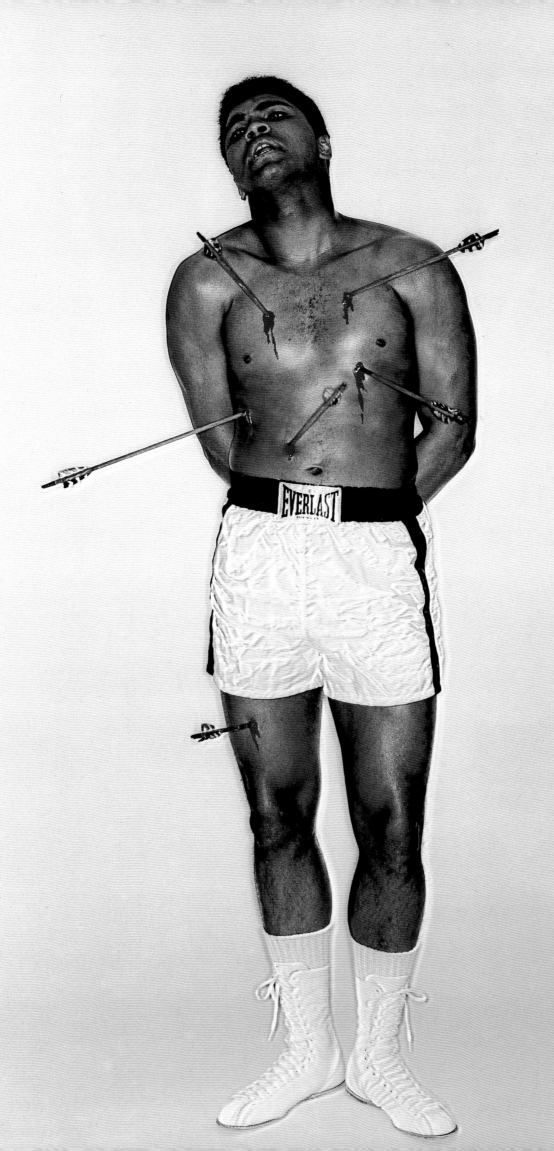

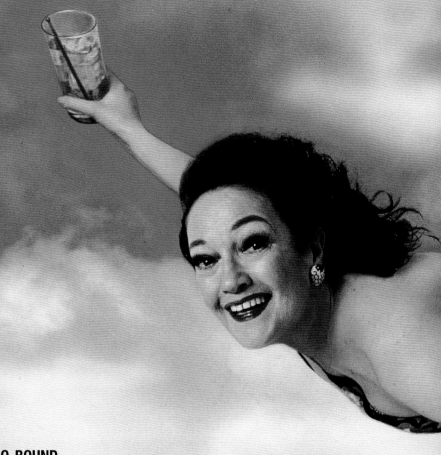

**46. IN 1942, LIKE WEBSTER'S DICTIONARY,
BOB HOPE AND BING CROSBY WERE MOROCCO-BOUND,
ON THE ROAD TO MOROCCO,
VYING FOR DOROTHY LAMOUR'S HAND.**

But the road was actually Sunset Boulevard and it led to a movie lot—the old camel and sand-dune
Morocco that was cooked up by Hollywood producers who had never set foot there.
As the competing pals (for Lamour *and* for scene-stealing) merrily sang "I'm off on the road to Morocco...
Like Websters Dictionary we're Morocco bound," America's young men were fighting
and dying in North Africa in our first engagements with Hitler's and Mussolini's desert rats. Go figure.

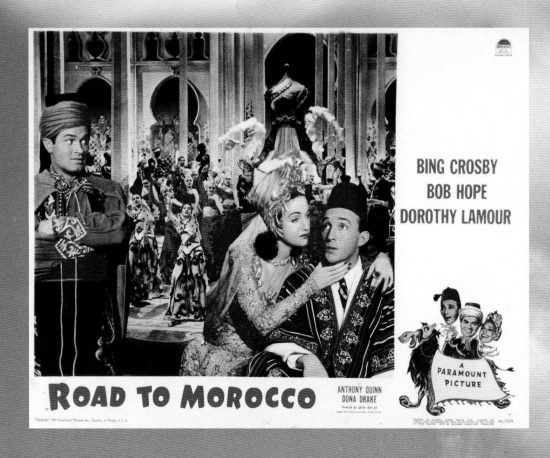

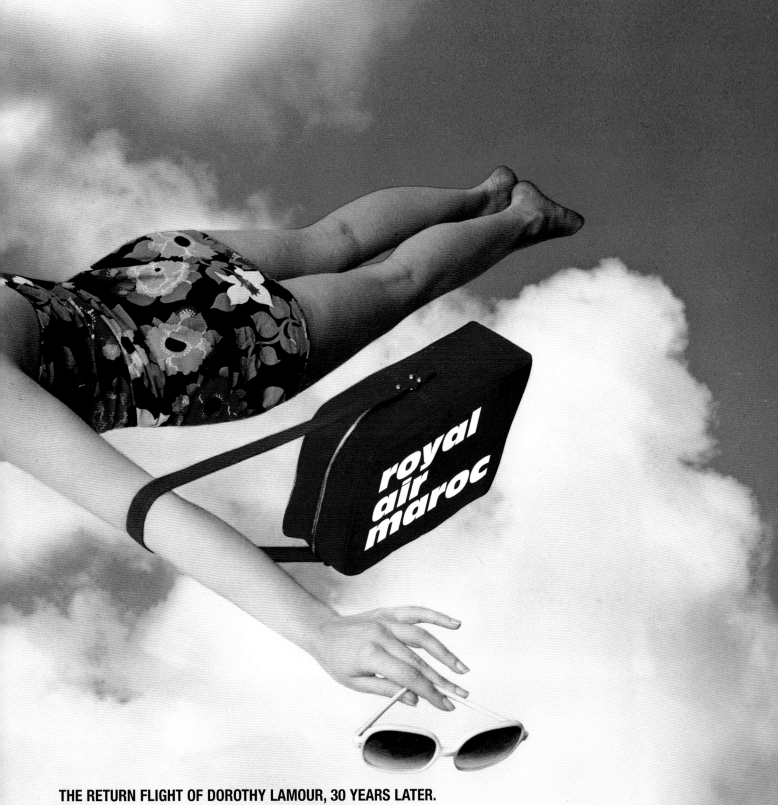

THE RETURN FLIGHT OF DOROTHY LAMOUR, 30 YEARS LATER.
(BUT, SHE HAD LOST HER ONCE-PETITE FIGURE.)

My job was to convince travelers that modern Morocco had blossomed into one of Europe's playgrounds,
an in-place for America's smart set. Always an exotic vacation spot, by 1972, Morocco was awash
in luxury hotels, stylish restaurants, swinging nightspots, beautiful Mediterranean beaches, golf courses, marvelous
fishing, even skiing (as well as the most unctuous snake charmers and belly dancers in the world).
I produced a luscious TV spot boasting the marvels of modern-day Morocco, driven by a Bing Crosby-sounding
voice singing "I'm off on the road to Morocco! Where is it? It's just south of Spain," and convinced
Dorothy Lamour to pose for a stunning two-page ad. Thirty years later, still vividly remembered, the famous
trio's female star would show up for a return flight on Royal Air Maroc, clad in her traditional sarong.
This time, her destination would not be the sandy Hollywood movie lot, but the for-real land of Morocco.
When we shot Ms. Lamour, she was still a stunning beauty, but her legs had (gulp!) lost their
curvaceousness! So I swapped Dorothy's legs for the gams of a youthful gymnast, hoping that somehow she
wouldn't be embarrassed by my somewhat arrogant substitution. When I showed this legendary
Hope and Crosby sex object her new, trimmed-down, juiced-up figure, she barked, "That's a lousy shot of my legs!"
Vanity, thy name is Woman.

**47. IN ORDER TO SHAME THE SWELLS WHO CLAIMED
THEY HAD RECEIVED INVITATIONS, TRUMAN CAPOTE LEAKED HIS
GUEST LIST TO *THE NEW YORK TIMES*.**

On the night of November 28th, 1966, Truman Capote threw "a little masked ball," reminiscent
of Versailles in 1788, in honor of *Washington Post* president Katharine Graham, inviting
540 of his closest friends. Frank Sinatra and Mia Farrow, William and Babe Paley, Harold Prince,
Andy Warhol, Rose Kennedy, Tallulah Bankhead, Gregory Peck, Lee Radziwill, Henry Ford II,
and William F. Buckley were among those anointed and summoned to the Black and White Ball
at the Grand Ballroom of The Plaza Hotel in New York, wearing masks and dressed,
of course, in black and white. They joined "Betty" Bacall and Jerome Robbins to dance the
night away. Capote was a talented writer but consumed by hobnobbing with the rich
and famous, who treated him like a Pekingese sitting on a needlepoint pillow for them to pet.
An anonymous poem of the time went like this:
Truman Ca-pote/is not nearly as dotty/as some of the people/who went to his party.
The complete guest list, believe it or not, was published in *The New York Times* the next morning.
It became a mark of tremendous status if your name was on it.

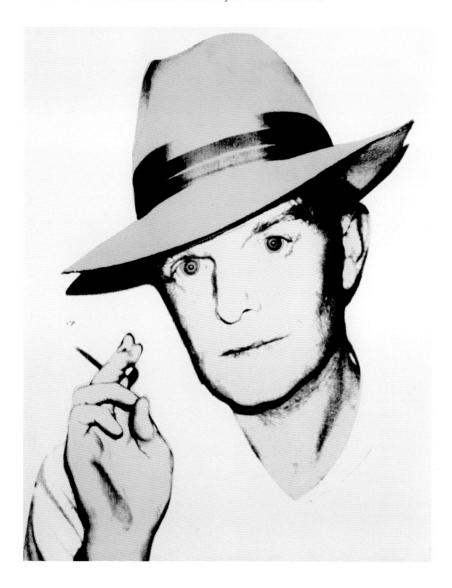

ONE YEAR LATER, ON THE COVER OF *ESQUIRE*, THE UNINVITED STRIKE BACK.

On the first anniversary of "The Party of the Century," the social world was still abuzz about the ball(s) of Truman Capote. The Gods of Power (celebrity, cultural, and political) spoke of it as Capote's greatest coup. Norman Mailer's deft backstab was, "To me, that party was greater than any of his books!" So I tried to put all the spin to rest with a final, sour-grapes *Esquire* cover depicting an eclectic and unmasked group of celebrities sweetly sticking their uninvited tongues out at Capote. Truman was not amused.

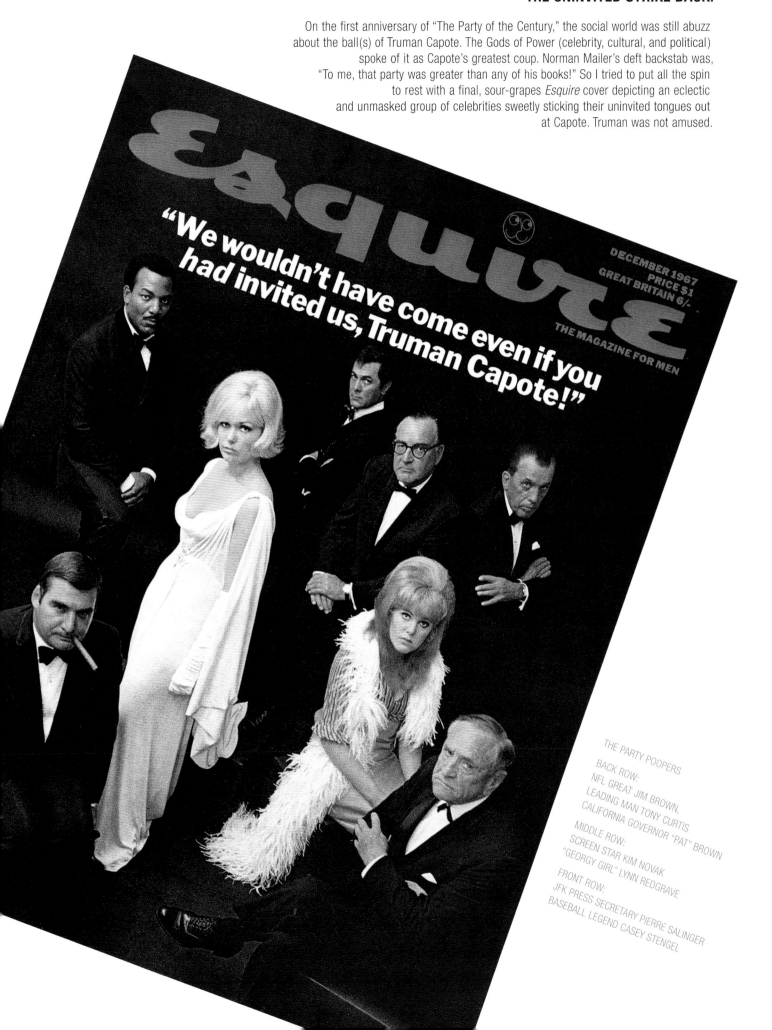

Esquire

THE MAGAZINE FOR MEN

DECEMBER 1967
PRICE $1
GREAT BRITAIN 6/-

"We wouldn't have come even if you had invited us, Truman Capote!"

THE PARTY POOPERS
BACK ROW:
NFL GREAT JIM BROWN,
LEADING MAN TONY CURTIS
CALIFORNIA GOVERNOR "PAT" BROWN
MIDDLE ROW:
SCREEN STAR KIM NOVAK
"GEORGY GIRL" LYNN REDGRAVE
FRONT ROW:
JFK PRESS SECRETARY PIERRE SALINGER
BASEBALL LEGEND CASEY STENGEL

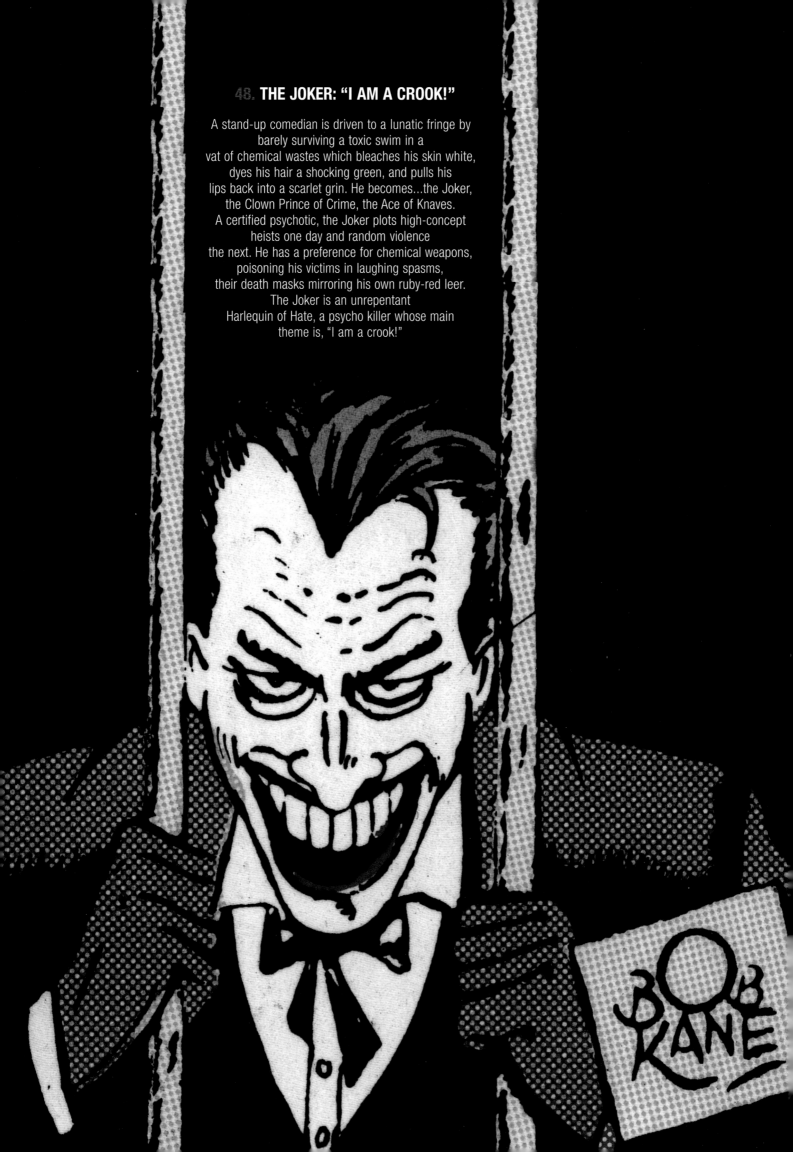

48. THE JOKER: "I AM A CROOK!"

A stand-up comedian is driven to a lunatic fringe by
barely surviving a toxic swim in a
vat of chemical wastes which bleaches his skin white,
dyes his hair a shocking green, and pulls his
lips back into a scarlet grin. He becomes...the Joker,
the Clown Prince of Crime, the Ace of Knaves.
A certified psychotic, the Joker plots high-concept
heists one day and random violence
the next. He has a preference for chemical weapons,
poisoning his victims in laughing spasms,
their death masks mirroring his own ruby-red leer.
The Joker is an unrepentant
Harlequin of Hate, a psycho killer whose main
theme is, "I am a crook!"

PRESIDENT RICHARD NIXON: "I AM NOT A CROOK!"

From the time he ran his first (slanderous) campaign against the incumbent Senator Helen Gahagan Douglas of California in 1950, Richard Nixon reminded me of the Joker, without makeup! In the spring of 1968, on the cover of *Esquire* magazine, before Tricky Dick was nominated, I taught him how to use makeup and become president! My composite shot was a satirical comment on the 1960 TV debates, when the Whittier whiz with the five-o'clock shadow lost to the handsome John F. Kennedy because he looked evil on America's screens. I located this profile shot (Nixon getting shut-eye on Air Force One) and we photographed the hands of four makeup artists, including the guy wielding the lipstick. The day it hit the newsstands, editor Harold Hayes got a phone call from Ron Ziegler, Nixon's press secretary (who remained his flunkey all the way through Nixon's infamous, dastardly days as president). He was miffed. In fact, he was incensed. You know why? The lipstick. "Showing Richard Nixon as a flaming queen is outrageous. If he becomes president, *Esquire* had better watch out!," he warned, and hung up.

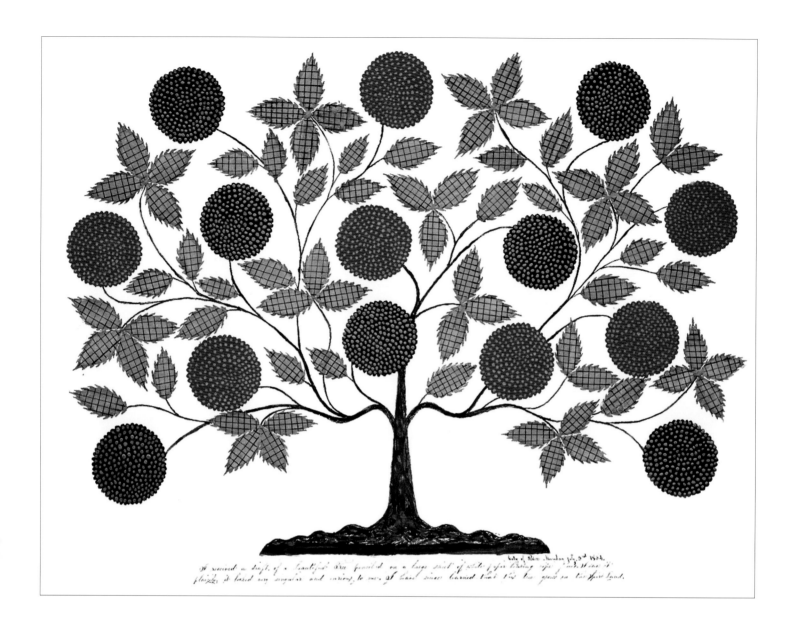

49. THE TREE OF LIFE

In 1854, Shaker Sister Hannah Cohoon created a drawing using ink and tempera on paper,
The Tree of Life, bringing to fruit her experience of receiving religious inspiration.
The inscription at the root of her drawing details her apparition: "The spirit shew'd me plainly the branches, leaves
and the fruit, painted or drawn on paper. The leaves were check'd or cross'd and the
same colors you see here. I entrusted Mother Ann to tell me the name of this tree." Mother Ann Lee,
founder of the Shakers, gave her this answer: "Your Tree is the Tree of Life."
The tree was part of a vision that called the Shakers to America, and it subsequently became a symbol of
unity of the Shaker church. Sister Hannah's creation is an American
masterpiece of bountiful, life-affirming nature, given to all humankind from the hand of their God.

80 SEASONS IN THE LIFE OF THE FOUR SEASONS

In 1979, for a 20th anniversary celebration of The Four Seasons, the visionary restaurant that converted dining in America into a theatrical and aesthetic experience, I designed a poster showing 20 stacked Four Seasons logos, creating a pattern of 80 trees. Eighty trees times fifty posters (each sequentially numbered in pencil to signify their exclusivity), each in a silver frame, hanging within an inch of each other, created a 50-foot wall flaunting a veritable orchard of 4000 trees! At the end of the dinner the proprietor Tom Margittai made a final toast to 50 honored guests who had important roles in the creation of the Seasons. Then he announced that the framed posters were a memento for each guest and that they should pluck one off the wall to hang at home. Fifty New York swells sprang to their feet in a mad scramble to acquire one of the lowest-numbered posters. (Three billionaires almost had a fistfight for "1 of 50.")

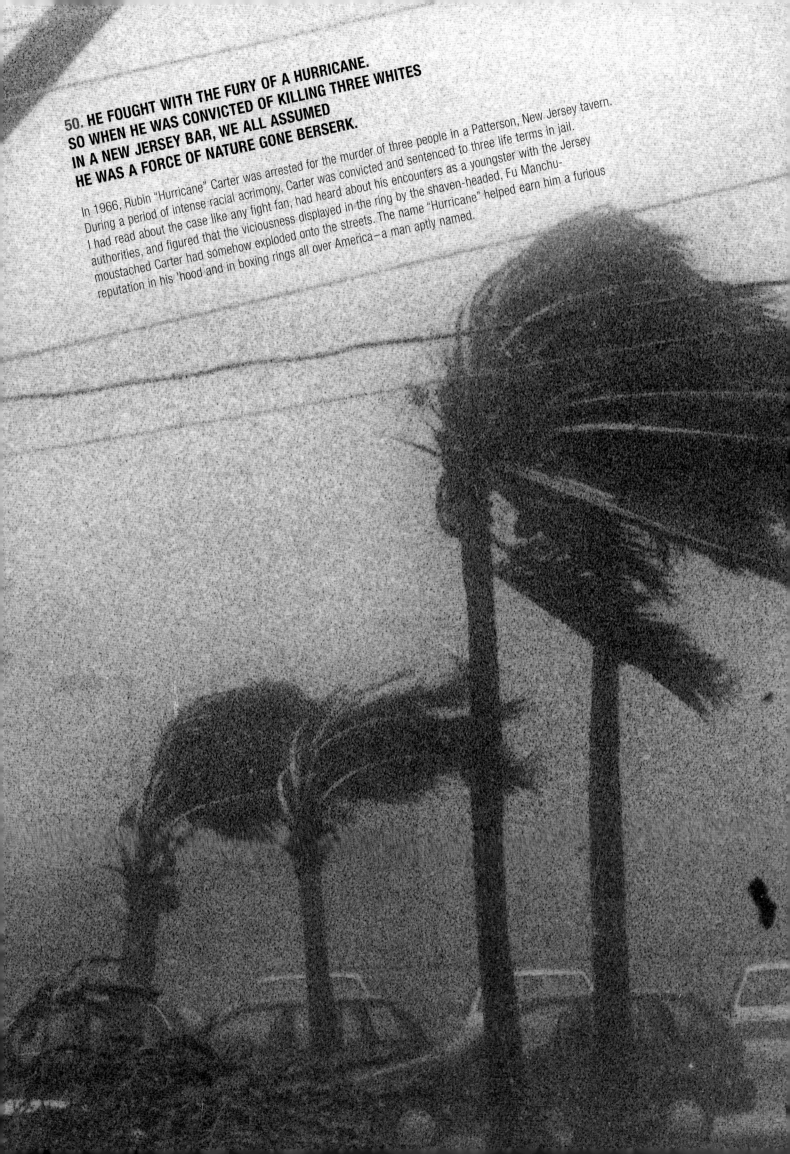

50. HE FOUGHT WITH THE FURY OF A HURRICANE. SO WHEN HE WAS CONVICTED OF KILLING THREE WHITES IN A NEW JERSEY BAR, WE ALL ASSUMED HE WAS A FORCE OF NATURE GONE BERSERK.

In 1966, Rubin "Hurricane" Carter was arrested for the murder of three people in a Patterson, New Jersey tavern. During a period of intense racial acrimony, Carter was convicted and sentenced to three life terms in jail. I had read about the case like any fight fan, had heard about his encounters as a youngster with the Jersey authorities, and figured that the viciousness displayed in the ring by the shaven-headed, Fu Manchu-moustached Carter had somehow exploded onto the streets. The name "Hurricane" helped earn him a furious reputation in his 'hood and in boxing rings all over America—a man aptly named.

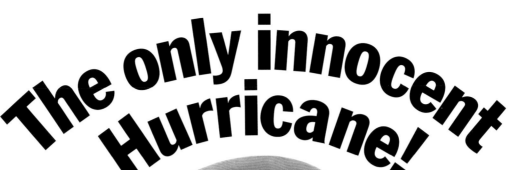

The only innocent Hurricane!

**BUT, AS THE JERSEY COPS WELL KNEW,
RUBIN CARTER WAS
THE ONLY INNOCENT HURRICANE!**

In 1974, two key prosecution witnesses recanted, while new lawyers unearthed the suppression of vital evidence that would certainly have exonerated Carter. At that same time, I read *The Sixteenth Round*, an amazing book written in blood, sweat, and rage by Rubin Carter while imprisoned in a cold, damp prison cell, after already having served eleven grueling years—with 289 left to go! His tale of racial injustice bowled me over, and after meeting with his lawyers, I was convinced he had been railroaded. Like a bolt of lightning, I was inspired (and professionally challenged) to use my talents to help get a man, framed and wrongfully convicted, out of the slammer. My strategy was to create a cause-célèbre campaign, starting with a tiny ad in the national edition of the *New York Times*, seemingly written and paid for by Rubin Carter, No. 45472, Trenton State Prison, headlined, *Counting today, I have sat in prison 3,135 days for a crime I did not commit*. I knew that the whole country would be buzzing about this outrageous ad from a convicted killer in prison, appealing for help. Within two weeks, I enlisted fifty-four famous men and women who were moved by his plea, including Hank Aaron, Ed Koch, Gay Talese, Ellen Burstyn, Howard Cosell, Norman Mailer, Jesse Jackson, Dyan Cannon, Bill Walton, Harry Belafonte, Burt Reynolds, Barry White, Bob Dylan—and the coup de grâce, Muhammad Ali—who publically led my guerrilla war to free the convict I called *The only innocent Hurricane*. As our chairman, Muhammad was the main attraction at Hurricane benefits I organized all over Manhattan, and committee members like Dyan Cannon and I appeared on TV talk shows as the press ran hundreds of stories, with dozens of TV segments. We handed out thousands of leaflets. We staged a Christmas vigil at the gates of Governor Brendan Byrne's mansion. We ran radio spots (beautifully read by Earl Monroe of the Knicks). Ali spoke out at every occasion, even dedicating his Las Vegas match with Ron Lyle to Carter. And Ali led a march of thousands past Trenton State Prison, all the way to the statehouse to meet with the shell-shocked governor of New Jersey. Inspired by our efforts, Bob Dylan wrote the explosive protest song, *Hurricane*, and we produced a "Night of the Hurricane" concert at Madison Square Garden in 1975. The Rubin Carter case became famous worldwide, and the pressure mounted, until the New Jersey Supreme Court ordered a second trial. But with missing evidence, a disappearing witness (who had recanted!), and an obsession on the part of New Jersey prosecutors to nail this incorrigible black man, the verdict was the same. But then, in 1985, the Federal District Court threw out the second conviction, and, in 1988, the United States Supreme Court, citing "grave constitutional violations," upheld the noble ruling that Carter had been unjustly convicted. Truly, Rubin Carter was proven "The only innocent Hurricane"!

51. CARY GRANT AND EVA MARIE SAINT WALK AMONG GIANTS.

North by Northwest is a 1959 cinematic masterpiece by Alfred Hitchcock depicting the odyssey of a suave advertising executive
(played by Cary Grant) mistaken for a U.S. spy by a nest of Nazi spies and pursued across America as he frantically
tries to stay alive. The chase culminates on a brilliant moonlight night as Grant and Eva Marie Saint (playing an undercover
U.S. agent) flee a modern cantilevered home perched atop the spectacular Mount Rushmore National Memorial,
climb down between the handsome, humongous heads of George Washington and Thomas Jefferson, and somehow survive
a cliff-hanging experience with the Nazi bad guys. During the depressing days of the Great Depression, Gutzon Borglum
lifted the spirits of Americans, molding the graceful, lifelike faces of four great presidents on a pine-clad mountain in South Dakota's
Black Hills, creating the world's most gigantic monument of sculpture. Hitchcock's scenario contrasting tiny humans
with four giants of American history stunned me in 1959, just a few years before I started creating *Esquire* covers, and I stored
the Lilliputian imagery in the computer in my head.

ANDY WARHOL IS SWALLOWED UP
IN A GIANT CAN OF CAMPBELL'S SOUP.

By 1969, the image of a Campbell's soup can was becoming the symbol of the Pop Art movement,
so I decided to show Andy Warhol being devoured by the monster he had created. This cover
has become the supreme statement of *Esquire's* skewering the celebration of pop culture in the '60s,
as its great editor Harold Hayes deconstructed celebrity. Maybe Andy was an innovator and
an original thinker, but he most certainly was a major-league showman. Any guy who can parlay
a soup can (not to mention that mundane Brillo box) into personal stardom may not fit
my definition of an artist, but Warhol certainly was hot stuff. We photographed
him and the open can of soup separately. When I dropped Andy in the soup, I almost
lost him. Warhol was no Cary Grant, but his bewigged puss helped *Esquire*
double the previous record for a one-month newsstand sale.

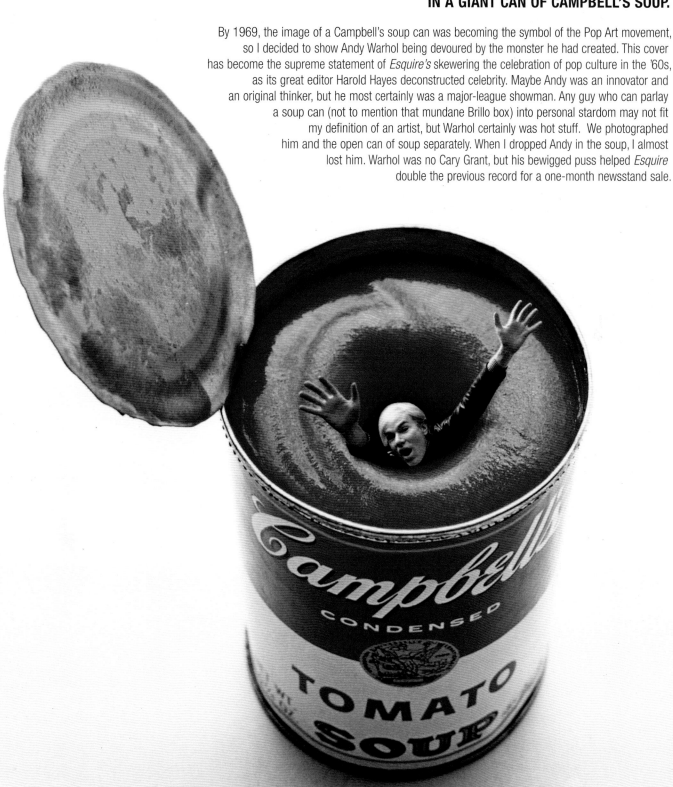

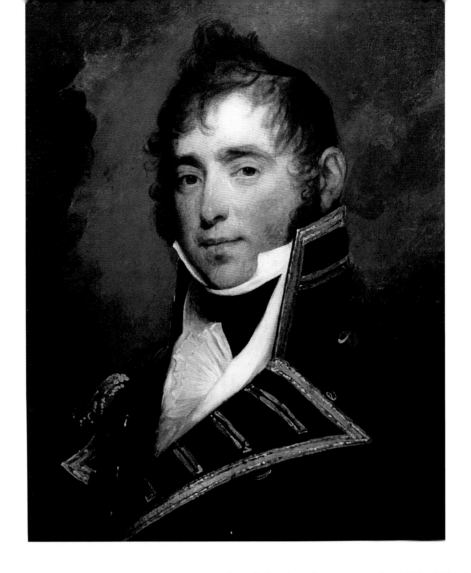

52. IN 1813, THE HEROIC LAST WORDS OF CAPTAIN JAMES LAWRENCE WERE "TELL THE MEN TO FIRE FASTER! FIGHT 'TIL SHE SINKS, BOYS! DON'T GIVE UP THE SHIP!"

In the War of 1812, Captain Lawrence, in command of the *U.S.S. Chesapeake*, engaged a frigate of the revengeful British Empire. After a short, bloody battle just outside Boston Harbor, the *H.M.S. Shannon* captured the *Chesapeake* as its captain lay mortally wounded by small arms fire and died of his wounds as a prisoner of the British. America had lost the battle, but the intrepid captain's last words lived on. (Shown is a portrait by Gilbert Stuart of the stalwart commander a year before the fatal battle.)

IN 1973, ISSUING THE SAME COMMAND, AN AD CAMPAIGN SAVES CUTTY SARK FROM GOING UNDER.

The captains of Cutty Sark scotch were debating whether or not to scuttle its famous logo. For more than 30 years, an estimated hundred million dollars had been spent to promote Cutty in an ad that showed a romantic painting of the ship at sea. A major account competition was launched. When it was my turn to present my Big Idea to their all-hands-on-deck management team, I stood up, wildly waved my arms and commanded, "Don't give up the ship!" and showed them dozens of ads zeroing in on the simple, old-fashioned drawing of the ship on their label, with a message tailored to each publication. I got the account. Cutty kept their ship, and sailed profitably into the sunset. (Shown is my prophetic take on President Richard Nixon in a scene from an infamous Cutty Sark sales film I created—more than a year *before* Nixon resigned! This outrageous scene of our president, played by a Nixon look-alike, alone at night in the Oval Office getting soused, with long intervals of sipping Cutty Sark between his incoherent spiel, had them rolling in the aisles at whiskey-distributor conventions. At the third showing, the FBI actually confiscated the film!)

"I won't give up the Ship.
They can't make me.
Never."

53. A SIX-SECOND STEP-BY-STEP VISUAL RECORD OF A HORRENDOUS ACT

After a tough political week in Texas, brought on by his courageous stand on civil rights in the South, militant right-wing groups warned that president John F. Kennedy would get a rude reception. Kennedy was in Texas with his wife Jackie to help hold the state for the Democrats in the upcoming 1964 election. Although placards appeared bearing JFK's picture and the words "Wanted for Treason," the Thursday receptions in San Antonio, Houston, and Fort Worth were warm and enthusiastic. On Friday, November 22, 1963, at 11:37, Air Force One touched down at Love Field and Dallas's greeting, like the 76-degree temperature, was warm and refreshing. At 11:50 am, seated in the big presidential Lincoln Continental limousine, his motorcade began to roll on an eleven-mile route through downtown Dallas. Because of the pleasant weather, the plastic bubble top was removed and the bulletproof side windows rolled down. Mrs. John Connally, seated in the jump seat with Texas Governor John Connally, turned smilingly to the president and said, "You can't say that Dallas isn't friendly to you *today.*" Jack Kennedy's reply was cut off by the sharp, brutal sound of a gunshot. Three shots seemed to have been fired, the last exploding the president's head on the impact of the bullet. Jacqueline Kennedy cried "Jack! Oh no! No!" as she reached for her stricken husband. A visual record of the act that shook the world was recorded by three Dallas spectators on 8mm color film, forever haunting the American psyche. The frightful sequence was over in less than six seconds.

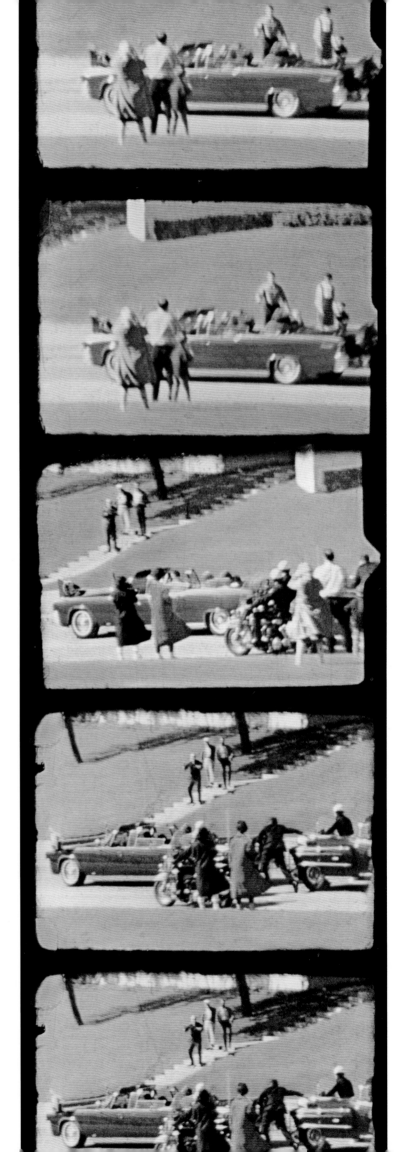

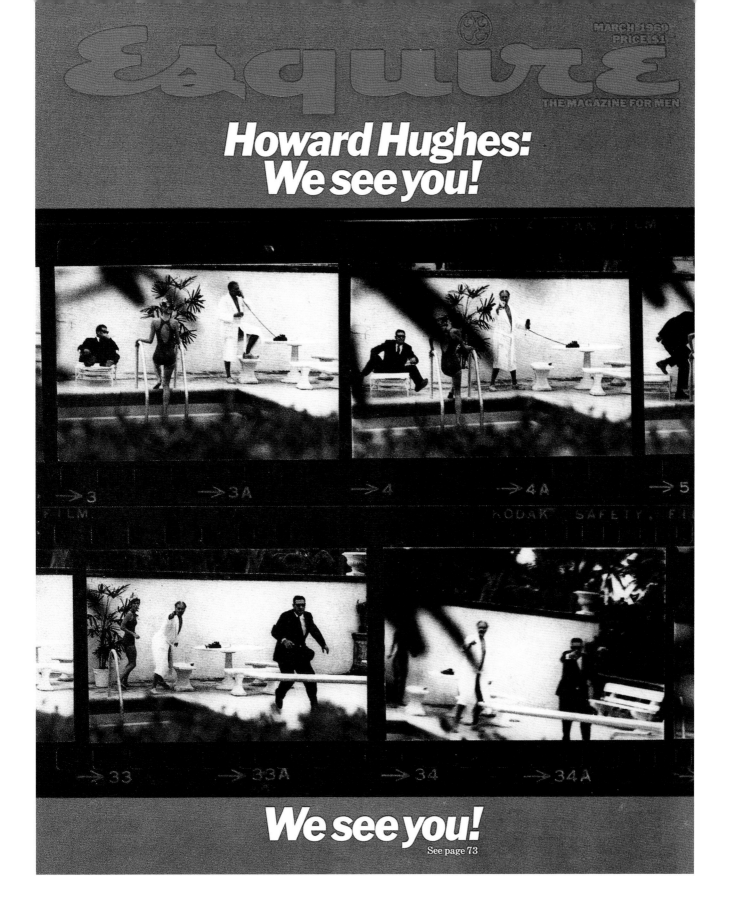

A SIX-SECOND STEP-BY-STEP VISUAL RECORD OF THE "DISCOVERY" OF THE INVISIBLE HOWARD HUGHES

This issue of *Esquire* was a big seller because at long last the elusive Howard Hughes was found—which proves once more that you can fool all of the people all of the time. I was simply spoofing the idiotic interest in America's best-known, least-seen mystery man.
The guy in the white bathrobe is an actor playing Howard Hughes. The woman in the bathing suit is a model who looked like Hughes' wife, actress Jean Peters. And the lug playing a bodyguard came from central casting, all staged at a private pool in Miami and photographed to look like the Hughes entourage had spotted us, as Tasso Vendikos clicked away on a 35mm Leica camera. Everyone thought the sighting was the real thing when this issue hit the newsstands, but the big thinkers at *Time* magazine figured out it was a hoax (duh!). The press pounced on editor Harold Hayes for an explanation, and he summed up the silly hoo-ha over the mystery celebrity. "What we're doing is an attempt to satirize the whole obsession with the idea that the world is constantly pursuing Howard Hughes." You can be sure Clifford Irving saw this cover in 1969, three years before he conjured up his bogus "authorized" Hughes biography— an incredible caper that landed him in the cooler.

Through hand gestures, any of us can interpret the personality and human reactions of a person, but cleavage lines in the palm are said by palmists to denote character, chart past events, and predict the future. This powerfully graphic French palmist's chart from 1640 was a roadmap for the professional fortune-tellers of that time, a woodcut seemingly drawing upon Oriental influences. Palmistry has always had a firm grip on the human need to attempt to foresee the future. "Come on, read my future for me," says Orson Welles as Hank Quinlan, the corpulent, corrupt, fedora-wearing Texas cop, to Marlene Dietrich in a non-typecast role as Tanya, a black-haired gypsylike madam in a raunchy Mexican border-town brothel in *Touch of Evil* (1958). Tanya takes his hand, glances at his sweaty palm, and says "You haven't got any."

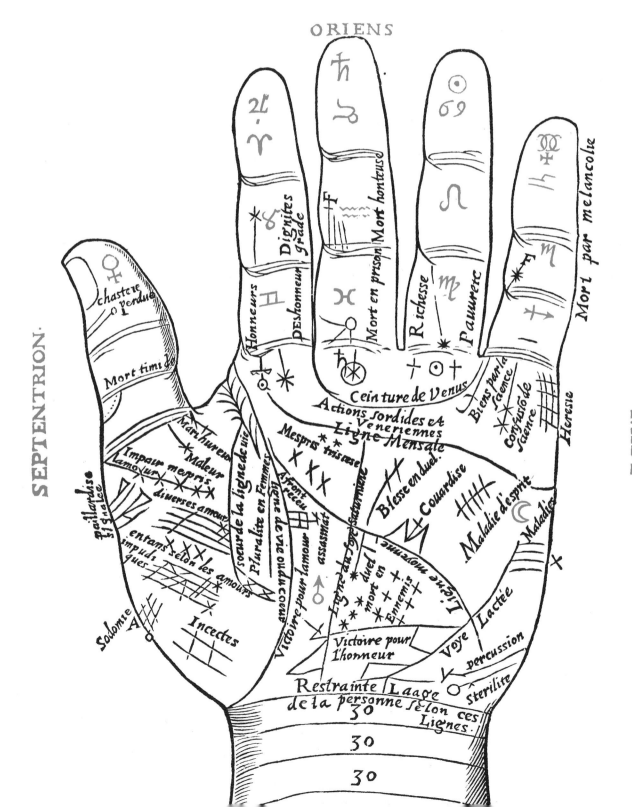

THE HAND OF A
"KING IN THE MUHAMMAD RELIGION"

A hands-on touch when I created the Ali/Frazier III 1975 "Thrilla in Manila"
fight program was to make contact with Madame Phyllis
Woodbury, a seer and palmist who did a thriving business in Harlem.
I handed her two life-size photos of men's hands (Muhammad Ali
and Joe Frazier) without telling her whose hands they were. After her
uncanny analysis (she said that the hand of the unnamed Ali revealed
him to have been a king in the Muhammad religion!),
I disclosed the identity of her subjects. *Then*, I asked for her prediction.
She, alas, said *Frazier* would win. Palmist, yes. Seer, no.

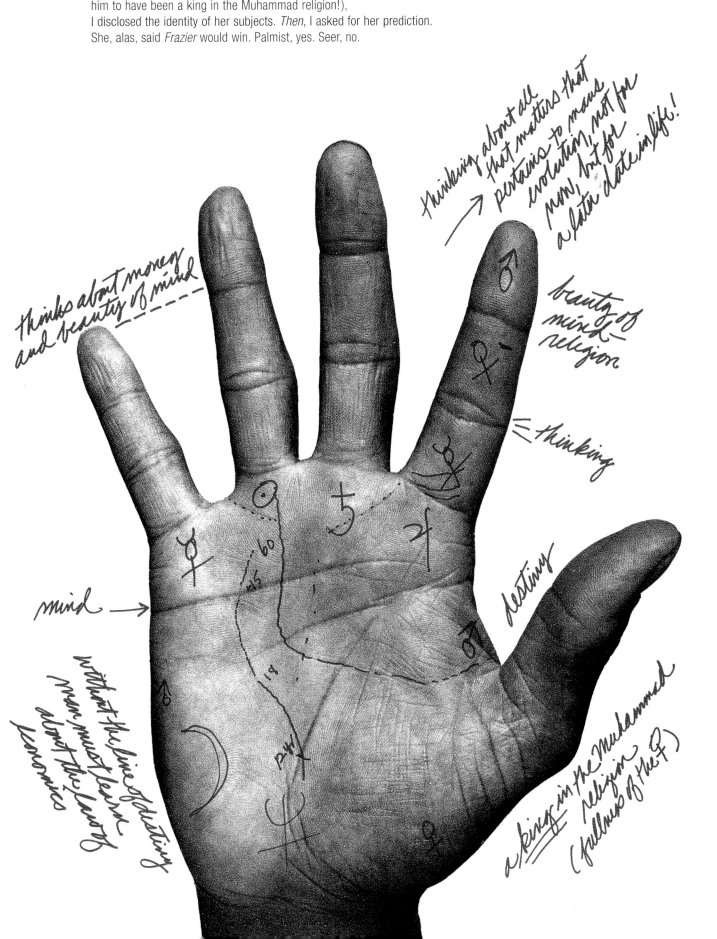

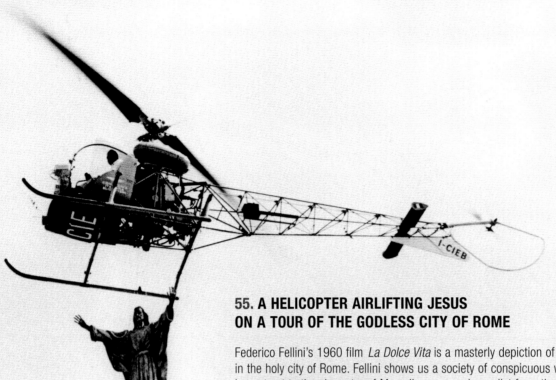

55. A HELICOPTER AIRLIFTING JESUS
ON A TOUR OF THE GODLESS CITY OF ROME

Federico Fellini's 1960 film *La Dolce Vita* is a masterly depiction of decadence and sin
in the holy city of Rome. Fellini shows us a society of conspicuous wealth and uninhibited sexuality,
in contrast to the character of Marcello, a young journalist from the provinces (played by
Marcello Mastroianni) who juggles sexual conquests and relationships throughout the film, but
remains spiritually impotent, resigning himself to a soulless life. A dictionary description
of epiphany is: "An appearance or revelatory manifestation of God or a divine being." Bingo!
Fellini's basic theme is a godless society's collective need for regeneration, and to make
his meaning crystal clear, in a stupendous opening scene, a helicopter carries a statue of the
Son of God, arms uplifted, gliding ominously over the sinful city. The juxtaposition of a
modern-day whirling helicopter carrying the iconic image of Christ, seemingly lamenting the
course of humankind, is one of the greatest visual statements in the history of film.
La Dolce Vita became a cause-célèbre as the Italian press and the Catholic Church condemned
it as immoral and pornographic and called for Fellini's arrest. Modern tragedy began
with Nietzsche's declaration that God is dead, and *La Dolce Vita* was the world's first great
modern film tragedy.

ST. PATRICK'S CATHEDRAL TRANSFORMED
INTO A COKE-AND-POPCORN MOVIE THEATER

A great photographic image is a secret within a secret. A great magazine cover, like
a strong package design, usually explains what's inside. A great issue of
Esquire enabled me to make a personal comment about what I thought the magazine
was trying to say. And in the '60s, this wildly inventive, deadly serious
publication was magazine journalism at its peak of achievement. The August 1970
issue featured a sheaf of articles on the spreading youth culture, but it seemed
to lack a definitive point of view. (I call it a hook.) To my mind, American postwar films,
unlike many great Italian films, basically remained white-bread until a stoned
Jack Nicholson, Peter Fonda, Dennis Hopper, and crew brought the biggie Hollywood
studios to their knees in 1969 with the cheapo culture-clashing *Easy Rider*,
opening the door to a new American era of film. So my hook was to focus on the
new movies and call them the Faith of our Children. Then, in an irreverent
juxtaposition, I superimposed the marquee of that low-budget runaway hit over the
majestic doors of St. Patrick's Cathedral. To American youth, *Easy Rider* had
become the cult film of the hip generation. The Roman Catholic Archdiocese was not
pleased. In a face-to-face meeting at his rectory, Cardinal Terence Cooke
dressed down this Greek Orthodox nonbeliever for what he considered a "blasphemous"
image, but I left him chuckling when I swore on a St. James Bible that whenever
I strolled past St. Paddy's in the future, I would always pull out four bucks (now $12.50)
if I felt like going in.

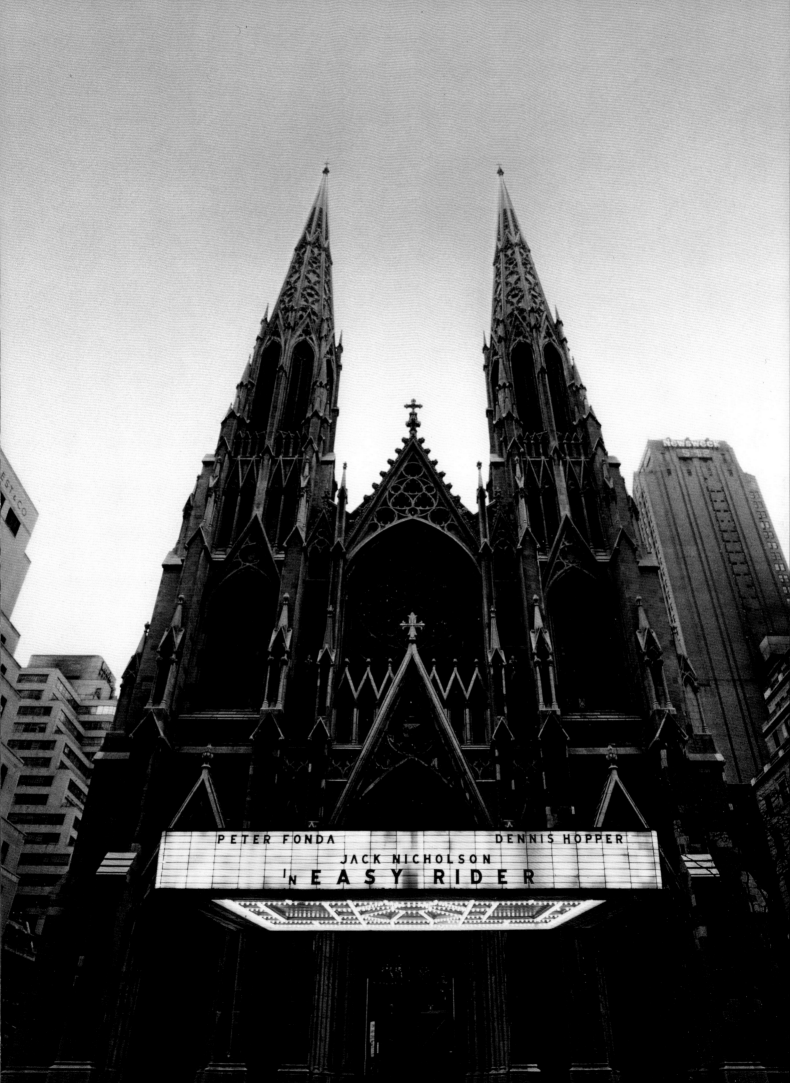

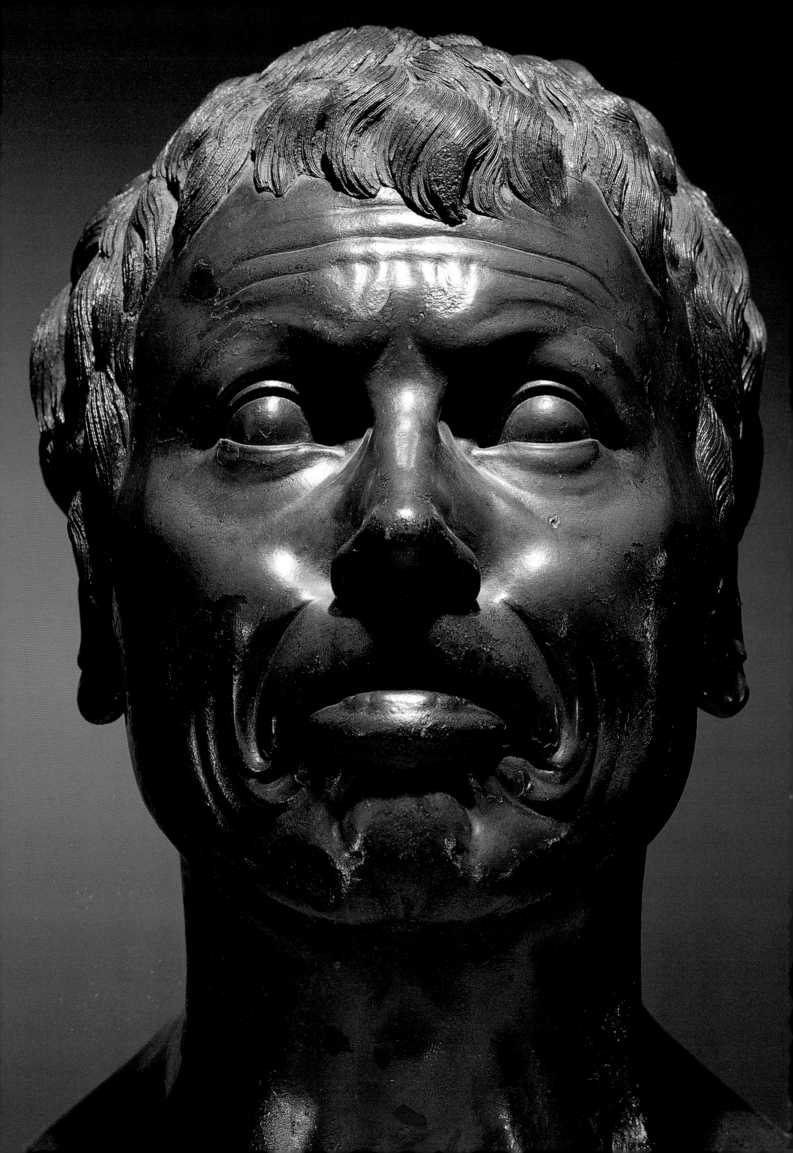

56. AMERICANS HATE TO SEE A GROWN MAN CRY...

Males in our society are not supposed to cry.
(Don't go by me. We Mediterranean men shed tears once
a week, just to keep in practice.) In 1972,
when Democratic Senator Edmund Muskie of Maine was
running in the primaries for the presidential
nomination, he self-destructed when he cried wet tears
on national TV, complaining about how his wife
had been maligned. But in Europe and much of the world,
shedding heartfelt tears is considered part of
a man's character and humanity. In Vienna in the late
eighteenth century, Franz Xaver Messerschmidt
was a maverick Austrian baroque sculptor who amazed
with his dramatic, individualistic view of human
expression. (He was the originator of a one-man movement
I call In-Your-Face-Expressionism.) The titles of his
sculpture explain his subject matter:
Simpleton, *Ill-Humored Man*, *The Sneezer*, *Strong Odor*,
Childish Weeping, *The Yawner*, *A Lecherous Fop*,
Arch-Rascal, *A Mischievous Wag*, *A Dismal and Sinister Man*,
Weepy Old Man, and *The Troubled Man* (shown).
These stunning psychological studies anticipated (and outdid)
the realism of the nineteenth century.
Recent research confirms that Messerschmidt's images
expressing such extreme emotional states
were probably driven by attacks of mental illness.
But I see his "character heads" as passionate
studies of the extreme manifestations of the human
experience, from an artist whose work
provides a bellyful of laughs.

...UNTIL A BUNCH OF SUPERSTAR ATHLETES SHED TEARS, BAWLING "I WANT MY MAYPO!"

Maypo had always been sold as a baby cereal, and the
marketing objective was to enlarge the age range
and try to get small fry, five to twelve years old, to beg
their moms for it. But instead of the traditional
use of a kid wailing at his mother, I made a 180-degree
turn away from the obvious. To appeal to the
preteenagers, I used the greatest superstars of professional
sports, and they hit it out of the park! I showed
Mickey Mantle, Willie Mays, Johnny Unitas,
Oscar Robertson, Dandy Don Meredith, and Wilt Chamberlain—
all in one television spot, crying for their Maypo and
shedding lifelike tears. Here was the ultimate sissification
of the American macho sports hero, a twisteroo on
the unconscionable hustles by jocks who manipulated kids
through hero worship. Instead, the sports greats
in the spot sold obliquely, displaying self-mocking wit.
Watching grown men cry on TV was hypnotic
theater. The words and visuals—superstars crying
I want my Maypo, followed by a macho voiceover—*The
oatmeal cereal that heroes cry for!*—gave the
campaign extraordinary power (making it the most tearful
TV spot ever made!). A single-minded merger of
words and pictures had been accomplished, resulting in
riveting imagery. American moms and dads loved it,
and their kids ate it up. Messerschmidt
woulda been proud of me.

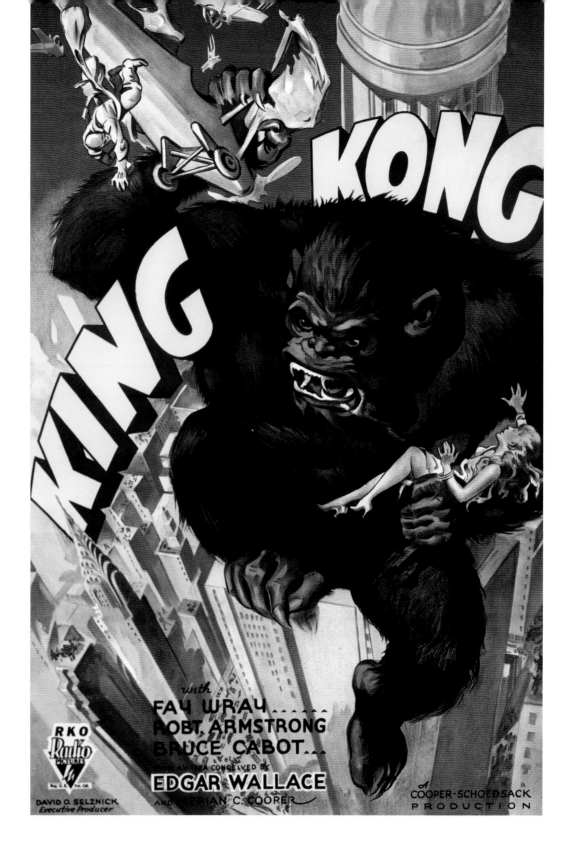

57. KING KONG OGLES FAY WRAY.

The most famous adventure-fantasy horror film of all time remains *King Kong*, created in the midst of the Depression in 1933, starring a beauty and her beast (Hollywood's tallest, darkest leading man).
The story of a plucky blonde (played by Fay Wray) and a frightening, gigantic 50-foot ape-monster, is a metaphoric retelling of the archetypal *Beauty and the Beast* fable. The major themes of *King Kong* are: the struggle for the survival of a ship of moviemakers on the primitive, fog-enshrouded, tropical Skull Island against the voodoo natives and the giant ape; the monster gorilla's crush on the shapely blonde dish from New York; and their poignant story of unrequited love. (One hot scene, excised by censors after the Hollywood Production Code took effect in 1934, was Kong peeling off Fay Wray's diaphanous dress while holding her unconscious in the palm of his mighty hand!) King Kong is in love, and he tenderly protects his captive human female. In the memorable final scene, he unleashes his rage as he climbs and then straddles the Empire State Building as aircraft buzz around him and riddle him with bullets. As I remember the film, Fay Wray develops the hots for Kong, and if they had their druthers, would have lived as happily as Tarzan and Jane (but it boggles the mind to imagine how they could have possibly consummated their love).

GERMAINE GREER OGLES KING KONG MAILER.

A September 1971 issue of *Esquire* contained a Norman Mailer piece taking proponents of the women's liberation movement to task, as well as a celebration of the then 38-year-old *King Kong* flick. So I mated the literary male-chauvinist monster, showing him going ape over the female-liberationist doll. When he saw this *Esquire* cover Germaine Greer looks ecstatic in the clutches of macho Mailer. When he saw this *Esquire* cover he called editor Harold Hayes and challenged him to a fistfight. Hayes, an ex-Marine, chickened out and asked me to take Mailer on. I refused. I told Mailer I wanted him to qualify first—by taking on Germaine. (I never heard from the feminist babe, but I rather imagine she got a rise out of the whole affair.)

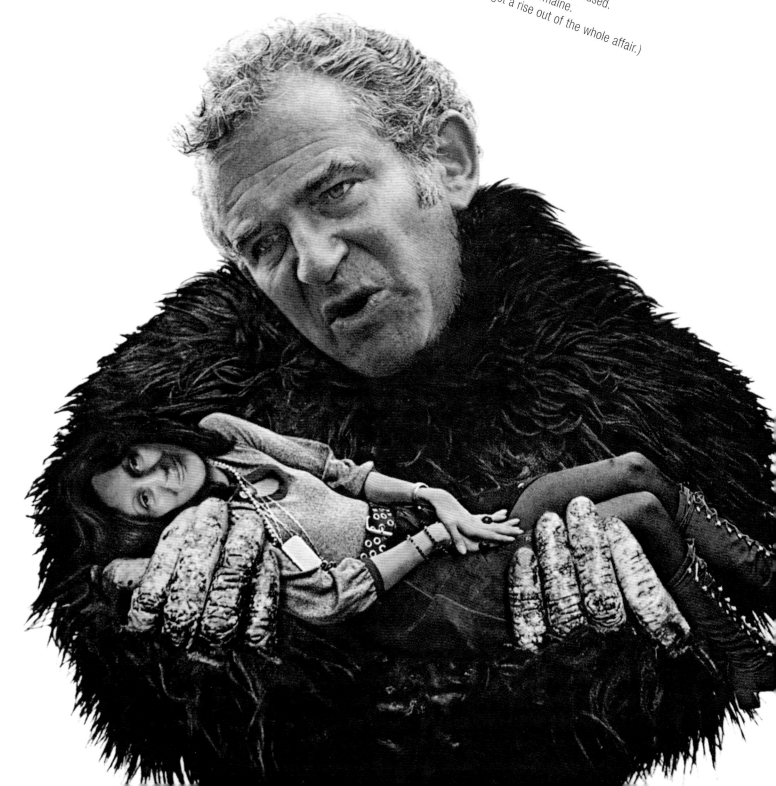

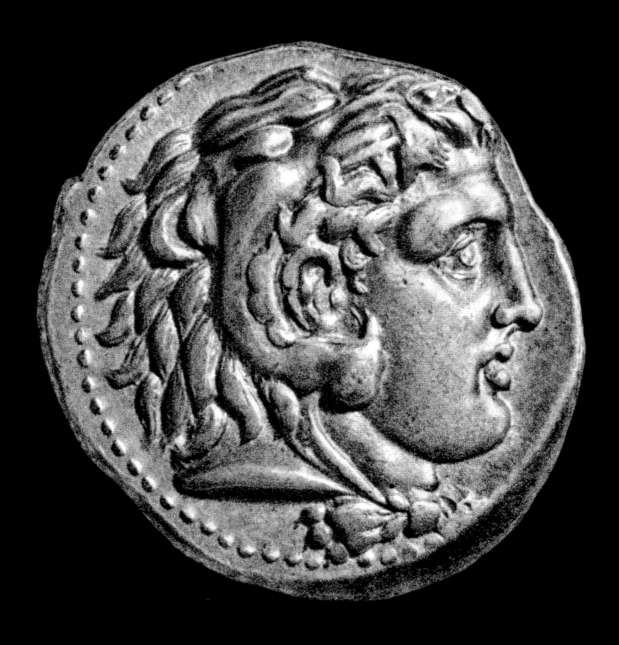

58. THE ICONIC HEAD OF HERAKLES...

In the Archaic and Ancient Greek worlds, Herakles was seen as the epitome of perfection, a hero who had to carry out
a series of superhuman tasks, eventually securing victory over the Giants.
Alone among the heroes, Herakles was given a reward, a place among the gods, becoming their companion for all eternity.
Celebration of his heroic achievements reached its peak in the brilliant drawings
of Greek myths by the vase painters of Attica in the fifth and sixth centuries BC. A century later,
raised to believe that he was descended from the Greek heroes Achilles and Herakles,
the young Alexander acquired a zealous reverence for the ancient Greek myths (Plutarch wrote that he slept with a
dagger and a well-thumbed copy of the *Iliad* beneath his pillow during his campaigns).
In Hellenistic Greece, the idea that a warrior or a leader might be idolized as a living
god on a coin was blasphemous. But in 326 BC, the charismatic, visionary leader Alexander the Great, tutored by
Aristotle and endowed with natural brilliance and a keen appreciation of ceremony
and the role of personal magnetism, realized the propaganda value of producing coinage. Supposedly designed
as a testament to Herakles, the mythological hero's profile looks remarkably similar
to that of the handsome young ruler of Macedonia! During the course of the warrior king's short but dynamic life—
he died at the age of 32—the Greek city-states and the colonies and nations he conquered on his
22,000 mile, 13-year invasion route from Macedonia to India, minted thousands of silver and gold coins framing Herakles
(with Zeus shown enthroned on the obverse side). As well as being an object of historical value,
like a fragment plucked from the Parthenon frieze, the Herakles coin is a genuine work of art, revealing beauty that one
is hardly prepared to find on so small a scale. Handling this ancient artifact from the
realm of Alexander the Great is a visceral experience: (gasp!) Could Aristotle, or even the young conqueror,
have once held this actual coin in his hand?

... AND THE ICON IN A CORNER OF MY BEDROOM

On September 21, 1978, sixteen days after my son Harry's twentieth birthday,
he was struck down with an undetected heart disorder, long-QT syndrome, which can kill young people
by disrupting their heartbeat. (The gene that can make a young person's
heart stop beating for no apparent reason was discovered in 1998.) Rather than beating, Harry's heart started
quivering, unable to pump blood efficiently, causing him to collapse,
unconscious, and he died before he could be quickly treated with an electric shock to get his brave heart
working correctly again. Harry, whose name means "Joy" in Greek,
was a powerfully strong young man, a living incarnation of the great Herakles: a warrior on the athletic field,
with a love for living, a probing mind, and a heart of gold. As my son was nearing 20,
my wife, Rosie, wanted him to have something special, something perfect. So she took Harry to be fitted
for a pluperfect Roland Meledandri custom-made suit. Weeks later, Rosie, my younger son,
Luke, and I buried Harry Joe in his new suit. It sears my soul. The photograph shown here is placed on a
Saint George icon in my bedroom, given to me by my parents when I was married,
at age 20. Since losing the joy of our life, Rosie, my son Luke, and I have gone on, living, working, remembering,
and laughing. As Abraham Lincoln said after the death of his son Willie:
"If I did not engage in levity, my heart would break."

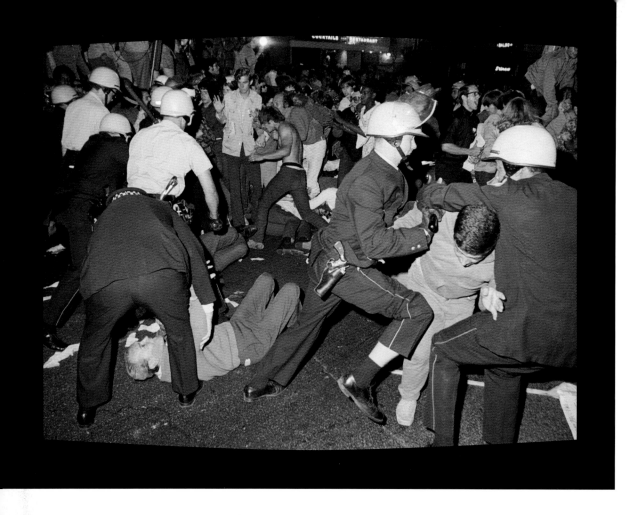

59. "THE WHOLE WORLD IS WATCHING! THE WHOLE WORLD IS WATCHING!" (AND SO WAS I.)

In 1968, America was a land reeling from the
shock of the recent assassinations of Martin Luther King, Jr.
and Senator Robert Kennedy and the ongoing
war in Vietnam. A debilitated and despondent President
Lyndon Johnson had shocked the world by
announcing that he would not seek a second term,
lobbing his Vietnam hot potato to a succeeding
president. Antiwar demonstrations, urban riots, and
militant student protests were the background
of the '68 Democratic National Convention, as the whole
world watched on their TVs. From all parts of
the nation, young Americans gathered to protest the
state of the nation. The television coverage
of bitter wrangling in the International Amphitheatre,
intercut with Chicago cops splitting open the
heads of students, hippies and yippies as they chanted
"The whole world is watching," laced together
with film footage of GIs in mortal combat in Nam,
traumatized the nation.

A PORTRAIT OF CHICAGO AT WAR WITH THE YOUTH OF AMERICA. (WITH A PHOTO TAKEN IN NEW YORK.)

Only *Esquire* editor Harold Hayes had the guts and the nuts
to assemble this stunning team of underground
intellectual mavericks to go to the fateful 1968 Democratic
convention in Chicago, and report to the nation.
Photographer Carl Fischer had been sent by Hayes to take photos
of the unholy quartet at the convention to accompany
their articles. But watching the ensuing carnage, I knew
Esquire had to run a dramatic "pictorial Zola" on its
next cover, as America was being transformed into a police state
before our very eyes. But we had to deliver a finished
cover within days! I came up with the idea of a Christlike
image of a jeans-clad student, lying in a bloody gutter
at the feet of the wildest literary men of the time: Jean Genet
(the French high priest of decadence), William Burroughs
(the Beat Generation expatriate spokesman), Terry Southern
(the irreverent *Candy* man), and John Sack
(the antiwar war correspondent). I called Carl and described
the shot, but when he tried to stage it, the paranoid
Chicago cops carted him off in a paddy wagon, releasing him
later that night. Getting the photo in the volatile Chicago
streets seemed impossible, so I had Fischer and *Esquire's*
reporting team jet back to New York, and we
grabbed this dynamic image on the safe streets of Harlem.
P.S. The convention went on to nominate the shell of
Hubert Humphrey, who had shrunk to being a
yes-man to his president. HHH fell victim to the bitterness
of the fray, ran an inept campaign, and got beat by
Tricky Dick's "secret plan" that promised to bring our boys
home by Christmas. 27,000 more dead GIs later,
home they came to an embittered America.

NOVEMBER 1968
PRICE 5

Esquire

**Jean Genet,
William Burroughs,
Terry Southern,
John Sack,
– Chicago!**

see page 83

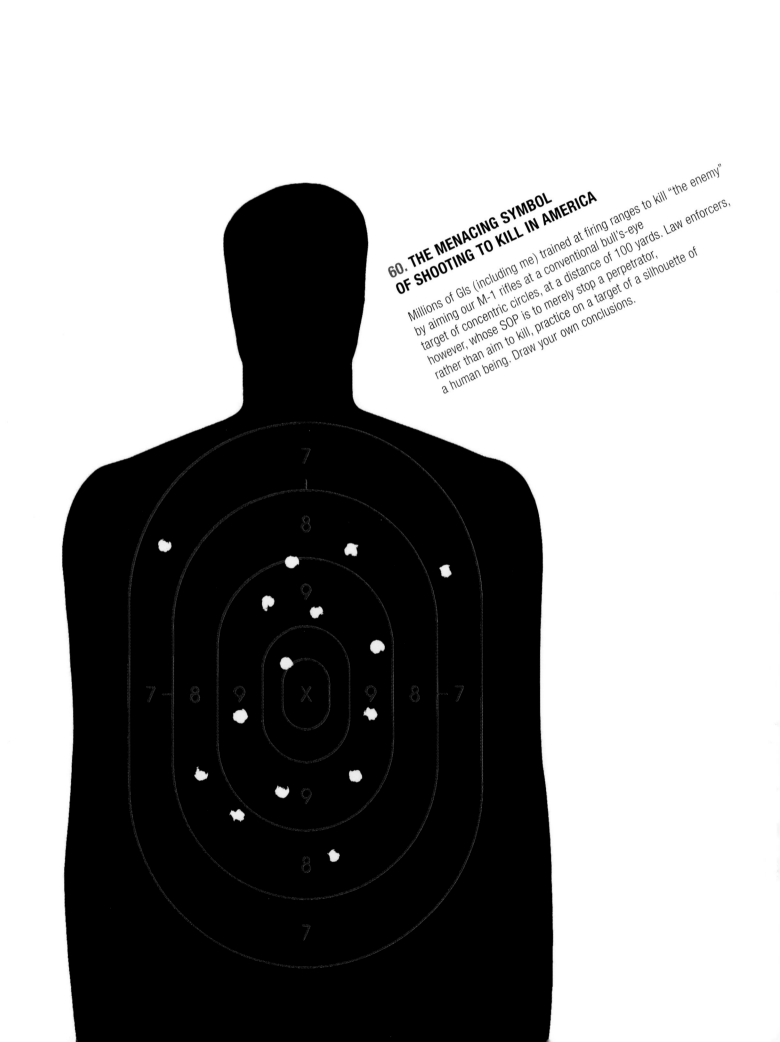

60. THE MENACING SYMBOL OF SHOOTING TO KILL IN AMERICA

Millions of GIs (including me) trained at firing ranges to kill "the enemy" by aiming our M-1 rifles at a conventional bull's-eye target of concentric circles, at a distance of 100 yards. Law enforcers, however, whose SOP is to merely stop a perpetrator, rather than aim to kill, practice on a target of a silhouette of a human being. Draw your own conclusions.

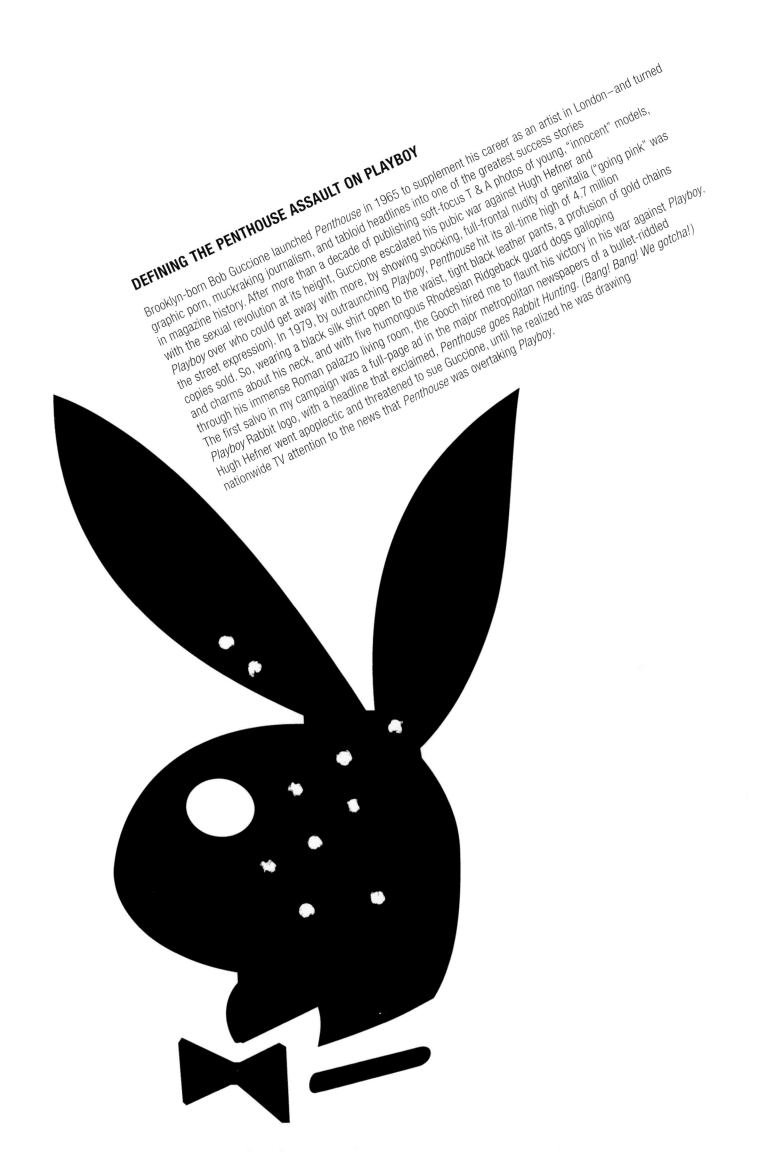

DEFINING THE PENTHOUSE ASSAULT ON PLAYBOY

Brooklyn-born Bob Guccione launched *Penthouse* in 1965 to supplement his career as an artist in London—and turned graphic porn, muckraking journalism, and tabloid headlines into one of the greatest success stories in magazine history. After more than a decade of publishing soft-focus T & A photos of young, "innocent" models, with the sexual revolution at its height, Guccione escalated his pubic war against Hugh Hefner and *Playboy* over who could get away with more, by showing shocking, full-frontal nudity of genitalia ("going pink" was the street expression). In 1979, by outraunching *Playboy*, *Penthouse* hit its all-time high of 4.7 million copies sold. So, wearing a black silk shirt open to the waist, tight black leather pants, a profusion of gold chains and charms about his neck, and with five humongous Rhodesian Ridgeback guard dogs galloping through his immense Roman palazzo living room, the Gooch hired me to flaunt his victory in his war against *Playboy*. The first salvo in my campaign was a full-page ad in the major metropolitan newspapers of a bullet-riddled *Playboy* Rabbit logo, with a headline that exclaimed, *Penthouse goes Rabbit Hunting. (Bang! Bang! We gotcha!)* Hugh Hefner went apoplectic and threatened to sue Guccione, until he realized he was drawing nationwide TV attention to the news that *Penthouse* was overtaking *Playboy*.

61. THE CROSS-EYED KABUKI ACTOR...

Japanese prints were an inspiration to artists such as Manet and Toulouse-Lautrec and were the favorite genre of the pioneering architect Frank Lloyd Wright (who actually supplemented his income by buying them in Japan and selling them in America). The woodblock-print (ukiyo-e) designer Utagawa Kuniyoshi (1797-1861) dominated the nineteenth century alongside the illustrious names of Hokusai, Hiroshige and Kunisada. Kuniyoshi portrayed the historic heroes (and ghosts) of Japan's warrior past and created rollicking images of hundreds of kabuki actors (who, at least to our Western eyes, deliciously overacted). This impressive portrait is a death (or memorial) print of the renowned actor Nakamura Utaemon IV, depicted in the role of a coarse-featured leader of a clan that dressed like monks, sporting shaved heads and magnificently crossed eyes.

...AND THE DOUBLE-CROSSING HEAVYWEIGHT CHAMPION.

For the legendary "Thrilla in Manila" (Sept. 30, 1975), the grudge rubber match between Muhammad Ali and Smokin' Joe Frazier, I created a fight program to be given to the hundreds of thousands of people who would attend closed-circuit locations in America. My old *Esquire* chum Harold Hayes and I included hilarious "interviews" with Muhammad and Joe dissin' each other, and our fight program became an instant collector's item. Down the side of each page of one spread I showed eight small photos of the fighters—Ali on the left, Frazier on the right—reacting to a word I fired at them..."Love!" (click), "Fear!" (click), "Surprise!" (click). Ali's mug shots were hysterical. Joe's reaction was identical for each word—a deadpan. My last command to Muhammad was, "Gimme the look you gave George Foreman when you quit playing possum and came off the rope-a-dope and knocked him on his ass!" Ali thought for a second, screwed up his face, crossed his eyes, and screamed, "The double-cross!"

62. THE LOWLY ROAD SIGN...

When you're smokin' down the road and a highway symbol looms on the right,
it gets your attention. It could be a fork in the road, a slippery when wet
warning, an order to reduce speed, a dangerous curve ahead—all a matter of life
or death. (Multimillion-dollar outdoor posters crave that kind of attention
and respect!) In the time it takes to spot it and absorb it, a highway message must
communicate a universally understood symbol in a nanosecond.
It doesn't have to be pretty—but it certainly has to be an eye-opener!

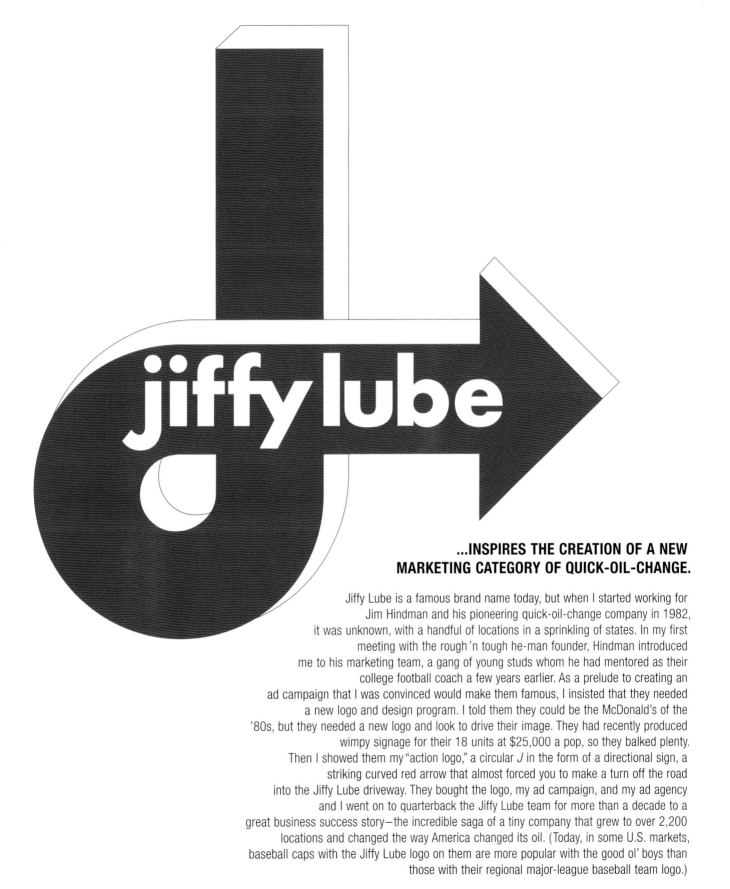

...INSPIRES THE CREATION OF A NEW MARKETING CATEGORY OF QUICK-OIL-CHANGE.

Jiffy Lube is a famous brand name today, but when I started working for
Jim Hindman and his pioneering quick-oil-change company in 1982,
it was unknown, with a handful of locations in a sprinkling of states. In my first
meeting with the rough 'n tough he-man founder, Hindman introduced
me to his marketing team, a gang of young studs whom he had mentored as their
college football coach a few years earlier. As a prelude to creating an
ad campaign that I was convinced would make them famous, I insisted that they needed
a new logo and design program. I told them they could be the McDonald's of the
'80s, but they needed a new logo and look to drive their image. They had recently produced
wimpy signage for their 18 units at $25,000 a pop, so they balked plenty.
Then I showed them my "action logo," a circular *J* in the form of a directional sign, a
striking curved red arrow that almost forced you to make a turn off the road
into the Jiffy Lube driveway. They bought the logo, my ad campaign, and my ad agency
and I went on to quarterback the Jiffy Lube team for more than a decade to a
great business success story—the incredible saga of a tiny company that grew to over 2,200
locations and changed the way America changed its oil. (Today, in some U.S. markets,
baseball caps with the Jiffy Lube logo on them are more popular with the good ol' boys than
those with their regional major-league baseball team logo.)

63. THE MOUTH-WATERING ROLLING STONES LOGO...

In the tidal wave of the Brit Invasion, the Rolling Stones washed up on our shores as an opposite polarity of pop sensibility to the Beatles. The Fab Four were the lovable good guys and the Stones, nasty and leering, plumbed the Dionysian dark side, with a logo that said it all. The lapping wet tongue and Jaggerish lips logo is the slickest rock group symbol ever. The wicked opposite of the Beatles was formed in 1962 by Mick Jagger, Brian Jones, and Brian Jones, but the graphic, first produced by Ruby Mazur, an album-cover artist, came out in 1972 as an illustration for the Stones' *Tumbling Dice* single. *Billboard* magazine has attributed the original logo to artist John Pasche, followed by a version by Mazur with two strange eyes peering out just above the wet lips, a sort of stylized representation of the face of Mick Jagger, who has always fronted the band. The most commonly seen version of the logo, and the one used most by the band, features only lips, a tongue, and two eyes in a bold, flat graphic design. Certainly, the logo is a memorable one, and it helped the Stones become one of the world's most recognized and enduring bands.

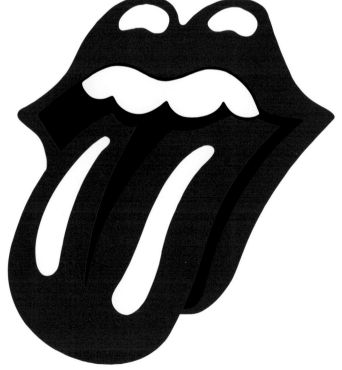

**...BRINGS THE STILLBORN MTV TO LIFE WHEN I SHOWED IT
LEAPING OUT OF THEIR LOGO IN MY 1982 I WANT MY MTV CAMPAIGN.**

After a zero first year of operation, MTV, launched in 1981, was an abject failure. The whiz kids at at the cable-TV network asked me to do an emergency "trade" campaign to change the minds of the cable operators of America, most of whom believed kids who rocked were into sex and drugs. The music companies, rock stars, and advertisers considered MTV a joke. But I had a better idea, the Big Idea: to go right to the rock-loving audience and shove MTV down the rock-hating cable operators' throats. It was guerrilla warfare at its nastiest. First, I introduced my changeable logo concept by shoving tongues, rocket ships, rock performers—the kitchen sink—into MTV's logo, transforming it into an action symbol. The very first logo-transforming symbol I choose was Mick Jaggers' kisser logo licking America's rock fans. Then I created a TV spot to inspire rock fans to call and yell, *I want my MTV!* at their cable operators. Overnight, the cable companies called Warner Amex and begged them to stop running the spots because they were drowning in a deluge of phone calls. America's cable honchos surrendered and put MTV on the air. But it couldn't have happened if the climactic moment of my commercial wasn't delivered by a legit rock star. Of the dozens we approached, the only one with the foresight, the moxie, the hubris, and the *lips* was Mick Jagger, who first brayed the industry-transforming words, *I want my MTV!*, to the rock fans of the world. In a matter of weeks, every rock star on the planet pleaded with us to mimic Jagger's plea in my follow-up commercials. Six months after the start of the campaign, *Time* magazine called MTV "the most spectacular pop-culture phenomenon since the advent of cable television—and, arguably, since the invention of the tube itself."

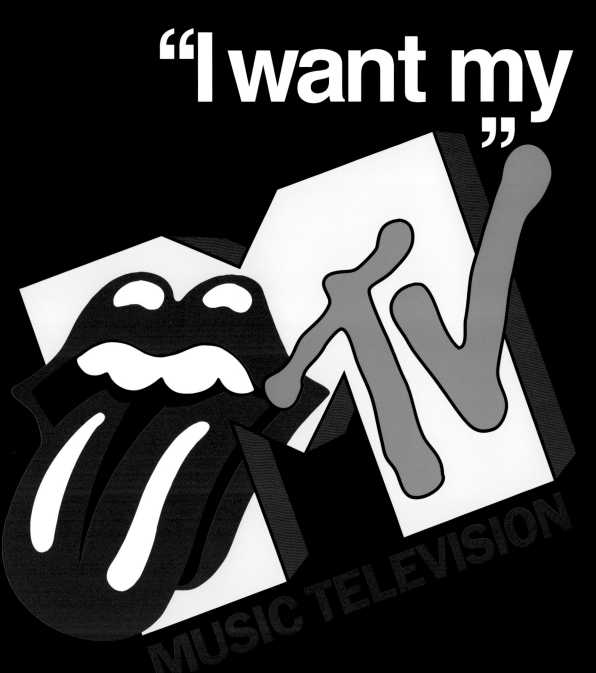

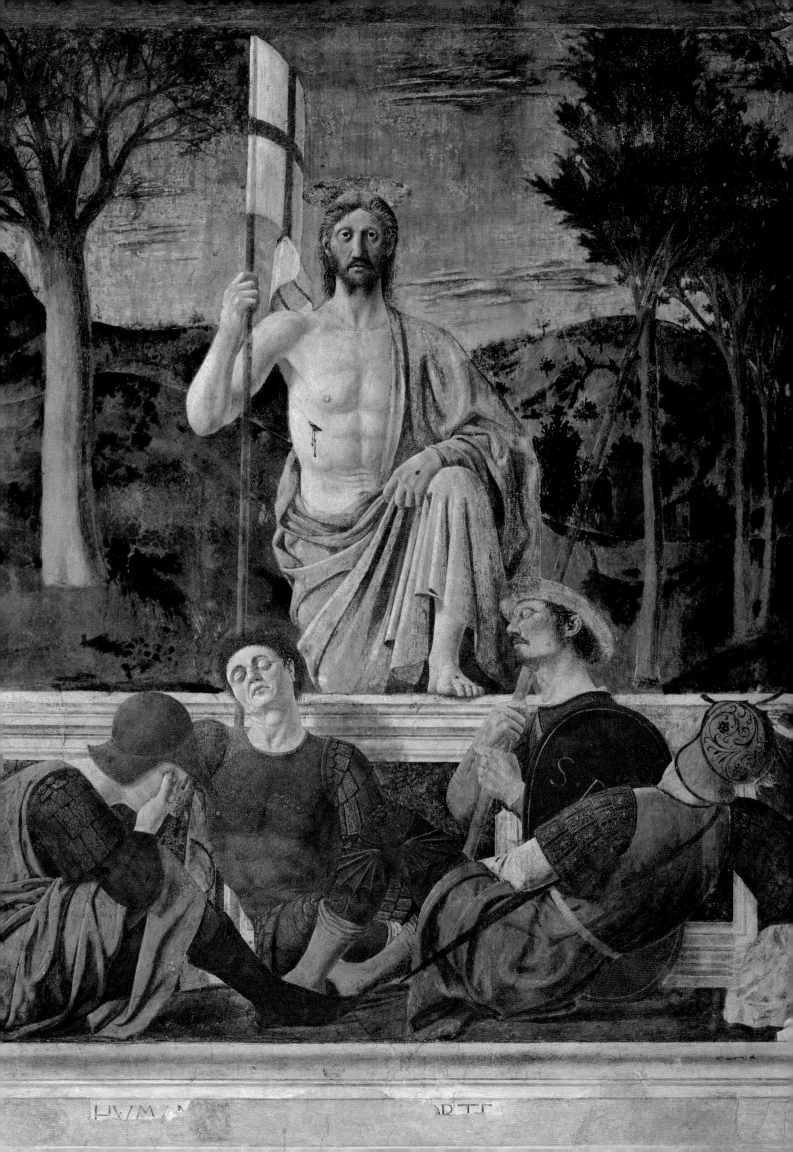

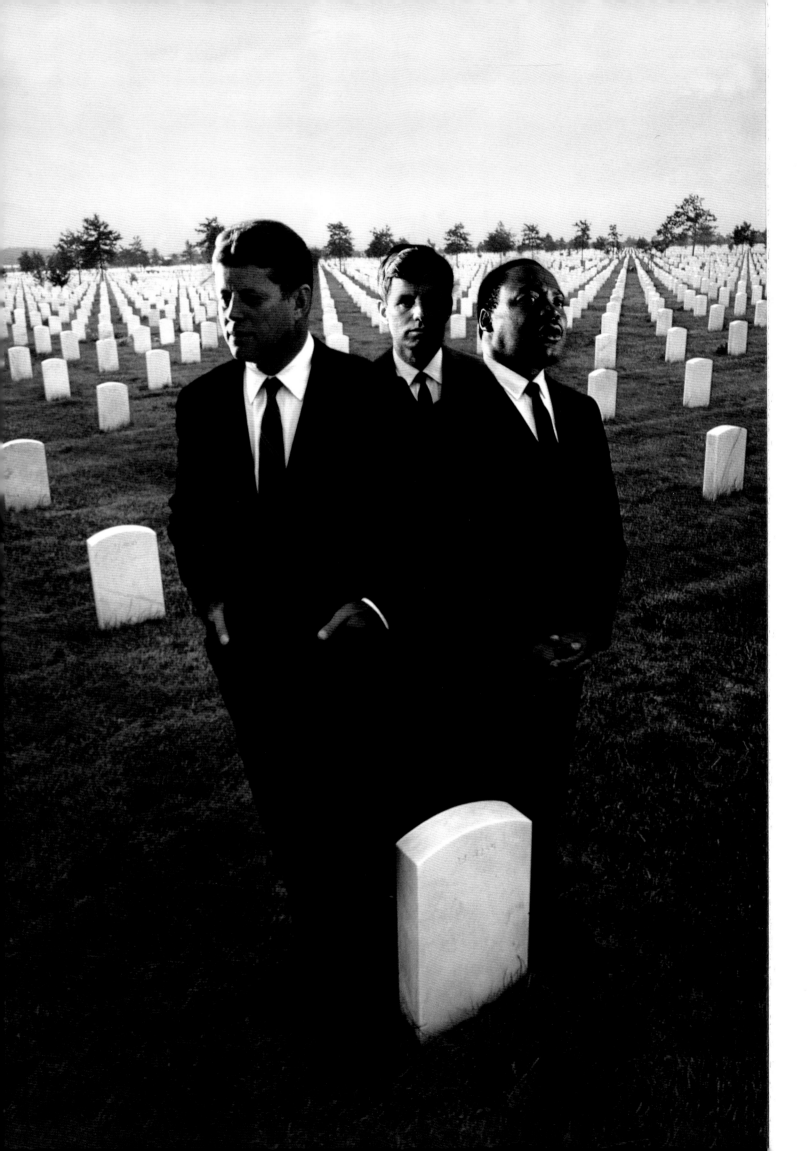

A RESURRECTION OF HOPE
FOR AMERICAN IDEALS.

Piero della Francesca's Easter epiphany,
The Resurrection of Christ, shouted across
time to me after America's final,
excruciating loss of Senator Robert F. Kennedy,
a man destined for greatness. (Working
closely with him in creating the ad campaign that
had helped him win a Senate seat in 1964,
a year after the assassination of his brother, I gained
an intense belief in him.) In 1968, for the
front cover of *Esquire*'s definitive 35th Anniversary
issue, I created a hagiographic fantasy of
the resurrection of our nation's three assassinated
leaders during the shockingly violent '60s.
As they hauntingly rise from the hallowed ground
of Arlington National Cemetery, we pay
homage to the two murdered Kennedy brothers
and Dr. Martin Luther King Jr. in a
dreamlike epitaph on the destruction of American
goodness. If my apotheosis elevates our
martyred leaders to divine status, so be it. It was
a time when America was put on the cross
and crucified, and we await its resurrection.

This Esquire *cover, along with dozens of others,
were installed in the permanent collection
of the Museum of Modern Art in New York City,
in 2008.*

64. PIERO DELLA FRANCESCA BRINGS CHRIST TO LIFE.

In the foreground of a morning sky, as a group of Roman soldiers guarding his sarcophagus sleeps, Christ rises in the red shroud of his entombment, reminiscent of an ancient hero. Ordinarily, Christ is depicted with a white shroud, but Piero interprets Jesus as having triumphed over his oppressors, and it is their blood that made his garment red. (Possibly, too, the royal color of red that we see signifies Christ the King, whose victorious reign over death and sin begins with his resurrection.) Blood drips from the wound in his right side, and the wounds of his hands and foot are marked, but rather as signs of victory than as a stigmata of sorrow. The artist's tempera and fresco masterpiece is not intended to stimulate our grief for Christ's sufferings on the cross but to excite our rejoicing in his triumph over death. With poetic realism, the great Italian Renaissance master shows Christ restored to the full majesty of his humanity. But now he is, at once, God and man. Created in 1458, time has destroyed some of the luster of the effects della Francesca intended, but it has not impaired the intensity of a victorious Resurrection, for some connoisseurs the greatest work of art in the world.

65. ANDY WARHOL'S BRILLO BOX GIVES BIRTH TO THE POP ART MOVEMENT.

Ever since the first cave painting, artists have sought to represent reality. From era to era, these realities have changed, never more so than in the twentieth century. But by the mid-1950s, most of the Western avant-garde was in the thrall of Abstract Expressionism which supposedly captured "emotional states in art." Reacting to its domination of the art world were a number of artists who believed that Ab-Ex had closed as many doors as it had opened, and they bemoaned the absence of any tangible reality in the work. Thus, Robert Rauschenberg and Jasper Johns reintroduced the figurative to art in a new and vivid way. Their mantle was taken up most conspicuously by the most famous art magpie of all, Andy Warhol. Today, he is the artist most closely identified with Pop Art. I first met the bewigged one (before he donned one) in the '50s when he was hustling his drawings and illustrations at Madison Avenue ad agencies. A product of the ad world, in 1960, he started painting free-hand images he gleaned from comic strips, advertisements, and products such as Coca-Cola bottles, Campbell's Soup cans, and the mundane, godawful-looking Brillo box. By 1962, he had adapted a silk-screen process that transformed photographs of subjects, ranging from celebrities and flowers to disasters such as car crashes and riots (interspersing those objects from the real world amid painting reminiscent of the Abstract Expressionists), with a gang of helpers rolling them off an assembly line at the New York studio he quite correctly named the Factory. But the most emblematic images of the Pop era were Andy's soup can and the Brillo box.

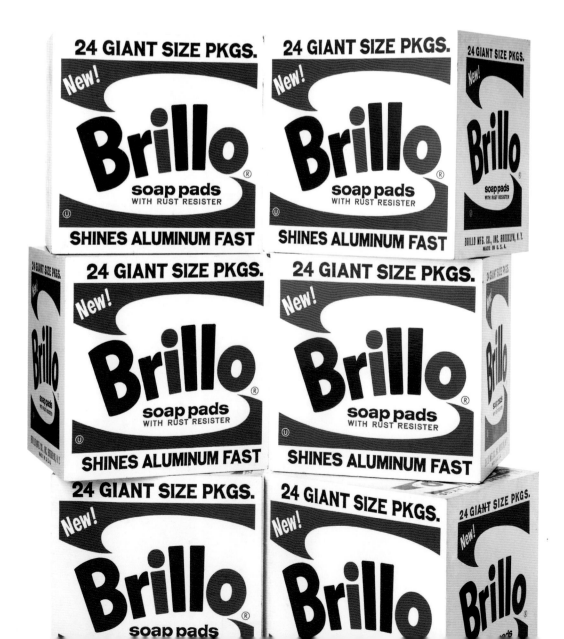

AViiON 7000 8000

Data General
Life just got a whole lot easier!

WE FIT 117 MIPS OF MAINFRAME POWER IN A PIZZA BOX! 1·800·DATA GEN (WE DELIVER)

- ✓ 117 MIPS
- ✓ STARTS UNDER $100,000
- ✓ AVAILABLE NOW!

MY TAKEOUT PIZZA BOX BRINGS A HIGH-TECH COMPANY BACK TO LIFE.

Back in 1982, advertising campaigns for business computers were mumbo jumbo that only "techie geeks" could understand. A struggling Data General asked me to create a campaign for its new, breakthrough, compact AViiON computer system. It had the power of a mainframe and could process tens of millions of bits of information, while needing far less space than conventional computers. It was powerful enough to compete aggressively against IBM and the rest of the big boys.

The first sight of AViiON's flat shape and surprisingly small size looked disarmingly un-computerlike. Not only did it *look* like a pizza box, I also soon found out it could *fit* into a pizza box! So I grabbed this common, universal image and cooked up a pizza-box campaign. I designed a box that became the selling focus for Data General. (The company's circular logo was actually shaped like a pizza pie!) The headline on the full page ads in the *New York Times* and the *Wall Street Journal* said: *Who just fit Mainframe Power in a Pizza Box? Data General presents the AViiON systems. (We deliver.)* The *Times*' ad column headlined the story on my campaign as a "Tasty Approach to High Tech." Carried away by my imagery, the *Times* went on to describe my pizza box with a flash of takeout passion: "Inside, it turns out, is a $150,000 computer, without anchovies." The day the first ad ran, Data General's stock leaped from two dollars to twenty-two dollars! And sales increased 600 percent, a testimony to what I've always called "the power of the (seemingly) outrageous idea!" (These days, they call getting an unusual idea "thinking outside the box." But for Data General, the big idea *was* a box!)

66. WISECRACKING BROTHERS LEN AND SAM ROSEN (AND FAMOUS BRO'S THROUGHOUT HISTORY) INSPIRE ME TO CREATE AN AD CAMPAIGN FOR THE BEST DELI WEST OF BROADWAY.

In 1980, the Rosen Brothers called me from their Brothers Deli in Minneapolis and begged me to visit and judge for myself if they weren't worthy of a Noo Yawk deli–style TV campaign. One bite of their smoked salmon, cream cheese, and onion on a Brothers Deli bagel, and I knew I was hooked.

Lever Brothers

Henry and Maurice Richard
Don and Dave Maloney
Mark and Marty Howe
Pete and Frank Mahavolich
Lynn and Muzz Patrick
Ken and Dave Dryden
Don and Bobby Murdoch
Dennis and Jean Potvin

James, Elliot, John and Franklin Jr.

Emperor Titus (78-81 AD)

Emperor Domitian (79-86 AD)

MORGAN'S ALUMINUM GLASS

Step Brothers

Donnie and Bobby Allison
Al and Bobby Unser
Richard and Maurice Petty

Raoul and Fidel Castro

Brothers Karamazov

CELEBRITY BROTHERS ALL OVER THE WORLD
RECOMMEND THE BROTHERS DELI IN MINNEAPOLIS.

One of the items on the menu I created for Len and Sam Rosen read: *If you don't pick the $5.95 Rockefeller Brothers Prime Ribs Combination, it's your own Vault!* Oh, Brothers! Groucho and Harpo impersonators slayed'em on TV and my brotherly menus, starring Huey, Dewey & Louie, the Dorsey Brothers, the Ringling Brothers, Frank & Jesse James, the Flying Wallenda Brothers (even Dr. Joyce Brothers), were being ripped off by hundreds of drooling customers. The Brothers Deli became a hot spot in the Twin Cities and the talk of the Midwest. Brothers Len and Sam kept reprinting the menus as they happily dished out the best deli west of Broadway.

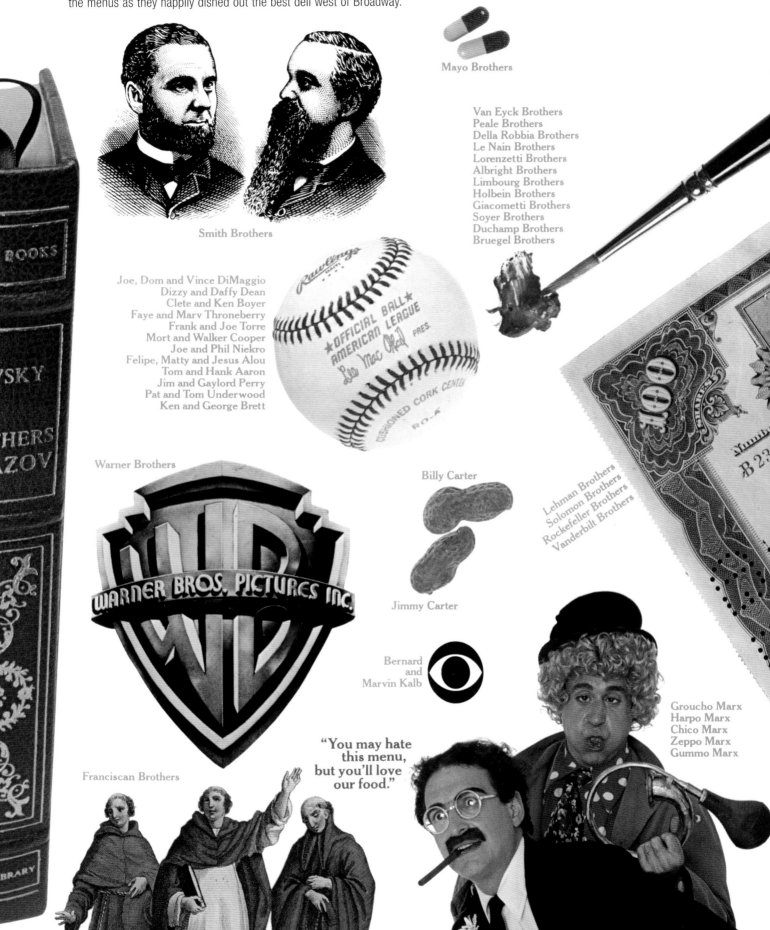

Mayo Brothers

Smith Brothers

Van Eyck Brothers
Peale Brothers
Della Robbia Brothers
Le Nain Brothers
Lorenzetti Brothers
Albright Brothers
Limbourg Brothers
Holbein Brothers
Giacometti Brothers
Soyer Brothers
Duchamp Brothers
Bruegel Brothers

Joe, Dom and Vince DiMaggio
Dizzy and Daffy Dean
Clete and Ken Boyer
Faye and Marv Throneberry
Frank and Joe Torre
Mort and Walker Cooper
Joe and Phil Niekro
Felipe, Matty and Jesus Alou
Tom and Hank Aaron
Jim and Gaylord Perry
Pat and Tom Underwood
Ken and George Brett

Warner Brothers

Billy Carter

Lehman Brothers
Solomon Brothers
Rockefeller Brothers
Vanderbilt Brothers

Jimmy Carter

Bernard
and
Marvin Kalb

Groucho Marx
Harpo Marx
Chico Marx
Zeppo Marx
Gummo Marx

"You may hate this menu, but you'll love our food."

Franciscan Brothers

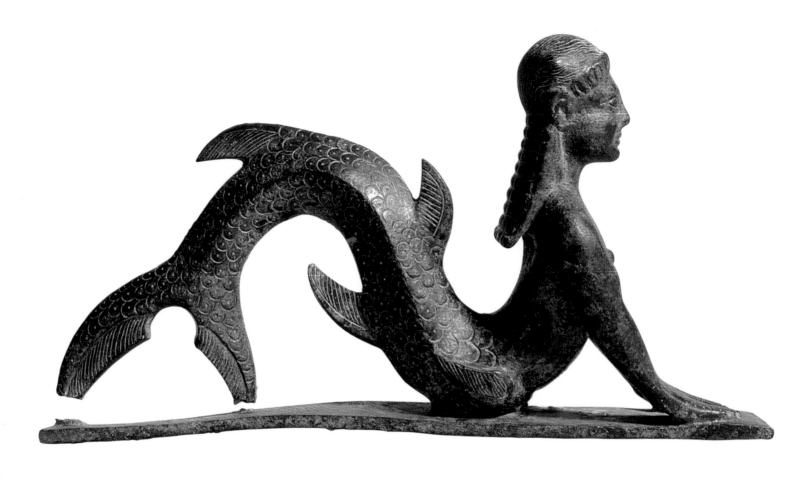

67. THE BODY OF A WOMAN AND THE TAIL OF A FISH

Legendary beings, half-human, half-fish, mermaids inhabit the sea. These lovely, cold-fish ladies came to the surface in ancient mythology and in European folklore. As described in these legends, Mermaids, called Sirens, are natural beings, who, like fairies, have magical and prophetic powers. Though long-lived, they are mortal but have no souls. Though sometimes kindly, mermaids are usually characterized as dangerous to man, bringing misfortune, and if offended, causing floods or other disasters. To see one on a voyage is an omen of shipwreck. Pictured is a sinuous Etruscan bronze of a mermaid fished out of Homer's Aegean Sea. In his epic poem the *Odyssey*, Homer recounts the arduous wanderings of Odysseus during his ten-year voyage home to Ithaca after the Trojan War. Circe, the queenly goddess, lays the course for the courageous warrior-king in literature's greatest evocation of man's journey through life, starting with a depiction of the Sirens as enchantresses of the sea, whose songs can tempt sailors to their doom:

First you will raise the island of the Sirens,
those creatures who spellbind any man alive,
whoever comes their way.
Whoever draws too close,
off guard, and catches the Sirens' voices in the air —
no sailing home for him, no wife rising to meet him,
no happy children beaming at their father's face.
The high, thrilling song of the Sirens will transfix him,
lolling there in their meadow, round them heaps of corpses,
rotting away, rags of skin shriveling on their bones...
Race past that coast! Soften some beeswax
and stop your shipmates' ears so none can hear,
none of the crew, but if you are bent on hearing,
have them tie you hand and foot in the swift ship,
so you can hear the Sirens' song to your heart's content.
But if you plead, commanding your men to set you free,
then they must lash you faster, rope on rope.

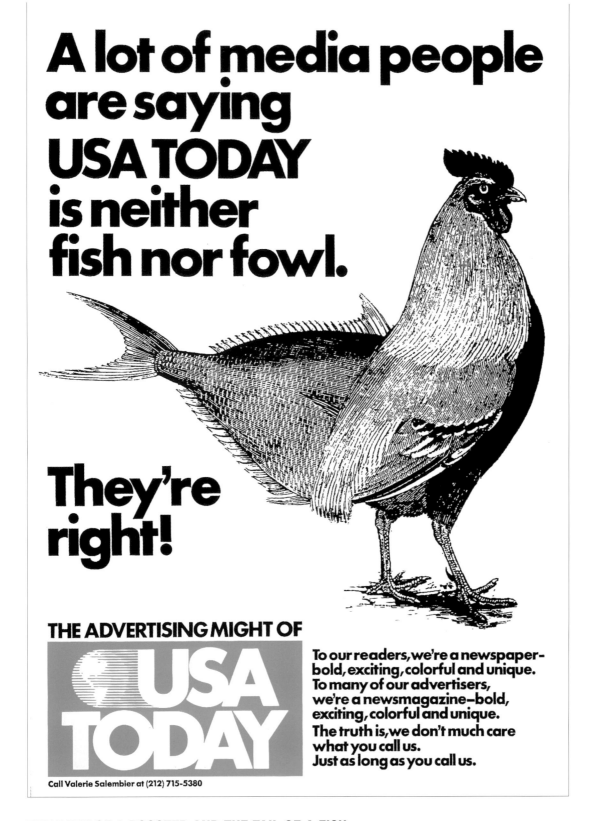

THE BODY OF A ROOSTER AND THE TAIL OF A FISH

One of the most important innovations in modern journalism was the creation in 1982 of the first national newspaper, *USA Today*. It was the brainchild of Gannett's gutsy chairman, Al Neuharth, and readers took to it immediately, but advertisers were staying away. In his biography, *Confessions of an S.O.B.* (Doubleday, 1989), Neuharth recalls the turning point for his breakthrough newspaper: "Our President Cathie Black met with Lois, and he had a simple message to her: 'Your product is better than your competitors,' he said, 'but you're not communicating that to the advertiser. The truth is, your advertising sucks.' We arranged a competition for the *USA Today* account. First Young & Rubicam made its presentation. Then George Lois came into a room of my poker-faced Gannett executives—all of them skeptical journalists—to hype his ideas. One ad tackled the question of *USA Today*'s identity head-on. Was it a newspaper or a newsmagazine? The ad showed a drawing of a creature that had a body of a rooster but the tail of a fish. *'A lot of media people are saying USA Today is neither fish nor fowl,'* his copy said. *'The truth is...we don't care what you call us. Just as long as you call us.'* I liked Lois' bright new approach. But it left us with a dilemma—it wasn't easy for us to ditch the country's largest ad agency. I asked Lois what people would say if we did that. 'They'd probably say you're finally getting your heads screwed on straight,' Lois replied. 'You're doing pussy advertising now. You ought to be doing triumphant fucking advertising.' The man spoke my language. I gave Lois part of my advertising—the part aimed at the trade press. It worked. *USA Today*'s advertising lineage took off. Within a short time, Lois had won the entire *USA Today* and Gannett account. And *USA Today* became the most successful newspaper in the nation." And that's no fish story.

68. EDVARD MUNCH HEARS AN AGONIZING SCREAM.

Few images in the history of art are as famous as Munch's 1893 painting *The Scream* (I call it "The Museum Scream") an image that sends a shiver up your spine and makes your hair stand on end. At the top of another version of the same subject, Munch, a neurotic Norwegian, scribbled, "Can only have been painted by a madman!" *The Scream* is autobiographical, an iconic expressionist visual based on Munch's actual experience of a scream he believed he heard, piercing through the air while on a walk near Oslo, after his two companions, seen in the background, had left him. Art historians' consensus has been that the agonizing sound was heard at a time when his mind was in an abnormal state. Recently however, astronomers at Texas State University have stated that they believe *The Scream* was the direct consequence of a cataclysm half a world away from Norway: the volcanic explosion on the Indonesian island of Krakatoa in 1883, which generated tsunamis that killed 36,417 people. The eruption lofted huge amounts of dust and gasses high into the atmosphere, where they remained airborne and for several months spread over vast parts of the globe, generating "twilight glows" with horizons suddenly flaming into brilliant scarlet, which crimsoned sky and clouds. The astronomers suggest that Munch witnessed that phenomenon which drove him, a decade later, to paint his cowering, grotesque figure, his mouth and eyes wide open, his hands clasped to his ears, as he viewed what he seems to have thought was hallucinatory. Munch, in fact, described the event with these words: "All at once the sky became blood-red... clouds like blood and tongues of fire hung over the blue-black fjord and the city...and I stood alone, trembling with anxiety... I felt a great unending scream piercing through nature."

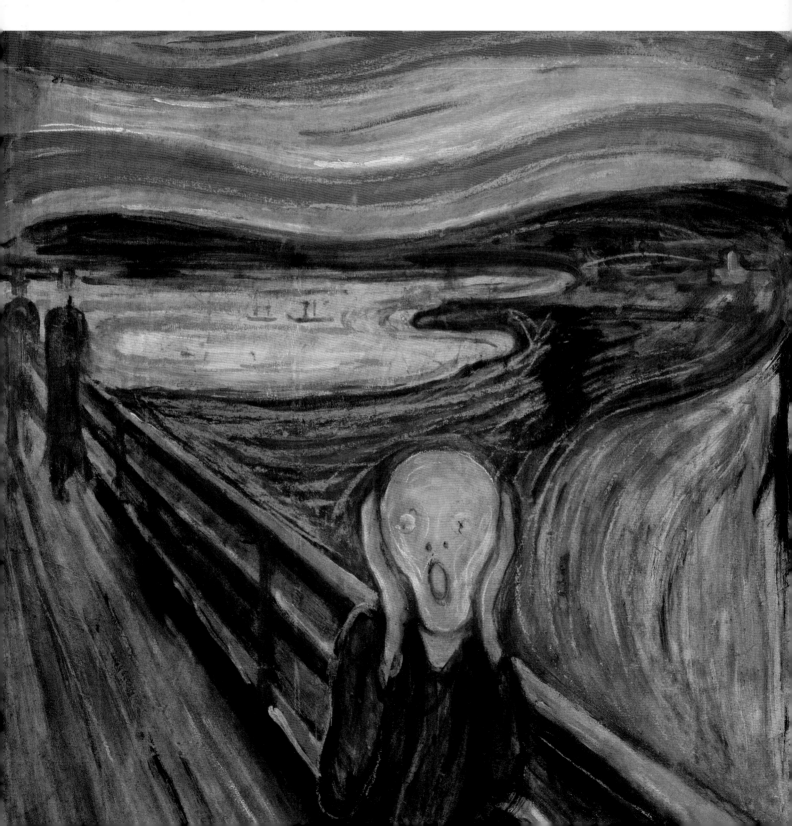

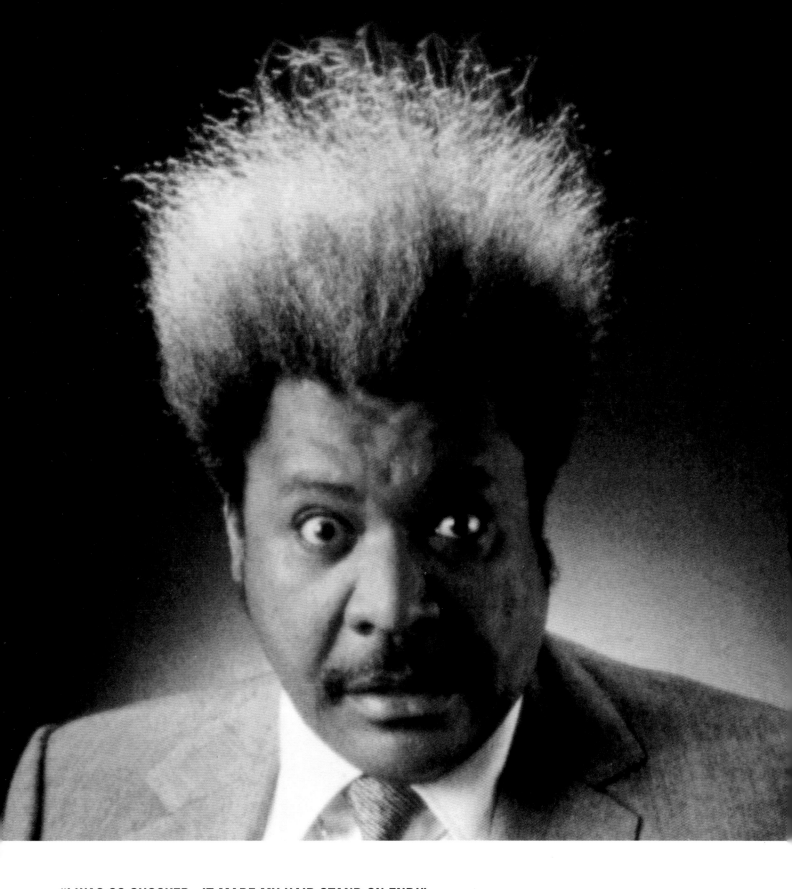

"I WAS SO SHOCKED — IT MADE MY HAIR STAND ON END!"

Don King, the most bombastic wheeler-dealer of our time, discovers Circuit City offers him
the lowest prices in town — without haggling! With the TV camera on an extreme
close-up of the flamboyant boxing promoter, King belts out his message of low prices for
electronic products at Circuit City. And when he delivers his punch line "It made
my hair stand on end," the camera widens to reveal his signature hairdo, seemingly springing
up in front of our eyes. Edvard Munch's haunting image has been more trivialized by our
popular culture than the *Mona Lisa*, than even Jackson Pollock's drip-action paintings,
and I plead guilty to depicting Don King's fright-hairdo as a reaction to his seemingly seeing
that same Armageddon-like sky and hearing the same agonizing scream that Munch
heard on that hallucinatory Scandinavian night in 1883.

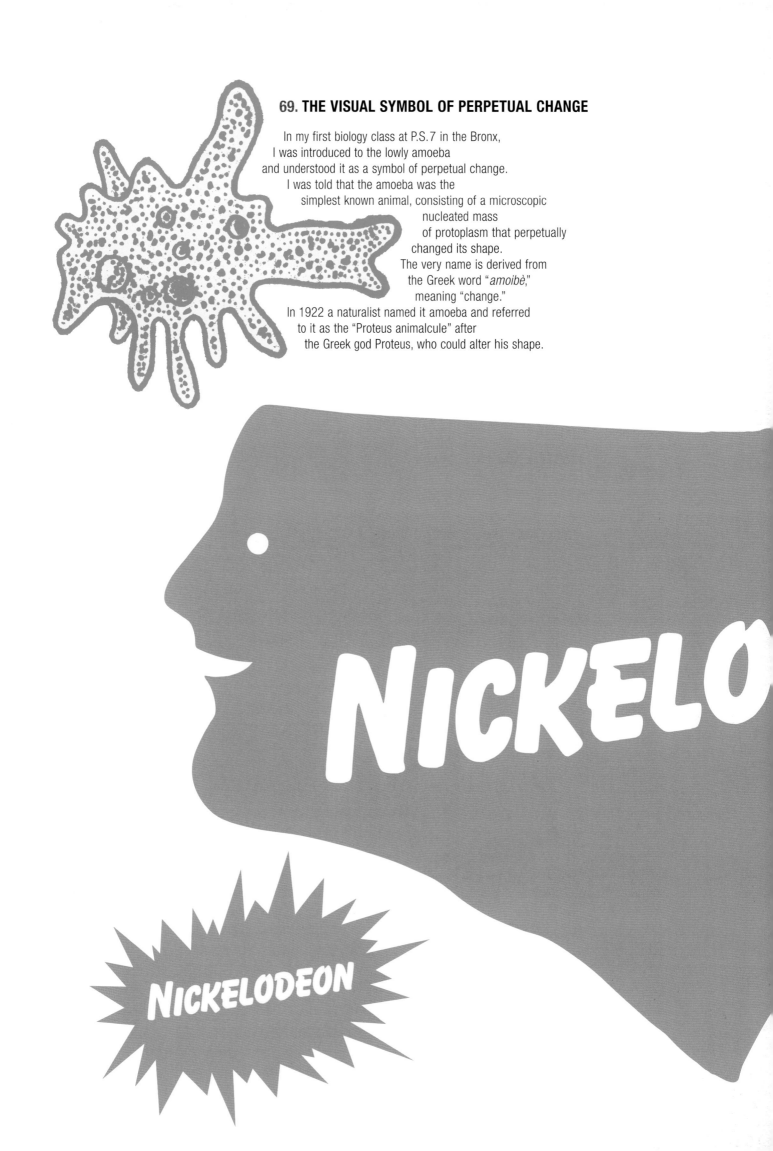

69. THE VISUAL SYMBOL OF PERPETUAL CHANGE

In my first biology class at P.S. 7 in the Bronx,
I was introduced to the lowly amoeba
and understood it as a symbol of perpetual change.
I was told that the amoeba was the
simplest known animal, consisting of a microscopic
nucleated mass
of protoplasm that perpetually
changed its shape.
The very name is derived from
the Greek word "*amoibè,*"
meaning "change."
In 1922 a naturalist named it amoeba and referred
to it as the "Proteus animalcule" after
the Greek god Proteus, who could alter his shape.

NICKELO

NICKELODEON

**INSPIRED BY THE AMOEBA,
THE PERPETUALLY CHANGING
NICKELODEON LOGO!**

In 1984 (going against all conventional advertising
rules of maintaining awareness of a brand),
I created the Nickelodeon logo, which, like a kid's
imagination, could morph into a zillion and
one different versions: a bomb, a guitar, an egg,
a turkey, a smile—even an amoeba.
From that day on, the only way you can tell
a real Nick logo from an imposter is—
the shape is always orange!

NICKELODEON

NICKELODEON

DEON

NICKELODEON

70. WHO IS THE BOWLER-HATTED MAN, TURNED AWAY FROM US, IN RENÉ MAGRITTE'S PAINTINGS?

René Magritte, obsessively and sometimes disturbingly, filled his paintings with men wearing derbies, which were a commonplace part of a gentleman's wardrobe in the 1920s and '30s. In most of his works, the man with the hat and the dark blue overcoat is turned away from us, gazing upon the mysteries of the horizon, creating images and meanings generated by the viewers imagination. Thus Magritte challenged the intellect of each viewer. As much as he denied it, we must believe the bowler-hatted man is the Belgian Surrealist himself, an observer of the world, a modern version of the solitary Romantic poet, contemplative and in tune with the silence of the cosmos. (When he had himself photographed, notably by Duane Michaels, Magritte usually wore the same nondescript overcoat and hat we see in his paintings.) His bowler-hatted every man, unidentifiable, serves as a trademark of Magritte's mythic presence, just as the blond wig has for Andy Warhol. How many men can be instantly identified from behind?

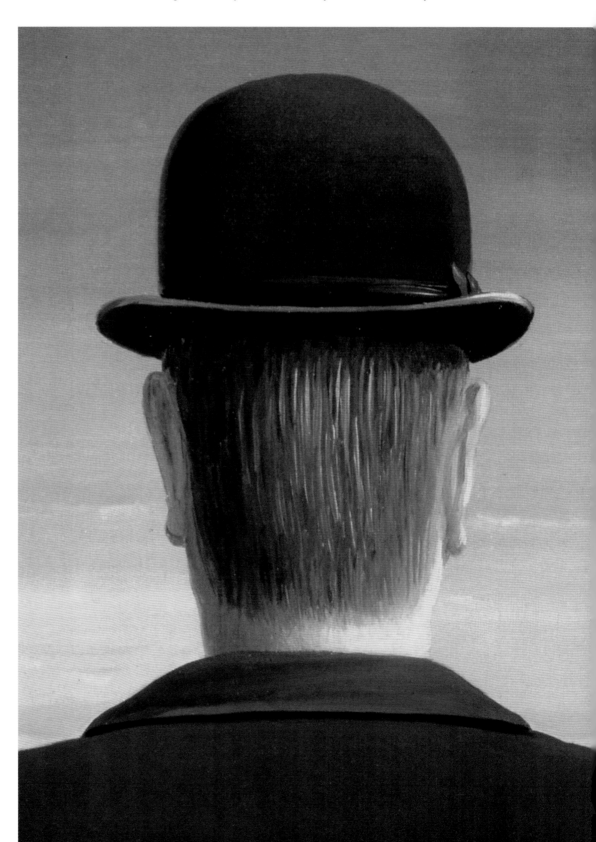

WHOSE MONUMENTAL BALD HEAD,
SEEN FROM BEHIND,
WAS ON THE COVER OF CUISINE MAGAZINE?

James Beard was 6'4" with an impressive bald head (decades before a shiny bald head was
a fashion statement). He stood out in a crowd. In 1983, I knew the coup for any food magazine would
be a "testimonial" from the most important man in the history of American cuisine. Jim was
a pal from my 35 years of designing and advertising for The Four Seasons restaurant, where his talents
and influence flourished. The Dean of American Cuisine declined to give endorsements or do
TV spots for hundreds of products, but he graciously became my celebrity star for Heckers Unbleached
Flour and the introduction of Mouton Cadet, an affordable Baron Philippe de Rothschild wine.
At the print shoot for my foldout *Cuisine* cover, with rollicking good humor, the legendary food giant
displayed the back of his imperial bald head (my homage to Magritte)—and on the foldout,
his monumental puss wolfing down a chicken wing.

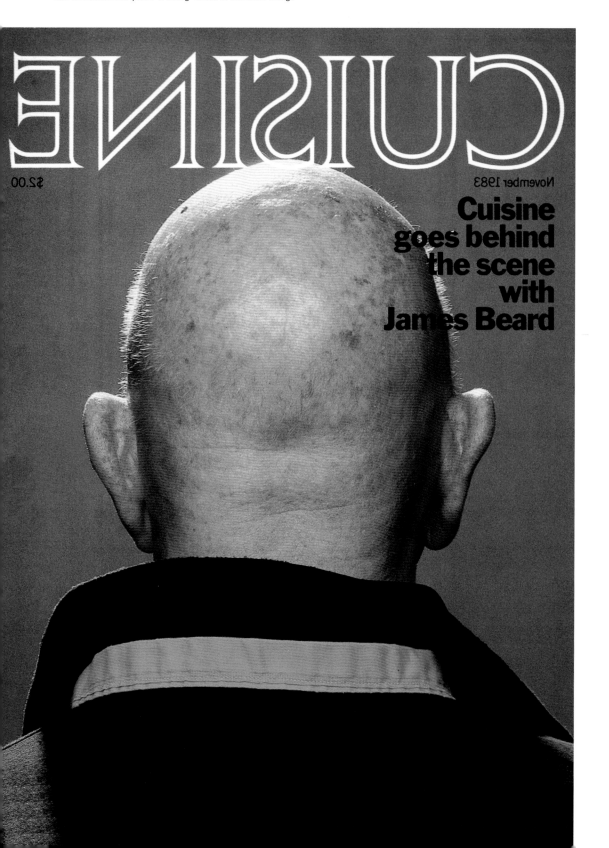

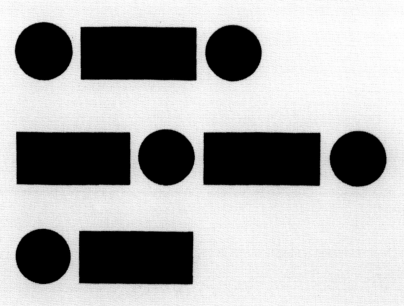

To the executives and management of the Radio Corporation of America:

Messrs. Alexander, Anderson, Baker, Buck, Cahill, Cannon, Carter, Coe, Coffin, Dunlap, Elliott, Engstrom, Folsom, Gorin, Jolliffe, Kayes,

Marek, Mills, Odorizzi, Orth, Sacks, Brig. Gen. Sarnoff, R. Sarnoff, Saxon, Seidel, Teegarden, Tuft, Watts, Weaver, Werner, Williams

Gentlemen: An important message intended expressly for your eyes is now on its way to each one of you by special messenger.

William H. Weintraub & Company, Inc. Advertising 488 Madison Avenue, New York

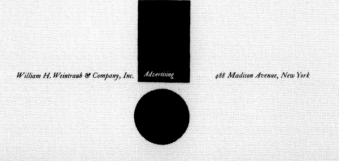

71. PAUL RAND SENDS A MESSAGE:
"DOT DASH DOT. DASH DOT DASH DOT. DOT DASH"
HUH?

The 1940s and early '50s were pioneering designer Paul Rand's most prolific period, and his creations were lightning bolts during my P.S. 7 and High School of Music & Art days of constant visual epiphanies. In 1954, in an attempt to get the attention (and ad account) of General David Sarnoff and his troops at the Radio Corporation of America, Rand created a startling ad for the William H. Weintraub Agency that ran on the back page of the *New York Times:* a bold design of Morse code glyphs which telegraphed the headline "RCA," followed by body copy that said that a message was on the way to each of the 32 execs, asking for their ad business. (Rand knew the General was proficient in Morse code, but his underlings all went to their code books.) The ad made history when the RCA switchboard was swamped with questions about what the symbols meant! But the boys in the gray flannel suits didn't give Rand the time of day—or their lucrative ad account.

THE 4 GREAT AMERICAN DESIGNERS FOR MEN ARE:

R_____ L_____

P_____ E_____

C_____ K_____

T_____ H_____

THIS IS THE LOGO OF THE LEAST KNOWN OF THE FOUR

In most households, the first three names
are household words. Get ready
to add another. His first name (hint) is Tommy.
The second name is not so easy.
But in a few short months everybody
in America will know there's a new look
in town and a new name at the top. Tommy's clothes
are easy-going without being too casual,
classic without being predictable.
He calls them classics with a twist.
The other three designers call them competition.

282 Columbus Avenue
at 73rd Street
New York, New York 10023
(212) 877-1270

© 1985 MURJANI

**MY 1985 POSTER MADE EVERYBODY IN TOWN ASK,
"WHO THE HELL IS T_ _ _ _ H_ _ _ _ _ _?"**

The young designer with a boyish grin and an unpronounceable name was totally unknown when my fashion
client Mohan Murjani launched him with a Tommy Hilfiger store on Manhattan's Upper West Side.
Given a $100,000 advertising budget, I had one shot to lure young men to trek up to Columbus Avenue and 73rd Street
to check out his duds, in the face of the enormous competition of the marketing power of Calvin Klein,
Perry Ellis, and Ralph Lauren. I had to create a fashion celebrity within a few weeks—and with one ad. So, with brazen
chutzpah, I challenged New Yorkers with an outrageous poster plastered on telephone kiosks on the
sidewalks of Manhattan, with an audacious claim. Tommy wasn't bowled over by tooting his own horn, but I convinced
him that my poster was his one shot at fashion stardom. Overnight, syndicated columnist Liz Smith wrote,
"This column is deluged by the curious who want to know who T_ _ _ _ H_ _ _ _ _ _ is!" Tommy Hilfiger became instantly
famous and set off an avalanche of national publicity within days. The day after the posters appeared,
Page 6 of the *New York Post* got the ball rolling with a blazing headline, and before the weekend, an article on the front
page of the *New York Times* business section asked, "Is Tommy Hilfiger successful because of his advertising,
or his clothes?" Along with the kiosk posters, I put up a gigantic half-block-long painted poster smack in the middle of
7th Avenue, totally pissing off every player in the shmatte business. A few months after the T_ _ _ _ ad appeared,
Calvin Klein, obviously livid as he watched Tommy's growing fame, saw me having dinner with my wife and friends one
night at Mr. Chow's. He strode over, stuck his finger in my face, and blurted out, "Lois, do you know it took
me 20 years to get where Hilfiger is today!" I politely grabbed his finger, bent it, and answered,
"Schmuck! Why take 20 years when you can do it in 20 days?!"

72. IN 1965, I WENT HOME TO GREECE, WHERE IT ALL BEGAN.

In early summer, when the mountain region of Návpaktos is usually sunlit, without a speck of cloud
to hold back the brilliant Greek light, I took my wife, Rosemary, and my father to his
birthplace of Kastaniá. I went home to Greece, at last, my first visit—a pilgrimage—way up, up,
a winding road to the top of a mountain to a village of forty families. After the most
memorable three days of my life among my hundred or so cousins, the villagers wept and waved
good-bye as we started down the mountain to where the road home began. Rain suddenly
pelted the car. My father blew his nose, wiped his eyes, and sank back between Rosie and me
into his private world. As we rounded a treacherous curve and a fresh gust of rain
sprayed the windshield, he said softly in Greek, "There's an old saying, 'When the son comes
home to the mountain, the mountain cries.'"
(This photo of Haralampos Lois as a Greek Evzone is the treasure of my life.)

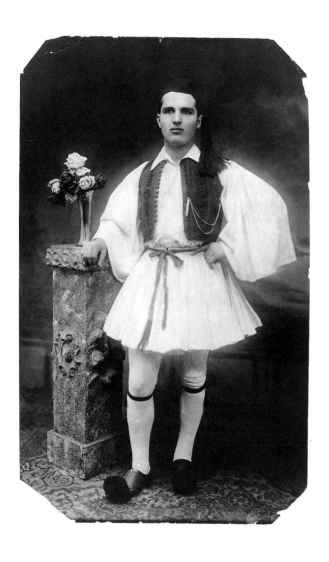

IN 1985, FOLLOWING A HIJACKING AT THE ATHENS AIRPORT, PRESIDENT REAGAN WARNED AMERICANS NOT TO TRAVEL TO GREECE. PLANES CARRYING TOURISTS STOPPED MID-AIR! SO WE RECRUITED 39 CELEBS (OF *NON*-GREEK LINEAGE) TO TELL AMERICA THAT THEY WERE "GOING HOME... TO GREECE!"

A miracle was needed—one that can only happen,
through the power of the Big Idea.
As a proud Greek American, Zeus struck me with
his lightning bolt when the Greek National
Tourist Organization begged me to somehow contain
this terminal damage to tourism in their
homeland. The Big Idea: *I'm going home...to Greece!*
But instead of recruiting famous Hellenic-
American celebs, I made a 180-degree turn from the
obvious and went after Americans of
non-Greek ancestry, who were "going home to Greece,"
the birthplace of democracy, "where it all
began." Our commercials were picked up by the
networks and ran gratis as newsbreaks,
demonstrating how Greece was fighting terrorism by
dramatizing how famous Americans would
not kowtow to terrorists! Olympic and TWA flights filled
to capacity and the Greek economy enjoyed
a landslide tourist season—its most glorious ever.

CLIFF ROBERTSON
My ancestor, Lieutenant John Robertson, was decorated by General Washington. Now this revolutionary Scot is going home... to Greece.

SALLY STRUTHERS
My grandparents came to America from a little fishing village in Norway. And now I'm going home... to Greece.

SHECKY GREENE
My mother vas coming from Russia to this vunderful America. Now I'm going home... to Greece.

RODDY McDOWALL
I was born in London and came to America when I was 12 years old. Now, at last, I'm going home... to Greece.

ZSA ZSA GABOR
I was born in Hungary. Now, darling, I'm finally going home... to Greece.

LLOYD BRIDGES
Mama used to tell me that my ancestors from the British Isles came over on the Mayflower. Now I'm going home... to Greece.

NEIL SEDAKA
My grandparents left Poland and Russia and came to Brooklyn. Now, at last, I'm going home... to Greece.

JOHNNY UNITAS
My people came from Lithuania at the turn of the century. Finally, I'm going home... to Greece.

E. G. MARSHALL
My great grandfather came to this country from Oslo, Norway, in 1850, and now I'm going home... to Greece.

EVA MARIE SAINT
My grandmother came to America from London in the late 1800s. And now I'm going home... to Greece.

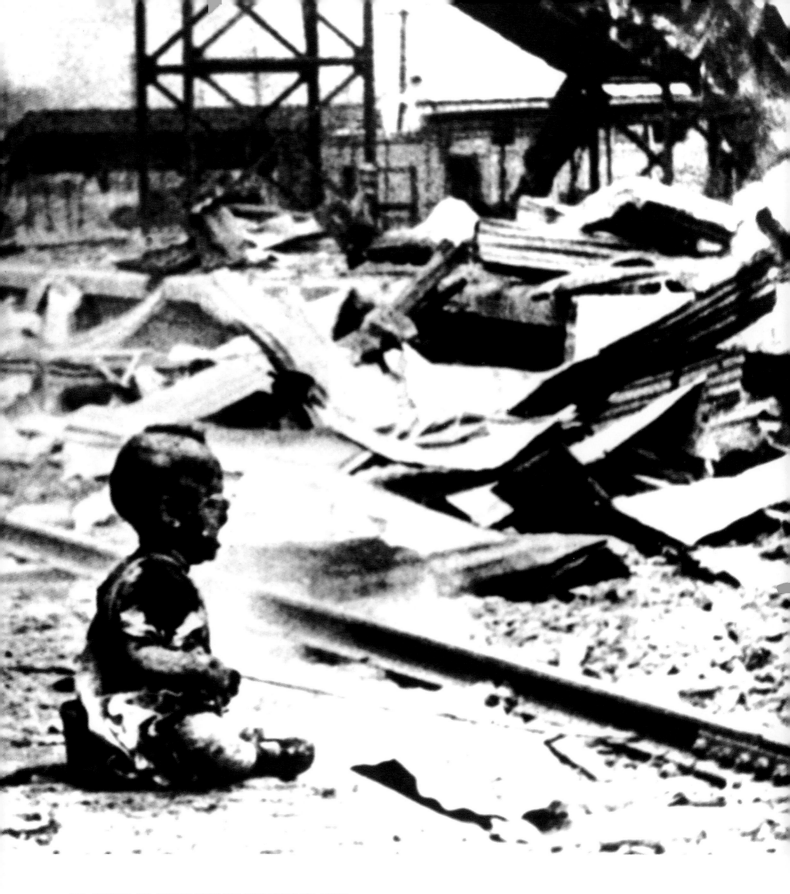

73. FROM AN EPIPHANY OF HORROR IN 1937...

Japanese planes bombed the southern railway station of Shanghai in a pre-Pearl Harbor act of atrocity
against the Republic of China. This news photo of a tiny, screaming baby, a victim of the Second Sino-Japanese war,
sitting helplessly amid the ruins of the railroad tracks, was considered the most shocking photograph
of war ever taken, surpassing the concentration camp photos from the American Civil War, and more horrendous
than even the photos of Japanese troops beheading Chinese civilians. (The image has remained
memorably etched in my mind's eye since I first saw it—when I was a mere six years old!) In the twentieth century,
over 170 million human beings were exterminated in genocides, holocausts, and wars. The ordeal
of the Second World War, the horrors of the Holocaust, and our genocidal savagery during the Korean, Vietnam,
and Iraq wars, which resulted in millions of civilian deaths, now make this extraordinary photograph,
taken in 1937, seem almost commonplace.

...TO A PORTRAIT OF AN AMERICAN WAR CRIMINAL,
 SEEMINGLY SITTING AMONG THE VERY KIDS HE KILLED.

In 1970, when I was told that *Esquire* had scheduled a long interview, "The Confessions of Lieutenant Calley," I knew instantly that I wanted to portray the unperturbed young officer, actually posing with a wide, toothy smile, lovingly surrounded by four Vietnamese children. Calley was awaiting trial for his role in the 1968 My Lai massacre, and when I told author John Sack what I had in mind, he gulped, and together we conned the infamous Lieutenant William Calley to pose. When the issue hit the newsstands, it chilled your bones. The disturbing image of this young nobody who had suddenly caught the attention of the world by putting a magnifying glass on the war, sitting among his victims, was totally devastating. A brouhaha erupted all across America over what was described in the U.S. Senate as another outrageous, "unpatriotic," antiwar *Esquire* cover. Along with millions of antiwar protesters, my graphic statements on covers of this popular men's magazine helped wake up America—but not until more than 58,000 Americans and as many as 3,000,000 Vietnamese were killed. Correctly, our collective national guilt continues because ultimately, our frightened, confused, but brave young men—even the notorious Lieutenant Calley—were fall guys, scapegoats for an atrocious war.

74. THE TOOLBOX OF VISUAL CLICHÉS

Webster's defines "cliché" as "a trite phrase or expression; a hackneyed theme." While cliché is a derogatory word in music and literary circles, the *visual* cliché is essential in the realm of graphic communications. Without it, there would be virtually no communications on the printed page or on television. An internationally understood visual symbol can immediately bring life to an idea, giving clear meaning to what could be an abstraction. In signage, posters, package design, and magazine covers, words can often be unnecessary—at times even excess baggage (how's that for a well-placed verbal and visual cliché!). If it is universally understood, a visual cliché can, with creativity, be made fresh and provocative by bestowing the kiss of life and reveal a truth as if for the first time. My ouevre is loaded with clichés: An image of Muhammad Ali with arrows piercing his body immediately states that the great champion was a modern martyr; drawing a graffiti moustache on Svetlana Stalin told uncritical worshippers of America's newest media-made anticommunist darling that I was branding her a fink; a self-applied halo over the head of Roy Cohn says that I'm labeling him a sanctimonious jerk.

My Wolfschmidt Vodka "talking bottle" campaign was a visual and verbal *orgy* of clichés. The first ad showed a full-size bottle hitting on a ripe "tomato" (a graphic cliché for a babe), expecting to copulate into a Bloody Mary. A week later, attempting to copulate into a "screwdriver," the Wolfschmidt bottle, lying on its side (a graphic cliché for the phallus), intends to seduce a juicy orange (a graphic cliché for the female navel). The skeptical orange asks,
Who was that tomato I saw you with last week?, the verbal/visual cliché climax to all my innuendo-imagery.

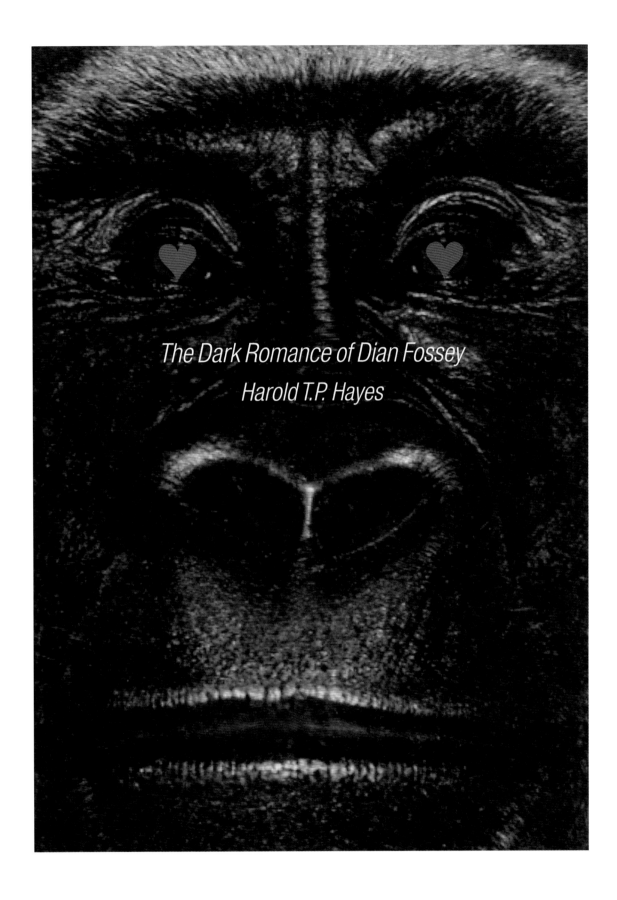

The Dark Romance of Dian Fossey
Harold T.P. Hayes

A CLICHÉ TRANSFORMED INTO A VISUAL OF UNREQUITED LOVE

In 1988, a year before he inexplicably died, Harold Hayes, the great ex-editor of *Esquire* in the '60s, with a compassionate heart and inspired prose, wrote a dark tale about the mystery of Dian Fossey's murder and the astonishing story of her remarkable life.
The eminent paleontologist Louis Leakey encouraged Fossey's dream to live and work in the Congo with the last remaining mountain gorillas, made famous in her book and later movie, *Gorillas in the Mist*. Living with mountain gorillas, she slowly earned their trust, becoming the world's leading authority on their physiology and behavior. Increasingly militant in her defense of her gorillas, her radical conservationist stand against game wardens, zoo poachers, and government officials who wanted to convert gorilla habitats to farmland led to her being hacked to death, presumably by poachers, in her Rwandan forest camp in 1985. Harold asked me to design the book jacket for *The Dark Romance of Dian Fossey*. Look deep into the gorilla's eyes. Is that passion emanating from the great beast's eyes, or is it the reflection of Dian Fossey's love?

75. THE MYTHOLOGICAL POWER OF THE MOVING CIRCLE...

From time immemorial, the sacred circle is what has made the world go around. On the day
of Creation, the Big Bang produced a universe of zillions of circles: stars (suns),
planets, and satellites. The earth we live on is one such circle, and it abounds with
mythology celebrating the spirituality of the circular image. Conveying the
dazzling optical experience of the movement of the seas, the spiral motif of dramatic
growth, so frequent in Bronze Age art, may well have also been
a sacred symbol of a cosmic order representing God—the alpha and the omega,
the beginning and the never-ending end. The bronze arm band shown here
(one of a glorious pair I own) is from Central Europe. During the fifteenth century BC,
a new warrior class emerged in Central Europe and the Alps, whose
wealth depended mainly on the newly discovered technology of making
bronze. Simplified and geometric, this motif of Bronze Age
art seems to embody the divine forces and movement of nature.
These arm bands were a worthy emblem of power
for the man or woman who wore them.

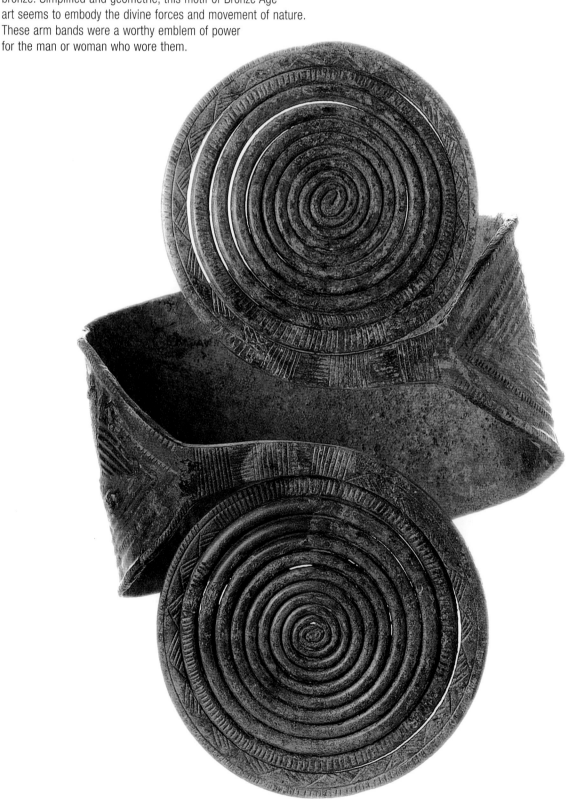

...BECOMES A LOGO OF A RAGING SEA.

In 1989, I created a logo for the Atlantic Bank, predominantly a bank for the Greek American community
(and backed by the Greek government), with business and shipping interests in
Greece that deal with the American market. My design incorporated circles in a continuous spiral
of undulating rhythm, strongly reminiscent of Cycladic and Minoan designs found
on pottery dating back 5,000 years, and Central European objects circa 1500 BC, all with
a powerful graphic resemblance to the movement of the sea. A TV commercial
introduced the design, with a flowing line forming the logo over spectacular footage of
a raging Aegean Sea. The shipping imagery and prehistoric references made
the Greek government justly proud of Atlantic Bank's new logo,
created by an American-born son of Greek parents.

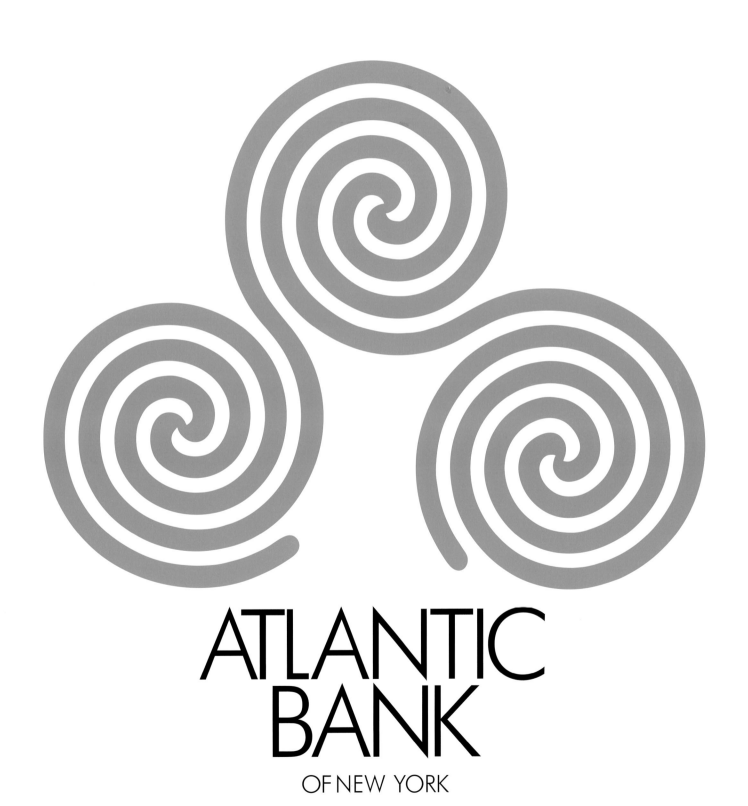

ATLANTIC BANK
OF NEW YORK

76. THE ULTIMATE KISS-OFF? A DREADED DEAR JOHN LETTER.

How best to characterize a WWII (or Korean, or Vietnam, or Gulf, or Iraq war) Dear John letter? Heartbreaking? Disloyal? Pernicious? Devastating? Treacherous? Humiliating? Unfeeling? Inhuman? Or all of the above? Imagine the emotional pain of a Tom, Dick, or Harry in our armed forces receiving a dreaded Dear John letter, thousands of miles from home.

**SO WHEN JOHN FAIRCHILD
MISTREATED
PAULINE TRIGÈRE,
I DICTATED A DEAR JOHN
MISSIVE TO HER
AND MAILED IT TO HIM IN
THE FORM OF AN AD.**

The legendary couturiere Pauline Trigère defined her marketing problem in one sentence: "Georges, people theenk I am dead!" During the '50s and '60s, the unpretentious aristocratic lady was properly regarded as a great talent, one of the first fashionistas. By 1988, she was of a certain age, and her longevity problem was compounded by an intramural fashion-industry vendetta: The most influential trade paper in the fashion world is *Women's Wear Daily*, headed by the dynast John Fairchild, who had been known to banish any mention in *WWD* of anyone who had offended or slighted the Fairchild power. According to Pauline, Fairchild's displeasure concerned her son criticizing the banishment of Geoffrey Beene. At one time or another, Fairchild had also blacklisted Hubert de Givenchy, Giorgio Armani, and Bill Blass. They all kept their mouths shut and took it on the chin. John Fairchild, the self-styled dictator of the fashion world, had set me up to make Pauline Trigère the Joan of Arc of Seventh Avenue. To deal with the Fairchild banishment head-on, I convinced Trigère to let me run a faux tearjerker Dear John letter ad in the *Fashions of the Times* (a *New York Times Magazine* section) for one $30,000 pop. I showed her letter, in her signature red-ink handwriting, surrounded by her tortoiseshell shades, her fountain pen, and her well-known turtle jewelry. After being warned by Geoffrey Beene and all her pals in the business that my ad would be her ruination, she said, "Screw it, Georges—run it!" A few days before the ad ran, the *Times*' alert marketing columnist spotted a preview copy and blew the lid off our counterattack with the lead piece on the front page of the *Times* business section—and zee shit hit zee fan! *Newsweek* magazine tracked down Fairchild skiing in Gstaad, Switzerland, and John-boy realized he would be hit by an avalanche of bad publicity. Trigère instantly became the heroine of the fashion world as congratulatory letters and phone calls were received from around the world with ongoing stories on TV, in newspapers, and full-scale magazine pieces for more than a year. The great lady batted her Gallic eyelashes while disarming the establishment; her customers flocked back to her; and she became more revered than ever for shaming the arrogant bullyboy of the fashion world.

May 12, 1944

Dear John,

You have been gone for such a long time, and I've been so lonely. It's so hard for me to write this to you. You are such a good person and I don't want to hurt you. I've been seeing another man for the past three months and he asked me to marry him. We were so happy in high school, but I'm a different person now. Please forgive me.

Fondly,
Jane

P.S. I hope you come home safely and we will always be friends.

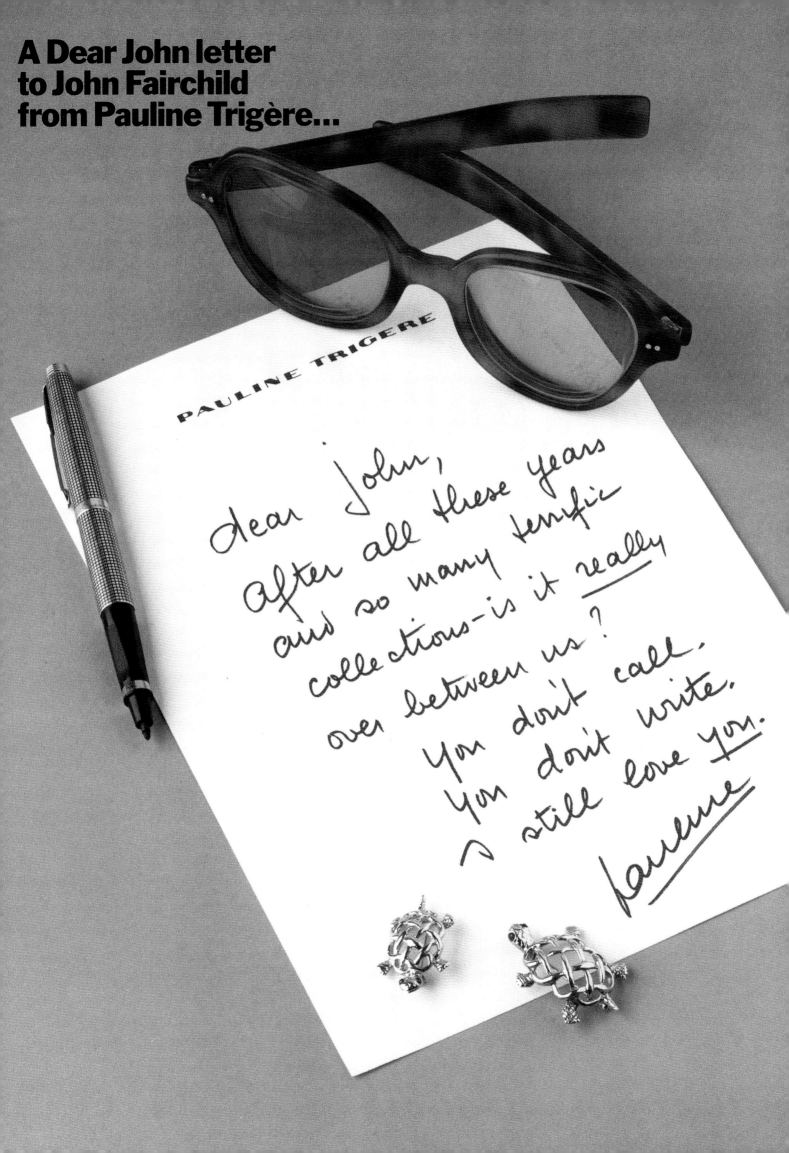

77. A SNAPSHOT OF A LOVE-AT-FIRST-SIGHT EPIPHANY.

In the autumn of 1949, my father woke me up at four in the morning to go with him to our weekly buying trip to the wholesale flower market on 28th Street—but I had surreptitiously passed an entrance exam to Pratt Institute in Brooklyn, payed my tuition with delivery tip money saved during my adolescent years, and was ready in earnest to move towards a career in art. "I can't go, Papa," I told Haralampos in the overnight fullness of our incense-drenched apartment. "I'm starting college today." My father shook his head slowly, realizing that his store, the business—my Greek patrimony—had been rejected by his only son. He left for the flower market without me, concealing his sadness with a stoic silence. But there was a further break that would cut even deeper that day. It was fully expected that I would marry a bona fide Greek girl at the Saint Spyridon Church in Washington Heights, where my two older sisters, Paraskeve and Hariclea, had married virile Greek men amid the pomp and soaring ritual of an Orthodox ceremony. Certainly I was destined to marry a Greek Orthodox girl—surely as Greek as my sisters. But on that same day, my first day of freshman orientation at Pratt, sitting in a classroom where attendance was being called, I heard a female voice answer to "Rosemary Lewandowski?" by naming her hometown, in an upstate accent, "Syy-racuse." A few minutes later, I saw her. In a strangely intuitive way, I knew she was the girl I would marry, from the very first second I saw her face (and after a l-o-o-ong check of her legs). Blonde, tall, and intelligently animated as she was talking to a fellow freshman, I was hard on her heels down the stairs to the front entrance of Pratt. "Hi, I'm Lois. George Lois. Me Tarzan, you Jane," I said cheekily. "Me Rosemary," she countered. "You arrogant!" But she put up with me long enough for a pal of mine from the High School of Music & Art to take this snapshot of us together. Our body language says it all: Rosemary's is self-protection, and mine is clearly hot-to-trot. I followed her from school that day, to the door of her dormitory, and she knew she had a tiger on her tail. There is a lovely twelfth-century troubadour poem from Provence that captures the magic of that day:

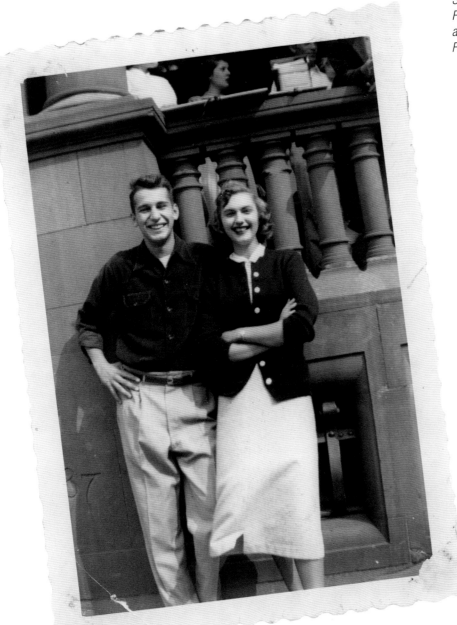

So, through the eyes love attains the heart
For the eyes are the scouts of the heart,
and the eyes go reconnoitering
For what it would please the heart to possess.

Rosemary Lewandowski was a second-generation Polish-American (decidedly not Greek) whose working-class Roman Catholic parents danced polkas. She came to New York to build a career and meet cultured people. Instead, she met me. In that one day, I had declared to my father that I would follow my passion: I would become an artist, and I had met the woman who would be at my side for the rest of my life.

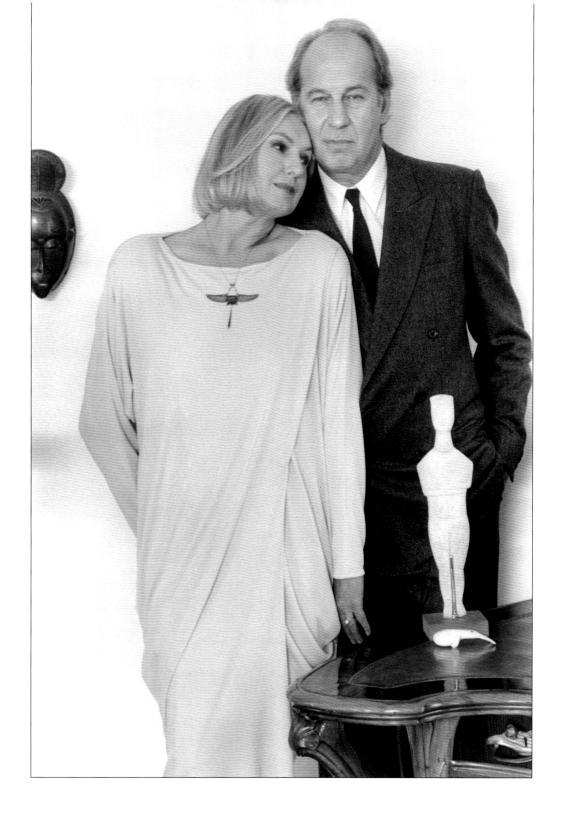

A PORTRAIT OF 50 YEARS TOGETHER

In the middle of our second year at Pratt, Herschel Levit, a maverick design teacher, told me that I should
be working in advertising, that I was wasting my time at school, and he sent me to a tiny lady named
Reba Sochis, a pioneering designer in a field bereft of women. After a few months of working as her head
designer at her superb studio, I eloped with Rosemary Lewandowski while my parents, Haralampos
and Vasilike, were on a pilgrimage to Greece. When they returned from their homeland, my mystical mother,
who collected omens and found clairvoyant signals in dreams, took one look into my eyes and
announced to me, "You got married." Then she said (she only spoke Greek to me), "Bring your wife."
"Better than a Greek wife," she said after she met my Polish bride. "Better than a Polish
mother-in-law," said the new Mrs. George Lois. "Better than most eligibles," said the draft board as the
Korean War raged. After two years in the Army, including nine months in the hell of Korea,
I came home to Rosie to build our new life—she as a sensational Precisionist painter, and me as an adman:
parents, grandparents, and lovers for 57 married years and counting, forever the apple of my eye.
As the saying goes, "Love is eternal—as long as it lasts." (The above 50th anniversary image was taken
in 2001 by the esteemed photographer Sheila Metzner.)

78.
WHAT DOES YOUR EYE SEE?
A VASE, OR TWO FACING PROFILES?

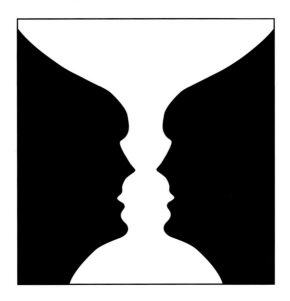

Optical illusions of one kind or another have been a part of human
experience since the beginning of history. The mirage seen in a desert; the moon illusion—
in which the orb rising over the horizon looks so much larger than when
high in the sky; and illusions created in light and shadow are just a few examples from
the natural world. Illusions were employed by Greek architects
to perfect the appearance of their temples. In the Middle Ages, misplaced perspective was
sometimes used in paintings for visual power. A favorite of mine
since I was a child is the "figure-ground reversal." The most famous example is Danish
psychologist Edgar Rubin's Vase Profile, which first appeared in print
in 1915: Your eye must alternate between the vase and the mirror profile of the woman.
Your eye has to think it, to see it.

"DON'T SHOW KASPAROV HOW
PUTTING HIS AND KARPOV'S PROFILE NOSE TO NOSE
MADE A CHESS PIECE MIRACULOUSLY APPEAR
BETWEEN THEM. HE'LL NEVER SPOT IT!"

For the World Chess Championship series between Gary Kasparov and his brilliant challenger,
Anatoly Karpov, which opened at the Hudson Theater in Manhattan in 1990, I created the
ultimate confrontation in the fierce combat of chess, inspired by Rubin's Vase Profile. Kasparov's
business managers insisted that the eagle-eyed Kasparov, arguably the greatest chess
player in history, would be oblivious to the illusion. When I showed the Russian chess genius
my poster, the white chess piece between his profile and Karpov's hit him like an
emotional illumination, and he gasped in astonishment. "Na Zdorovye, tovarich!" he said,
"Kasparov and Karpov, nose to nose, and betveen them—ah vite kveen!"

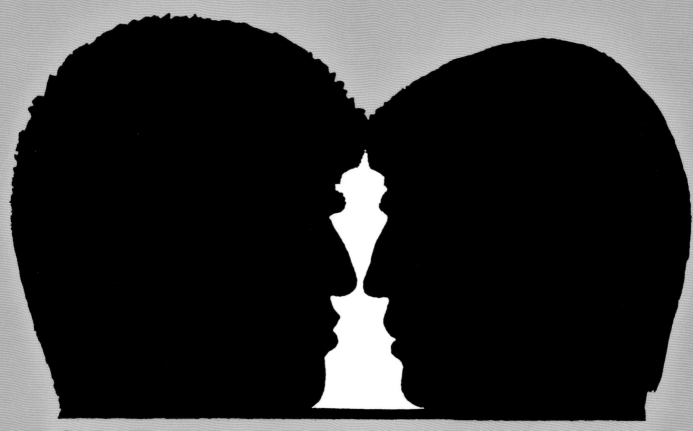

GARRY KASPAROV VS. ANATOLY KARPOV 1990 WORLD CHESS CHAMPIONSHIP

OCTOBER 8 – NOVEMBER 10, 1990
NEW YORK CITY

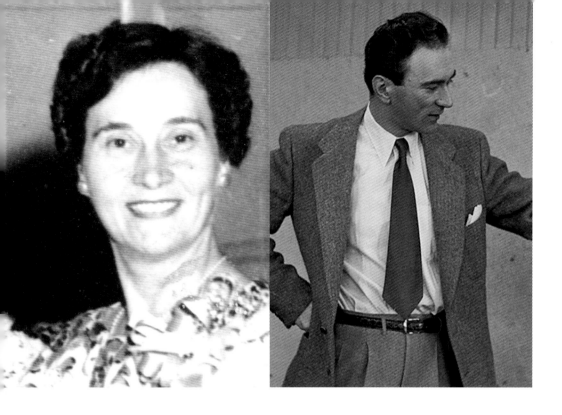

Tom McAnulty
Sculpture and drawing
Master of the fine arts

Richard Lund
Biology
Nobody teaches quite like...

Larry Sullivan
Chinese Scholar
Your brush with history

G.N. Rao
Optical Design
Look to your future

Richard Garner
Greek Classicist
If you seek a hero

Judith Baumel
Poetry
Mentor is a Mentor is a Mentor

Carmen de Lavallade
Dance
Every day is opening night

Gene Hecht
Professor of Physics
Physics with a punch

Coleman Paul
Behavioral Science
The Birdman of Adelphi

79. THE TWO TEACHERS WHO MENTORED ME WHEN I WAS A TEENAGER...

There are teachers who are full of fire...for their subject,
for the joy of teaching it, and for the enduring
satisfaction of helping students fulfill their dreams. The very
best of them are usually mavericks, nonconformers
in the oversupervised and constricted world of education.
Just one great teacher can make a lifetime of
difference to a student. I found my first guardian angel
when Ida Engel, my art teacher at P.S. 7 in the
Bronx, pointed this 14-year-old to the High School
of Music & Art. And in my second year at
Pratt Institute, Herschel Levit threw me out of school
because he insisted that I was ready to take on
the world and foment a creative revolution in advertising.

...INSPIRED A CAMPAIGN FOR YOUNG PEOPLE TO SEEK OUT THEIR MENTOR AT ADELPHI UNIVERSITY.

From the day an extraordinary educator by the name of Peter Diamandopoulos became president
of Adelphi University in 1985, a mediocre college at best, he didn't offer education theory,
he applied shock therapy. "Give me great teachers, and give them access to students. Find me masters
who can't *breathe* without teaching." He struck out on his own, rejected trendiness in
education, and exalted the timeless as he proclaimed a return to glory through the pursuit of excellence,
putting to use his theories on redefining the Western tradition for the students of the
twenty-first century. Dr. D's changes were swift and sure: Bad teachers out; good teachers in. And the
shock waves reverberated through the traditionalists at Adelphi and its defensive teacher's
union until he was driven out, just as he was making his dream of a great university come true. But not
before I had the privilege of creating an ad campaign for him defining his progress by
running full-page ads in the *New York Times* and Long Island *Newsday* that championed the best of
his inspired army of hands-on teachers, all instigators and visionary thought-builders.
The striking portraits of nine of them (opposite), each capturing their area of teaching, are by my
son Luke Lois (who also worked beside me designing every page of this book).

**FOR THE JACKET OF MY BOOK _WHAT'S THE BIG IDEA?_,
I NEEDED A VISUAL THAT DEPICTED ME GETTING AN IDEA...
HOW ABOUT A LIGHTBULB?!**

In the ad game, I'm known as the practitioner of the Big Idea, so in a how-to
book published in 1991, to dramatize my title, _What's the Big Idea?_,
I went the traditional route of a lightbulb visual. Except I went a step further
by substituting my beaming mush for the lightbulb. What a turn-on!
(Edison is probably turning over in his grave.)
P.S. The thrill of a eureka moment is thought of as a lightning bolt from out
of the blue—an intuitive, unconscious concept, sometimes arrived at
on the basis of very little information: Your inner computer sifts through your
DNA of experience and insights, and a creative idea is instantly born.
But all inner computers, unlike the Internet, are not equal. Real creativity leaps
from a passionate life source of seeing, feeling, and thinking.
No idea, ever, is heaven-sent.

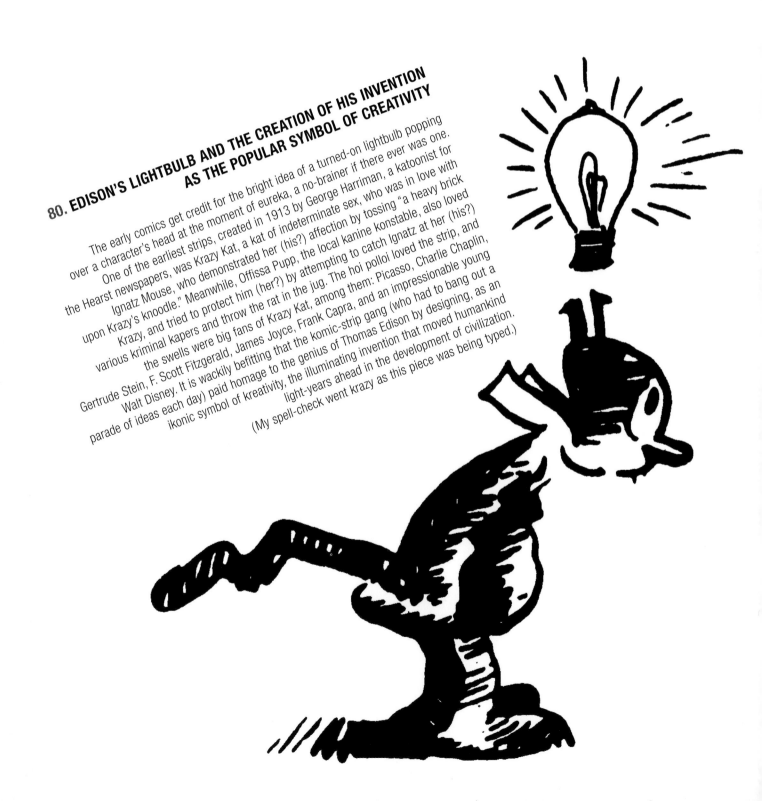

80. EDISON'S LIGHTBULB AND THE CREATION OF HIS INVENTION AS THE POPULAR SYMBOL OF CREATIVITY

The early comics get credit for the bright idea of a turned-on lightbulb popping
over a character's head at the moment of eureka, a no-brainer if there ever was one.
One of the earliest strips, created in 1913 by George Harriman, a katoonist for
the Hearst newspapers, was Krazy Kat, a kat of indeterminate sex, who was in love with
Ignatz Mouse, who demonstrated her (his?) affection by tossing "a heavy brick
upon Krazy's knoodle." Meanwhile, Offissa Pupp, the local kanine konstable, also loved
Krazy, and tried to protect him (her?) by attempting to catch Ignatz at her (his?)
various kriminal kapers and throw the rat in the jug. The hoi polloi loved the strip, and
the swells were big fans of Krazy Kat, among them: Picasso, Charlie Chaplin,
Gertrude Stein, F. Scott Fitzgerald, James Joyce, Frank Capra, and an impressionable young
Walt Disney. It is wackily befitting that the komic-strip gang (who had to bang out a
parade of ideas each day) paid homage to the genius of Thomas Edison by designing, as an
ikonic symbol of kreativity, the illuminating invention that moved humankind
light-years ahead in the development of civilization.
(My spell-check went krazy as this piece was being typed.)

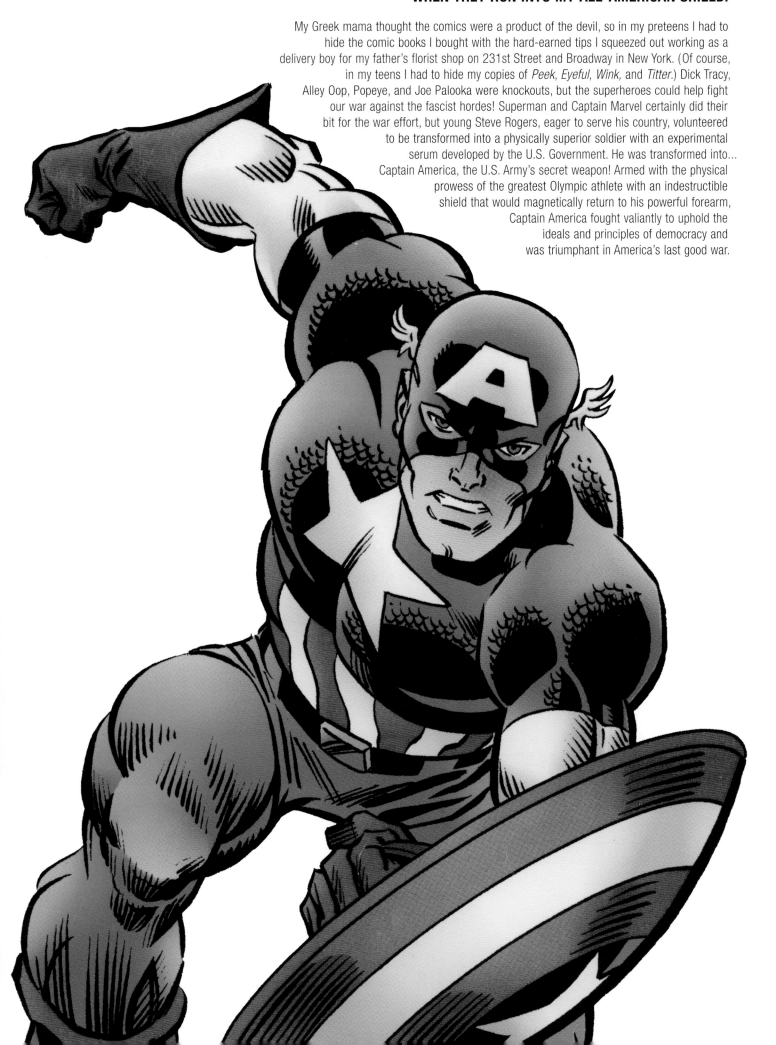

81. "I AM CAPTAIN AMERICA. HITLER, MUSSOLINI, AND TOJO WILL GO THBONNK WHEN THEY RUN INTO MY ALL-AMERICAN SHIELD!"

My Greek mama thought the comics were a product of the devil, so in my preteens I had to hide the comic books I bought with the hard-earned tips I squeezed out working as a delivery boy for my father's florist shop on 231st Street and Broadway in New York. (Of course, in my teens I had to hide my copies of *Peek*, *Eyeful*, *Wink,* and *Titter.*) Dick Tracy, Alley Oop, Popeye, and Joe Palooka were knockouts, but the superheroes could help fight our war against the fascist hordes! Superman and Captain Marvel certainly did their bit for the war effort, but young Steve Rogers, eager to serve his country, volunteered to be transformed into a physically superior soldier with an experimental serum developed by the U.S. Government. He was transformed into... Captain America, the U.S. Army's secret weapon! Armed with the physical prowess of the greatest Olympic athlete with an indestructible shield that would magnetically return to his powerful forearm, Captain America fought valiantly to uphold the ideals and principles of democracy and was triumphant in America's last good war.

**"I AM ALARMO, SHOUTING FROM THE ROOFTOPS.
BURGLARS GET OUTTA TOWN
WHEN THEY SEE THE SLOMIN'S SHIELD!"**

Slomin's was alarmed. Its 1-800-ALARM-ME direct-response phone lines weren't ringing, and sales of
its home-security system had slumped. Competitors had stolen Slomin's marketing concept
of offering free hardware and installation with a five-year contract, and the copycat security systems
were becoming a threat. Slomin's needed a super idea. I turned its lawn shield into
a logo and named it *The Slomin's Shield*. The authority of the shield logo lent credence to
TV spots of families singing *Shield your home: The Slomin's Shield!* Call volume
tripled and telemarketing doubled, the company's business took off, and it opened virgin
territories. Then, in a thunderbolt, Captain America to the rescue! I created
Alarmo, an animated superhero wielding The Slomin's Shield (along with a seven-inch
replica action toy that kids pestered their parents for). Within months,
Alarmo muscled Slomin's into being the power brand of home-security systems.
P.S. Crime continues to go down wherever Alarmo stands watch.
(But it has been reported that people are stealing their
neighbors' Slomin's Shield signs and
planting them in their own front lawns!)

**THE
SLOMIN'S
SHIELD™**
HOME SECURITY SYSTEM

82. THE WHITE MALE SYMBOL OF AMERICA

Uncle Sam, the story goes, was named after Samuel Wilson, a meat-packer who,
during the War of 1812, supplied the U.S. Army with beef in barrels labeled "U.S." One of Wilson's workers
joked that the "U.S." stood for "Uncle Sam" Wilson, leading to the idea that the
meat shipments symbolized the federal government, and somehow, the symbolic character Uncle Sam was born.
Wilson was known for fairness, reliability, and honesty and was devoted to his country.
But Ol' Sam Wilson looked nothing like our popular image of the lean, mean, white-goateed Yankee decked out
in a star-spangled suit and a top hat. The angular and avuncular look of America's
new uncle was an invention of political cartoonists, notably Thomas Nast. Then, in 1917, during World War I,
James Montgomery Flagg created "the most famous poster in the world,"
with his depiction of Uncle Sam (posed by himself) sternly pointing at America's young men, and commanding
I WANT YOU for the U.S. Army, a homage to (more accurately, a rip-off of)
a British recruitment poster showing Lord Kitchener in the same aggressive pose. In many political hot spots
throughout the world, a burning or hanging-scarecrow version of nasty
Uncle Sam has become a symbolic image of protest against America's cavalier forays overseas.

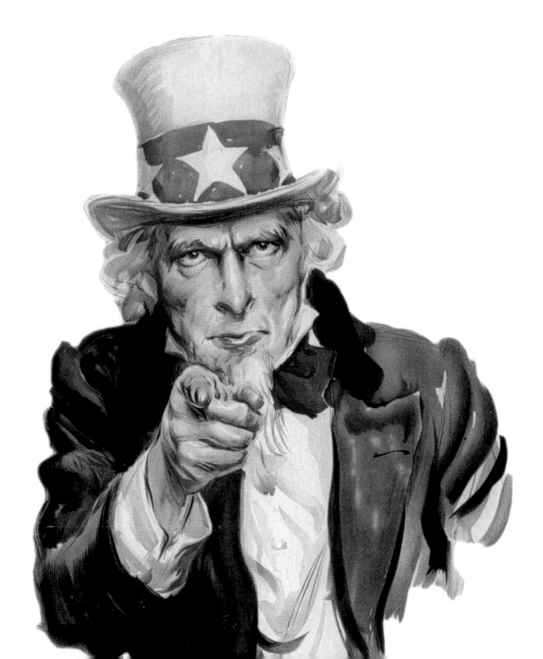

A GREAT BLACK MAN INSISTS, "I AM AMERICA!"

In 1966, a few years after converting to Islam, Muhammad Ali emerged (at that time controversially
among both blacks and whites) as a true superhero in the annals of American
history with his courageous stand of refusing to fight in a bad war against the people of Vietnam,
based on his religious and moral beliefs. Knowingly facing an end of
his glorious boxing career and a long jail term, he looked into the eye of all Americans and with
a blast furnace of racial pride, declared, "I am America. I am the part
you won't recognize; but get used to me. Black, confident, cocky—My name, not yours. My religion,
not yours. My goals, my own. Get used to me." A knockout performance by the
now-accepted Worldwide Ambassador of Courage and Conviction! My image of Uncle Sam transformed
into the great-grandson of a slave was created for my 2006 book, *Ali Rap*,
based on the rap, witticisms, insults, wisecracks, courageous stands, and words of inspiration from
the heart and soul of the brash young Cassius Clay,
as he steadily grew into the magnificent man who is Muhammad Ali.

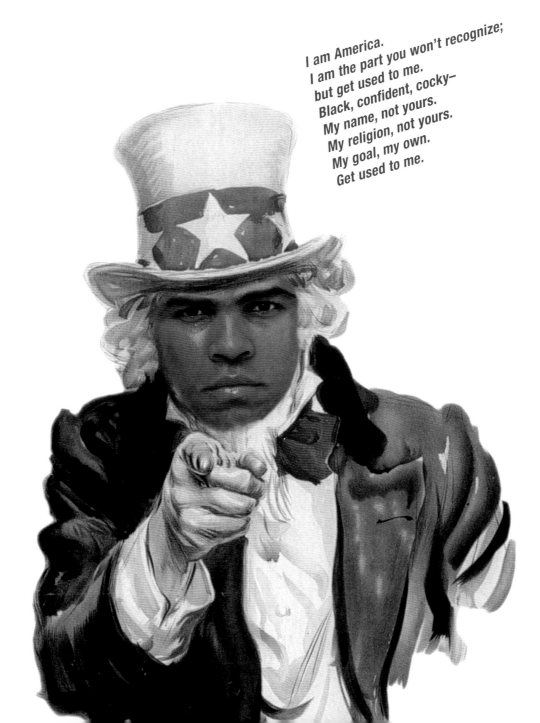

I am America.
I am the part you won't recognize;
but get used to me.
Black, confident, cocky—
My name, not yours.
My religion, not yours.
My goal, my own.
Get used to me.

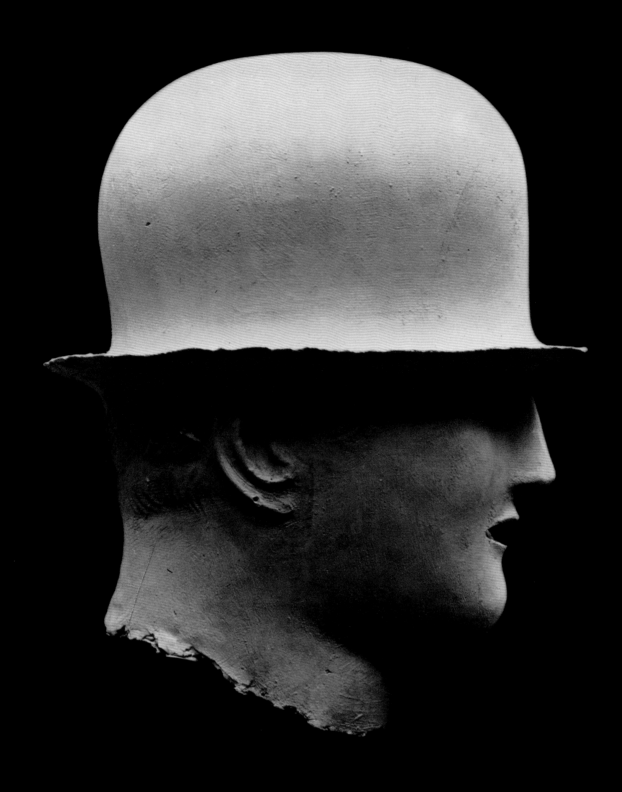

83. DELIVERING BOUQUETS TO A GREAT ARTIST

The highlight of my days as a florist's son was when I delivered a regular weekly order of a dozen roses to the
Alderbrook country estate of Elie Nadelman, overlooking the Hudson River in the Delafield section
of well-to-do Riverdale. Universally accepted today as one of America's greatest twentieth-century sculptors,
the Polish-born Nadelman transformed the classical principles of Greek sculpture into a modern
idiom (seemingly by the hand of a hip Praxiteles) becoming an overnight sensation in his formative years in
Paris in 1909. When he came on to the American scene, (influenced by American folk art)
Nadelman boldly introduced genre subjects into his repertoire with stylized, fluid, unerringly elegant, and totally
charming sculptures—a couple dancing the tango in contemporary garb; a woman at the piano;
an orchestra conductor in his tux and tails; a man in a bowler hat. During five years of flower deliveries,
I showed Nadelman my drawings, and after he placed his roses in a vase of water, he would
lead me into a carriage house next to his gabled home to show me, an adolescent aspiring artist, his latest
creations. A year before his death, in 1946, when I told him that I had been accepted into the
High School of Music & Art, the great man grabbed my gaunt teenage shoulders, hugged me dearly,
and planted a European-style kiss on each of my cheeks.

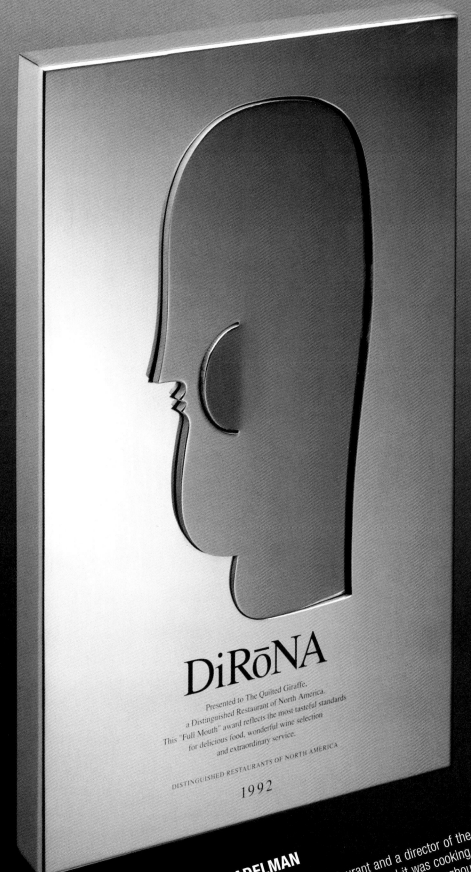

DiRōNA

Presented to The Quilted Giraffe,
a Distinguished Restaurant of North America.
This "Full Mouth" award reflects the most tasteful standards
for delicious food, wonderful wine selection
and extraordinary service.

DISTINGUISHED RESTAURANTS OF NORTH AMERICA

1992

EN HOMAGE TO ELIE NADELMAN

In 1992, Tom Margittai of The Four Seasons restaurant and a director of the Distinguished Restaurants of North America, asked me to name and design an award it was cooking up to honor only the very finest dining establishments in its trade organization throughout the U.S., Canada, and Mexico. I used an acronym derived from the four words of its organization, calling it the DiRoNa, and designed a beautifully produced stainless-steel award inspired by a Picasso sculptural concept of creating a sculpture from one flat sheet of material.

The shining DiRoNa Award was proudly hung by 300 recipients at the entrance to their eateries. My DiRoNa Award was a homage to my childhood (and still) hero Elie Nadelman: a Nadelman-like profile, sublimely munching gourmet food. Imitation is the sincerest form of flattery, and I believe that the sublime sculptor would have licked his chops at my prankish tribute.

84. "HI-YO, SILVER, AWAAAAY!"

The Lone Ranger was no stranger in my home when I was growing up
in the wild, wild West Bronx—always thrilling to the opening
narration on a weekly radio show that premiered in Detroit in 1933:
"A fiery horse with the speed of light, a cloud of dust and
a hearty Hi-Yo, Silver—The Lone Ranger!" The narrator continues,
with words memorized by millions of American kids:
"With his faithful Indian companion, Tonto, the daring and resourceful
masked rider of the plains led the fight for law and order
in the early West. From out of the past come the thundering hoofbeats
of the great horse Silver—the Lone Ranger rides again!"
As the narrator's voice builds to the accompaniment of Gioacchino Rossini's
William Tell Overture we hear the clarion call of the Lone Ranger:
"Hi-yo, Silver, Awaaaay!" The Lone Ranger came vividly to life in 1949
when Clayton Moore (shown) and Jay Silverheels became
the Lone Ranger and Tonto on television and in the local moviehouse.
The warm and respectful friendship between cowboy
and Indian was a profound statement at a time when Hollywood depicted
the Indian as a "red devil"—and the duo forever ride on
in the annals of American pop culture.

"WHO WAS THAT HANDSOME MASKED MAN?"

In a 1997 TV campaign, I catapulted the then unknown
Rio All-Suite Hotel and Casino into the front ranks of Vegas's hottest casinos,
starring 15 masked celebs dramatizing each of Rio's attractions
under the theme "Where the Hidden You Comes Out to Play." Over a driving
big band delivering a "Rio...Vegas Style!" showbiz tune, a masked
seven-foot Wilt Chamberlain exclaims, "Everybody gets a suite big enough for
the Big Dipper." Nancy Sinatra, with shoes made for walking, adds,
"How suite it is!" And Carol Channing, with *Hello, Dolly!* pizzazz, flashes a
"He-llo, Rio!" The legendary dancer Donald O'Connor sells the nightclub
with "Put on your dancing shoes and meet me at Club Rio!" The parade of
stars marches on until a purring Eartha Kitt steals the show with her
inimitable reaction to the appearance of Baseball Hall of Famer Reggie Jackson,
"Who was that handsome masked man? Me-yeoww."
The Lone Ranger rides again!

TOP ROW:
DOWNTOWN JULIE BROWN
ADAM WEST
WILT CHAMBERLAIN

MIDDLE ROW:
GENE SHALIT
CAROL CHANNING
DONALD O'CONNOR

BOTTOM ROW:
TOMMY TUNE AND LESLIE ANN WARREN
REGGIE JACKSON
EARTHA KITT

85. THE AERIAL DUEL OF PICASSO'S PEACE DOVE AND THE COLD WAR HAWKS.

In the divisive climate of the Cold War,
Pablo Picasso played a militant
role in the peace movement, with contributions
of his pigeon-turned-dove images
spreading their wings all over the world,
in the form of drawings, lithographs,
programs, postcards, matchboxes, key rings,
plates, scarfs, pins, jewelry, and most
importantly, posters. A symbol that resonates
throughout the Christian and non-Christian
world, the dove had been endowed with spirituality,
and associated with peace and resurrection,
representing the Holy Spirit in images of Christ's
baptism as the messenger of hope,
and returning with an olive branch in its beak
to bring Noah tidings of the end of
the Flood. World-famous as the creator of
the dove as a metaphor for peace,
Picasso even named a daughter Paloma
("dove" in Spanish). But the greatest
artist of the twentieth century was persona
non grata in America and was refused
a visa to visit the U.S. by President Truman.
He was even accused of spying for
the Soviet Union. Picasso's reaction?
"One really has to have the jitters
to be scared of a dove!"

AFTER THE END OF THE COLD WAR, THE DOVE REAPPEARS AS A SYMBOL FOR THE FREE SPIRIT AWARD.

In 1992, I was given the honor to design the Al Neuharth Free Spirit of the Year Award for
the Freedom Forum (doing yeoman service protecting the freedom of the press).
The award, which comes with a $1 million gift, is presented annually to "a courageous
achiever who accomplishes great things beyond his or her normal circumstances."
Fittingly, the first honoree was the journalist Terry Anderson, who had been abducted from
the streets of Beirut and imprisoned for almost seven years, held as a hostage
by a group of Shiite Muslims in Lebanon. Inspired by Picasso's dove of peace, as well as
his breakthrough sculptural technique of cutting shapes out of a single plane
to create forms, I designed a dove springing out of a sheet of stainless steel—still tethered,
but yearning to be free. As a newly freed political prisoner, Anderson was brought to
tears holding the award in his arms during the first presentation dinner in Washington, D.C.
But a few years later, my dove was replaced by a new award with the threatening
wings of an eagle. It seems that in the atmosphere of the Bush administration's preemptive war
policy, "peace" had once again become a fearful, politically incorrect message.
Pablo Picasso was right: "One really has to have the jitters to be scared of a dove!"

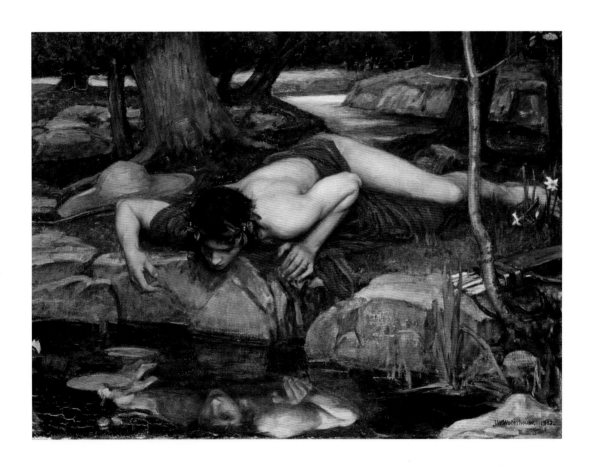

86. IN GREEK MYTHOLOGY, NARCISSUS LOVES HIS MUG...

Once upon a time in the ancient world, young Narcissus, fatigued by hunting
in a voluptuous game-packed forest, lay down at a clear fountain
with water like silver, to quench his thirst. The beautiful youth saw his own
image in the pristine water and gazed with admiration at those
bright baby blues, that aquiline nose, the chiseled chin, the rosy cheeks,
the ivory neck, those luscious locks curled like the locks of the
God Apollo, the pulsating lips—and fell in love. (Shown is a detail of a painting
by the neoclassical British painter John William Waterhouse
depicting Narcissus' divine revelation.)

"I love my MUG"

IN AN AMERICAN TV COMMERCIAL, RICHARD "JAWS" KIEL LOVES *HIS* MUG...*ROOT BEER*!

Pepsi-Cola suspected, after it bought a little-known root beer brand called Mug, that it had a real clinker. Beyond its buyer's remorse, I had to change an old-fashioned turn-of-the-nineteenth-century beverage into a modern, popular drink with mass-appeal. When Alan Pottasch, Pepsi's hip creative director, suggested that perhaps I should rename its problem-child pop drink, I blurted out (pointing to my mug) "I love my Mug!" He dug where I was headed. The two memorable un-narcissistic mugs I chose to belt out my self-effacing message were 7' 2" Richard "Jaws" Kiel, the shark-toothed villain of two popular James Bond 007 films, and the outrageous Phyllis Diller (whose mug changes every year). The double entendre of their delivery, raucously sung in a sunny, funny jingle, along with the enthusiastic acceptance of the campaign by the all-important Pepsi bottlers, made Mug the No.1 root beer in New York in a few short months. Pepsi-Cola honchos celebrated with a Mug Beerfest, where I plastered a "mug shot" of each of the Pepsi bottlers and their affiliates on specially designed *I Love My Mug* mugs, and to this day, they look into their morning coffee (or their afternoon root beer) and fall in love.

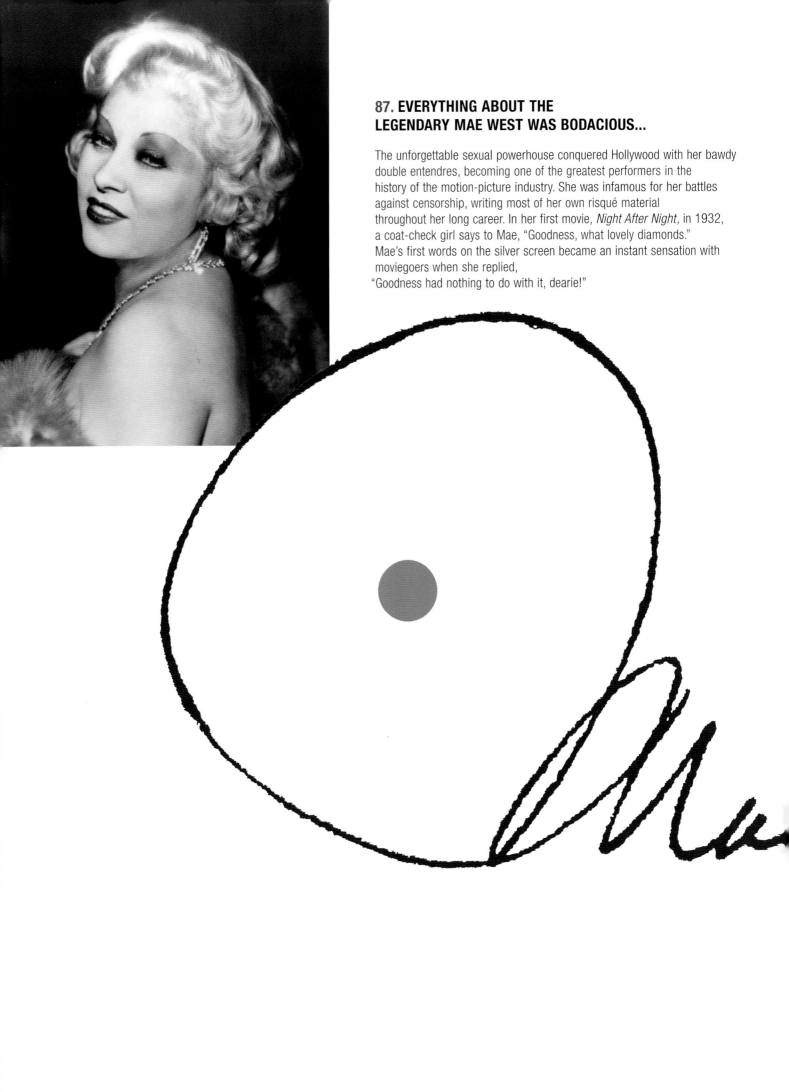

87. EVERYTHING ABOUT THE LEGENDARY MAE WEST WAS BODACIOUS...

The unforgettable sexual powerhouse conquered Hollywood with her bawdy double entendres, becoming one of the greatest performers in the history of the motion-picture industry. She was infamous for her battles against censorship, writing most of her own risqué material throughout her long career. In her first movie, *Night After Night*, in 1932, a coat-check girl says to Mae, "Goodness, what lovely diamonds." Mae's first words on the silver screen became an instant sensation with moviegoers when she replied, "Goodness had nothing to do with it, dearie!"

...INCLUDING HER AUTOGRAPH!

In 1970, when I showed Tom Margittai and Paul Kovi, the owners of
the legendary Four Seasons restaurant in New York, the idea of
presenting a thick, lush, pigskin-covered book to renowned celebrities,
they recoiled at its hoi-polloi brashness. But they took a whack at it,
and it soon became a signature event among their world-famous guests.
The remarkable archive of autographs and salutations became a
Who's Who of some of the most important people of the twentieth century.
But the one that knocked my eyeballs out was the suggestive
autograph (sans nipples) of the bodacious Mae West.

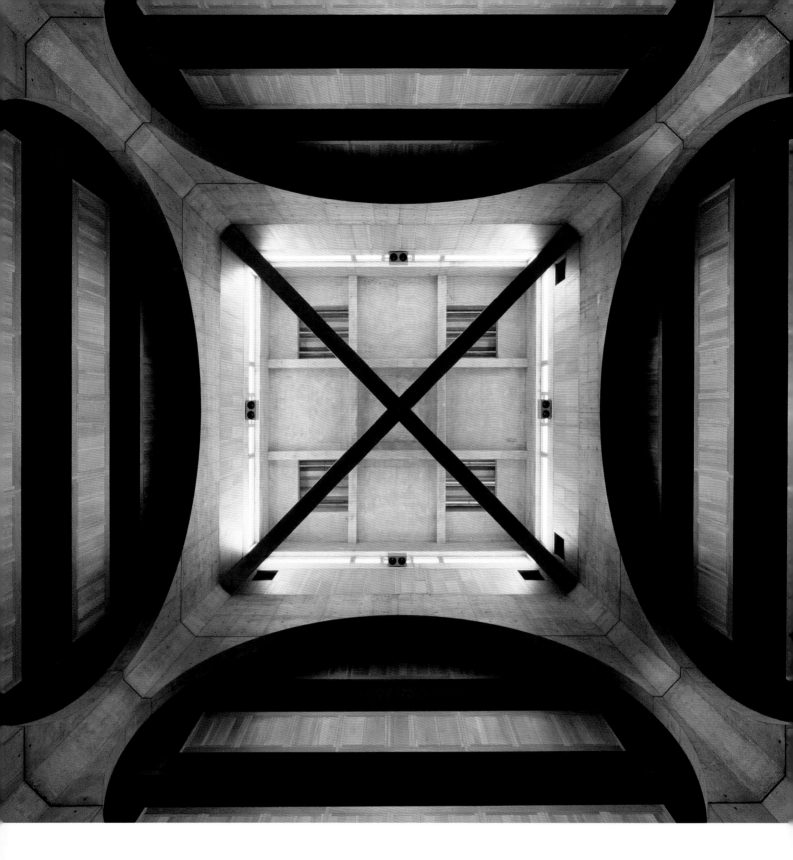

88. THE ARCHITECTURAL GLORY OF THE CIRCLE, THE TRIANGLE, AND THE SQUARE

Far beyond even the works of the holy trio of modern architects, Frank Lloyd Wright, Le Corbusier, and Mies van der Rohe, Louis Kahn's ouevre is startlingly spiritual and mysterious. Represented by only a small handful of completed masterwork's, Kahn's structures are starkly abstract, richly evocative yet strangely silent, echoes of the reverent remains of the greatest structures of ancient civilizations, with glorious light, nuances and dark shadows, as if in the presence of God. From 1965 to 1972, he created the Library and Dining Hall of Phillips Exeter Academy in Exeter, New Hampshire. The detail shown is the Central Hall of the library. As the eye is cast to the heavens, we are met by a composite visual synthesis of man's intellectual and mathematical genius: the circle, the square, and the triangle (formed by an X), all intermingling with an ever-changing interplay of light. His majestic use of symbolic geometry and textured light, along with the presence of thousands of surrounding books, charges the space with meaning appropriate to a building dedicated to the worship of knowledge and learning.

A LOGO FOR 20 TIMES SQUARE?
HEY, HOW ABOUT A CIRCLE,
A MULTIPLICATION SIGN, AND A SQUARE!

I don't think I've ever been surprised by an "address logo". A multitude of handsome ones have been designed over the centuries, but they are what they are: utilitarian, and devoid of imagination. (The giant red numeral 9 that proudly sits on the sidewalk at the entrance of the Eiffel Tower-shaped Solow Building at 9 West 57th Street, designed by Chermayeff and Geismar, is the most attention-getting building number, ever.) When I was asked to create a logo for a new development of the Lawrence Ruben Company and Vornado Realty Trust, a statement I made a week before while lecturing at a School of Visual Arts class came back to haunt me: "There's a great solution, a Big Idea, buried in every assignment, whether for a new brand name, ad campaign, poster, letterhead, matchbook cover — even a number slapped on a building." I've always maintained that I never "create" an idea. Getting a Big Idea is not an act of inspiration but rather one of discovery. My logo for 20 Times Square proves me right.

89. THE MEANEST, MOST MISERLY MAN IN THE WORLD.

Ebeneezer Scrooge, the main character in Charles Dickens's 1843 novel, *A Christmas Carol*, is a coldhearted, selfish man who despises Christmas and all good things that engender happiness. The ghost of his business partner, Jacob Marley, damned to walk the earth for eternity, bound in chains as a result of his own greed, warns Scrooge that he risks the same fate, and that as a final chance of escape he will be visited by the Ghosts of Christmas Past, Present, and Yet to Come. A better yarn is hard to find, and the final legacy of Scrooge weeping over his own cheap and unkept grave, begging the Ghost of Christmas Yet to Come for redemption, and awakening in his bed on a joyous Christmas morning as he transforms into a symbol of repentance and forgiveness, gives hope to us all. But little does Ebeneezer, who becomes a man of generosity and tenderness, know that he would forever exist as a symbol of meanness and that his catchphrase, "Bah! Humbug!" would be his epitaph. (Shown is a sketch of Scrooge by John Leech, who illustrated the first edition of *A Christmas Carol* in 1843.)

EBENEEZER SCROOGE DELIVERS A MESSAGE TO THE NASTY PHONE COMPANIES.

In 1999, an ingenious device to protect consumers from being ripped off on long-distance phone calls
was a product we named PhoneMiser: Plugged into your PC (keeping your
current long-distance carrier), PhoneMiser guaranteed the lowest cost on every call made, with
savings that slashed phone bills up to 60 percent. The miserly Ebeneezer Scrooge
taught us all how to save a buck or two as a memorable spokesman on TV and radio, in print,
and in-your-face packaging.

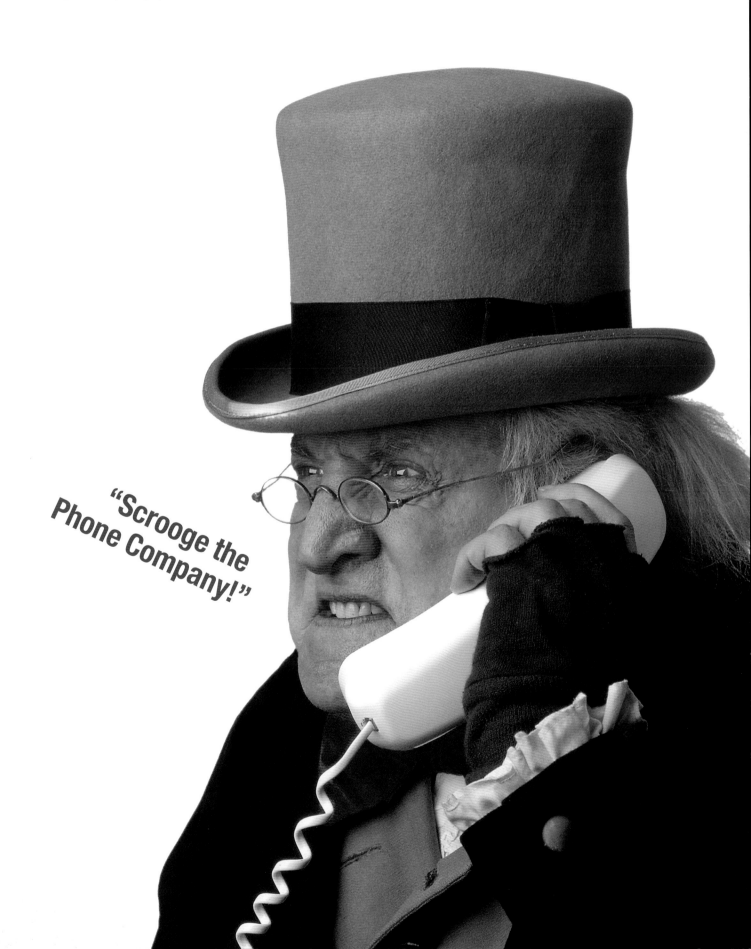

"Scrooge the Phone Company!"

Standing on the water
Casting your bread

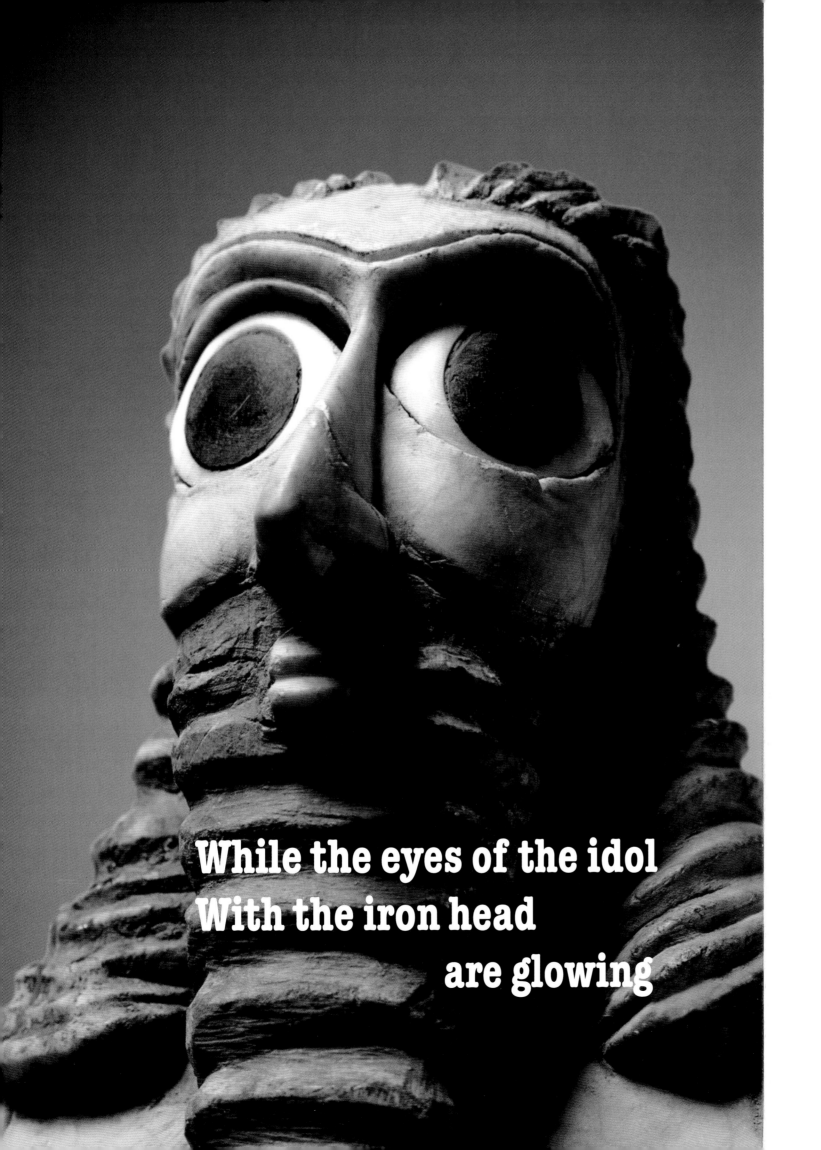

While the eyes of the idol
With the iron head
 are glowing

The past shouts across time to us. Great art is the
bedrock of civilization, a shorthand of human experience.
In 1983, Columbia Records asked Bob Dylan,
an artist whose music captured the zeitgeist and
imagination of the whole world, to promote
his new *Infidels* album with a music video, a medium
he had previously spurned. Bill Graham, the
trailblazing rock impresario, asked me to create and
produce a video of the iconic song *Jokerman.*
In gratitude for Dylan's dynamic help in my campaign
to free the innocent Rubin "Hurricane" Carter,
I leapt at the chance. My Big Idea was to intercut close-ups
of footage I would shoot of Dylan performing
his six-minute song with images from the history of art.
I chose images that I believed would dramatically
add visual force and enduring power to each specific phrase
of his lyrics and overlaid the words so they could
be read on-screen as the piercing wail of Bob Dylan's voice
was heard. (A poet should be read as well as
heard. His sandpaper voice and the snarl and grit of
his words chill the bones.) *Rolling Stone* magazine
said, "George Lois' unique concept of Dylan's lyrics with
sculpture by Michelangelo and paintings by
Hieronymus Bosch and Francisco Goya spliced with
close-ups of Dylan...was spectacular."
Kurt Loder added, "Bob Dylan's *Jokerman*, created by
the brilliant New York adman George Lois, makes
most run-of-the-mill rock videos look like the glorified
cola commercials they generally are." *Back Stage*
said: "Bob Dylan's music video, *Jokerman*, brings forward
a revolutionary new look in the genre. Its pioneering
design by legendary adman George Lois is a trendsetter."
MTV named *Jokerman* the Video of the Year.
(Alas, it was the only music video I was ever asked to create.)

90. IN 1983, BOB DYLAN BROUGHT MUSIC,
ART, AND POETRY TO THE POP
MUSIC FANS OF AMERICA ON MTV:
DÜRER, A SUMERIAN IDOL,
TURNER, A MINOAN SNAKE GODDESS,
MICHELANGELO, MANTEGNA,
THE CHARIOTEER OF DELPHI, PICASSO,
LINDNER, BOSCH, UCCELLO,
O'KEEFFE, CURTIS, GOYA, MUNCH,
AND AN AZTEC GODDESS,
IN A SWEEPING HISTORY, EACH
IMAGE DRAMATIZING THE
LYRICS OF *JOKERMAN*, ALL IN ONE
MUSIC VIDEO.

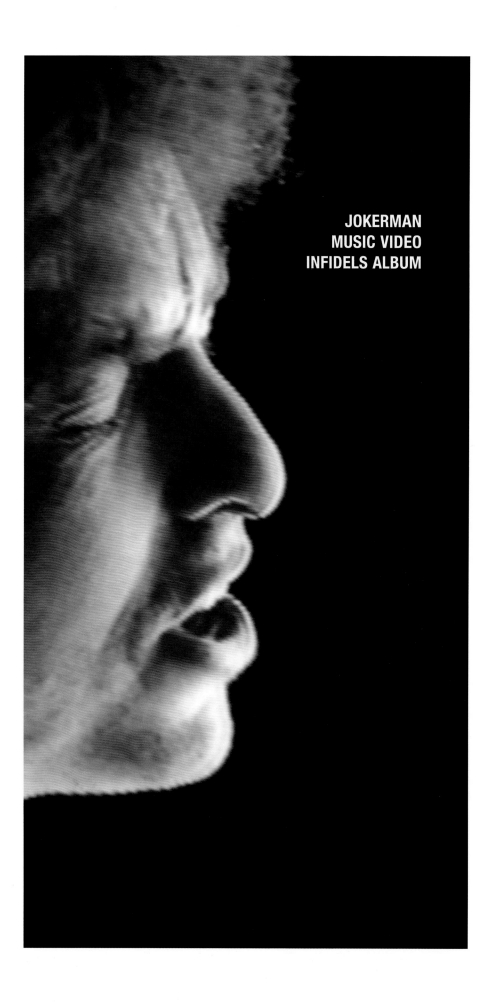

**JOKERMAN
MUSIC VIDEO
INFIDELS ALBUM**

Standing on the water
Casting your bread
Self-Portrait in Furred Coat,
Albrecht Dürer depicting
himself as Christ, 1500

While the eyes of the idol
With the iron head are glowing
Sumerian Idol, 2700 BC

Distant ships sailing
Into the mist
The Slave Ship
(slavers throwing overboard
the dead and the dying),
J.M.W. Turner, 1840

You were born with a snake
In both of your fists
Minoan Snake Goddess,
Crete, 1500 BC

While a hurricane was blowing
Bob Dylan poster,
Milton Glaser, 1966

Freedom just around
The corner for you
Moses, by Michelangelo, 1514

But with the truth so far off
What good will it do?
Man in Bondage,
from the Book of Urizen,
William Blake, 1795

Jokerman dance
To the nightingale tune
Bird fly high
By the light of the moon
Oh Oh Oh Jokerman
(Verse of live Dylan)

So swiftly the sun
Sets in the sky
Photos of Dylan as a young man

You rise up and say
Goodbye to no one
Dead Christ,
Andrea Mantegna, 1490

Fools rush in where
Angels fear to tred
Marines hitting the beach
in Lebanon

Both of their futures
So full of dread
You don't show one
Marine funeral

Shedding off
One more layer of skin
Keeping one step ahead
Of the persecutor within
Chameleon sequence
of Dylan's disguises

Jokerman dance
To the nightingale tune
Bird fly high
By the light of the moon
Oh Oh Oh Jokerman
(Verse of live Dylan)

You're a man of the mountains
You can walk on the clouds
The Delphi Charioteer, Greek,
fifth century BC (In mythology
he rode through the skies)

Manipulator of crowds
You're a dream twister
Portrait of Adolf Hitler

You're going to
Sodom and Gomorrah
But what do you care?
Footage of A-bomb blast

Ain't nobody there would want
To marry your sister
Crying Woman,
Pablo Picasso, 1937

Friend to the martyr
A friend to the woman of shame
Woman and Man,
Richard Lindner, 1971

You look into the fiery furnace
See the rich man without any name
The Musician's Hell,
Hieronymus Bosch, 1510

Jokerman dance
To the nightingale tune
Bird fly high
By the light of the moon
Oh Oh Oh Jokerman
Comical moonwalk
of actual astronaut footage

Well, the Book of Leviticus
And Deuteronomy
Jewish illuminated manuscript
depicting God giving
Moses His laws, German, 1300

The law of the jungle and the sea
Are your only teachers
Island man of New Guinea,
photo by Malcolm Kirk, 1965

In the smoke of the twilight
On a milk-white steed
The Battle of San Romano,
Paolo Uccello, 1435–50

Michelangelo indeed
Could have carved out your features
Hand of *David*, by Michelangelo,
1504 (posed by artist's own hand)

Resting in the fields
Far from the turbulent space
Cow's Skull – Red, White and Blue,
Georgia O'Keeffe, 1931

Half asleep near the stars
With a small dog licking your face
Chief Joseph of the Nez Perce,
photo by Edward S. Curtis, 1903

Jokerman dance
To the nightingale tune
Bird fly high
By the light of the moon
Oh Oh Oh Jokerman
(Verse of live Dylan)

Well the rifleman's stalking
The sick and the lame
The Third of May 1808
(firing squad),
Francisco Goya, 1814

Preacherman seeks the same
Who'll get there first is uncertain
Armor of Henry VIII,
English, 1520
quick cut montage of jokers

Nightsticks and water cannons
Tear gas, padlocks
Molotov cocktails and rocks
Behind every curtain

Francisco Goya etchings

False hearted judges
Muhammad Ali as Saint Sebastian,
Esquire cover, 1968, George Lois

Dying in the webs that they spin
Colossal Head,
Palazzo Orsini, Bomarzo, Italy

Only a matter of time
'Til night comes stepping in
Slain Leaders
(JFK, RFK, Dr. King)
at Arlington Cemetery,
Esquire cover, 1969, George Lois

Jokerman dance
To the nightingale tune
Bird fly high
By the light of the moon
The Joker,
(Batman, D.C. Comics)

Oh Oh Oh Jokerman
Photo of comical Ronald Reagan,
(live Dylan playing harmonica)

It's a shadowy world
Skies are slippery gray
The Scream, Edvard Munch, 1893

A woman just gave birth
To a prince today
And dressed him in scarlet
Goddess of Earth and Procreation
giving birth, Aztec, 1400

He'll put the priest in his pocket
Put the blade to the heat
Take the motherless children
Off the street
And place them at the feet
Of a harlot
Oh Jokerman,
You know what he wants
Oh Jokerman,
You didn't show any response
Jokerman dance
To the nightingale tune
Bird fly high
By the light of the moon
Oh Oh Oh Jokerman
(Sequence of live Dylan),
moon dissolves over Dylan,
pull back as moon
becomes Dylan's eye in the sky

IN THE MIDST OF THE GREAT DEPRESSION:
"THE ONLY THING WE HAVE TO FEAR IS FEAR ITSELF."

Reeling from the effects of the Great Depression, with a third of the nation ill-clad, ill-fed,
and ill-housed, the people of America desperately looked to the federal government
for help, and elected Franklin Delano Roosevelt as their president in 1932. After being sworn
in on March 4, 1933, FDR, a man of action, immediately took on responsibility for the
welfare of the people, and speaking to an anxious America, laid out a plan of action he called
the New Deal. He prefaced his progressive plans with ten iconic words that
gave hope to the millions of Americans huddled around their radios:
"The only thing we have to fear is fear itself."

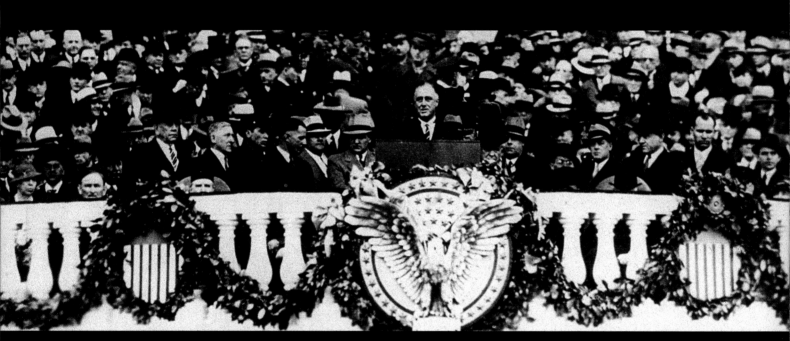

IN 2004, IN THE MIDST OF A DISASTROUS "PREEMPTIVE WAR"
"THE ONLY THING WE HAVE TO FEAR IS FEAR ITSELF."

In the 2004 Democratic presidential primaries, *Fear Ends, Hope Begins* were the passionate, yet unheeded
words delivered by Representative Dennis Kucinich in speeches and in my pro-bono ad campaign.
Democrats knew full well that the cocky congressman from Cleveland was the *only* candidate who voted against an
out-of-control Bush administration that clearly intended to attack Saddam Hussein with a preemptive
war on Iraq. Kucinich was right when he doubted the existence of weapons of mass destruction;
was right that Bush's fear-mongering warning that "Iraq's smoking gun could be a mushroom cloud" was a fabrication;
was right that American men and women were losing their lives, arms, and legs in vain;
was right that the administration, in the name of fighting terrorism, would bring about the destruction of our civil liberties;
was right that we were creating a world of new terrorists with our illegal actions;
was right that the war would severely harm our economy;
and absolutely right that we would lose the love and respect of the whole world.

FEAR ENDS.

"The future of our country and our planet
will be decided not on the battlefield,
but in the heart and mind of every man, woman and
child in the world. With the support of the
visionary voters across the nation,
America can begin to lead the world towards peace."

HOPE BEGINS.

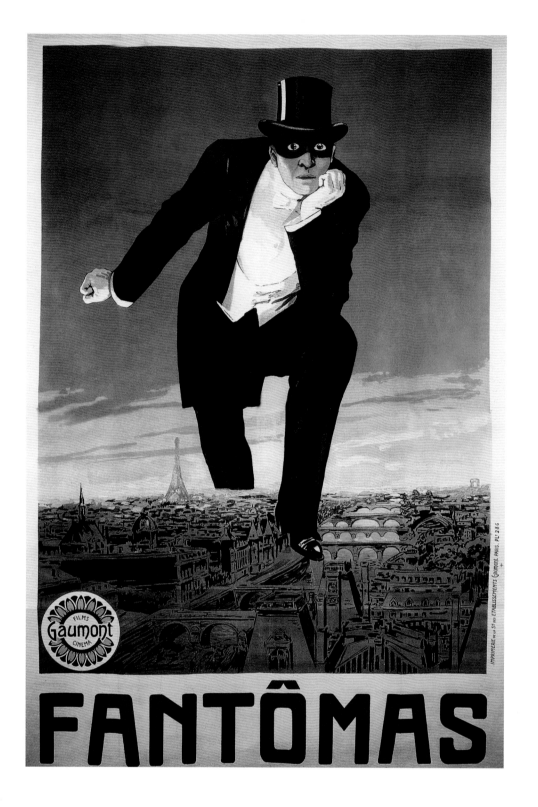

92. FANTÔMAS, THE LORD OF TERROR, LURKING OVER THE CITY OF PARIS

In 1913, Gaumont produced the first of five films, along with a memorable poster, promoting the arch-criminal antihero Fantômas (the Genius of Evil and the Emperor of Crime—a prototype of the cruel Joker of *Batman* fame). Adapted from a series of immensely popular, pre-WWI French thrillers, Fantômas carries out the most appalling crimes: substituting sulfuric acid in perfume dispensers in a Parisian department store; forcing a victim to witness his own execution face-up in a guillotine; or releasing plague-infested rats on an ocean liner. Bourgeois-busting Surrealist artists and poets adored the primitive era of the newly born medium of silent film, which was scorned by mainstream art and literary critics, and were drawn to *Fantômas* and the fantastic cinematic imagery of nightmarish dreams. To promote the first film, Fantômas was depicted in an unforgettable poster as a giant masked gentleman in formal dress looming over the heart of Paris. The notorious villain who cunningly robbed, tortured, and killed scores of innocent victims, had originally clutched a deadly dagger in the film poster, but the Gaumont producers forced artist Gino Starace to paint it out, leaving only a kid-gloved, clenched fist. But the silent-film poster showing evil running amok, lost none of its intoxicating power.

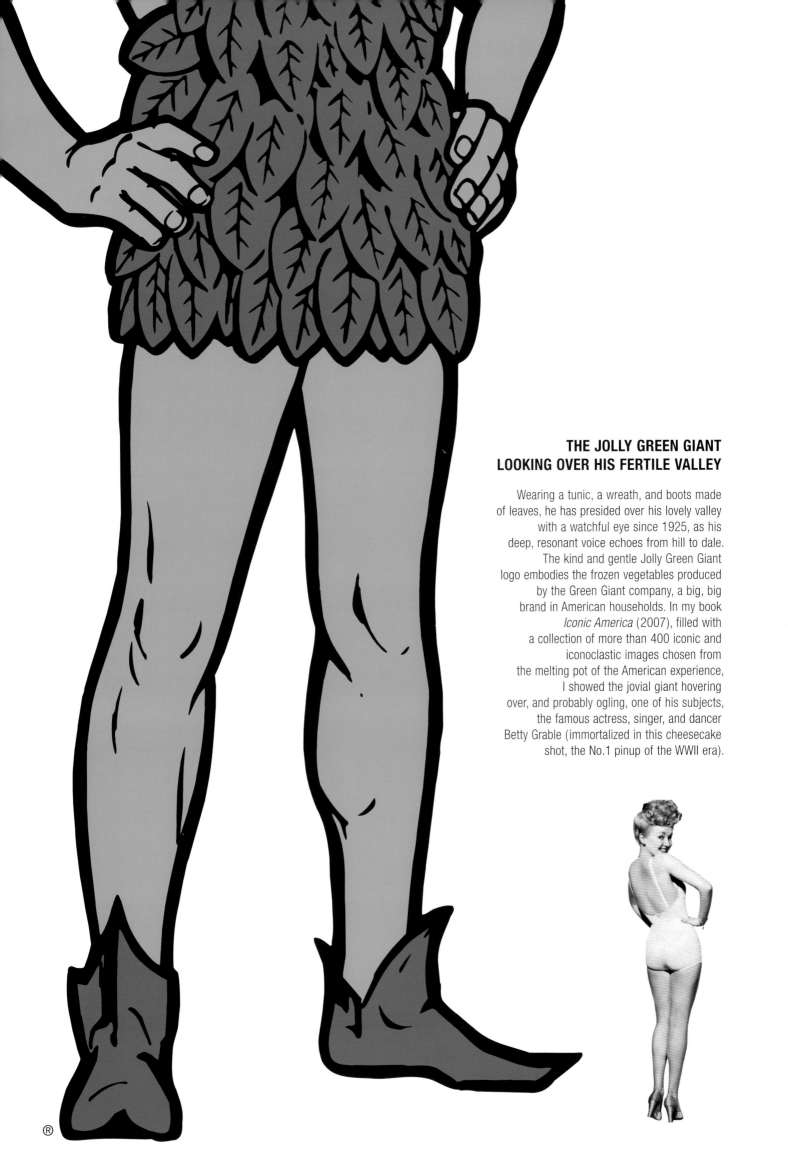

THE JOLLY GREEN GIANT
LOOKING OVER HIS FERTILE VALLEY

Wearing a tunic, a wreath, and boots made
of leaves, he has presided over his lovely valley
with a watchful eye since 1925, as his
deep, resonant voice echoes from hill to dale.
The kind and gentle Jolly Green Giant
logo embodies the frozen vegetables produced
by the Green Giant company, a big, big
brand in American households. In my book
Iconic America (2007), filled with
a collection of more than 400 iconic and
iconoclastic images chosen from
the melting pot of the American experience,
I showed the jovial giant hovering
over, and probably ogling, one of his subjects,
the famous actress, singer, and dancer
Betty Grable (immortalized in this cheesecake
shot, the No.1 pinup of the WWII era).

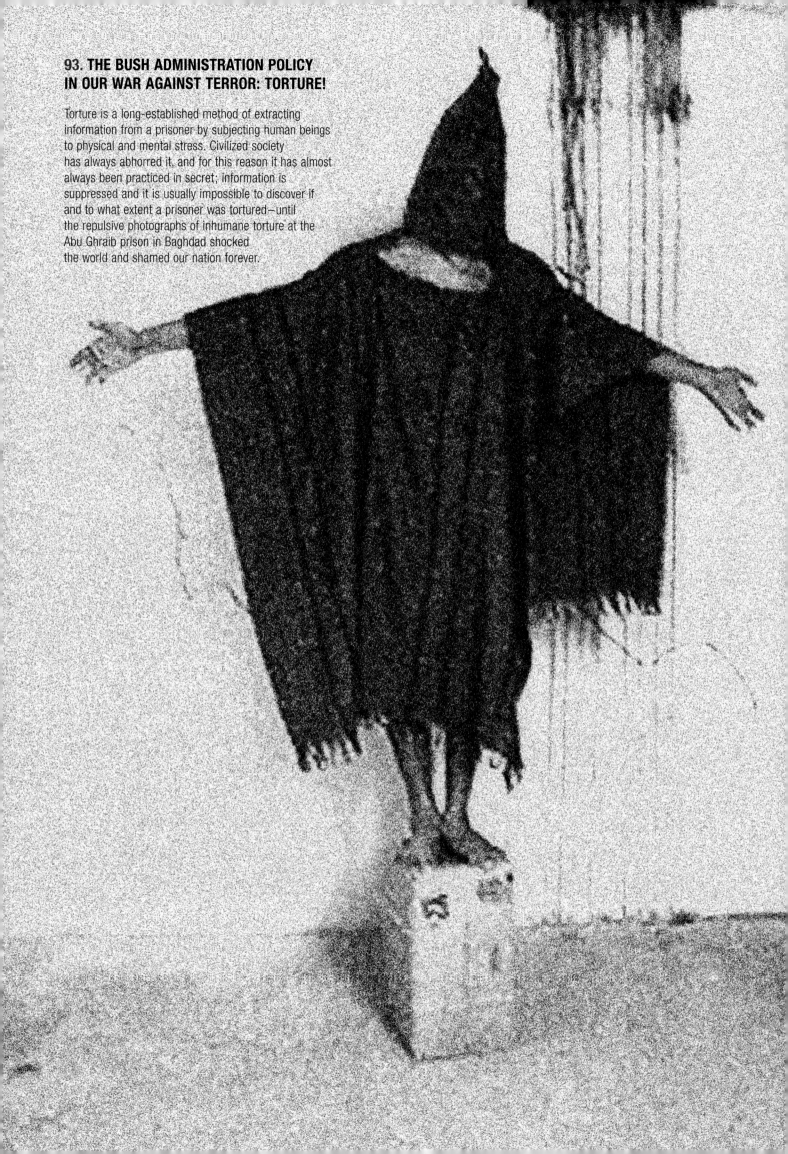

93. THE BUSH ADMINISTRATION POLICY IN OUR WAR AGAINST TERROR: TORTURE!

Torture is a long-established method of extracting information from a prisoner by subjecting human beings to physical and mental stress. Civilized society has always abhorred it, and for this reason it has almost always been practiced in secret; information is suppressed and it is usually impossible to discover if and to what extent a prisoner was tortured—until the repulsive photographs of inhumane torture at the Abu Ghraib prison in Baghdad shocked the world and shamed our nation forever.

AN UNHEEDED CALL TO IMPEACH THE PRESIDENT OF THE UNITED STATES

The illegal actions in the name of "national security" have perpetuated fear throughout the land and inflicted hatred and contempt for America throughout the world. The habitual lying of the president and all the president's men has cost the lives of thousands of young men and women in the U.S. military, killed hundreds of thousands of innocent Iraqis, severely harmed our economy, endangered our civil liberties, and inspired and empowered millions of new terrorists in the Islamic world for many generations to come. With a litany of charges against the Bush administration, his policy of systemic torture, in disregard of the Geneva Convention as well as the moral judgment of the world, is reason enough to impeach the president for what can only be labeled "war crimes." Sadly, the Democratic Party chickened out. My juicy "Im-Peach" approach was conceived as a way to add style and wit to a deadly serious attack on a catastrophic presidency (and it would have sold a hell of a lot of Georgia peaches).

IM-PEACH!

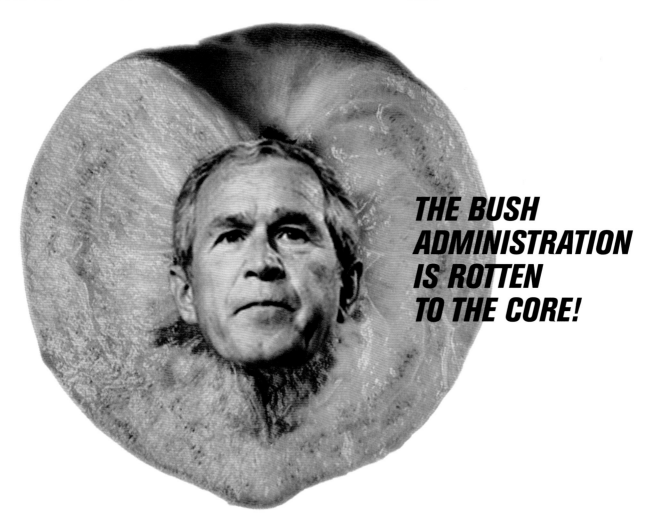

THE BUSH ADMINISTRATION IS ROTTEN TO THE CORE!

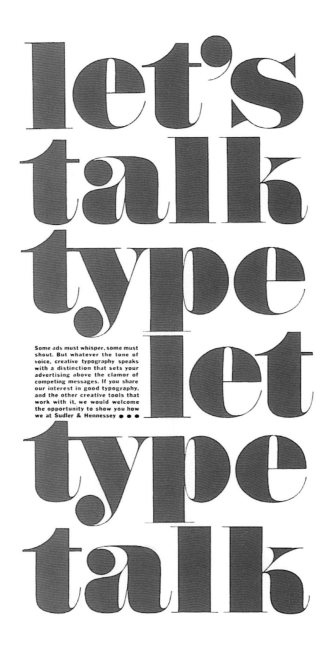

Some ads must whisper, some must shout. But whatever the tone of voice, creative typography speaks with a distinction that sets your advertising above the clamor of competing messages. If you share our interest in good typography, and the other creative tools that work with it, we would welcome the opportunity to show you how we at Sudler & Hennessey ● ● ●

94. "LET TYPE TALK!" AND THE NEW YORK DESIGN REVOLUTION

The decades of the '50s and '60s were the golden age of Modernism in American graphic design, inspired by Paul Rand, who showed the way with the groundbreaking visual and typographic power of his work, expressed in his book *Thoughts on Design*. Published in 1947, it was a visionary look at the emerging role of the contemporary designer. (The copy I bought when I was 16 is in my library, threadbare.) The first beneficiaries of his ouevre were four other sensational New York talents: Bill Golden of CBS Television, Lou Dorfsman of CBS Radio, Gene Federico, and Herb Lubalin. The inimitable Lubalin was the pivotal figure of typographic expressionism in America with his consummate ability at arranging, nestling, and elegantly fitting together classic letterforms in groupings that became almost sculptural on the printed page in their negative and positive shapes. I worked alongside him at his pharmaceutical ad agency, Sudler & Hennessey, as the creative director of its consumer business. I was looking over his shoulder when he wrote and designed his classic *Let's talk type—let type talk* ad, which remains the manifesto of those exciting experimental times. In 1958, when I left Herb Lubalin to join Doyle Dane Bernbach, the ad agency tilling fertile ground for the massive Creative Revolution of the '60s, I was recognized as the enfant terrible of the New York school of design.

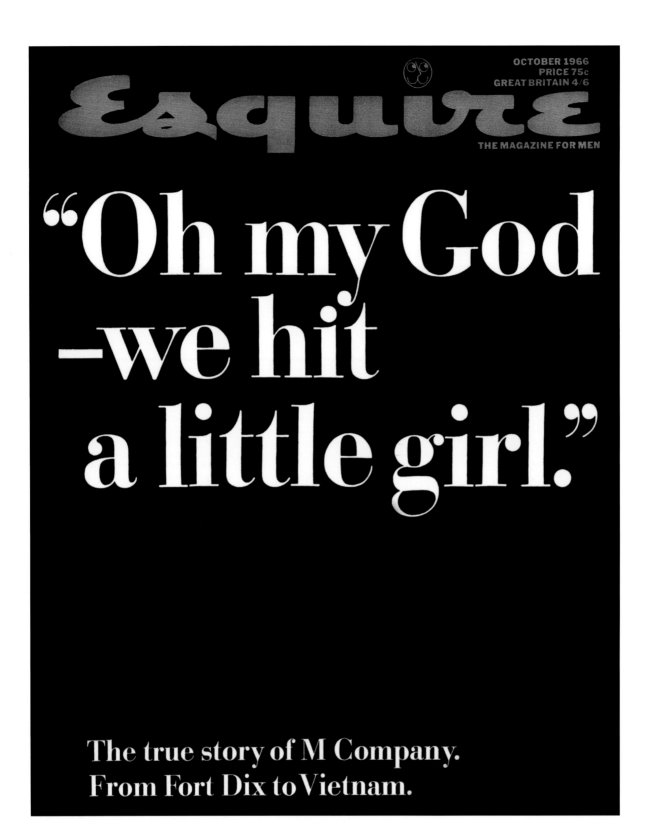

OCTOBER 1966
PRICE 75c
GREAT BRITAIN 4/6

Esquire
THE MAGAZINE FOR MEN

"Oh my God –we hit a little girl."

The true story of M Company. From Fort Dix to Vietnam.

WHAT DID I BRING TO MODERN TYPE EXPRESSIONISM? SIMPLICITY!

In my first days at Doyle Dane Bernbach, I was considered by a few of its star
art directors to be a "de-signer," a "Lubalinite," an implied allegiance of form over function.
It only took my first ad to make them understand that I was an in-your-ear graphic
communicator (see No.12). The key word in understanding my approach to communicating
graphically and typographically is simplification – in concept and design.
My work during my career, whether in print ads, television commercials, magazine covers,
or packaging was to communicate directly, with a fusion of image and word,
backed by what I call *The Big Idea*, to sear a product's unique virtues into a consumer's
brain. I have always considered that my role as an art director was to
transform communication from that of a design artisan to that of a shaper of ideas.
As a mature designer, my use of typography has always been dramatic,
ultrareadable simplicity. The above and the following fifteen pages are examples
of how I followed Herb Lubalin's lead and made my type talk.

The words are a GI's
horrified reaction as he
comes upon the body
of a dead Vietnamese child,
more than two years
before the world heard of
the My Lai massacre.
I was sharply criticized by
members of Congress
for my "premature" indictment
of the Vietnam war on the
October 1966 cover of *Esquire*.

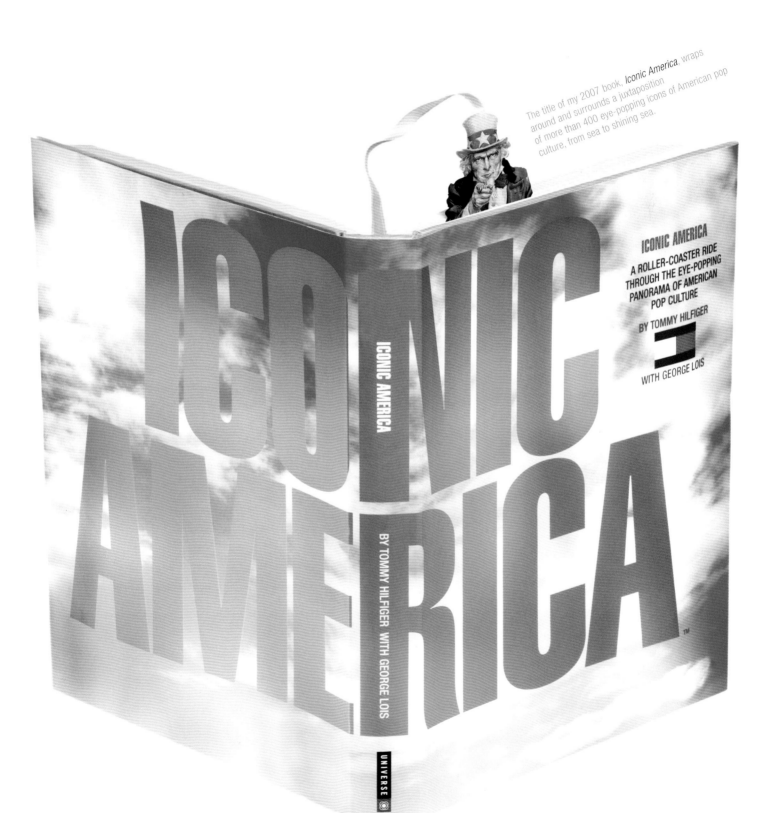

The title of my 2007 book, *Iconic America*, wraps around and surrounds a juxtaposition of more than 400 eye-popping icons of American pop culture, from sea to shining sea.

ICONIC AMERICA

A ROLLER-COASTER RIDE THROUGH THE EYE-POPPING PANORAMA OF AMERICAN POP CULTURE

BY TOMMY HILFIGER

WITH GEORGE LOIS

ICONIC AMERICA

BY TOMMY HILFIGER WITH GEORGE LOIS

UNIVERSE

My Wolfschmidt Vodka campaign,
week after week, showed inanimate objects
talking a blue streak with
Wolfschmidt, all in sexy double entendre.

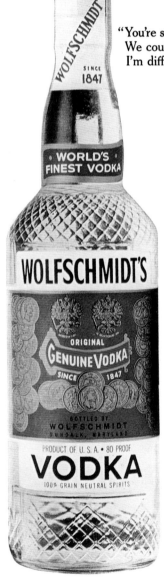

"You're some tomato.
We could make beautiful Bloody Marys together.
I'm different from those other fellows."

"I like you, Wolfschmidt.
You've got taste."

Wolfschmidt Vodka has the touch of taste that marks genuine old world vodka. Wolfschmidt in a Bloody Mary is a tomato in triumph. Wolfschmidt brings out the best in every drink. General Wine and Spirits Company, N.Y. 22. Made from Grain, 80 or 100 Proof. Prod. of U.S.A.

The final insult to the Edsel, the most spectacular failure
in the history of the American auto industry,
is this graphic in my *Iconic America* book, visualizing the Edsel
as synonymous with the proverbial "lemon."

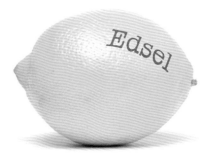

The week after the Wolfschmidt
bottle romanced a tomato, an orange
(an avid reader of *Life* magazine)
puts down the flirting wolf.

"You sweet doll, I appreciate you. I've got taste.
I'll bring out the real orange in you. I'll make you famous.
Kiss me."

"Who was that tomato
I saw you with last week?"

Wolfschmidt Vodka has the touch of taste that marks genuine old world vodka. Wolfschmidt in a Screwdriver is an orange at
its best. Wolfschmidt brings out the best in every drink. General Wine and Spirits Company, New York 22, N.Y. Made from Grain, 80 or 100 Proof. Product of U.S.A.

"John, is that Billy coughing?"

"Get up and give him some Coldene."

In 1960, my first ad at Papert Koenig Lois.
No product, no ingredients,
no diagrams, no body copy, no logo.
Just a darkened bedroom
with a sleepy couple being awakened
by their coughing kid.
Their prefeminism repartee was the
talk of the ad world in 1960.

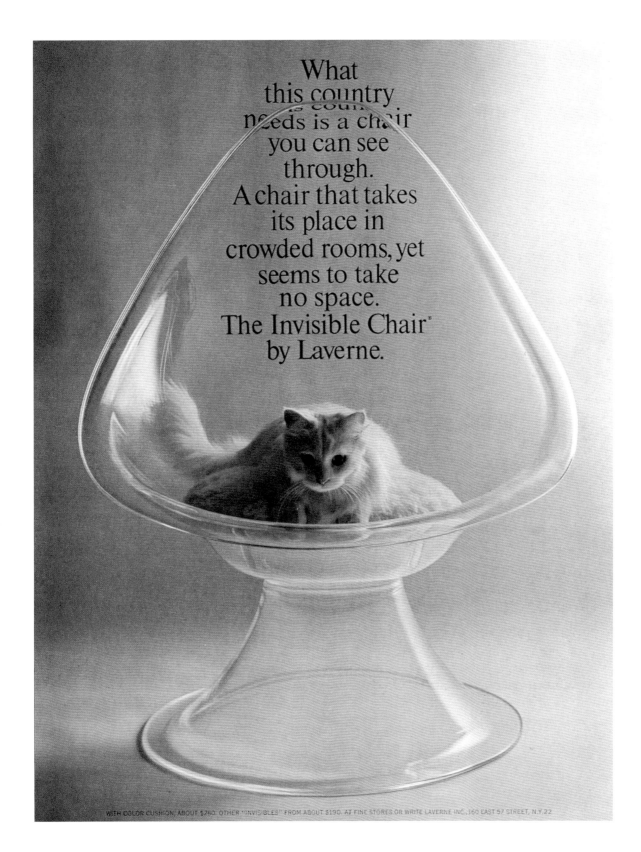

What
this country
needs is a chair
you can see
through.
A chair that takes
its place in
crowded rooms, yet
seems to take
no space.
The Invisible Chair®
by Laverne.

WITH COLOR CUSHION, ABOUT $260. OTHER "INVISIBLES" FROM ABOUT $190. AT FINE STORES OR WRITE LAVERNE INC., 160 EAST 57 STREET, N.Y. 22

In 1960, my first color ad at Papert Koenig Lois—
the ideal marriage of art and copy.
When you read, "a chair you can see through,"
you actually do! (Is that clear?)

In 1987, the Type Directors Club published *A Twenty-Four Page Book*, bemoaning the hard-to-find, slighted page number in publications. It had asked 24 designers to create a page on which their assigned number would "emerge as the center and focus, indeed the totality of the page." I was given the numeral 13. My design reflects the total absence of that unlucky number in many American buildings (and their elevators).

Spotting the word "ouch" in the middle of the word "Voucher" gave me a visual-word mnemonic, a powerful statement against the proposed undemocratic school program.

There's an ouch in every Voucher!

Just try to say "Voucher" without saying "ouch!"
The Voucher School Program can hurt your kids,
hurt your school, hurt your country, and hurt you.
To find out why, call or write the
Citizens Committee for Public Information on Vouchers
40 West 57th Street, New York, NY 10019

**CITIZENS COMMITTEE
FOR PUBLIC INFORMATION
ON VOUCHERS**

1.800.VOUCHER

24
23
22
21
20
19
18
17
16
15
14
12
11
10
9
8
7
6
5
4
3
2
1

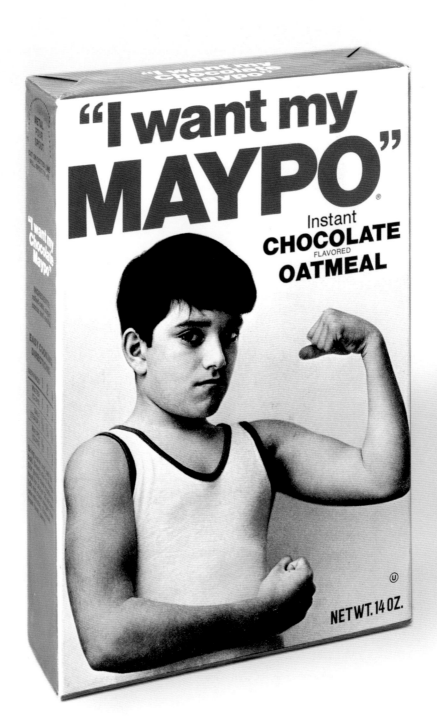

Maypo had been a cereal for the three-to-six-year-old market. To corral the older kids, I showed husky, contemporaneous boys. The superboy on this chocolate-flavored Maypo package is my son Harry when he was ten, exclaiming "I want my Maypo." The popular advertising slogan, slapped on the front of the Maypo box, was a knockout on the supermarket shelf.

You don't have a cold!
I dode hab a code?
You have an allergy!
I hab an allergee?

It can sneeze like a cold, tear like a cold, sniff like a cold, cough like
a cold, blow like a cold, feel like a cold—and still be an allergy. One
way to tell: if you have 3 or more colds a year, the chances are good
your cold is an allergy.* Take Allerest.
 This new tablet calms the cough, the sneeze, the tears, the runny
nose, the itchy eye of allergic colds. No cold tablet can work as well.

If you wake up sneezing, take Allerest. If you have 3 or more colds
a year, take Allerest. If you...ah-ah-choo! Take Allerest.
 (*When you have a cold, you usually develop resistance that
should protect you for some time. So if you have repeated colds, 3
or more a year, take Allerest. Your druggist has Allerest and will tell
you about it.) 24 tablets for $1.25 – PHARMACRAFT LABORATORIES

ALLEREST FOR ALLERGY

WHAT ALLEREST HAS: ALLERGY SPECIFICS DOCTORS PRESCRIBE: PHENYLPROPANOLAMINE HYDROCHLORIDE 25 MG.; CHLORPHENIRAMINE MALEATE I MG. & METHAPYRILENE FUMARATE 5 MG.; CALCIUM ASCORBATE 37½ MG.
WHAT ALLEREST DOESN'T HAVE: UNLIKE COLD AND SINUS TABLETS, NO ASPIRIN, NO ANALGESICS. (SOME PEOPLE ARE ALLERGIC TO THEM.) NO CAFFEINE, NO BARBITURATES, NO STIMULANTS, NO HABIT FORMING DRUGS.

Blowing up the Cutty Sark
Scotch label with the
funky type and wrapping
it around a holiday
gift box created a startling
Pop Art effect.
And four boxes placed
side by side on
a liquor store shelf
(or in a store window)
created an
eye-popping poster!

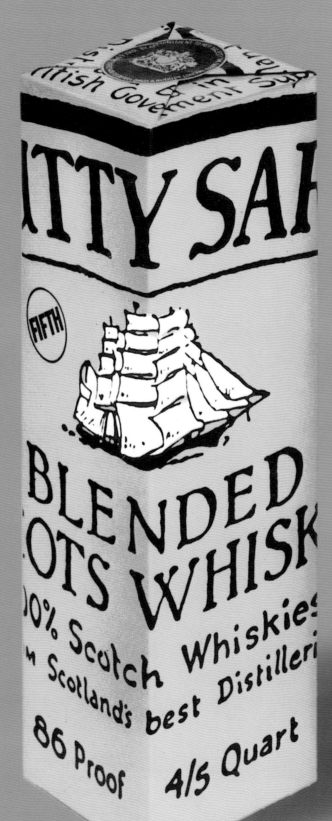

America's roast beef yes sir!

For an **Arby's** ad campaign,
a definitive design
that spells out precisely
who Arby's is.

During a horrendous seven-year period when a military junta ruled Greece (1967–74),
Washington tacitly approved the fascist Greek colonels' takeover.
Concentration camps defiled the land that first created democracy. This was one of a series
of ads to raise money to help political prisoners and their families
stay alive (and to raise doubts about the morality of tourism). A decade later I helped
bring tourism to a democratic Greece with my ad campaign,
I'm going home...to Greece, where it all began.

Weep for Greece.

Poor betrayed Greece.
Dead speech.
Dead press.
Dead liberty.

The silence makes it worse.
Greece is so quiet today, that it's easy to forget.
Across that gentle land, a wicked government demands
allegiance, exacts obedience, destroys opposition.
The list of political prisoners grows every day.
The torture of "traitors" is refined, hour by hour.

To: North American Greek Relief Fund.
% St. Peter's Episcopal Church
346 West 20th Street
New York City, 10011

I can afford $_____
I enclose my check for that amount.
This is how we distribute contributions:
$28.50 per month to families of political prisoners.
$42.30 per month to large families.
$14.10 per month to relatives living alone.

NAME_____

ADDRESS_____

CITY_____ STATE_____ ZIP_____

Which of the candidates for the United States Senate

has the better chance of becoming

a great United States Senator?

A *great* United States Senator.

Type in a TV spot can be hypnotic if it's expressing a uniquely powerful message. Two years after President John F. Kennedy was assassinated, his younger brother Robert ran for the Senate in New York. I created commercials that evaporated his "carpetbagger" problem, but as we entered the final week of the campaign, I was shaky about a large bloc of undecided voters. I begged Kennedy to let me produce this spot: With a visual of a foreboding black background, we hear an ominous voice saying, *When you're in the election booth, think about this*...the voice-over continues as we begin seeing the words to the left dramatically appear, phrase by phrase. The astounding thing about the commercial was that I never identified that it was a **Robert Kennedy** ad! After he won with a plurality of 720,000 votes, Bobby and his campaign manager, brother-in-law Steve Smith, said to me, "Maybe we would still have beaten Senator (Kenneth) Keating without your last-minute attack, but that was the best political commercial we ever saw!"

ELVIS
LIVES

lvis Presley, the King of Rock 'n' Roll,
s immortalized with this color treatment
f the world famous line, *Elvis Lives*,
naking a mystical graphic connection of
he five letters in each iconic word.

These Dimetane ads that ran in medical magazines directed at doctors are part of a campaign I created in 1956 while I was in charge of consumer advertising at Sudler & Hennessey, a pharmaceutical ad agency. A half-century later, they are mistakenly thought to have been designed by Herb Lubalin, one of my inspirational mentors, who was a partner at S&H. Herbie, who died too young, in 1981, had a profane way with words (as well as type). He once wrote of me: "Lois is a four-letter word for talent." Every time I visit the Herb Lubalin Study Center of Design and Typography at Cooper Union and see my Dimetane ads, my heart swells with pride — but I get the urge to scratch my head.

1. HARALAMPOS LOIS

My father had been a shepherd in a primitive mountain hamlet that scraped against the Greek sky, high above the northern rim of the Isthmus of Corinth, a hundred miles west of Athens. In 1907, when he was 14, he came down from the mountain on a bony mule and headed, alone, for America. His heartfelt loyalty to his Greek ancestry and his passion for forging a new life in a new world taught me that to live a fulfilling life, a man must live, and act, courageously.

2. IDA ENGEL

Growing up in a loving Greek family in the Bronx, it was understood that the only son of Haralampos and Vasilike would finish high school and take over his father's florist shop. But my drawings at P.S.7 caught the eye of my seventh-grade art teacher, Mrs. Engel, who handed me a black, stringed portfolio filled with my drawings, which she had saved, and sent me to the High School of Music & Art (a brilliant specialized school founded in 1936 by Mayor Fiorello LaGuardia) for an all-day entrance exam. When I was enthusiastically accepted, I knew that I would never be a florist.

3. PAUL RAND

At the very pinnacle of my graphic forefathers stands the name of Paul Rand. Cantankerous, irascible, loving—bristling with talent, brimming over with taste, and endowed with invincible personal conviction—the original and badass Rand showed the way. His fresh, pioneering work first appeared in 1938, and when I entered high school, in 1945, he had already acquired international stature, accelerated by his 1947 book *Thoughts on Design*, which takes an honored place in my extensive library. Now a tattered bible, I read and reread it a thousand times in my early teens. Rand's talent and instinct created an absolutely supreme standard for the rest of my life. When the Pratt Institute Gallery (in Brooklyn) was inaugurated in 1985, honoring Pratt's most important students with a two-man exhibition entitled *Paul Rand & George Lois, The Great Communicators*, it was a young boy's dream come true.

4. HERSCHEL LEVIT

I suffered through my first year at Pratt because it was an unsophisticated rehash of my formative years at the High School of Music & Art. But after the few months of my second year, Herschel Levit, a bow-tied, aesthete design teacher, jump-started my career by sending me to Reba Sochis. Mr. Levit inspired 31 years of Pratt students, and amazingly, seven of his student protégés have been inducted into the Art Directors Club Hall of Fame: George Lois—1978; Steve Frankfurt—1983; Len Sirowitz—1985; Steve Horn—1987; Bob Giraldi—1991; Sheila Metzner—1997; and Stan Richards—1999.

5. REBA SOCHIS

The greatest day of my professional life was when I met Reba Sochis—a great designer, a great dame, a great curser. The loveliest lady in the world of design (with a nose more crooked than mine) was the first of the creative pioneers I worked with who were inducted into the Art Directors Club Hall of Fame (joining Bill Golden, Herb Lubalin, Bill Bernbach, and Bob Gage). One week out of Pratt, when I cashed my first paycheck of $45, I couldn't believe I was actually being paid to refine my craft in her queendom of perfectionism.

6. BILL GOLDEN

After being drafted into the Army and returning home from Korea in 1953, Reba Sochis sent me to Lou Dorfsman at CBS Radio, who sent me to CBS Television, the most elite atelier of brilliant design talent in the world. Bill Golden, another totally fearless, uncompromising perfectionist, was my boss. Golden was the father of corporate image, symbolized by the CBS Eye. To a young designer (I was 22) he was an icon of integrity, taste, and courage.

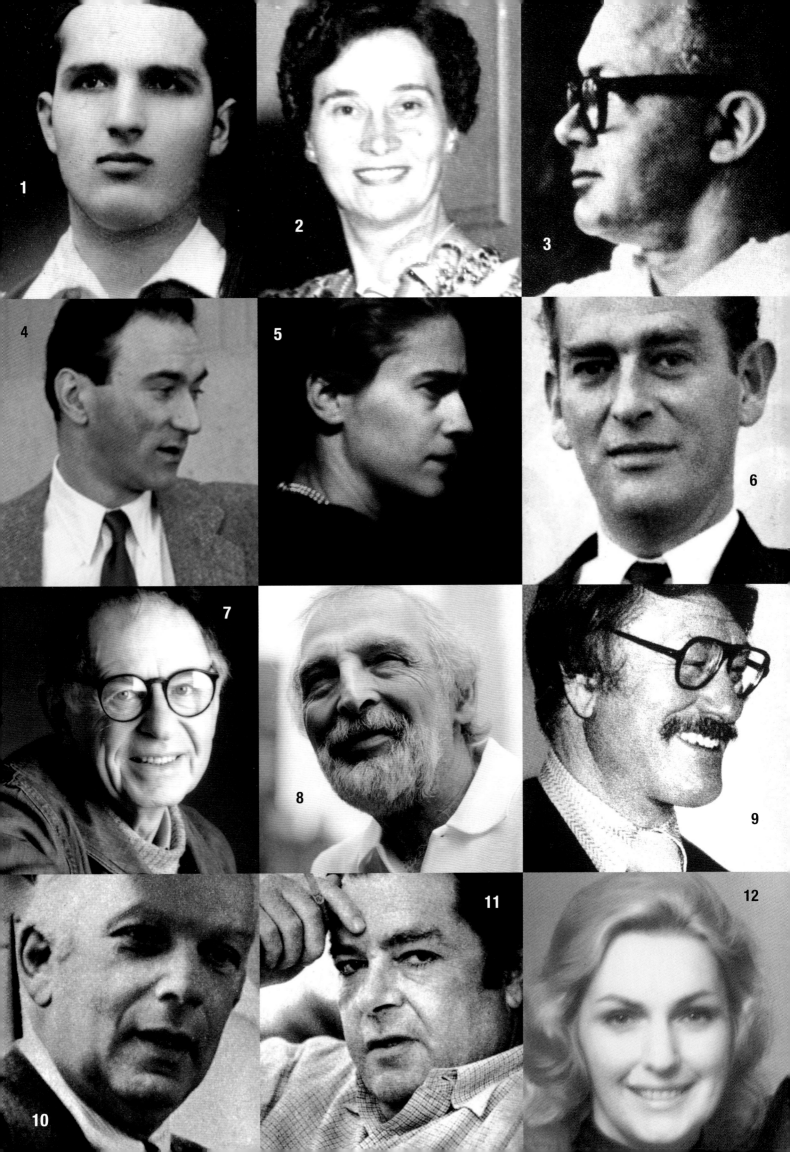

7. KURT WEIHS

I met the unassuming, courtly Kurt Weihs in 1953 at CBS Television, when he brilliantly supervised Bill Golden's advertising department. In 1949, he had designed the CBS Eye, inspired by the all-seeing eye of God drawn on a nineteenth century Shaker birth certificate that Golden had spotted on the cover of *Antiques Magazine*. Kurt and his childhood sweetheart, Erika, somehow escaped Austria after Hitler had taken power, among only a few in their families who survived the Holocaust. When I started my ad agency in 1960, I stole Kurt away from CBS and he worked alongside me for another 40 glorious years. It inspired me just knowing he was sitting next door, in five beautifully designed agency offices we created together.

8. HERB LUBALIN

Leaving Bill Golden's ivory tower was wrenching, but I knew that working alongside Herb Lubalin was my next step to stardom. Herbie was a meteor in the graphic arts field. His pages glistened, his type talked, his ideas moved. And his influence throughout the entire world was enormous. (His color choices in his ads, editorial, logos, and promotional pieces were always unexpected and handsomely unusual. Then I found out he was color-blind!)

9. LOU DORFSMAN

Lou Dorfsman, I'm proud to say, has been my mentor since the day he interviewed me and sent me to Bill Golden. Then in 1956 he convinced me to do a stint with his best pal, Herb Lubalin. A few years later Lou chickened out on starting the new ad agency Herb Lubalin and I wanted to open: Lubalin Dorfsman Lois. We designed a letterhead, found office space, but it didn't happen. To console me, Lou once again orchestrated moving me to the top of the ad world by sending me to Bill Bernbach's breakthrough creative agency, Doyle Dane Bernbach. I quickly got a hot reputation, and a year later started my own agency, Papert Koenig Lois. I can't imagine what my life would have been like without the influence and friendship of one of the design masters of our time, Lou Dorfsman.

10. BILL BERNBACH

Bill Bernbach was the greatest force for good in an industry that is still regarded by too many as an evil occupation. When copywriter Bernbach emerged on the scene in 1948 (the year he founded Doyle Dane Bernbach), he was the loneliest of voices in a wilderness of schlock. Bernbach precipitated what the marketing world now accepts as the Creative Revolution. In 1960, following in his groundbreaking footsteps, I started the world's second creative agency, and the Creative Revolution of the '60s bloomed and flowered.

11. BOB GAGE

Doyle Dane Bernbach got its initial creative reputation from the graphic power of Bob Gage's immensely warm and humane advertising. In the early '50s, Gage tackled the printed page and it hasn't been the same since. He made it jump. He made it shout. And he made it look simple. The four greatest advertising art directors of all time (in my unashamed opinion) were Bob Gage, Bill Taubin, Helmut Krone, and yours truly, and in the late '50s, the four of us worked in successive rooms at DDB. We were thrilled to be in one another's company, but competed with a frightening passion. But Gage was the first.

12. ROSEMARY LOIS

When I say, "I'd like to thank my wife" (as in a typical Oscar acceptance speech), it isn't just paying loving lip service. In two years of going steady, and 57 years of marriage, she has loved me, fed me, raised our kids, was one of the few female art directors of her time, has a career as a dynamic easel painter, and sees (and OKs) everything I produce and then some—working with me as a thinker and copywriter on ads, TV spots, slogans, and brand names I usually take credit for. What a dame!

1931 George Lois is born June 26 in Manhattan, to immigrant Greek parents, Vasilike Thanasoulis Lois and Haralampos Lois. (Lois is not an anglicized name. Logios, meaning "orator," has been traced back to the time of Alexander the Great.)

1932 Haralampos opens Columbia Florist at 231st Street and Broadway, in the Irish Catholic section of the West Bronx, New York, where George and his older sisters, Paraskeve and Hariclea, are raised.

1945 George divides his boyhood between delivering flowers, schoolwork, sports, and drawing, drawing, drawing. Ida Engel, his art teacher at P.S. 7, sends her student to the High School of Music & Art.

1949 His heroes are Joe DiMaggio, Franklin Delano Roosevelt, Constantin Brancusi, Arturo Toscanini, Stuart Davis, and the trailblazing designer Paul Rand. George graduates and enters Pratt Institute in Brooklyn, tuition paid with years of flower-delivery tips. He meets Rosemary Lewandowski and it's love at first sight.

1950 In his second year at Pratt, Herschel Levit, Lois's design teacher, sends him to Reba Sochis, the owner of a stylish design studio, where he becomes her protégé.

1951 Underage, and without the consent of his parents, George and Rosemary elope (the smiling bridegroom above).

1952 Lois' career is interrupted by Army service in the Korean War (photo above taken during R&R in Tokyo).

1953 Newly returned from Korea, mentor Lou Dorfsman sends Lois to Bill Golden at CBS Television. He is a multi-award winner at the New York Art Directors Club and American Institute of Graphic Arts award shows.

1955 Lois leaves CBS to enter the roughhouse world of advertising, joining the Lennen & Newell ad agency. His time there is brief and explosive.

1956 He escapes to Sudler & Hennessey. Working alongside Herb Lubalin as the creative director of its consumer division, he wins dozens of design awards.

1958 Intervening once again, Lou Dorfsman sends Lois to Bill Bernbach at Doyle Dane Bernbach ("the only creative agency in the world"). He becomes a driving force in the Creative Revolution and wins three gold medals at the New York Art Directors Club show for his work on Volkswagen, Chemstrand, and Goodman's Matzos. His dream year comes to a climax with the birth of his first son, Harry Joe.

1960 At age 28, George Lois and Julian Koenig leave DDB to found Papert Koenig Lois. George is the first art director in history with his name on the masthead of an important ad agency. After a few months, PKL is referred to as "the second creative agency in the world." The Creative Revolution is in full gear.

1962 Lois' first iconic *Esquire* cover hits the newsstands in October. Luke George Lois, George and Rosie's second son, is born.

1963 Papert Koenig Lois becomes the first publicly held ad agency in history. Lois is named Art Director of the Year by the Art Directors Club of New York.

1965 George's first visit to his tiny ancestral village of Kastania, in Greece, with Rosemary and his proud father at his side.

PAPERT KOENIG LOIS ACCOUNTS
1960–67 (partial list):

Allerest: *Ah, Nature – Ah Choo!*
Aunt Jemima Syrup:
Aunt Jemima, what took you so long?
Breakstone Yogurt:
Breakstone, the more cultured yogurt!
Charley O's: *This is the kind of bar I always wanted to open, and finally did.*
Charlie Brown's Ale & Chop House:
Let's talk it over at Charlie Brown's.
Dilly Beans:
Break the smoking habit – eat Dilly Beans!
Robert F. Kennedy (for Senate):
Let's put Bobby Kennedy to work for New York!
La Fonda del Sol:
We said fiesta at La Fonda del Sol, not siesta!
National Airlines:
Is this any way to run an airline? You bet it is!
New York Herald Tribune:
Who says a good newspaper has to be dull?
Puss 'n Boots:
Who knows more about cats than Puss 'n Boots!
Simplicity Patterns:
If I can sew, you can sew.
Wolfschmidt: *If vodka has no taste, how come I can tell which one is Wolfschmidt?*
The Newarker (airport restaurant):
The Newarker must be a great restaurant – look at all the planes parked outside!
Trattoria: *The Trattoria is full of Bologna!*
Xerox: *Terrific – but which one is the original?*

1967 The restive Lois leaves Papert Koenig Lois to start all over again. PKL, he feels, had grown too fat and comfortable for his taste and becoming a public corporation had altered the soul of his agency. With his new partners, Ron Holland and Jim Callaway, Lois Holland Callaway soon repeats the rapid success of PKL.

1968 Rosemary Lois (Lewandowski-Lois) has her first one-woman art show, with a glowing review in the *New York Times*.

LOIS HOLLAND CALLAWAY ACCOUNTS
1967–77 (partial list):

Mayor Lee Alexander: *One of the Six Best Mayors in America.*
Braniff: *When you got it, flaunt it!*
Channel 2 News:
Boy, what a bunch of Newsbreakers!
Cutty Sark: *Don't Give up the Ship!*
Harrison J. Goldin
(for New York City comptroller):
The Young Dynamo!
Edwards & Hanly:
The Brokers you've waited for.
Heckers Flour: *Unbleached Forever.*
Inver House Scotch Whiskey:
Inver's in, in Miami.
Senator Warren Magnuson:
Keep the big boys honest!
Maypo cereal: *I Want My Maypo!*
Milk plus 6: *Like my hair?*
Meet my hairdresser. (We show a cow.)
Naugahyde: *The Nauga is ugly, but his vinyl hide is beautiful.*
New York Post:
New York is a newspaper town again!
Olivetti typewriters: *The Olivetti Girl.*
OTB: *Bet with your head, not over it.*
Ovaltine: *Meet my old pal Ovaltine!*
Perhaps perfume: *Have Chanel and Arpege heard the news? Perhaps.*
Pirelli: *P-i-r-e-l-l-i...Pirelli – the molto fantastico tire.*
Pontiac Choir Boys: *Now hear our gentle voices calling: Please bring dough!*
Redbook magazine: *Redbook, frankly, is written for Young Mamas.*
Royal Air Maroc:
I'm off on the Road to Morocco.
Senator Hugh Scott: *The most powerful senator Pennsylvania ever had.*
The Star (weekly tabloid):
Reach for a Star.
Wheatena: *I know I feel Meaner when I eat my Wheatena.*

1971 Elected president of the Art Directors Club of New York, Lois founds the Art Directors Club Hall of Fame, the ultimate recognition of lifetime achievement in advertising and design creativity for professionals throughout the world.

1972 The publication of Lois's first book, *George, be careful*, receives rave reviews. The *New York Times* says, "George Lois may be nearly as great a genius of mass communications as he acclaims himself to be."

1974 *The Seven Year Itch*, a retrospective at New York's TGI Gallery, exhibiting seven years of work from Lois Holland Callaway, packs 'em in.

1975 Lois initiates a passionate battle to exonerate Rubin "Hurricane" Carter. He draws bolts of criticism from the conservative press, the advertising press, and finally, some important clients. (Undaunted, he is vindicated in 1988 when Carter is freed by the U.S. Supreme Court.)

1976 His book *The Art of Advertising* is published by Harry N. Abrams, soon to be called "the bible of mass communications."

1977 Lois stuns Madison Avenue—again. He quits LHC to become president of an industrial-corporate ad agency, Creamer FSR. During a whirlwind fifteen months, the obscure agency (with its name changed to Creamer Lois) becomes the hottest creative agency in America.

1978 The sudden, tragic death of his beloved, gifted 20-year-old son, Harry—mourned forever by the Lois family.

1978 Soon after the death of George's son, Lois becomes the youngest inductee into the Art Directors Club Hall of Fame. His friend Senator Bill Bradley makes the emotional presentation.

1978 Citing a profound dispute over business practices, George departs Creamer Lois. He starts the fourth agency to bear his name, Lois Pitts Gershon. Marketing pro Bill Pitts and media guru Dick Gershon become partners. Once again Lois's agency is instantly successful, remaining intact (eventually called Lois/USA) until his "retirement" in 1999.

LOIS/USA ACCOUNTS
1978–99 (partial list):

AFL-CIO: *Union, Yes!*
Arby's: *America's Roast Beef, Yes Sir!*
Circuit City: *The lowest prices in town, without haggling!*
Data General: *Mainframe power in a pizza box.*
Morton Downey Jr.: *The Mighty Mouth of Television!*
ESPN: *In Your Face!*
Food and Wine from France: *French wine is French art.*
Greek National Tourist Organization: *Go home to Greece, where it all began.*
Harrah's Marina Hotel Casino: *The other Atlantic City.*
HBO Comedy: *We're talking serious comedy here.*
Tommy Hilfiger: *A star is worn!*
Honda dealers: *Honda, the car that sells itself.*
InterContinental Hotels: *InterContinental, encore et encore!*
Jiffy Lube: *We get you because we're fast, we keep you because we're good.*
Lifestyle condoms: *It's a matter of condom sense.*
MTV: *I want my MTV!*
Nickelodeon: *Nickmania!*
New York Blood Center: *Give blood. Save a neighbor.*
North American Greek Relief Fund: *Weep for Greece.*
Purolator Courier: *Call 1.800.BEEP.BEEP!*
Reebok Pump: *Pump up and Air out!*
Rio All-Suite Hotel & Casino, Las Vegas: *Where the hidden you comes out to play!*
Ritz Camera Centers: *Say cheese...with Ritz!*
Signature magazine: *There's power in a Signature.*
Slomin's Home Security: *Shield your home—the Slomin's Shield.*
Time magazine: *Make time for Time.*
Pauline Trigère: *A Dear John letter to John Fairchild.*
Trump Castle: *Live the Trump life!*
USA Today: *First they called us McPaper. Now they call us No. 1!*
WABC-TV Eyewitness News: *We're here to tell you the truth.*
Warner Amex Cable Communications Inc.: *America is going WACCI!*

1982 Lois receives an honorary Doctor of Fine Arts degree from Pratt Institute for his "trendsetting career in advertising," and gives an inspirational speech, the first keynote address ever given by an advertising art director in Pratt's history.

1984 The One Club adds art directors to its Copywriters Hall of Fame. The newly named Creative Hall of Fame inducts George Lois as one of its first art directors.

1985 A two-man retrospective, *Paul Rand & George Lois, The Great Communicators*, inaugurates the new Pratt Institute Gallery in Brooklyn, to honor its "two most illustrious alumni."

1987 Another Lewandowski-Lois retrospective.

1989 George and Rosemary's first grandson, George Harry Lois, is born to Luke and Diane Lois.

1990 *The Wall Street Journal* names "The 10 Best Marketing/Advertising Breakthrough Successes of the Previous Decade." Four out of ten are from the Lois agency (MTV, USA Today, Jiffy Lube, and Tommy Hilfiger).

1991 George Lois' third book, *What's the Big Idea?*, becomes a primer for advertising and marketing schools throughout the world.

1992 A second grandson, Alexander Luke Lois, is born.

1993 *Art & Antiques* magazine names Rosemary and George Lois one of America's Top Art Collectors for the eighth year in a row.

1994 Lois receives the School of Visual Arts Masters Series Lifetime Achievement award, and is the subject of a comprehensive retrospective exhibit.

1995 The *Wall Street Journal* honors George Lois as a "Creative Leader."

1995 With the retirement of partners Bill Pitts and Dick Gershon, onetime client Ted Veru becomes a partner. National expansion brings growth to Lois/USA, with agencies in Chicago, Los Angeles, and Houston.

1996 *Covering the '60s: George Lois—The Esquire Era*, is published.

1996 The American Institute of Graphic Arts awards Lois the lifetime achievement Medal Award for being "the century's most accomplished progenitor of Big Idea advertising."

1998 The Hellenic Medal Society of New York presents Lois with the Distinguished Hellene Award, calling him "the Golden Greek of Advertising." George observes that "Golden Greek is redundant."

1999 *Advertising Age* names Lois "one of the most important men of advertising in the the twentieth century."

2000 Lois begins a new career creating books and as an entrepreneur, delving into new business concepts and products for the marketplace.

2001 Rosemary and George Lois celebrate their 50th wedding anniversary, more in love than ever.

2002 Phaidon publishes *$ellebrity*, George Lois' fifth book, dealing with his extraordinary ad campaigns using celebrities in fresh and outrageous ways.

2004 The Society of Publication Designers awards Lois its Herb Lubalin Lifetime Achievement Award, the first given to an ad man.

2004 Lois creates, pro bono, the ad campaign for Dennis Kucinich, the only Presidential candidate who voted against the Iraq war.

2006 George Lois' sixth book, *Ali Rap: Muhammad Ali, The First Heavyweight Champion of Rap*, is accompanied by an ESPN TV special.

2007 Lois creates his seventh book, *Iconic America, A Roller-Coaster Ride Through the Eye-Popping Panorama of American Pop Culture.*

2007 The AmericanLife TV Network taps Lois for an advertising and design program and the "I'm a Baby of a Baby Boomer" campaign is born.

2008 George Lois' iconic *Esquire* covers are installed in the permanent collection of the Museum of Modern Art, celebrated with a yearlong exhibit.

CREDITS

1 Réunion des Musées Nationaux / Art Resource, NY Drawing by George Lois © 1944 **2** Stedelijk Museum, Amsterdam, The Netherlands © Art Resource, NY George Lois High School design © 1946 **3** CBS letterhead, © George Lois **4** James Brooks, Fangle, 1973, acrylic on canvas, 76 x 76 inches: Collection Herb and Sue Yager, courtesy Manny Silverman Gallery, Los Angeles, Calif. Art © Estate of James Brooks / Licensed by VAGA, New York, NY. CBS Letters, © George Lois **5** Erich Lessing / Art Resource, NY Triple Crown sales kit, © George Lois **6** St. George and the Dragon by Albrecht Dürer, © Bettmann / CORBIS CBS ad, © George Lois **7** Ben Shahn, courtesy George Lois **7** Photo by Bill Jacobellis American Airlines ad, © George Lois **8** © Francis G. Mayer / CORBIS Esquire cover, © George Lois creator, photographer Harold Kreiger **9** Greek vase painting, collection of George Lois © George Lois creator, photographer Carl Fischer **10** Sweatshop, photographer unknown ILGWU ad, © George Lois **11** Hot dog, illustrator unknown Logo, © George Lois **12** Detail of Garden of Delights / Bosch, Hieronymus, © Erich Lessing / Art Resource, NY. Kerid ad, © George Lois **13** Courtesy George Lois Allerest ad, © George Lois **14** Hulton Archive/Getty Images Esquire cover, © George Lois creator, photographer Carl Fischer **15** © Morton Beebe/CORBIS Chair ad, © George Lois **16** Santa © George Hinke Esquire cover, © George Lois creator, photographer Carl Fischer **17** Tarzan and family, 1941 EV1765 Xerox ad, © George Lois **18** © The Metropolitan Museum of Art / Art Resource, NY and © 2008 Estate of Pablo Picasso / Artists Rights Society (ARS), New York Logo, © George Lois **19** Nickel photo © Luke Lois Esquire cover, © George Lois creator, photographer Carl Fischer **20** Giovanna delgi Albizzi Tornabuoni, 1488 (oil on panel) by Domenico Ghirlandaio (Domenico Bigordi) 1499-94. © Thyssen-Bornemisza Collection, Madrid, Spain/The Bridgeman Art Library Poster, © George Lois **21** © 2008 Man Ray Trust / Artists Rights Society (ARS), NY / ADAGP, Paris Esquire cover, © George Lois creator, photographer Carl Fischer **22** Lamp photograph, © 2008 Luke Lois, lamp courtesy Lillian Nassau, LLC Coty ad, © George Lois **23** Morocco, Marlene Dietrich, 1930, © Hulton-Deutsch Collection / CORBIS Esquire cover, © George Lois creator, photographer Carl Fischer **24** Film still from the collection of George Lois Braniff TV stills, © George Lois, Director Timothy Galfas **25** Film still from the collection of George Lois Esquire cover, © George Lois creator, photographer Carl Fischer **26** N.Y. Bets, © George Lois **27** Teke mask, courtesy George Lois Esquire cover, © George Lois creator **28** Publicity stills, courtesy George Lois Coty ad © George Lois **29** Esquire cover © George Lois creator, photographer Dick Richards **30** L.H.O.O.Q., 1919/64 (pencil over colour litho) by Marcel Duchamp (1887-1968) © The Israel Museum, Jerusalem, Israel / Vera & Arturo Schwarz Collection of Dada and Surrealist Art / The Bridgeman Art Gallery. © 2008 Artists Rights Society (ARS), New York / ADAGP, Paris / Succession Marcel Duchamp Esquire cover, © George Lois creator **31** Uncle Sam, Photograph by Carl Fischer Film still, George Lois creator, Director Timothy Galfas **32** Saint Francis in Meditation 1635-9, Francisco de Zurbarán, oil on canvas, 152 x 99 cm, The National Gallery, London. Esquire cover, © George Lois creator, photographer Carl Fischer **33** Masks courtesy of George Lois Logo, © George Lois **34** © 1959 United Artists Esquire cover, © George Lois creator, photographer Carl Fischer **35** Unsigned Japanese netsuke, Lion (shishi), mid 18th century, lacquer, h. 1 1/18 in. (2.8 cm), Toledo Museum of Art, Gift of H.A. Fee, 1950.78 Ad, © George Lois **36** Hulton Archive / 2004 Getty Images Photo by Luke Lois **37** © Al Hirschfeld. Reproduced by arrangement with Hirschfeld's exclusive representative, The Margo Feiden Galleries Ltd., New York, www.alhirschfeld.com Esquire cover, © George Lois creator, photographer Carl Fischer **38** with respect to 49.7.19, Petrus Christus, (Netherlandish, active by 1444, died 1475/76), Portrait of a Carthusian, 1446, Oil on wood, Overall 11 1/2 x 8 1/2 in. (29.2 x 21.6 cm); painted surface 11 1/2 x 7 3/4 in. (29.2 x 18.7 cm): The Metropolitan Museum of Art, The Jules Bache Collection, 1949 (49.7.19) Image (c) The Metropolitan Museum of Art / Art Resource, NY. Esquire cover, © George Lois creator, photographer Carl Fischer **39** Photo collection of George Lois Four Seasons photograph by Carl Fischer **40** © Bettmann / CORBIS New York, NY Esquire cover, © George Lois creator, photographer Carl Fischer **41** Esquire cover, © George Lois creator, photographer Carl Fischer Award photographed by Luke Lois **42** © Bettmann / CORBIS Esquire cover, © George Lois creator, photographer Carl Fischer **43** Printed by permission of the Norman Rockwell Family Agency Copyright © 1943 Norman Rockwell Family Entities Olivetti ad, © George Lois, photographed by Timothy Galfas **44** Courtesy George Lois © George Lois **45** Saint Sebastian postcard courtesy George Lois Esquire cover, © George Lois creator, photographer Carl Fischer **46** Movie poster, © Paramount Pictures Royal Air Maroc ad, © George Lois creator, photographer Carl Fischer **47** © 2008 Andy Warhol Foundation for the Visual Arts / ARS, New York / CORBIS Esquire cover, © George Lois creator, photographer Carl Fischer **48** Courtesy of D.C. Comics. Esquire cover, © George Lois creator, photographer (hands) Carl Fischer **49** Shaker Tree of Life, 1854 (drawing), Hancock Shaker Village, Pittsfield, Massachusetts, Hannah Cohoon. Poster, © George Lois **50** Courtesy George Lois Carter logo, © George Lois **51** Courtesy George Lois Esquire cover, © George Lois creator, photographer Carl Fischer **52** Master Commandant James Lawrence, USN (1781-1813), oil on wood, 28.5" x 23.5", by Gilbert Stuart (1755-1828), Boston, circa 1812. Painting in the U.S. Naval Academy Museum Collection. Bequest of George M. Moffett, 1952. Official U.S. Navy Photograph, now in the collections of the National Archives. Sales film still, George Lois creator, Director Timothy Galfas **53** AP Archive Esquire cover, © George Lois creator, photographer Tasso Vendikos **54** Palmist Chart, courtesy George Lois Ali hand-photograph by Carl Fischer **55** Film still courtesy George Lois Esquire cover, © George Lois creator, photographer Carl Fischer **56** Franz Xaver Messerschmidt: The Troubled Man, courtesy of the Oesterreichische Galerie Belvedere, Vienna. TV commercials, George Lois creator, Director Timothy Galfas **57** King Kong, 1933. Courtesy: Everett Collection Esquire cover, © George Lois creator, photographer Carl Fischer **58** Coin photographed by Luke Lois Harry Lois photographed by Reba Sochis **59** © Bettmann / CORBIS Esquire cover, © George Lois creator, photographer Carl Fischer **61** Collection of Herbert Egenolf, Germany Photo by Carl Fischer **62** Logo, © George Lois **63** © The Rolling Stones Copyright © 2007 MTV Networks, a division of Viacom International Inc. – All Rights Reserved. **64** Erich Lessing / Art Resource, NY Esquire cover, © George Lois creator, photographer Carl Fischer **65** © 2008 Andy Warhol Foundation for the Visual Arts / ARS, New York Photograph by Luke Lois **66** © George Lois **67** Courtesy George Lois Ad, © George Lois **68** Erich Lessing / Art Resource, NY and © 2008 The Munch Museum / The Munch-Ellingsen Group / Artists Rights Society (ARS), NY TV still, George Lois Creator, Director Ed Libonati **69** Copyright © 2007 MTV Networks, a division of Viacom International Inc. – All Rights Reserved. **70** Herscovici / Art Resource, NY and © 2008 C. Herscovici, London / Artists Rights Society (ARS), New York Cuisine, George Lois creator, photographer Carl Fischer **71** Courtesy of Marion Rand Ad, © George Lois **72** Courtesy George Lois TV stills, George Lois creator, Director Timothy Galfas **73** H. S. Wong / Stringer / Getty Images Esquire cover, © George Lois creator, photographer Carl Fischer **74** Courtesy George Lois **75** Photograph by Luke Lois Logo, © 2008 New York Commercial Bank **76** Ad photographed by Luke Lois **77** Courtesy George Lois Portrait by Sheila Metzner **78** Poster, © George Lois **79** Photographs courtesy George Lois All professor photographs by Luke Lois **80** © Krazy Kat King Features Syndicate Photograph by Luke Lois **81** Captain America, 1942. Courtesy of Marvel Entertainment, Inc. Alarmo, © George Lois **82** Uncle Sam by James Montgomery Flagg Digital art, © George Lois **83** © Estate of Elie Nadelman Photograph by Luke Lois **84** Courtesy George Lois TV campaign created by George Lois, Director Phil Arfsman **85** © 2008 Estate of Pablo Picasso / Artists Rights Society (ARS), New York Photograph by Luke Lois **86** John William Waterhouse, The Bridgeman Art Library TV campaign created by George Lois, Director Phil Arfsman **87** Publicity still courtesy of George Lois Digital art created by George Lois **88** Exeter ceiling photograph by Grant Mudford Logo © George Lois **89** Photograph by Luke Lois **90** Self-Portrait by Albrecht Dürer, 1500. © The Gallery Collection/Corbis Sumerian Idol, Photo Jean Mazenod/Citadelles & Mazenod, Paris Film still of Bob Dylan from Jokerman music video, created by George Lois, Director Jerry Cotts **91** Hulton Archive/Getty Images Poster, © George Lois **92** © Leonard de Selva / CORBIS Jolly Green Giant courtesy General Mills / Betty Grable 1943 / Everette Collection **93** Im-Peach logo, © George Lois **94** Courtesy George Lois Esquire cover, © George Lois, Creator Iconic America book photo by Luke Lois Wolfschimt ads, © George Lois Digital art, by Luke Lois Coldene ad, © George Lois Laverne ad © George Lois Voucher ad © George Lois A Twenty-four Page Book © George Lois Hebrew lettering © George Lois Maypo package © George Lois Allerest ad © George Lois Cutty Sark box design © George Lois Arby's graphic © George Lois Greek Relief Fund ad, © George Lois Robert Kennedy for Senator film clip, © George Lois Elvis graphic, © George Lois Dimetine ads, © George Lois

INDEX

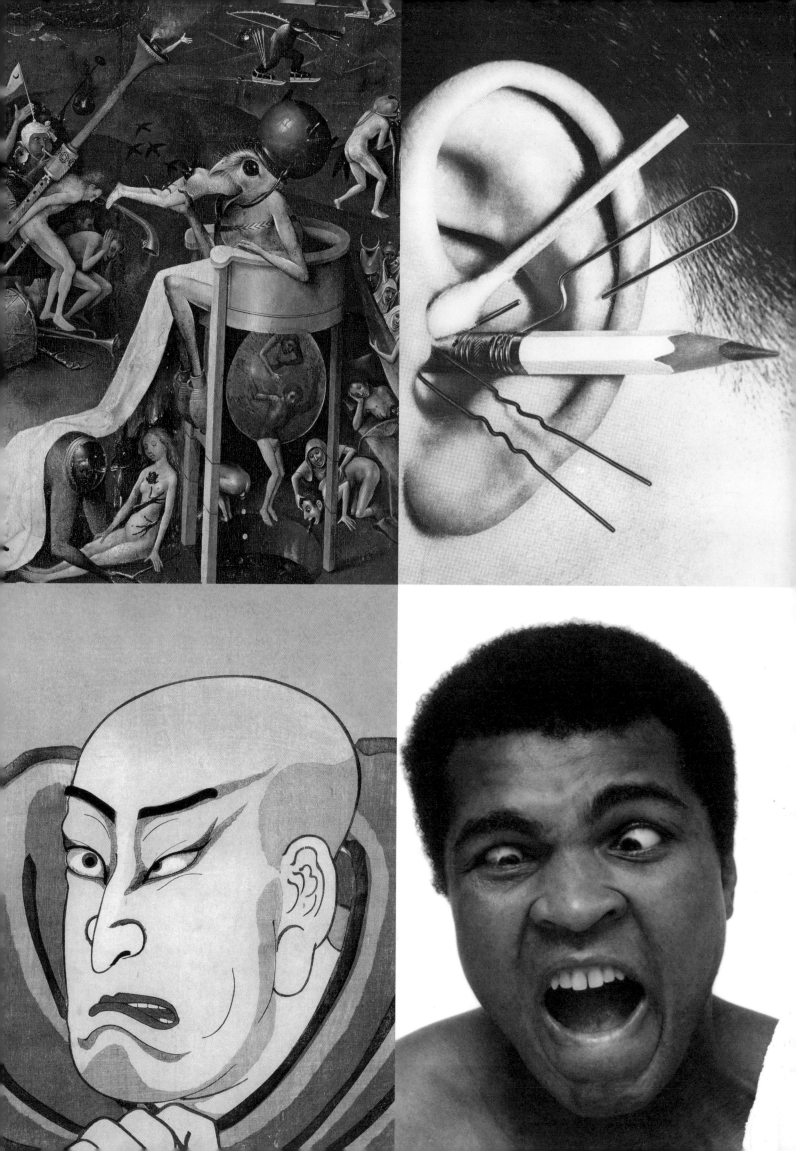